Classical New York

Classical New York

Discovering Greece and Rome in Gotham

Elizabeth Macaulay-Lewis and Matthew M. McGowan, Editors

EMPIRE STATE EDITIONS

AN IMPRINT OF FORDHAM UNIVERSITY PRESS

ESE NEW YORK 2018

Visit us online:
www.empirestateeditions.com
www.fordhampress.com

Library of Congress Cataloging-in-Publication Data available online at https://catalog.loc.gov.

Printed in the United States of America

20 19 18 5 4 3 2 1

First edition

CONTENTS

Reflections 235
Elizabeth Macaulay-Lewis and Matthew M. McGowan

This book grew out of a conference held at New York University in March 2015 on "Classical New York: Greece & Rome in NYC's Art, Architecture, and History." Four of those papers, those by Elizabeth Macaulay-Lewis, Margaret Malamud, Francis Morrone, and Jon Ritter, reappear here. The conference was sponsored by the New York Classical Club, a beloved, plucky nonprofit that has promoted the study of classical antiquity in New York City for over one hundred years (since 1900) and might well lay claim to treatment in a book like this. The idea behind the conference was to enrich and expand the conversations many of us had long been having in our classrooms, with our colleagues, on formal and informal tours of Grand Central Terminal or Wall Street's Federal Hall, to say nothing of Green-Wood Cemetery in Brooklyn or Sailors' Snug Harbor on Staten Island. We hope that this book enriches, expands, and enlivens those exchanges, even if the New York Classical Club has to wait for a successor volume to get its due. As with many conversations, much is left unsaid here or treated only cursorily, and even monuments of major significance—such as those at Green-Wood and Snug Harbor—have not been included at all. What we have here are instead soundings on the topic of "Classical New York," rather than a synthesis of what we know.

Thus, this book makes no claim to comprehensiveness. Like the conference before it, it aims to add breadth and depth to the conversations we have with our students, colleagues, friends, and you, dear reader, about the place and meaning of ancient Greece and Rome in our experience of New York City today. In fact, conversation lies at the heart of this book and goes beyond the words we exchange with one another to include the multiform dialogues, quotations, echoes, and reflections that link so many of New York City's buildings, sites, monuments, and works of art with ancient Greece and Rome. And not only with antiquity itself but also with the lengthy and variegated reception of the classical past from antiquity to the present.

Indeed, we take for granted that the "classical" of our title is hardly something static, a precise moment or fixed idea from fifth-century Athens or first-century Rome, hermetically sealed and magically transported to Midtown Manhattan to reappear, for example, in Old Pennsylvania Station (1910) or the New York Public Library's Main Building (1911). The classical here is something more protean and, we believe, more dynamic, for it is still alive in our interaction with some of New York's oldest buildings, such as St. Paul's Chapel (1766) in Lower Manhattan, as well as with some of its newest, like the

National September 11 Memorial & Museum (2011–14) nearby. In fact, the key to our title may lie in "discovering Greece and Rome," since this project has always been about discovery and the interplay of old and new. Of course, one can always quibble with titles, but leaving the cover blank—like the pediment of Federal Hall (see Morrone's chapter)—was not an option. What follows here, we hope, is a contribution, however modest and incomplete, to the conversation ongoing from classical antiquity about how we shape space—be it civic, religious, academic, theatrical, or domestic—and then, how we make use of that space and the objects in it. To that end, we ask only that you pick up and read: *tolle, lege*!

Classical New York

Classical New York

Elizabeth Macaulay-Lewis and Matthew M. McGowan

The Main Branch of the New York Public Library stands as a monument to the power of classical antiquity to inspire architectural form and shape civic space (Figure 0.1).[1] The architects behind the library, John Merven Carrère and Thomas Hastings, had been trained at the École nationale supérieure des Beaux-Arts in Paris in the early 1880s before apprenticing at McKim, Mead & White, the architectural firm most intimately connected to the rebirth of classical forms in New York City. In 1885, they set out to form their own practice, Carrère & Hastings, and by the time they received the commission to build the library in 1897, they were wholly devoted to the eclectic neoclassicism of the Beaux-Arts style.[2] Their building was dedicated in 1911 with great fanfare—the US president, the governor of New York State, and the mayor of New York City were all there—and it remains among the finest examples of Beaux-Arts architecture in the United States.[3]

Among the more notable classical features are the monumental arches of the library's entrance, which span three large bays, like those of the triumphal Arch of Constantine in Rome. In place of the statues of Dacian captives on the attic of Constantine's Arch, however, Carrère and Hastings let stand on their attic six eleven-foot-high sculptures representing History, Drama, Poetry, Religion, Romance, and Philosophy—understood to be the major genres of literature—and signifying the library's aspiration to be a public center of learning and culture for the burgeoning metropolis.[4] The direct quotation of Constantine's Arch and the more general evocation of imperial Rome in the library's grand façade no doubt resonated with citizens of New York, the de facto capital of a nascent American empire.[5]

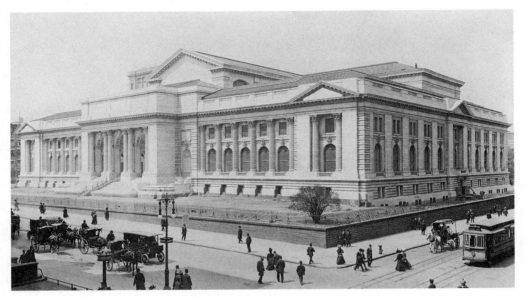

FIGURE 0.1. Main Branch of New York Public Library, Stephen A. Schwarzman Building at Forty-Second Street and Fifth Avenue, 1908. Detroit Publishing Company.
Courtesy of the Library of Congress.

Often forgotten about the library's Main Branch is its predecessor, the Murray Hill Distributing Reservoir, also known as the Croton Reservoir. This was New York City's first reservoir and the crown jewel of the Croton Aqueduct (1837–42), among the most ambitious public-works projects in the early life of a rapidly growing nation. The reservoir spanned over four acres along Fifth Avenue between Fortieth and Forty-Second Streets and was built in the style of a massive Egyptian temple with granite and gneiss walls nearly fifty feet high and twenty-five feet thick in places (Figure 0.2).[6] Along the tops of these walls were public promenades popular for strolling; these were considered an additional benefit of the reservoir.

Of course, the primary benefit came from the reservoir's clean water, which dramatically improved the quality of life in the city by helping prevent the spread of waterborne diseases such as yellow fever and cholera. The Neo-Egyptian enclosure, moreover, made a deft choice for such a dynamic feat of engineering. In the early nineteenth century, the architecture of ancient Egypt suggested to architects and patrons alike "strength, solidity and immortality in the face of the ravages of time."[7] At least in part because the Pyramids and the Sphinx still stood and could be visited, Egyptian architecture became a model in nineteenth-century Europe and the United States for technically advanced structures such as railroads and suspension bridges and, in the case of the Croton Aqueduct, also reservoirs.[8] Clearly, the proverbial waters of the Nile gave added significance to Neo-Egyptian elements in the reservoir's construction.

Like much else in New York City, however, what was new and sensational soon became outdated or merely "unexceptional."[9] By the 1870s, the Croton Reservoir, once a symbol of progress and modernity, stood as an emblem of New York's aging infrastructure, and

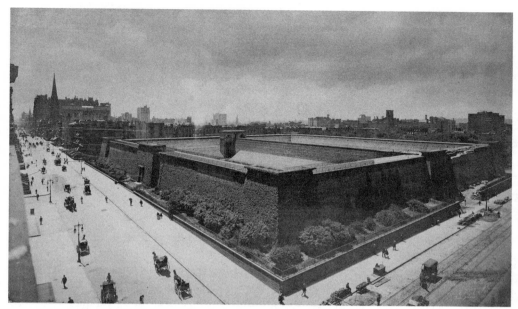

FIGURE O.2. The Murray Hill Distributing Reservoir, or the Croton Reservoir, 1899.
Courtesy of the Museum of the City of New York.

in 1877 the Department of Public Works proposed its demolition.[10] The reservoir stayed at least partly operative until 1890, by which time it was already a local pastime of sorts to suggest ideas for repurposing the site, for example, as a park, an armory, an opera, a polytechnic institution, and even a beer garden.[11] It was finally decided in 1897 to establish a public library formed out of the Astor and Lenox Library collections and supported by the resources of the Tilden Trust, the three sources acknowledged in inscriptions on the façade of the library's portico.[12] The site was of course advantageous, in the heart of Manhattan and readily accessible to the public.[13] Like its predecessor, the Croton Reservoir, the Public Library made the city a better place to live. In both instances, the architects repurposed key concepts and components of ancient architecture: Greek and Roman for the library and Egyptian for the reservoir. The reservoir's Neo-Egyptian features reflected the technological achievements of its construction and suggested a kind of permanence associated with the Pyramids and the Sphinx. By the same token, the adaptation of Rome's triumphal architecture and Paris's Beaux-Arts style demonstrated the genuinely lofty aspirations of New York City, the nation's economic and cultural capital with an imperial agenda of its own.[14] Both buildings contributed to New York's arrival over the course of the nineteenth century as a cosmopolitan city ready to invest in grand civic monuments in the service of the people.

This book, *Classical New York*, offers a selective survey of diverse and often divergent reinterpretations of classical antiquity in the art and architecture of New York City from roughly 1830 to about 1940. Throughout this study, we refer to the process of reinterpretation and appropriation of recognizably classical forms and motifs in contemporary buildings, monuments, and works of art as the "reception" of classical antiquity. Thus, the

stratified layering of two ancient civilizations in successive buildings along Fifth Avenue—the remains of the reservoir form the foundations for the library—serves as the beginning of our reflections on the reception of classical Greece and Rome as themselves successors to ancient Egyptian culture. Shane Butler has recognized the importance of such layering to the understanding of the reception of classical antiquity, and he pointedly allies his project of "Deep Classics" with the stratigraphical reading common in geology.[15] Butler's work serves as a helpful resource in conceptualizing the larger process of reception on view in many of the buildings and monuments analyzed in this volume. Still, our operative analogy is conversation and the complex and often fragmented communication that takes place when many parties are brought together.

Indeed, conversation lies at the heart of this book, which emphasizes the fluid and non-linear reception of classical antiquity. This is in keeping with recent work in classical reception studies, which has notably moved away from a longstanding focus on "tradition" (from the Latin *tradere*, to "hand down"). Scholarship on the "classical tradition" tends to accept that "literature, art, and social structures of antiquity were *handed down* to successive generations, to be transformed and absorbed into new institutions and cultures," as Craig Kallendorf has recently explained.[16] Although Kallendorf argues that the handing down of classical ideas and forms in literature and art involves the active participation of readers,[17] recent work in the reception of classical antiquity seeks to avoid the connotation of passivity implied in the unidirectional flow of influence passed on from antiquity to the present.[18] The discipline of reception studies, which has its roots in 1960s Germany and the principles of reception history (*Rezeptionsgeschichte*) and afterlife (*Nachleben*), employs reappropriation and reworking as interpretive terms where, in the words of Lorna Hardwick, "the focus is on the two-way relationship between the source text or culture and the new work and receiving culture."[19] The work of Hardwick and others—there has been an explosion of studies in the reception of classical antiquity since the early 1990s[20]—now constitutes a growing subfield of classical studies, which has in turn brought about a widening of what it means to study the cultures of ancient Greece and Rome. It is safe to say that, over against thirty years ago, we now have a much broader understanding of the exchanges between antiquity and later civilizations, exchanges that embrace everything from literature and art to science and cinema.[21] Yet there has been a notable gap in the study of archaeology, art history, and architecture in reworking and reinterpreting the material aspects of classical antiquity.[22]

We fully acknowledge—even happily celebrate—that the "classical" of our title has often been filtered through medieval, renaissance, or late-modern periods in places outside Greece and Italy and translated into something quite distinct from its Greco-Roman forebears. In many ways, the story of classical New York starts with neoclassical reinterpretations of Greek and Roman originals that could be found across Europe, particularly in Britain, France, and Germany. These northern European models often served as intermediaries between classical antiquity and the United States, where the reception of Greek and Roman art and architecture was rarely direct or based on firsthand contact with classical monuments, especially through the antebellum period (1790–1860). Books about the ancient world, however, had a wide readership in the nineteenth-century United States

and gave Americans virtual access to classical art and architectural forms.[23] When considering the reception of classical antiquity in New York and across the United States, it is helpful to keep in mind a process of "triangulation,"[24] where books on classical art and architecture blend with Americans' experience of the neoclassical or Beaux-Arts imported from Europe. This belongs to what we would call a "Neo-Antique" way of thinking, which was very at home in America during the period in question and which acknowledges that neoclassical (and Neo-Egyptian) buildings often combine ancient architectural styles with later ones.[25]

Indeed, after the Civil War, more American artists and architects started to study in Europe, especially at the École des Beaux-Arts in Paris, where like Carrère and Hastings they became familiar with different neoclassical styles that had flourished during the eighteenth and nineteenth centuries. They also began to visit Italy and Greece with greater frequency and to verse themselves directly in classical forms. By the end of the nineteenth century, American archaeologists were established enough, following their European counterparts, to begin the systematic study of ancient monuments and sites.[26]

The end of the nineteenth century also witnessed the most clear commitment on the part of American architects to their classical forebears in Greece and Rome. In 1893, the World's Fair in Chicago created the "White City," a collection of temporary buildings in neoclassical style, especially the style of imperial Rome, as part of the Columbian Exposition celebrating the four-hundredth anniversary of Christopher Columbus's exploration of the New World. The fair served as an occasion for the United States to demonstrate that it was the artistic, technical, and architectural equal of Europe. The pavilions of the Columbia Exposition were designed by the five most important American architectural firms, including three from New York City: Richard Morris Hunt, George B. Post, and McKim, Mead & White; one from Boston: Peabody & Stearns; and Van Brunt & Howe of Kansas City.[27]

The successful reinterpretation of classical forms at the Chicago World's Fair, and in particular the exuberant celebration of Roman architecture there, had a major impact on architectural developments in the United States. First and foremost, it made the classical corpus a viable source of influence and inspiration. As several contributors here note— Malamud, Ritter, Simard—the New York architectural firm of McKim, Mead, & White played a significant role in the design of the Columbian Exposition and became widely recognized as the preeminent representative of the Beaux-Arts style in New York City. The more general embrace of classical architecture by those involved in the fair also provided significant impetus to the most important contemporary trend in urban design, the City Beautiful movement.

Although its roots go back to the middle of the nineteenth century,[28] the City Beautiful movement gained its most critical momentum from the Columbian Exposition. Nearly a decade later, in 1901–1902, the McMillan Plan for Washington, DC, gave City Beautiful further prominence on a national level and paved the way for the marked influence the movement would have on the urban design of New York City in the early twentieth century. Neoclassical forms provided the movement with the architectural language it required, as, for example, in New York's Foley Square, which Jon Ritter discusses. The ideas of City

Beautiful also reverberated in more subtle ways in New York, as Jared Simard's chapter on the construction of Rockefeller Center demonstrates. Rockefeller Center is in many ways a city within a city, and the buildings, their design, and the complex's sculptural program create a stunningly unified effect in keeping with the basic tenets of the movement.

Yet from even before the nation's founding, the classical world had been an important part of the intellectual life of the United States.[29] As this volume aims to show, New York's artists and architects and their patrons repeatedly looked to the classical past for more than just forms; they sought knowledge, inspiration, and an air of refinement from Greco-Roman antiquity in designing buildings and erecting monuments. It is hard not to generalize here and thus to miss the individual trees for the proverbial forest, but we can be sure that, in New York between 1830 and 1940, the idea of "Greece and Rome" was used to lay claim to a status signified by architectural form, to structure the growing city's public spaces, and even to cultivate a civic identity and express social belonging. And no wonder: the classics of Greece and Rome lay at the heart of a traditional education in America from the very founding of the United States.[30] Of course, the history of the study of classical antiquity in American education lies outside the purview of this volume. Still, we might note, again in the broadest terms, that from the end of the eighteenth and through the nineteenth century, Americans shifted their attitude toward the classical past and replaced a fascination with Roman history and republicanism with an eclectic, more personal interest in (Athenian) Greek literature, philosophy, and culture.[31] This shift corresponds rather generally to American society becoming more democratic and to classics being displaced, by more practical disciplines it seems, from the center of the secondary-school and college curriculum.

On some level, nearly the inverse happens in architecture. After an intermittent flourish of so-called Greek Revival in the first half of the nineteenth century, documented in this volume by Francis Morrone, Rome and its imperial rhetoric appear to dominate the American adaptation of classical architecture. By the end of the nineteenth and the beginning of the twentieth century, Roman architectural forms were taken to have been ideally suited to the creation of American civic and public architecture.[32] On another level, if we look at classical reception in New York only through a Roman lens and limit our gaze to architecture, for example, we will miss critical aspects of what was clearly a complex and often contradictory process. Thus in art—sculpture and vase painting in particular—what was Greek was prized above its Roman counterpart and, as Elizabeth Bartman's chapter demonstrates, was actively sought by the Metropolitan Museum of Art from the late nineteenth through much of the twentieth century. In fact, as nearly all the chapters in this volume attest, both Greece and Rome are vital in different measures and at different times and thus provide different models for appropriation and reuse; the one is privileged over the other only at the expense of understanding the whole.

Understanding the whole, however, may not be the point, certainly not here, where our approach is selective, to say the least, and perhaps overly fragmentary, in keeping with a certain aesthetic of the fragment associated with the study of classical antiquity. Indeed, our attention here tends to linger over the late nineteenth and early twentieth century, when the reception of Greco-Roman art and architecture was at its peak. Save for Elizabeth

Macaulay-Lewis's contribution on Stanford White's rendition of the Pantheon, the Gould Memorial Library in the Bronx, we even fail to venture off the island of Manhattan. This focus is obvious and perhaps unavoidable for an introductory volume of this kind, but one yearns for an alternative book or at least a follow-up volume, with a potential focus on "Deep Classics," to borrow Butler's phrase, that goes beyond the obvious and reaches further into the rich history of classical reception at sites in Brooklyn, Queens, and Staten Island. One need only think of Sailors' Snug Harbor on Staten Island, with its magnificent "temple row," which is still the finest example of Greek Revival in New York City and, for that matter, anywhere in the United States.[33] There are other such sites, for example, New York's national historic landmark cemeteries, Green-Wood in Brooklyn and Woodlawn in the Bronx.[34] In Queens there is the Beaux-Arts courthouse of the state supreme court in Long Island City (1876)[35] or the Free Synagogue of Flushing designed by McKim, Mead, & White in 1921. None of these is in this volume.

Précis of the Chapters

This volume eschews discussing every known element of classical architecture or Latin inscription to be found in the city's five boroughs. Rather it brings together here case studies that span more than a century and offer the chance to explore the multifaceted reception of classical art, architecture, and epigraphic practices during a critical transition in New York's history from one of several East Coast cities with economic significance to the commercial and cultural capital of the United States and a global center of finance, media, and art. In what follows, however, two broad categories of studies seem to emerge: Some chapters—including those of Morrone, Ritter, Macaulay-Lewis, and Gensheimer—deal with how and why a classicizing building references a particular ancient building or style; they focus primarily on the monuments and less on the architects or patrons behind them. Other chapters—like those of Malamud, Bartman, Simard, McDavid, and McGowan— attempt to understand works of art, buildings, theatrical performances, and the Latin language by how they were used or appreciated; they tend to privilege the perspective of patrons, architects, and users. The various chapters cover material that often dips into the seventeenth and eighteenth centuries, but their chronological arc generally begins in the early part of the nineteenth century with the appearance of Greek Revival in New York City and goes well into the twentieth century when, for example, the sculptural program at Rockefeller Center bluntly recasts classical (Greek) myth in a notably modern form.

Francis Morrone's chapter sets the stage by focusing on the Customs House (1833–42), better known to New Yorkers as Federal Hall, on Wall Street. Morrone uses architectural evidence to chart a cultural and intellectual history of the era and to demonstrate that Greece was at the forefront of American minds as the country moved away from a (Roman) republican model of government to become more openly democratic. Indeed, Morrone shows how the architecture of the Customs House evokes the ideals of ancient Greece, the birthplace of democracy, even as it nods to the creation of the modern, independent

Greek state (1832), a newborn nation struggling for freedom from longstanding oppression, much as the United States had been about a generation before.

The question of public benefit is one of the unifying themes in this volume, and it looms large in Elizabeth Bartman's chapter on the formation and early development of the Metropolitan Museum of Art's classical collection. Bartman traces the abiding tension between "archaeology," or what is understood to promote scholarly rigor, and "aesthetics," or a connoisseur's appreciation of what looks pleasing in the collection of ancient material, a tension still in evidence today in many museums and private collections. The divide between archaeology and aesthetics, Bartman suggests, is related to the prejudice for what is Greek over what is Roman. Just as American classicists tended to shift their emphasis from Rome to Greece over the course of the nineteenth century, the art of Greece held a superior position in the formation of the Metropolitan Museum of Art's classical collection and, more generally, in the minds of curators, archaeologists, and collectors in late-nineteenth and early-twentieth-century America.

Margaret Malamud's chapter on the "Imperial Metropolis" documents the use of Roman architecture in New York City to give physical form to America's unique expression of empire. Her study demonstrates that the American appropriation of imperial Rome in New York was not limited to "high" art and architecture. Rather, Roman "bread and circuses"—including the recurring destruction of Pompeii—were recreated as popular entertainments for the city's working classes. Malamud shows that the broad and popular invocations of Rome to be found in New York during the late nineteenth and early twentieth centuries reached high and low across class lines and, curiously for such a distinctly imperial phenomenon, appear to have played a staunchly democratic role.

Roman architecture continues as the dominant force in Elizabeth Macaulay-Lewis's investigation into the classically inspired university libraries of late-nineteenth-century New York. The Pantheon, surely among the most celebrated and perhaps the most influential structure from ancient Greece and Rome, served as the model for the research libraries for the two most ambitious attempts at university campus design in New York's history: The Low Library (1895–97), designed by Charles Follen McKim for the new Morningside Heights campus of Columbia University, and the Gould Memorial Library (1894–99), designed by Stanford White, McKim's partner in the city's most renowned architectural firm, McKim, Mead & White, for the new University Heights campus of the University of the City of New York (later New York University). Macaulay-Lewis focuses primarily on the Gould Library, one of New York's forgotten treasures, which she interprets together with White's elegant curvilinear portico, the likewise forgotten Hall of Fame for Great Americans (1901). The two buildings and, for that matter, Columbia's Low Library give physical shape to ambitious academic undertakings intent on quoting the classics in multiple forms.

The potential clash between an educated (political) elite and everyday New Yorkers lies at the heart of Jon Ritter's look at "The Expression of Civic Life" in the New York Civic Center at Foley Square in Manhattan. Ritter ties the construction of the elaborate complex of civic buildings—including Guy Lowell's Colosseum-like New York County Courthouse (1913–27)—to the City Beautiful movement across the United States in the late

nineteenth and early twentieth century. City Beautiful was heavily influenced by the European Beaux-Arts tradition and often availed itself of an eclectic neoclassical style, which Ritter calls "American Renaissance." Ritter contrasts the comparatively wide-open and meticulously planned "classical" Civic Center with the vibrant hodgepodge of commercial buildings dominating Broadway to the immediate west of Foley Square. He demonstrates that political will and architectural form can only accomplish so much if the public derives but a limited benefit.

Jared Simard treats a private venture that offered—and continues to hold—vast benefits for the public at large: Rockefeller Center (1933–39) and its sculptural program. It was New York's most important building project of the Depression Era and provided an immeasurable boon to the city in a time of need. As Simard shows, the iconic Art Deco sculptures of the mythological Titans Prometheus and Atlas reflect the generous philanthropy of John D. Rockefeller Jr., the name and (nearly titanic) force behind the construction of "the city within a city" that Rockefeller Center became. Simard analyzes the artistry of the two sculptures in light of each figure's mythological background. He underscores the symbolic resonance of Greek myth in relation to the architectural, commercial, and international plan of the complex as a whole. The end result is fresh insight into the significance of Rockefeller Center and its classically inspired sculptural program.

No book on classical reception in New York City would be complete without a discussion of the Old Pennsylvania Station (1910), perhaps the most overt quotation of classical form in the history of the city of New York. It, too, was designed by Charles McKim of McKim, Mead & White, and as Maryl Gensheimer documents in "Rome Reborn: Old Pennsylvania Station and the Legacy of the Baths of Caracalla," McKim took direct inspiration from Caracalla's Baths in Rome. Gensheimer explains that it was not merely the grandeur of Rome's imperial baths that inspired McKim but that there seems to have been a commonality of purpose to the constructions. The ancient structure and its modern incarnation were both gathering places for a large number of people and thus served similar social functions. That the ruins of Caracalla's Baths still remain and continue to impress while historic Penn Station was completely razed and exists now only in name adds a bitter poignancy to Gensheimer's article and, indeed, to her final reflection on transportation and "modern American life."

Allyson McDavid's article draws on Gensheimer's piece to investigate an understudied feature of American life from the mid–nineteenth to the early twentieth century: "The Roman Bath in New York: Public Bathing, the Pursuit of Pleasure, and Monumental Delight." McDavid explores the physical form of baths and finds New York's first public bathing complexes to be entirely wanting in comparison to the lavish grandeur of Rome's imperial *thermae*. As the century nears its end and (socially) progressive ideas begin to take hold (1890–1920), New York's ethnic baths come to reflect the city's interest in social reform and providing pleasure for traditionally marginalized populations. At every juncture, McDavid is keen to point out the phenomenological stakes involved in the construction of baths in urban environments. In both ancient and modern times, the sensory experience of bathing provides an invaluable opportunity for all members of society, especially the marginalized, to cleanse and rejuvenate. She concludes that the private, ethnic

baths of early-twentieth-century New York offered an obvious public good, not unlike the more prominent neoclassical buildings such as the Metropolitan Museum of Art (1902), the New York Public Library (1911), and the Cunard Building (1921), all of which appropriated and redeployed in some measure the form of imperial *thermae* in their construction.

The final contribution to our volume, by Matthew M. McGowan, offers a general survey of the Latin inscriptions of New York City. McGowan's basic conceit is that inscriptions or the set of words written, engraved, or traced in Latin upon a monument or building form a discrete subcategory in the rhetorical traditions of classical architecture. As is the case for architectural elements, epigraphical texts typically provide information about a building or monument that is important to both patrons and viewers: Patrons try to convey something of professional, political, or ethical significance—or a combination of these—while viewers are invited to engage with the structure beyond a merely formal level. McGowan describes this engagement as "artful dialogue," in which the Latin words of an inscription—the "ancient and permanent language" of his title—often look back to the classical past even as they project forward to a regularly recurring encounter with a viewer in the here and now. In the process of this encounter, the structure itself becomes the medium of conversation, and McGowan follows this artful dialogue from public memorials and funerary monuments to an illustrious academic institution, ending with his own reflection on the moving quotation of the ultimate classic, the Latin poet Virgil, at the National September 11 Memorial & Museum in Lower Manhattan.

McGowan's personal reflection serves as the jumping-off point for the editors' more general "Reflections" in the book's coda on what this volume has taught us and where to go from here. Taking a brief look back over the material covered, the editors suggest different avenues, some even nonmaterial, for further study of the reception of classical antiquity in New York City.

NOTES

1. The building is now known as the Stephen A. Schwarzman Building, after the Wall Street financier who donated $100 million to underwrite major renovations to the building's exterior from 2007–10; see Marc Santora, "After a Big Gift, a New Name for the Library," *New York Times*, April 23, 2008.

2. Henry Hope Reed, *The New York Public Library: Its Architecture and Decoration* (New York: Norton, 1986), 10–11, 14.

3. Phyllis Dain, *The New York Public Library: A History of Its Founding and Early Years* (New York: New York Public Library, 1972), 334.

4. Reed, *The New York Public Library*, 48. Paul Wayland Bartlett designed the sculptures, which were carved by the Piccirilli brothers.

5. Margaret Malamud, "*Translatio Imperii*: America as the New Rome, ca. 1900," in *Classics and Imperialism in the British Empire*, ed. Mark Bradley (Oxford: Oxford University Press, 2010), 249–82; Margaret Malamud, *Ancient Rome and Modern America* (Malden, MA; Oxford: Wiley-Blackwell, 2009), 150–85.

6. John B. Jervis, *Description of the Croton Aqueduct* (New York: Slamm & Guion, 1842), 26–27: "On the outside walls an Egyptian cornice is laid, which accords with the general style of the work."

7. Richard G. Carrott, *The Egyptian Revival: Its Sources, Monuments, and Meaning, 1808–1858* (Berkeley: University of California Press, 1978), 103.

8. Carrott, *The Egyptian Revival.*

9. Christopher Gray, "The Library's Extremely Useful Predecessor—Streetscapes," *New York Times,* January 20, 2011.

10. Gray, "The Library's Extremely Useful Predecessor."

11. Gray, "The Library's Extremely Useful Predecessor"; see also contemporary articles from the *New York Times,* "Against the Beer Garden," March 12, 1891; "The Library Site Again," April 25, 1895; "The Old Reservoir," June 30, 1896.

12. Gray, "The Library's Extremely Useful Predecessor." From left to right on the library's façade, the inscriptions read, "The Lenox Library / Founded by James Lenox / Dedicated to History, Literature and Fine Arts / MDCCCLXX"; "The Astor Library / Founded by John Jacob Astor / For the Advancement of Useful Knowledge / MDCCCXLVIII"; "The Tilden Trust / Founded by Samuel Jones Tilden / To Serve the Interests of Science and Popular Education / MDCCCLXXXVI." Beneath these inscriptions, running along the architrave, is "MDCCCXCV The New York Public Library MDCCCCII," with 1895 signifying the incorporation of the library and 1902 the laying of the cornerstone.

13. As signaled in key inscriptions throughout the building, e.g., in the Office of the Board of Directors above the mantelpiece designed by F. M. L. Tonetti, "The City of New York has erected this building for the free use of all the people / MCMX"; in the basement on the western side of the entrance corridor near what used to be the Circulation Library is a plaque, which reads, ". . . The City of New York / undertook to construct, / at public expense, / a building upon this site / to be used and occupied / by the New York Public Library, / Astor, Lenox, and Tilden Foundations, / so long as it should maintain herein / a free library and reading room for the people." See also "The Library Site Again," *New York Times,* April 25, 1895, in which the paper says about the site: "Greatest of all of the considerations that must be taken into account is that of accessibility. To it all others should yield, for on it depends the library's value to the public."

14. See Malamud's chapter in this volume.

15. Shane Butler, "Introduction: On the Origins of 'Deep Classics,'" in *Deep Classics: Rethinking Classical Reception,* ed. Shane Butler (London: Bloomsbury Academic, 2016), 3–4.

16. Craig Kallendorf, "Introduction," in *A Companion to the Classical Tradition,* ed. Craig Kallendorf (Malden, MA: Blackwell, 2007), 1 (emphasis ours). Kallendorf's work follows in the tradition of Gilbert Highet, *The Classical Tradition: Greek and Roman Influences on Western Literature* (New York: Oxford University Press, 1949); and R. R. Bolgar, *The Classical Heritage and Its Beneficiaries* (Cambridge: Cambridge University Press, 1954); to which can be added Michael Silk, Ingo Gildenhard, and Rosemary Barrow, eds., *The Classical Tradition: Art, Literature, Thought* (Oxford: Wiley-Blackwell, 2014).

17. Kallendorf, "Introduction," 2.

18. For example, Lorna Hardwick, *Reception Studies: Greece & Rome,* New Surveys in the Classics 33 (Oxford: Oxford University Press, 2003); Charles Martindale and Richard Thomas, eds., *Classics and the Uses of Reception* (Malden, MA: Blackwell, 2006). See also Tim Whitmarsh, "True Histories: Lucian, Bakhtin, and the Pragmatics of Reception," 115; and Simon Goldhill, "Touch of Sappho," 250, both in *Classics and the Uses of Reception,* for more reflection on the significance of the term "reception."

19. See Hardwick, *Reception Studies,* 2–4, on the difference between the *classical tradition,* where "influence" and "legacy" are the operative interpretive terms, and the process of *classical reception,* with its emphasis on reappropriation and reworking, "where the focus is on the two-way relationship between the source text or culture and the new work and receiving culture. Analysis of the principles and assumptions underlying selectivity and contextual comparisons between source and receiving conditions are vital tools."

20. Traditional journals have seen their contributions in "reception" increase dramatically, and at least two new journals have been added to the field, *International Journal of the Classical Tradition*, founded in 1994, and the *Classical Receptions Journal*, founded in 2009.

21. For example, on classics and the postcolonial, see Lorna Hardwick and Carol Gillespie, eds., *Classics in Post-Colonial Worlds* (Oxford: Oxford University Press, 2007). For recent work on the classics and film, see Martin M. Winkler, *Classics and Cinema* (Lewisburg, PA: Bucknell University Press, 1991); Maria Wyke, *Projecting the Past: Ancient Rome, Cinema, and History* (New York: Routledge, 1997); Jon Solomon, *The Ancient World in the Cinema*, rev. ed. (New Haven, CT: Yale University Press, 2001); Jeffrey Richards, *Hollywood's Ancient Worlds* (London: Continuum), 2008; Pantelis Michelakis and Maria Wyke, *The Ancient World in Silent Cinema* (Cambridge: Cambridge University Press, 2013); Joanna Paul, *Film and the Classical Epic Tradition* (Oxford: Oxford University Press, 2013).

22. By contrast, Egyptologists have long been interested in Egyptomania, or the reinterpretations of Egyptian art and architecture after antiquity; see Bob Brier, *Egyptomania* (Brookville, NY: Hillwood Art Museum, 1992); Joy M. Giguere, *Characteristically American Memorial Architecture, National Identity, and the Egyptian Revival* (Knoxville: University of Tennessee Press, 2014); Jean-Marcel Humbert, Michael Pantazzi, and Christiane Ziegler, eds., *Imhotep Today: Egyptianizing Architecture* (London: UCL Press, Institute of Archaeology, 2003); Jean-Marcel Humbert and Clifford Price, eds., *Imhotep Today: Egyptianizing Architecture* (London: UCL Press, Institute of Archaeology, 2003); Stephanie Moser, "Reconstructing Ancient Worlds: Reception Studies, Archaeological Representation, and the Interpretation of Ancient Egypt," *Journal of Archaeological Method and Theory* 22, no. 4 (2015): 1263–1308; Sally MacDonald and Michael Rice, eds., *Consuming Ancient Egypt* (Abingdon: Routledge, 2016).

23. Perhaps foremost among these books for artists and architects was James Stuart and Nicholas Revett's *Antiquities of Athens* (1762), on which see Morrone, in this volume.

24. On the idea of triangulation, see Elizabeth Macaulay-Lewis, "The Architecture of Memory and Commemoration: The Soldiers' and Sailors' Memorial Arch Brooklyn, New York and the Reception of Classical Architecture," *Classical Receptions Journal* 8 (2016): 447–78; Marden Nichols, "Domestic Interiors, National Concerns: The Pompeian Style in the United States," in *Housing the New Romans: Architectural Reception and Classical Style in the Modern World*, ed. Katharine von Stackelberg and Elizabeth Macaulay-Lewis (New York: Oxford University Press, 2017), esp. 128.

25. Katharine von Stackelberg and Elizabeth Macaulay-Lewis, "Introduction: Architectural Reception and the Neo-Antique," in *Housing the New Romans: Architectural Reception and Classical Style in the Modern World*, ed. Katharine von Stackelberg and Elizabeth Macaulay-Lewis (New York: Oxford University Press, 2017), 7–9.

26. The American School for Classical Studies at Athens was founded in 1881; the American Academy in Rome in 1894.

27. Additional firms from Chicago were added after complaints that there were no local firms involved. See David Van Zanten, "Burnham, Daniel H. (1846–1912), Architect, Urban Planner, Writer," Grove Art Online, Oxford Art Online, http://www.oxfordartonline.com/subscriber/article/grove/art/T012586.

28. Gail Fenske, "City Beautiful Movement," Grove Art Online, Oxford Art Online, http://www.oxfordartonline.com /subscriber/article/grove/art/T017886.

29. The bibliography here is already sizable and growing rapidly, but Richard Gummere's *The American Colonial Mind and the Classical Tradition* (Cambridge, MA: Harvard University Press, 1963) and Meyer Reinhold's collection of articles, *Classica Americana: The Greek and Roman Heritage in the United States* (Detroit, MI: Wayne State University Press, 1984), are still seminal. More recently, Carl J. Richard has made important book-length contributions to the study of classical learning in the foundation and early history of the United States; see his *The Founders*

and the Classics: Greece, Rome, and the American Enlightenment* (Cambridge, MA: Harvard University Press, 1994); and *The Golden Age of the Classics in America: Greece, Rome, and the Antebellum United States* (Cambridge, MA: Harvard University Press, 2009).

30. The history of the study of classical antiquity in the United States lies outside the purview of this volume, but excellent contributions have been made in recent years by Caroline Winterer, *The Culture of Classicism: Ancient Greece and Rome in American Intellectual Life 1780–1910* (Baltimore, MD: Johns Hopkins University Press, 2002); Caroline Winterer, *The Mirror of Antiquity: American Women and the Classical Tradition, 1750–1900* (Ithaca, NY: Cornell University Press, 2007). See also Gummere, *The American Colonial Mind*, 55–75; Reinhold, *Classica Americana*, 25–28; Richard, *Founders and the Classics*, 12–38; Richard, *The Golden Age of the Classics in America*, 1–40.

31. Richard, *The Golden Age of the Classics in America*, 41; Winterer, *The Culture of Classicism*, 44–76.

32. Steven L. Dyson, "Rome in America," in *Images of America*, ed. R. Hingely (Portsmouth, RI: Journal of Roman Archaeology, 2000), 57–70; Malamud, *Ancient Rome and Modern America*, chap. 5.

33. The five interlocking Greek Revival buildings at Snug Harbor are regarded as "the most ambitious moment of the classic revival in the United States" and the "most extraordinary suite of Greek temple-style buildings in the country," according to David W. Dunlap, "Dispute Grows," *New York Times*, March 23, 1987. Dunlap goes on to note that, built around the 1833 Building C, the buildings of Sailors' Snug Harbor "form a symmetrical composition on Richmond Terrace, an eight-columned portico in the center and two six-columned porticoes on either end." See Gerald J. Barry, *The Sailors' Snug Harbor: A History, 1801–2001* (New York: Fordham University Press, 2000); and Morrone's chapter in this volume.

34. Elizabeth Macaulay-Lewis, "Entombing Antiquity: A New Consideration of Classical and Egyptian Appropriation in the Funerary Architecture of Woodlawn Cemetery, New York City," in *Housing the New Romans: Architectural Reception and the Classical Style in the Modern World*, ed. Katharine von Stackelberg and Elizabeth Macaulay-Lewis (New York: Oxford University Press, 2017), 190–231.

35. See Kenneth Jackson, ed., *The Encyclopedia of New York City*, 2nd ed. (New Haven, CT: Yale University Press, 2010), 320.

The Custom House of 1833–42:
A Greek Revival Building in Context

Francis Morrone

Introduction

The building that New Yorkers of today know as "Federal Hall" and that is properly called Federal Hall National Memorial, at 26 Wall Street, at the northeast corner of Nassau Street, was designed in 1833 and constructed between 1834 and 1842 as the United States Custom House, the most important federal building outside of Washington, DC. After only twenty years, the government required a larger Custom House, and 26 Wall Street served for the next fifty-eight years as the federal Subtreasury. Today's name, which dates from 1955, reflects the building's use as a National Park Service–administered museum dedicated to George Washington and to the history of 26 Wall Street itself. Federal Hall was the name of the building that preceded the former Custom House on its site. A 1788 remodeling of the 1704 city hall, Federal Hall served the new nation as its first capitol building, and it was the site of the first presidential inauguration, April 30, 1789. In 1812, some years after the capital's relocation to Washington, DC, Federal Hall was rather unceremoniously razed.

The Custom House of 1833–42 is, arguably, the most important building surviving from New York's "Greek Revival" of the 1830s and 1840s. It is the city's only truly Parthenon-esque building, an example of the highest building craft of its time, and the work of a succession of several of the ablest and most interesting designers of the city's first era of professional building design. The building reflects the "Greek mania" that strongly marks the American culture of the time; it also reflects architecture's transition from

Georgian neoclassicism to the romantic styles that would dominate the remainder of the nineteenth century. It is the most significant surviving artifact of New York City's phil-hellenic era.

The Original Federal Hall

In 1704, New York built a new city hall on Wall Street.[1] It was to replace the Stadt Huys on Pearl Street, which had served since Dutch colonial days. The two-story-plus-attic Georgian structure was effortlessly handsome in the manner of its time. Projecting end pavilions, each two window bays wide, rose to hipped roofs, each with a single dormer, or window projecting vertically from a sloping roof. The pavilions flanked a small plaza, reached from the sidewalk by five shallow steps, behind which a triple arcade led into the central section of the building. On the second floor of the central section were three openings, a window on either side of a double doorway that opened onto a balustraded balcony. The plaza, meanwhile, formed the sort of intermediary space, a little less casual than the sidewalk, a little less formal than inside the building, a type of space rare in the colonial city. At the attic story of the central section was a pitched roof with three dormers and, rising from the center top of the building, a balustraded and arcaded cupola surmounted by a weathervane. This was, in its width, its gestures toward urban design, and its crowning cupola, one of the most imposing and distinctive structures in a still largely unembellished and unimproved colonial outpost. For the next eight decades, the building served in its original function and was the scene of notable events including, in 1735, the trial for seditious libel of the printer John Peter Zenger and, in 1765, the meeting of the Stamp Act Congress.

In 1788, following ratification of the US Constitution, New York prepared to take its place as the nation's capital. As part of these preparations, the city hall was renovated into Federal Hall, the national capitol. The French artist Pierre L'Enfant was placed in charge of this renovation. He placed in front of the plaza a colonnade extending a little farther outward than the fronts of the flanking wings. At the first floor, four blocky piers screened the plaza. At the second floor of this central section and rising through the attic story, four Doric columns, of rather impressive dimensions, screened a loggia far more spacious than the balcony it replaced and supported an entablature in turn surmounted by a pediment with raking cornices enclosing a low-relief sculpture of the Great Seal of the United States. Rising from the center top of the building was an octagonal cupola ringed around its top by urns. At the second floor, the fenestration was changed to an elegant multipaned sash in vertically elongated frames with marble cap-molded lintels, with, set in the wall above the windows, marble panels with relief carvings (Figure 1.1).

The earlier city hall was a simple, unpretentious, handsome building. The later Federal Hall, on the other hand, was a building that—as well it might have done, being the capitol of a new nation—put on airs. New York's buildings were becoming not only larger and functionally more complex; they were also becoming rhetorical—their appearance was

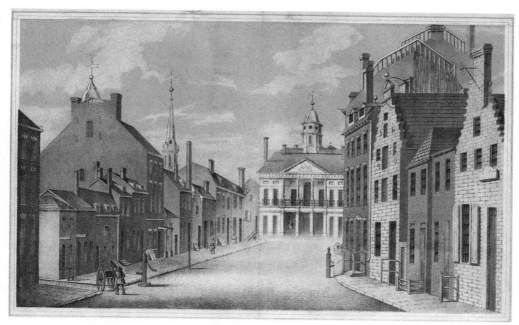

FIGURE 1.1. View north on Broad Street toward Wall Street and Federal Hall, 1797, George Holland; color lithograph by H. R. Robinson.
Courtesy of the Library of Congress.

meant to say something. And for all these reasons, New York began to move from a building culture dominated by artisan-builders to one dominated by trained professional architects. L'Enfant occupies a kind of halfway position in the evolution. He was, at the very least, a self-conscious and talented designer. He would go on to plan, with President Washington's patronage, the new capital city on the Potomac.

On April 30, 1789, on the loggia of Federal Hall, George Washington was administered the oath of office as the first president of the United States. That Federal Hall was a building the equal in historical importance to Philadelphia's Independence Hall did not prevent its demolition in 1812 and replacement by row houses. By that time, the national capital had long since moved out of New York, first to Philadelphia, then to the new city of Washington, DC. And New York had just built the beautiful city hall, just off Broadway at Murray Street, that still serves the city today.

Following his inauguration, President Washington and his entourage traveled a few blocks up Broadway to a service at St. Paul's Chapel, at Fulton Street.[2] St. Paul's had been built before the revolution, in the 1760s, and added its tower in 1794. It very closely follows the tower of James Gibbs's St. Martin in the Fields, in London, completed in 1724. There were, via the Romans and the Renaissance, many residual elements of classical Greek architecture to be found in European and American buildings, not least among those elements being the orders themselves. In a sense, we should classify St. Paul's tower as "Greek Survival," not "Greek Revival."

The Greek Revival

Nonetheless, a new and sophisticated interest in classical Greek architecture was beginning to influence American practice by the 1790s. Samuel Blodgett's First Bank of the United States, built in 1796 and still standing in Philadelphia, was "the first temple of business which could be literally so named, the ancestor of all the columned banks in the country."[3] But Blodgett's bank, with its relief panels, Corinthian pilasters, and rooftop balustrade, was still thoroughly a Georgian building. The outstanding example of the introduction of Grecian forms is Benjamin Latrobe's Bank of Pennsylvania, in Philadelphia, built between 1798 and 1801, a chaste Ionic temple with a hexastyle portico, a broad flight of steps, and a blank pediment. We see the inspiration of the Temple of Ilissus, illustrated in the most important single source for knowledge of classical architecture in eighteenth- and nineteenth-century Northern Europe and America, *The Antiquities of Athens and Other Monuments of Greece*, compiled by the British duo of James Stuart and Nicholas Revett (London 1762–1816).[4] One cannot help noting that Latrobe's bank—sadly demolished in 1867—also features a prominent dome. The popularity of domes in the American Greek Revival is a subject to which we will return. Latrobe wrote to his friend Thomas Jefferson, on May 21, 1807, "I am a bigoted Greek in the condemnation of the Roman architecture of Baalbec, Palmyra and Spalatro. . . . Wherever, therefore, the Grecian style can be copied without impropriety, I love to be a mere, I would say a *slavish*, copyist."[5] He goes on to say that such copying may seldom be done "without impropriety," because the conditions of modern life won't warrant it. Our architecture shall inevitably be a hybrid, though the Grecian element may be put forward.

Latrobe's student William Strickland (1788–1854) gave us America's first Parthenon-esque public building with his Second Bank of the United States, designed in 1818 and built in 1819–24, in Philadelphia. Unlike Latrobe's bank, it is still standing. It is an octastyle Doric temple of somber grandeur, with matching porticoes on front and rear. Indeed, if we might call Latrobe's Bank of Pennsylvania chaste, we would call Strickland's bank austere. A very wide but not especially high flight of steps leads to the colonnade of eight fluted columns rising to Doric capitals and supporting an entablature with a frieze of triglyphs and metopes. Topping it off is a pediment with raking cornices framing a large, empty triangular space.

Strickland once said "that the student of architecture need go no further than the *Antiquities of Athens* as a basis for design."[6] The Londoner James Stuart (1713–88) was of humble background, apprenticed as a fan painter, and was self-taught in Greek, Latin, and Italian. At the age of twenty-nine he went to Italy to study art, supporting himself as a *cicerone* or "tour guide" for English-speaking visitors. In Italy he met the architect Nicholas Revett (1721–1804), the well-born son of a landowning Suffolk family. In 1750, Stuart and Revett embarked on their ambitious project to go to Athens to draw and describe what survived of ancient Greek architecture. They remained there until 1754.[7]

Greek philosophy and literature had, in one way or another, continued from ancient times to the present to exert its influence on the Western mind, from the use made of

Aristotle by Thomas Aquinas in the thirteenth century to the Neoplatonism of Marsilio Ficino, which influenced Michelangelo, in the fifteenth century. The American Founding Fathers were steeped in Greek thought. Greek was part of the classical education that Thomas Jefferson received at the College of William and Mary.[8] Yet for all the study and admiration of the ancient Greeks, very little was then known about the artifacts of classical Greek civilization. The archaeology boom of the eighteenth century would change that. The excavations at Herculaneum (1738), Pompeii (1748), Palmyra (1750), and Split (1757) added to our knowledge and understanding of Roman antiquity. But beginning in 1752, with *Recueil d'antiquités* by the Comte de Caylus, Greece, for the first time, came into focus.[9] By 1753, the abbé Laugier, in his *Essai sur l'architecture*, was able to say, "It is therefore true that architecture is only under moderate obligation to the Romans and that it owes everything that is valuable and solid to the Greeks alone."[10] Winckelmann's advocacy of Greek over Roman models in art followed soon after.[11] The publication in 1758 of Julien-David Le Roy's *Les ruines des plus beaux monuments de la Grèce* provided the first practical Greek stylebook for architects.[12]

But for the English-speaking world, Stuart and Revett stand supreme. Before them, few had traveled to Greece to study its ruins, to catalogue and describe what they saw, and to speculate on the original appearances of ruined buildings.[13] The first of what were eventually four folio volumes of *Antiquities of Athens* was published in 1762, with the subsequent volumes appearing in 1787, 1795, and 1816.[14]

In New York, Martin Euclid Thompson's Merchants' Exchange of 1825–27, on the south side of Wall Street between William Street and Hanover Street, was not, with its towering Federal-style cupola, quite full-blown Greek Revival. But Thompson used, for his two-story tetrastyle portico, the Ionic order of the temple of Athena Polias (fourth century BCE) in Priene, in Ionia, as illustrated in the second volume (1787) of *Antiquities of Athens*.[15] Thompson's building was destroyed in the Great Fire of 1835 and replaced by the new Merchants' Exchange (1836–42) by Isaiah Rogers.

In an address to the American Academy of the Fine Arts, in New York, in 1824, the prominent writer, politician, and General Theological Seminary professor Gulian Verplanck said of America's architecture that

we have borrowed most of it from France and England, and by no means from the best models which these countries afford; it is only within a very few years that we have begun to think for ourselves, or to draw directly from the purer fountains of antiquity. Hence it is that when our increasing riches enabled us to erect large and expensive public edifices, instead of embodying in them those pure forms and scientific proportions of Grecian art . . . many of our most costly buildings have been vitiated by the predominance of that taste which prevailed on the continent of Europe, in the reign of Louis XIV, and which was universal in Great Britain throughout most of the last century, though it has now given way, as it did in an earlier period in France, to a much more classical style. I mean that corruption of the Roman, or rather Palladian architecture, which delights in great profusion of unmeaning ornament, in piling order upon order, in multitudes of small and useless columns, and mean and unnecessary pilasters, in numerous and richly decorated windows.[16]

The term "Greek Revival" was used as early as 1842 by C. R. Cockerell in an address to the Royal Academy.[17] By then, "Grecian" architecture had become fashionable in Britain and on the Continent. In America, the Greek Revival had become the first national style of architecture. As William H. Pierson Jr. put it, "Adopted by the common man as well as the professional, it became the first style in American history to be consciously understood and embraced as a truly national mode of building."[18] An English architect, William Ross, who later worked as a draftsman on the Custom House, wrote, in late 1835, "The Greek mania here is at its height, as you infer from the fact that everything is a Greek temple from the privies in the back court, through the various grades of prison, theatre, church, custom-house, and state-house."[19]

In his essay "Rome in America," Stephen L. Dyson argued that the term "Greek Revival" is a misnomer:

> State houses, churches, courthouses, Southern plantation mansions, and the town and country residences of the northern élite all were built in a style that was called Greek Revival but whose basic forms and major architectural elements were more Roman than Greek. They employed domes, columned façades, and the Ionic and especially the Corinthian order in an eclectic but impressive manner.[20]

In a large sense, Dyson is correct. As we will see, the prevalence of domes in "Greek Revival" buildings, as noted by Dyson, is proof that architects were interested in a more generalized classical expression than in one that was exactingly Greek. This does not mean, however, that architects were not deeply impressed and influenced by such works as *Antiquities of Athens*, which suggested approaches to forms and ornamentation different from what then prevailed, and that jibed with, and contributed to, a philhellenism that pervaded American culture. Not least, without reference to Greek, as distinct from Roman, architecture, we cannot describe what it is that made Strickland's Second Bank of the United States feel so different from what had gone before it in America, nor can we explain the self-understanding of a Laugier in France or a Gulian Verplanck or Benjamin Latrobe in America.

Collectively, the late Georgian, which in America is often called "Federal," and the Greek Revival, both heavily influenced by eighteenth-century archaeology, are referred to as "neoclassical." At the same time, the Greek Revival points forward to the romanticism that dominated the nineteenth century. Like the Gothic Revival that flourished simultaneously with the Greek Revival and that was practiced by many of the same architects, the Greek Revival was, in the words of Geoffrey Scott, a "casting on the screen of an imaginary past the projection of its unfulfilled desires."[21] The architectural historian Henry-Russell Hitchcock used the term "romantic classicism" to refer to buildings that, for example, combined Parthenon-like porticoes and Pantheon-like domes.[22]

New York at the Time of the Custom House

Thompson's Merchants' Exchange was built just as New York was poised to enter upon its economic paramountcy—the reign of the "Empire City"—vis-à-vis the rest of America.

Between 1817 and 1825, New York State undertook, without any federal help or the help of any other state, the construction of the Erie Canal, the 363-mile-long canal that linked the Hudson River, near Albany, to Lake Erie, at Buffalo, to create a continuous watercourse, via the Great Lakes, from America's newly settled agricultural interior to New York Harbor. Before the Erie Canal, New York was already America's busiest seaport, but it had competition. After the canal, which made New York the port of transshipment for the interior's agricultural goods, the port of New York soon grew busier than the next several largest ports combined, and by the beginning of the Civil War New York handled more than 60 percent of the nation's exports. The Erie Canal's length exceeded by more than thirteen times that of the longest canal yet built in America, and it was, by any measure, a larger public-works project than had ever been undertaken in Europe. As such, it not only provided an economic boon to New York and to a great string of boom towns all along its route and the shores of the Great Lakes; it also signaled to the world what the young nation was capable of. As the canal drew to completion, the *Times* of London wrote that New York was destined to be the "London of the New World."[23] The population of New York City rose from 96,373 in 1810, to 123,706 in 1820, to 202,589 in 1830, to 312,710 in 1840. By 1850, New York, with 515,547 people, was the seventh most populous city in the world, exceeded among European cities only by London and Paris.

In the years before the federal income tax, the federal government relied for revenue on customs duties, or the tariffs on imported goods. The federal Customs Service, established in 1789, had as its first responsibility the collection of customs duties. The building in which the Customs Service's administrative work and the actual transfers of funds took place was called the Custom House, and thus one such building would be found in any port city engaged in foreign trade. It only stands to reason that if New York were the nation's preeminent port of foreign trade, then the city would boast the nation's most important Custom House. By 1852, 95 percent of the federal government's revenue came from customs duties. And New York City accounted for an astonishing 75 percent of the federal government's customs revenue.[24] The collector of customs for the Port of New York, an immensely powerful position in the days before federal civil-service reform, was paid a higher annual salary than the president of the United States.

It was a time that saw a vast increase in the amenities of daily life. Steam-ferry service had, beginning in 1814, led to the development of Brooklyn Heights, across the East River from lower Manhattan, as the city's first commuter suburb. Soon, the horse-drawn omnibus (1827) and the horse streetcar (1832) would allow for suburban development in a northerly direction on Manhattan Island. By 1858, horsecar lines operated on Second, Third, Fourth, Sixth, Eighth, and Ninth Avenues. The Greek Revival row house, the predominant form of residential building of the 1830s and 1840s in New York, bore a temple-like distyle portico, as though leading into a sanctum, and developed against the background of an unprecedented separation of domestic from public life and of the new role of the nuclear family as what Christopher Lasch called a "haven in a heartless world."[25]

During the period of design and construction of the Custom House on Wall Street, the New York & Harlem Railroad began its use, in 1839, of steam locomotives. The painter Samuel F. B. Morse, working out of his studio in the University of the City of New York

(later known as New York University) building on the east side of Washington Square, demonstrated his invention, the electric telegraph, in 1837. In 1842, the year the Custom House opened, New York's Croton water system became operational. Gaslight had begun to illuminate the city's streets in the 1820s and by 1850 had become standard for interior illumination. James Gordon Bennett's *New York Herald*, begun in 1835, may be said to be the first modern newspaper.

America of the 1830s was a world of Jacksonian laissez-faire and frontier-pushing rugged individualism. It was a time of wild speculation in land, both in established and new towns and cities and on the frontier. This unbridled speculation led to the burst land bubble and string of bank failures that was the Panic of 1837, one of the worst economic calamities in the nation's history. And it was in this period that, partly as a result of the Erie Canal boom, partly as a result of President Jackson's decision not to renew the charter of the Bank of the United States in 1836, that Wall Street became the epicenter of the nation's financial and banking systems. Whether in New York or the remotest frontier outpost, by the 1830s the bank vied with and often excelled the church as the most prominent building type.

In literature, it is the time of the nature poetry of William Cullen Bryant, of Hawthorne, of Emerson, and of Poe. Throughout this time, young Walt Whitman worked as a printer and reporter and wrote poetry. Henry James was born in Manhattan in 1843, a year after the Custom House opened, and chose that year as the setting of his 1880 novel *Washington Square*. In painting, Thomas Cole, who was a good friend of the Custom House's architects, painted his five Course of Empire paintings, commissioned by the New York merchant Luman Reed and now in the New-York Historical Society, between 1833 and 1836.

It must also be mentioned that much has been made of what has been called the "Greek mania," as Gulian Verplanck termed it,[26] among many Americans of the early nineteenth century. The identification by Americans of their democracy with that of ancient Athens is easy to see. The Greek War of Independence (1821–32) against the Ottoman Empire was an international cause célèbre somewhat like the Spanish Civil War of a century later. Not least did the war rivet the attention of Americans, who viewed Greece as a nation fighting for its independence in much the way America had in living memory. New York became a center of fundraising for the Greek rebels. The Greeks contracted with New York shipyards to build warships. In September 1823, an organization called the Greek Ladies of Brooklyn and New York erected a twenty-foot-high Greek cross on Brooklyn Heights and toasted it with the words "May the Grecian cross be planted from village to village, and from steeple to steeple, until it rests on the dome of St. Sophia."[27] In art, one of the most popular works of the nineteenth century in America was the sculpture *The Greek Slave* by Hiram Powers, the first marble version of which was made in 1844. In the artist's own description of the subject, "The Slave has been taken from one of the Greek Islands by the Turks, in the time of the Greek revolution, the history of which is familiar to all."[28] The popular poet Fitz-Greene Halleck, of whom there is a statue in Central Park, wrote "Marco Bozzaris," one of his most famous poems, in 1825,

about the Greek general who had died in 1823. When Samuel Francis Smith wrote "My Country, 'Tis of Thee" in 1832, he included the lines:

> I love thy rocks and rills,
> Thy woods and templed hills.

The Greek temple had become as American as apple pie. Taken together, the archaeo-logical interest in ancient Greece, the new appreciation and promotion of classical Greek architecture, and the political identification with Greek independence represent one of history's great moments of philhellenism.

The Architects of the Custom House

The New York Custom House had from 1799 to 1815 occupied the building known as Gov-ernment House, which when it was built was meant to be the nation's Executive Mansion, at Bowling Green. After 1815, the Customs Service occupied one of the houses on the site of the recently demolished Federal Hall. The United States Customs Service hired the firm of Town & Davis to design the new Custom House in 1833. Town & Davis was one of the nation's most successful architectural firms.

Ithiel Town was born in 1784 in Thompson, Connecticut, in Windham County. His father was a farmer, and he apprenticed as a carpenter before going to Boston to work in the studio of the famous architect Asher Benjamin. Town's first important buildings were two churches on the Green in New Haven: First Congregational Church (1812–15) and Trin-ity Episcopal Church (1813–16). The latter of these was one of the earliest Gothic churches in the United States. Town, a gifted engineer, invented, in 1820, the wooden-truss con-struction system that became standard for the countless rapidly erected railroad and canal bridges all across the country in the early nineteenth century.[29] This made him a rich man. He opened a New York City office in 1827 and in 1827–28 worked in partnership with Martin E. Thompson. In 1829, Town formed a partnership with Alexander Jackson Davis. They were joined in 1832–33 by James Harrison Dakin. The partnership of Town and Davis lasted until 1835. Among their notable commissions were several state capitols. These included the Connecticut State Capitol (1828–31, demolished 1889) in New Haven, the North Carolina State Capitol (1833–40), and the Indiana State Capitol (1831–35). All of these are in the Greek Revival style, and, indeed, Town and Davis were as responsible as anyone for making the Greek Revival standard for state houses across the country. Note also that two of these were in the design or construction process concurrently with the New York Custom House. Not only did Town & Davis win some of the most sought-after commissions in the country, but they carried out several such high-profile projects simultaneously.[30]

In 1836, Town built his own Greek Revival house in New Haven, which was later ex-tensively remodeled by another architect and then demolished in 1957. This was to house his enormous library of architectural books and prints.[31] Town is estimated to have owned

perhaps eleven thousand volumes, the largest collection of architecture books in the United States, larger than the library of Sir John Soane in London, and possibly the largest such library in the world. In addition, Town owned some twenty thousand engravings. He was extremely generous in providing architects and scholars with access to his library. One person to whom he provided access was his very good friend the painter Thomas Cole. Town commissioned from Cole a painting that was to include architectural and landscape elements. For the architecture, Cole made use of Town's library. The painting that resulted, *The Architect's Dream* (Toledo Museum of Art) of 1840, is one of the most familiar images in all of American art. An architect, recumbent upon a freestanding column, surveys a giddy scene of buildings—a Greek temple, a Roman aqueduct, an Egyptian temple, a Gothic church—arrayed along a lagoon. The picture sums up the romantic eclecticism of the time in architecture. Town, alas, rejected the painting: He said Cole had neglected the landscape element![32] Ithiel Town died in New Haven in 1844. Upon his death, his library was sold off piecemeal.

Alexander Jackson Davis was born in New York City in 1803, the son of a bookseller. He trained as a printer and in the early 1820s began to pursue a career as an artist. He studied at the American Academy of the Fine Arts, around the time Gulian Verplanck made his address extolling Grecian architecture, and at the National Academy of Design, among the founders of which in 1825 was Ithiel Town. Davis was an exceptionally gifted drafts-man, a highly skilled engraver, and one of the earliest lithographers in America. He may, in his youth, have had no peer in New York as an architectural renderer. His training as an architect consisted of a stint as a draftsman in the office of the prominent New York architect Josiah Brady, followed by work for Ithiel Town and Martin Thompson, during which time he benefitted from his extensive perusal of Town's library. Davis was only twenty-six when he entered into his partnership with the forty-five-year-old Town in 1829.[33]

After his time with Town, which yielded such notable buildings as the state houses in North Carolina and Indiana, the New York Custom House, and New York University (1833–36), Davis embarked upon a solo career, typically working by himself and taking on others only as needed. He became particularly renowned as a residential architect, help-ing establish taste and standards in suburban architecture. His book *Rural Residences* (1838) was a great success, and his major residential commissions range from Lyndhurst, one of the nation's most beautiful Gothic Revival houses, in Tarrytown, New York, built in 1838–42 and expanded (by Davis) in 1864–67; the model suburb of Llewellyn Park, in West Orange, New Jersey, begun in the 1850s (and where Davis himself resided); and the Edwin Litchfield house, 1854–57, in Brooklyn, a masterpiece of the Italian rural villa style Davis did so much to popularize. He was closely associated with the enormously influential landscape gardener Andrew Jackson Downing, with whom he collaborated on Llewellyn Park and whose best-selling books *Cottage Residences* (1842) and *The Architecture of Country Houses* (1850) were il-lustrated by Davis. Davis, who lived to the age of eighty-nine, closed his office in 1878—the year he unsuccessfully participated in the competition for the design of the Long Island (now Brooklyn) Historical Society on Brooklyn Heights.

John Frazee was born in 1790 in Rahway, New Jersey, the son of a carpenter. As a boy he endured poverty and a lack of formal schooling; he worked as an indentured farmhand.

Between 1804 and 1811 he apprenticed with a builder, and it was during that time that he first began to carve stone. He married in 1813, and he and his wife had ten children. He set up a stonecutting business in New Brunswick, New Jersey, and after some growing pains was able to move to New York City and establish himself as a marblecutter in 1818. His stock-in-trade included tombstones and mantelpieces. In 1824–25 he executed a marble bust of the lawyer John Wells, the founder of the firm that is today called Cadwalader, Wickersham & Taft, for Grace Church, then located on Broadway and Rector Street.[34] In the 1840s, when Grace Church moved uptown to Broadway and Tenth Street, the bust was relocated to St. Paul's Chapel, on Broadway and Fulton Street, where it is on view today. This fine work has been called the first known marble likeness ever to be executed by a native-born American artist, and it made Frazee's reputation. He was admitted as a full academician to the American Academy of the Fine Arts right around the time Alexander Jackson Davis was studying there. In 1825, Frazee was the only sculptor among the founding members of the National Academy of Design. In 1831, Frazee was the first native-born artist to receive a congressional commission, for the bust of John Jay in the US Capitol. He produced a few other notable works, including, in 1834–35, four marble busts—of Daniel Webster, Nathaniel Bowditch, John Lowell, and John Marshall—for the Boston Athenaeum. During this time his wife died, and he remarried. With his second wife he fathered another ten children. This required that Frazee find regular employment. And this is why in July 1835 this well-known sculptor took a job as superintending architect of the New York Custom House. He devoted himself to the Custom House—with only a few outside sculptural commissions—until 1842. Frazee must surely be credited with Town and Davis among the architects of this building. He died in 1852.[35]

Finally, we must mention Samuel Thomson. Thomson was born in 1784 in Taneytown, Carroll County, Maryland, and became a prominent carpenter-builder in New York City. His association with the Custom House, though brief, was critical in shaping the building we see today. Thomson had been the builder, but not the designer, of the Sailors' Snug Harbor campus on Staten Island, second only to Thomas U. Walter's Girard College, Philadelphia, as an ensemble of Greek Revival buildings in America.[36] He also worked on buildings on land owned by Sailors' Snug Harbor around Washington Square, in Manhattan, and may, indeed, have been the designer-builder of the celebrated row of Greek Revival houses still standing at nos. 1 to 13 Washington Square North. Thomson himself was the original occupant of 4 Washington Square North. He is also often cited as the designer as well as the builder of the Thirteenth Street Presbyterian Church, built in 1847, one of the city's Greek Revival landmarks.[37] Thomson was also an early director of the New York & Harlem Railroad, which was both the first horsecar line and the first steam railroad in New York City. He died in 1850.

The Custom House, 1833–42

The secretary of the treasury approved Town & Davis's design for the Custom House in 1833. That design would be significantly modified by two other architects before the

Custom House opened for business in 1842. In the original approved design, Town & Davis used a double row of columns on the front and rear of the building. They placed acroteria, or architectural ornaments, at the ends and at the apex of the triangular pediments on front and rear. A high central dome and lantern rose from the building, clearly visible on the exterior. The central dome meant that the plan of the building was different from what we see today. The original plan was a Greek cross, with the rotunda in the exact center of the plan.[38]

Construction began in January 1834. At Ithiel Town's prompting, Samuel Thomson was hired as builder. Thomson had a difficult relationship with his Customs Service bosses.[39] When they removed from Thomson some of his responsibilities and commensurately reduced his salary, Thomson, in a fit, resigned, in April 1835. He not only resigned: He absconded with the building's plans. These were not, we may presume, the Town & Davis plans but rather modifications made by Thomson at the behest of the Customs Service, which felt the central rotunda took up too much space and the central dome to be an unnecessary structural complication. Consequently, Thomson reorganized the plan, moving the rotunda to the front of the building and not articulating the dome on the exterior at all.[40] Presumably to save money, he also substituted a single row of columns on the front and rear porticoes (Figures 1.2–1.3).

Three months after Thomson quit, in July 1835, the Customs Service hired John Frazee to take his place.[41] Frazee found himself in a difficult position. Without Thomson's plans, Frazee had to draw up his own, but they would have to be based on the foundation already dug and the stone already cut to Thomson's specifications. Frazee was largely responsible, if not for the interior plan, which had been set by Thomson, then for virtually all of the interior detailing. In addition, he transformed what had originally been envisioned as a third-floor storage attic into a full office floor. This floor was at the level of the entablature on the outside of the building. To illuminate the room, Frazee imported half-inch-thick glass from France for use in the metopes of the frieze. The metopes thus became windows for the third floor, even as they appeared on the outside to be made of marble.[42]

Frazee was a perfectionist with great faith in his own judgment. He clashed frequently and for several years with Walter Bowne, one of the building commissioners. Bowne sought to keep costs down and grew bitterly frustrated with how long it was taking to complete the building. Indeed, when we look at the building's construction dates—1834 to 1842—we do wonder why it took so long. One delay was caused by Thomson's absconding with the plans and Frazee's necessity of practically starting over from scratch. Other delays were caused by the use of marble, which was shipped from Westchester County. When the East River froze over in the winter, marble could not be shipped, and this meant lengthy annual delays in construction. And being a government building, work sometimes had to be suspended awaiting new appropriations. Add it all up, and it took nine years to build the Custom House.

The collector at the time construction commenced was Samuel Swartwout, who had served since 1829. It was Swartwout who asked Thomson to modify and simplify Town & Davis's original plan. Present from the beginning, and the most engaged and eager of the building's overseers, was the aforementioned Walter Bowne. He was a direct descendant of the Flushing Quaker John Bowne and had served from 1829 to 1833 as mayor of New York

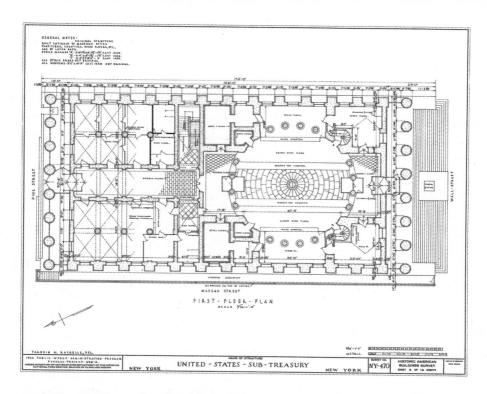

FIGURE 1.2. Custom House, first-floor plan reflecting Samuel Thomson's alterations to original design by Town and Davis. Historic American Buildings Survey.
Courtesy of the Library of Congress.

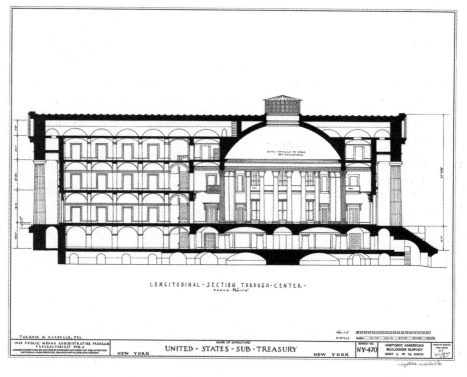

FIGURE 1.3. Custom House, longitudinal section of building as built. Historic American Buildings Survey.
Courtesy of the Library of Congress.

City. He was a serious and influential man, concerned to keep costs in line and expedite completion of the building. Indeed, had not Jesse Hoyt replaced Swartwout as collector in 1838, Bowne would have prevailed, and the Custom House would be less interesting to us today than it is. In Hoyt, Frazee had a champion who typically backed the architect when he was up against Bowne. But for Hoyt, a lawyer and politician appointed to the collectorship by President Van Buren, as many simplifications would have been made to Frazee's plans as had been made by Samuel Thomson to Town & Davis's plans.[43]

As it happens, both Swartwout and Hoyt were accused of embezzlement. President Van Buren removed Hoyt from office in 1841. Hoyt's replacement, John J. Morgan, lasted only a month before a new president, William Henry Harrison, named Edward Curtis, a lawyer and congressman, to the position. By then, it was too late to make any changes to the nearly completed building, even had Morgan or Curtis been so inclined. Curtis, who had nothing whatever to do with the planning and construction of the new Custom House, had the honor of presiding over its formal opening in 1842.

The completed Custom House measured ninety feet on its portico ends on Wall Street and Pine Street and 192 feet on its Nassau Street side.[44] On its east side, the Custom House abutted Martin E. Thompson's Branch Bank of the Bank of the United States, a distinguished Federal-style bank building in which the central section bore a colonnade of four engaged Ionic columns, above which rose a broad pediment, nearly identical in design to the two pediments of the Custom House, with raking cornices framing an empty triangular space. Thompson's building was demolished in 1912, but the façade was salvaged, stored, and, in 1924, reerected in the American Wing of the Metropolitan Museum of Art. Today, the façade is the focal element of the museum's vast Engelhard Court.

The columns of both the Wall Street and the Pine Street porticoes of the Custom House measure thirty-one feet high and eight feet and five inches in diameter. By comparison, the columns of the Parthenon are thirty-four feet high and six feet and two inches in diameter. The exterior walls are of marble quarried in Eastchester, in Westchester County, New York. Canals and infant railroads notwithstanding, in the 1830s and 1840s it was still rather too great a chore to acquire building stones from remote locations. This would change: Just look at the daunting variety of marbles, from all over the world, used in the New York Public Library (1899–1911)! The stone of the Custom House is not polished marble. It has a rough, nubbly finish and, though white, a dingy hue. These qualities of the stone lend to the building a great deal of its brooding affect; they work with the massive Doric colonnades and the blank pediments to create an overall impression of sobriety or somberness that we may variously interpret as expressing "republican simplicity," that virtue prized by Thomas Jefferson and by Henry James's Dr. Austin Sloper in *Washington Square*, or, perhaps, a certain melancholy, like some of the songs of Stephen Foster or the face of Lincoln.

A peculiar and notable thing about the Custom House is its pronounced northward slope. On Pine Street, one ascends but three steps to enter the building. On Wall Street, one ascends eighteen steps. When viewed from Pine Street along its Nassau Street side, the Custom House appears to be rising up out of the ground, an appearance that adds to the building's sense of power (Figures 1.4–1.5).[45]

FIGURE 1.4. Custom House, granite base and marble pilastrade on Nassau Street.
F. Morrone.

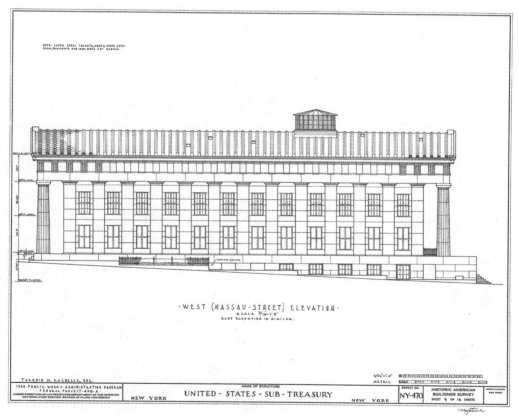

FIGURE 1.5. Custom House, Nassau Street elevation. Historic American Buildings Survey.
Courtesy of the Library of Congress.

The Custom House has identical porticoes on front and rear. Like Town & Davis's earlier Connecticut State Capitol (1828–31), it "reads" as peripteral, the result of the deeply modeled pilastrade (of thirteen pilasters) along Nassau Street.[46] No other similarly ambitious temple-front building was ever built in New York City.

Viewed head-on from Wall Street or from Broad Street, which is the continuation of Nassau Street to the south of Wall Street, the Custom House is grand indeed. The stair that leads up to the portico is nearly as wide as the building. The eight columns rise from the top of the steps and carry a broad entablature surmounted by a pediment as wide as the building, with raking cornices enclosing a broad, empty triangular expanse. We find in the Greek Revival, unvaryingly, the blank pediment. It is true that the carvers gifted in this sort of work were few and far between in the America of the time. Yet we also find in the late Georgian period, in such buildings as Blodgett's First Bank of the United States (1796), in Philadelphia, or in the original Federal Hall, as remodeled by L'Enfant (1788), at a time when pediment carvers could only have been even dearer, that pediments were not always left blank. And so we must surmise that the blank pediment was primarily an *aesthetic* choice, perhaps a part of the romantic cult of ruins. Given the economic exigencies, the choice was easy to make. Nothing, in any event, is so somber as a Doric temple with a giant blank pediment. Such architects as Strickland, Town, and Davis well knew, from *Antiquities of Athens*, that the Parthenon, when new, was not nearly so somber as the buildings they were turning out, though the ruin of the Parthenon certainly was (Figure 1.6).

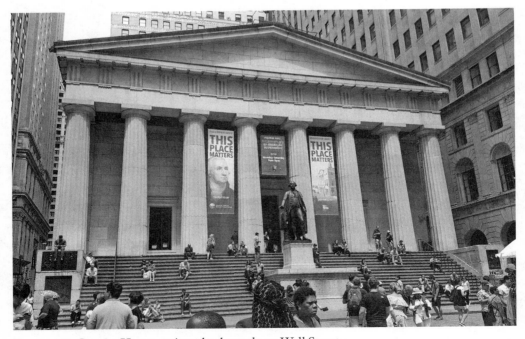

FIGURE 1.6. Custom House, stair and colonnade on Wall Street.
F. Morrone.

The entrance is recessed deeply beyond the columns. In dead center of the wall is a high doorway with an eight-panel double door of iron (sixteen feet high, eight feet wide).[47] It is much higher and wider than the symmetrically placed flanking windows, which are handsomely framed and have, like the doorway, strong cap-molded lintels. Through the iron doors, one enters into one of the grandest and most surprising rooms in New York, a rotunda in which sixteen columns and eight pilasters, twenty-five feet high, enclose a circle of sixty feet in diameter, with a dome cresting at fifty-four feet beneath an iron-and-glass skylight sixteen feet in diameter.[48] The grandeur comes from these lofty dimensions plus the exquisite detail, courtesy of John Frazee. The surprise comes from the dome and the use of the Corinthian order. Together these make for a "Roman" interior that belies the "Greek" exterior. This was not unusual in the "Greek Revival," which in this sense may be regarded as an extension of late-eighteenth-century neoclassicism with the increasing incorporation of "Grecian" elements. A notable quality of the Greek Revival was that it maintained great continuity with what preceded it while at the same time inaugurating the new romanticism that would dominate the remainder of the nineteenth century. In the original Town & Davis design, a high dome, dead center in the plan, was a distinguishing exterior feature of the building. Samuel Thomson, at the behest of his bosses, moved the dome to the front (south) and suppressed it: He made it a saucer dome, not articulated on the building's exterior (Figure 1.7).

The rotunda—originally called the Collector's Room—is enclosed by high fluted columns and pilasters with Corinthian capitals carrying a nicely rendered Corinthian entablature. The dome rises from the top of the cornice in a series of panels in the form of vertically elongated coffers in a chevron pattern, each coffer with a palmette sprouting from both its upper and its lower inverted-v (Figure 1.8). There are twenty of these

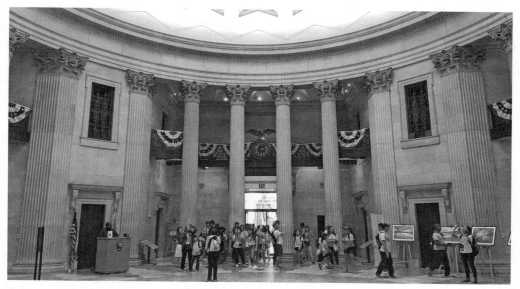

FIGURE 1.7. Custom House, view south across rotunda.
F. Morrone.

FIGURE 1.8. Custom House, view of dome from rotunda.
F. Morrone.

panels, just as there are twenty rosettes in a circle, enclosed by a chevron molding, at the base of the skylight. There are four sets of four columns each. Three of these screen recessed spaces; the fourth, opposite the entrance, leads to a corridor, to the north of the rotunda, comprising a sequence of four groin vaults separated by arches that spring from boxy pilasters, with anvil-like capitals, along the walls. The corridor runs between what were originally office spaces along the east and west sides of the building. Separating each set of columns in the rotunda is a wall, framed by pilasters, in the lower part of which is a heavy iron door in a stone frame topped by a pair of voluted brackets supporting a crown molding ornamented with palmettes. An egg-and-dart molding runs around the doorway.[49] Of the four rooms these doorways lead to, one was originally the office of the collector.

Just beyond the rotunda to its north are the stairways to the second floor. The iron railings, designed by Frazee, feature balusters of intertwining, filigreed floral forms and rail terminations in scrolled acanthus-leaf designs. On the second floor, the railings, of patinated iron, that encircle the rotunda feature bare-breasted mermaids in flowing seaweed skirts and with outstretched arms clutching stalks that belong to filigreed floral forms much like those of the stairways. These sea nymphs were no doubt thought an appropriate embellishment to a building that owed its existence to waterborne commerce. The figures are extraordinarily charming—"like classic burlesque queens," wrote Ada Louise Huxtable[50]—and today inevitably make the visitor think of the Starbucks mermaid. A frieze below these railings features an anthemion motif (Figure 1.9).

The second and third floors and the basement originally contained offices.[51] The basement is impressive for its squat, heavy peripheral columns, corresponding to the columns of the rotunda above, and especially a great central cylindrical support that has a touch of the sublime neoclassical majesty of the architecture of Ledoux.[52]

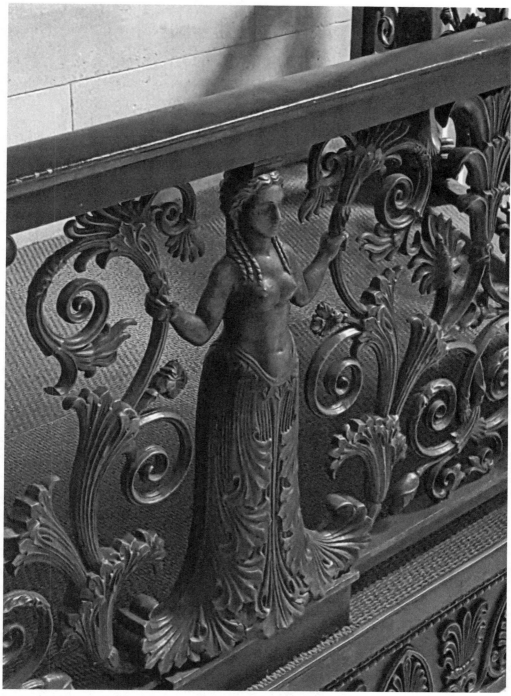

FIGURE 1.9. Custom House, patinated iron mermaids, rotunda railings.
F. Morrone.

The Customs Service outgrew the building in twenty years. In 1862, Customs moved to the former Merchants' Exchange at 55 Wall Street, Martin Thompson's building (1836–42) built concurrently with 26 Wall Street. In that year, 26 Wall Street became the federal Subtreasury Building. Before the Federal Reserve System, the Treasury Department maintained six regional offices that held gold and silver reserves. It was during Subtreasury days, in 1883, that John Quincy Adams Ward's superb bronze statue of George Washington was set on a high granite plinth at the bottom of the steps on Wall Street. The statue commemorated the centennial of the end of the Revolutionary War, though it was also a slightly premature celebration of the centennial (1889) of Washington's inauguration, which took place in the loggia of the old Federal Hall, very near to the spot where Ward's over-life-size figure stands. The statue thus reminded those who viewed it that this was historically hallowed ground. Today it is impossible for anyone to imagine the former Custom House without also picturing the statue. The Subtreasury remained in the building until 1920.

In April 1939, in commemoration of the sesquicentennial of the first inauguration, Secretary of the Interior Harold Ickes designated 26 Wall Street as a National Historic Site.[53] This was the result of a strenuous lobbying effort undertaken by the American Scenic and Historic Preservation Society, led by George McAneny and Gardner Osborn.[54] The Custom House "was going to be sold as surplus federal property" until McAneny and Osborn intervened.[55] On August 11, 1955, 26 Wall Street was designated a National Memorial, nationally one of only thirty sites to bear that appellation. In the west wall of the groin-vaulted corridor between the rotunda and Pine Street is a plaque honoring McAneny, "Pioneer in City Planning, Protector of Historic Places, Leader of a City, Friend Beyond Compare." Under the jurisdiction of the National Park Service, Federal Hall National Memorial, as it is called, is a museum with exhibits related to the history of the original Federal Hall as well as of the later 26 Wall Street. In addition, there are daily Park Ranger–led tours of the building. It is wonderful that the building is open to the public and free of charge. Most of John Frazee's interior work remains, and stepping into 26 Wall Street is like traveling in time to the America of Andrew Jackson and Martin Van Buren.

Conclusion

The former Custom House was one of the earliest buildings to be designated as a landmark by the New York City Landmarks Preservation Commission upon its founding in 1965.[56] The rotunda achieved "Interior Landmark" status, a rare designation, in 1975. In view of how cavalierly the old Federal Hall was razed after only a little more than a hundred years, we may be very thankful that its replacement was spared the same fate. Though 26 Wall Street has had an interesting history of uses, it is for us a window onto values and attitudes that pervaded a city that, in the 1830s and 1840s, appeared marked for a great destiny. It is, above all, New York's most eloquent reminder of the philhellenism of the 1830s and 1840s.

NOTES

1. Louis Torres, "Federal Hall Revisited," *Journal of the Society of Architectural Historians* 29, no. 4 (December 1970): 327–38.

2. See McGowan's chapter in this volume.

3. Christopher Tunnard and Henry Hope Reed, *American Skyline: The Growth and Form of Our Cities and Towns* (New York: New American Library, 1956), 93.

4. James Stuart and Nicholas Revett, *The Antiquities of Athens* (London: printed by John Haberkorn, 1762–1816), 7–11; chap. II, plates I–VIII. See also Calder Loth, "Classical Comments: The Ionic Temple on the Ilissus, Athens," *Classicist Blog*, July 7, 2010, http://blog.classicist.org/?p=191.

5. Benjamin Henry Latrobe, *The Journal of Latrobe* (New York: D. Appleton and Co., 1905), 139.

6. Agnes Addison Gilchrist, *William Strickland, Architect and Engineer, 1788–1854* (New York: Da Capo, 1969), 31.

7. Jacob Landy, "Stuart and Revett: Pioneer Archaeologists," *Archaeology* 9, no. 4 (December 1956): 252–59.

8. Carl J. Richard, *The Founders and the Classics: Greece, Rome, and the American Enlightenment* (Cambridge, MA: Harvard University Press, 1994), 187–94.

9. Lola Kantor-Kazovsky, "Pierre Jean Mariette and Piranesi: The Controversy Reconsidered," *Memoirs of the American Academy in Rome. Supplementary Volumes* 4 (2006): 149–68.

10. Marc-Antoine Laugier, *An Essay on Architecture*, trans. Wolfgang Herrmann and Anni Herrmann (Los Angeles: Hennessy & Ingalls, 1977), 40.

11. See Bartman's chapter in this volume.

12. Henry-Russell Hitchcock, *Architecture: Nineteenth and Twentieth Centuries* (New York: Viking Penguin, 1987), 14.

13. Lesley Lawrence, "Stuart and Revett: Their Literary and Architectural Careers," *Journal of the Warburg Institute* 2, no. 2 (October 1938): 131.

14. James Stuart and Nicholas Revett, *Antiquities of Athens*, ed. Frank Salmon (New York: Princeton Architectural Press, 2007).

15. Stuart and Revett, *Antiquities*, vol. 2, chap. II, plate X.

16. Gulian C. Verplanck, *An Address Delivered at the Opening of the Tenth Exhibition of the American Academy of the Fine Arts* (New York: Charles Wiley, 1824), 14–15.

17. Jane Turner, *Encyclopedia of American Art before 1914* (Oxford: Oxford University Press, 2002), 198.

18. William H. Pierson Jr., *American Building and Their Architects*, vol. 1: *The Colonial and Neoclassical Styles* (New York: Oxford University Press, 1970), 417.

19. William Ross, "Street Houses of the City of New York," *Architectural Magazine* 2 (November 1835): 490–93.

20. Stephen L. Dyson, "Rome in America," in *Images of Rome: Perceptions of Ancient Rome in Europe and the United States in the Modern Age*, ed. Richard Hinley (Portsmouth, RI: Journal of Roman Archaeology Monographs, 2000), 60.

21. Geoffrey Scott, *The Architecture of Humanism: A Study in the History of Taste* (1914; repr., New York: Norton, 1974), 41.

22. Hitchcock, *Architecture: Nineteenth and Twentieth Centuries*, 13–22.

23. John Steele Gordon, *An Empire of Wealth: The Epic History of American Economic Power* (New York: HarperCollins, 2004), 109.

24. Eric Homberger, *New York: A Cultural and Literary Companion* (Oxford: Signal, 2002), 50.

25. Christopher Lasch, "The Family as a Haven in a Heartless World," *Salmagundi* 35 (Fall 1976): 42–55.

26. Verplanck, *An Address*, 14–15.

27. Henry R. Stiles, *A History of the City of Brooklyn* (Brooklyn: published by subscription, 1869), 2:202.

28. Joy S. Kasson, "Narratives of the Female Body: *The Greek Slave*," in *Reading American Art*, ed. Marianne Doezema and Elizabeth Milroy (New Haven, CT: Yale University Press, 1998), 168.

29. "Town Patents the Lattice Truss Bridge—Today in History: January 28," ConnecticutHistory.org, http://connecticuthistory.org/town-patents-the-lattice-truss-bridge-today-in-history.

30. Roger Hale Newton, *Town and Davis, Architects, Pioneers in American Revivalist Architecture, 1812–1870* (New York: Columbia University Press, 1942).

31. H. Allen Brooks Jr., "The House of Ithiel Town: Its Date of Construction and Original Appearance," *Journal of the Society of Architectural Historians* 13, no. 4 (1954): 27–28.

32. Ellwood C. Parry III, "Thomas Cole's Imagination at Work in the Architect's Dream," *American Art Journal* 12, no. 1 (Winter 1980): 41–59.

33. Jane B. Davies, "Alexander Jackson Davis," *American National Biography Online*, http://www.anb.org/articles/17/17-00208.html.

34. Thayer Tolles, "Modeling a Reputation: The American Sculptor and New York City," in *Art and the Empire City: New York, 1825–1861*, ed. Catherine Hoover Voorsanger and John K. Howat (New Haven, CT: Yale University Press, 2000), 137–38.

35. Frederick S. Voss, "John Frazee," *American National Biography Online*, http://www.anb.org/articles/17/17-00297.html.

36. Barnett Shepherd, "Sailors' Snug Harbor Reattributed to Minard Lafever," *Journal of the Society of Architectural Historians* 35, no. 2 (May 1976): 108–23. On Sailors' Snug Harbor, see the Introduction to this volume.

37. David W. Dunlap, *From Abyssinian to Zion: A Guide to Manhattan's Houses of Worship* (New York: Columbia University Press, 2004), 288.

38. Louis Torres, "Samuel Thomson and the Old Custom House," *Journal of the Society of Architectural Historians* 20, no. 4 (December 1961): 186.

39. Torres, "Samuel Thomson and the Old Custom House," 186.

40. William Ross, "Plan, Elevation, Section, &c., with a descriptive Account of the Improvements lately made at the Custom-House, New York," *Architectural Magazine* 2 (December 1835): 526.

41. Louis Torres, "John Frazee and the New York Custom House," *Journal of the Society of Architectural Historians* 23, no. 3 (October 1964): 143.

42. Torres, "John Frazee and the New York Custom House," 145–46.

43. Torres, "John Frazee and the New York Custom House," 143–50.

44. Birseye Glover Noble and Charles F. Stirling, *Nichols' Illustrated New York: A Series of Views of the Empire City and Its Environs* (New York: C. B. & F. B. Nichols, 1847), 17.

45. "U.S. Custom House, 28 Wall Street, New York, New York County, NY," measured drawing, Historic American Buildings Survey, National Park Service, US Department of the Interior, after 1933, from Prints and Photographs Division, Library of Congress (HABS NY,31-NEYO,53-), sheet 9 of 15.

46. Pierson, *American Buildings and Their Architects*, 421–22.

47. "U.S. Custom House, 28 Wall Street, New York, New York County, NY," measured drawing, Historic American Buildings Survey, National Park Service, U.S. Department of the Interior, after 1933, from Prints and Photographs Division, Library of Congress (HABS NY,31-NEYO,53-), sheet 14 of 15.

48. Noble and Stirling, *Nichols' Illustrated New York*, 17.

49. "U.S. Custom House, 28 Wall Street, New York, New York County, NY," measured drawing, Historic American Buildings Survey, National Park Service, U.S. Department of the

Interior, after 1933, from Prints and Photographs Division, Library of Congress (HABS NY,31-NEYO,53-), sheet 12 of 15.

50. Ada Louise Huxtable, *Classic New York: From Georgian Gentility to Greek Elegance* (New York: Anchor, 1964), 70.

51. "U.S. Custom House, 28 Wall Street, New York, New York County, NY," measured drawing, Historic American Buildings Survey, National Park Service, U.S. Department of the Interior, after 1933, from Prints and Photographs Division, Library of Congress (HABS NY,31-NEYO,53-), sheet 11 of 15.

52. Thomas T. Waterman, "U.S. Sub-Treasury Building," Written Historical and Descriptive Data, Historic American Buildings Survey, National Park Service, US Department of the Interior, 1935, p. 2, from Prints and Photographs Division, Library of Congress (HABS NY-470).

53. "Ickes Designates N.Y. Subtreasury Historic Site," *Washington Post*, April 30, 1939.

54. "Gardner Osborn," New York Preservation Archive: Preservation History Database, http://www.nypap.org/preservation-history/gardner-osborn.

55. Gregory F. Gilmartin, *Shaping the City: New York and the Municipal Art Society* (New York: Clarkson N. Potter, 1995), 327.

56. Landmarks Preservation Commission, *Federal Hall National Memorial Designation Report [LP-0047]*, New York, City of New York, December 21, 1965.

The Imperial Metropolis

Margaret Malamud

In this chapter I argue that when America completed her continental conquest and embarked on overseas conquests, analogies between the ancient Roman and modern American empires were utilized to articulate and celebrate the latter.[1] Fully aware of Great Britain's claims to being the new Rome, Americans asserted that the United States, not Great Britain, was the modern successor to the ancient Roman Empire. The American ex-colonies staked a claim to the inheritance of classical antiquity both by employing the same compelling strategies and techniques of cultural ownership that had been so extensively employed by the British and by forging new independent analogies and connections with Roman civilization and empire.[2]

Across the nation, negative references to the decadence, immorality, and imperial overreach of ancient Rome, previously common in the eighteenth and nineteenth centuries and a defining feature of late-Victorian discourses, were now overshadowed by a celebratory linking of the ancient Roman and modern American empires. Rome's fabled might was translated into power and wealth in the built environment and in mass entertainments as a positive ground of identification.[3] Visual representations and recreations of Roman imperial prosperity and luxury stimulated consumerism and consumption in the cornucopia of the new American empire. The symbolic elasticity and flexibility of the neo-Roman idiom allowed plutocrats, imperialists, and ordinary Americans to invoke the power, might, and wealth of Rome as a positive model for America even as labor movements and political reformers warned against repeating Rome's collapse.[4] While the tradition of culling admonitory exempla from the myth of the rise and fall of Rome persisted, especially in the

rhetoric of anti-imperialists, it was overshadowed by a showy celebratory conflation of the ancient Roman and modern American empires. New York was the city that celebrated America's imperial destiny with the most enthusiasm, no doubt because New Yorkers knew their city was the commercial and cultural capital of the nation.

Visions of Empire

A discussion of turn-of-the-century New York's architecture and entertainments must begin with the hugely influential Columbian Exposition. The Columbian Exposition's white plaster city used neoclassical art and architecture to celebrate the benefits of American power and plenty.

The planning committee for the Columbian Exposition recruited prominent architects from around the country to design the Exposition's major buildings, and the result was a monumental, harmonious, and unified vision of a utopian city (Figure 2.1).[5] Most of the architects who designed the "White City," as it came to be called, had trained in Paris and had traveled extensively in Europe. They admired European uses of Roman architecture, particularly in the imperial cities of Paris and London, and their creations for the Exposition effectively introduced Beaux-Arts architecture to the United States. Millions of Americans visited the White City. It was, said one rapturous observer, "the finest architectural view that has ever been beheld on our planet."[6] For some visitors, the White

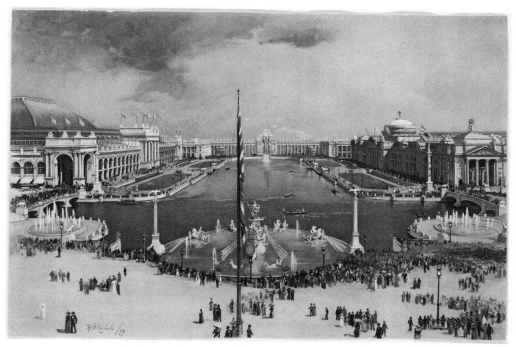

FIGURE 2.1. Court of Honor, World's Columbian Exposition, Chicago, 1893. Lithograph.

City suggested a Celestial City: "To see this miracle of harmonious form at sunset, with all its lovely length shining down the lagoon," commented one visitor, "is easily to believe in its heavenly origin."[7] It seemed to some people that the New Jerusalem was incarnate in the White City, an image that has deep roots in American culture. For others, imperial Rome was the analogy that sprang easily to mind.[8] One visitor claimed it was grander than even the fabled magnificence of Rome: "No Roman emperor in the plenitude of his power ever conceived so vast a festival as this," he boasted.[9] The White City thus articulated in plaster two mythic origin narratives: America as the new Rome and America as the City on a Hill, the New Jerusalem.[10]

Daniel Burnham, the chief architect of the White City, preferred the Roman analogy. He claimed it was "what the Romans would have wished to create in permanent form."[11] Like London and Paris, the White City's neoclassical architecture signified imperial grandeur, civic order, and authority. The incorporation of classical architecture and its adaptations in Renaissance and European neoclassicism into a new American architecture suggested that American civilization had assimilated, and now stood poised to supersede, the cultural achievements of past and present civilizations and empires. The 1893 fair, said one enthusiast, marked "a point in civilization never before reached by any people" and that it was "the dawn of a new era."[12] The final act of Imre Kiralfy's *America*, an elaborate stage-spectacle produced for the 1893 Columbian Exposition, featured the nations of the world bowing in homage to the Goddess of Chicago.[13] Kiralfy intended this to represent American genius and America's position in the hierarchy of empires and civilizations. Looking back at the 1893 Columbian Exposition in 1924, the architectural critic Lewis Mumford suggested that America's imperial age was foreshadowed in the Chicago Exposition: It "reproduced in miniature the coming imperial order." Roman-inspired architecture, he wrote with disdain, was eminently suitable for the times, since it was the "very cloak and costume of imperial enterprise."[14]

The White City was the antithesis of the gritty, industrial, immigrant reality of Chicago, that "Hog Butcher for the World, / Tool Maker, Stacker of Wheat, / Player with Railroads and the Nation's Freight Handler; / Stormy, husky, brawling, / City of the Big Shoulders," as the socialist writer and poet Carl Sandburg famously described it. This Chicago stood cheek by jowl with, but a world away from, the White City's ordered, harmonious, and unified mirage of urban life. The utilization of the architectural language of Rome, filtered through the Beaux-Arts movement, created a deeply satisfying illusion of imperial grandeur, civic order, prosperity, and authority. The 1893 Columbian Exposition launched an architectural revival of classicism, a movement architectural historians have called the "American Renaissance."[15] Neoclassicism remained a key feature of the White City style as it spread across the nation. In the realm of urban design it was called the City Beautiful movement, and it transformed urban spaces and architecture in a host of major American cities.[16]

The City Beautiful movement took on the task of fabricating a grand and unifying civic architecture and creating architectural spaces for the acting out of America's new imperial role and identity.[17] Architects such as Stanford White and Daniel Burnham helped create and choreograph sets for civic activities, pageants, and spectacles. In city after city across

the nation, Roman references were translated into power and wealth in the built environment and became a positive ground of identification in federal and state office buildings, train stations, public baths, museums, civic monuments, concert halls, libraries, banks, and universities. In this respect, the United States was following hard on the heels of European cities, particularly London and Paris, in the pursuit of lavish neoclassical architecture and the provision of public amenities. This process of triangulation, as Elizabeth Macaulay-Lewis has observed, allowed the American built environment "to have the benefit of two forms of reception: Classical and European."[18] It also enabled the United States to outshine the Old World in terms of the scale and magnificence of its new buildings and monuments.

In Chicago, even as the Columbian Exposition opened, Frederick Jackson Turner delivered his now famous address to the American Historical Association's 1893 annual meeting. In "The Significance of the Frontier in American History," he argued that the frontier (along with its Indian inhabitants) was the crucible in which American democracy, inventiveness, independence, and individualism were forged.[19] For Turner, the closing of the frontier was cause for concern—was anything left to conquer? Certainly the closing of the American West coupled with rapid industrialism precipitated a desire for further territorial acquisitions no longer necessarily contiguous with the existing nation. Illinois's Senator Cullom, an ardent advocate of American expansion and a major backer of the Chicago Exposition, put it bluntly: "It is time someone woke up and realized the necessity of annexing some property. We want all [*sic*] this northern hemisphere."[20] Industrial capitalists wanted new overseas markets in Asia, and acquiring several islands in the Pacific that were strategically located for refueling was the first logical step. The Philippines were taken as spoils of the 1898 Spanish-American War. Hawaii and Guam were also annexed in 1898. In addition to these Pacific territories, the United States annexed Puerto Rico in 1898 and oversaw the formation of a "protectorate" in Cuba in 1903.

"Take up the White Man's burden," Rudyard Kipling told Americans in 1899:

> Send forth the best ye breed—
> Go bind your sons to exile
> To serve your captives' need;
> To wait in heavy harness,
> On fluttered folk and wild—
> Your new-caught, sullen peoples,
> Half-devil and half-child.[21]

The business elites who backed the Spanish-American War and sponsored other world's fairs and expositions were eager to respond to Kipling's challenge (although perhaps they did not read the poem very carefully). An advertising poster for the 1899 Omaha Greater America Exposition proclaimed that the Exposition would contain the United States' "First Colonial Exhibit." The poster showed Uncle Sam holding a globe and pointing to the Philippines and Cuba. The globe is encircled with a banner reading "The White Man's Burden." "Omaha will be the first American city to exploit the wonders of the colonial possessions," announced the 1899 official guide of the Exposition.[22] By the end of the 1890s,

the visions of empire evident in the world's fairs and expositions had become a reality: America had joined the European imperial powers as a great power ruling over millions of non-Europeans, and the good citizens of Omaha could share in the spoils.

Apologists for American imperialism cited progress, Manifest Destiny, and the spread of civilization as justification for dominion. Speaking in favor of an American empire in early 1900, Senator Albert J. Beveridge announced that "the power that rules the Pacific . . . is the power that rules the world" and that the "imperial destiny" of America was "to establish the supremacy of the American republic over the Pacific and throughout the East till the end of time" (Figure 2.2).[23] Having embraced empire, confident that God was on Christian America's side, many Americans now looked to imperial Rome as a source for symbols of her new imperial power and position.

New York: The Imperial Metropolis

A lavish public spectacle was held in New York City on September 28–30, 1899, to commemorate Admiral Dewey's victory in Manila Bay. The three-day event featured a parade with over thirty thousand members of the military escorting Dewey and his entourage through the streets of New York. Members of the National Sculpture Society designed a massive Roman triumphal arch through which Admiral Dewey was to pass in a celebration of the emergence of America's overseas empire (Figure 2.3).[24] The arch was placed in one of the city's most prominent intersections, where Broadway, Fifth Avenue, and Twenty-Fourth Street meet at Madison Square, where a temporary arch to George Washington had stood.[25] The official program for the event hailed the arch with approval: "Nothing could have been more appropriate. The Romans were masters in their temporary and permanent commemoration of triumphs; other nations have only followed their example."[26] Fifth Avenue was termed the "Appian Way" of New York and "the fit approach for triumphal processions."[27] The arch was the architectural frame for the parade, and it served as a symbolic gateway through which the military units were to pass.

The Dewey Arch was modeled on the Arch of Titus in Rome, which commemorated the sack of Jerusalem by the emperors Vespasian and Titus, and, like the Arch of Titus, the Dewey Arch celebrated conquest. Just as Roman triumphal arches displayed images of the conquerors and conquered on their walls, the Dewey Arch depicted prominent naval heroes and territories acquired as a result of the Spanish-American War. The arch applauded American imperialism by illustrating what the National Sculpture Society described as the "four patriotic steps." In Michele H. Bogart's words, "To the northeast stood the *Call to Arms* (Patriotism) by Philip Martiny; at the southeast was *The Combat* (War) by Karl Bitter; at the southwest was *The Victors Returning* (Triumph) by Charles Niehaus; and at the northwest *The Warriors Resuming Their Occupations* (Peace) by Charles Chester French."[28] The arch was crowned with John Quincy Adams Ward's *Naval Victory*, four sea horses drawing a ship with a modified Nike of Samothrace Victory at the prow. On the west side of arch, on the high relief panel, was Johannes Gelert's *Progress of Civilization*, which showed two figures in the bow of a boat and a woman standing beneath a furled sail.

FIGURE 2.2. Senator Albert Jeremiah Beveridge, 1902, by Thomas Fleming. Published in Thomas Fleming, *Around the Capital with Uncle Hank* (New York: Nutshell Publishing Co., 1902).

According to David Brody, "Gelert depicts these figures moving forward carrying pride and progress with their travels," a peaceful and positive representation of the expansion of the American empire. "Progress," Brody notes, "takes place without bloodshed. This sculptor shows the underlying confidence and assumptions that provoke imperialism, or what

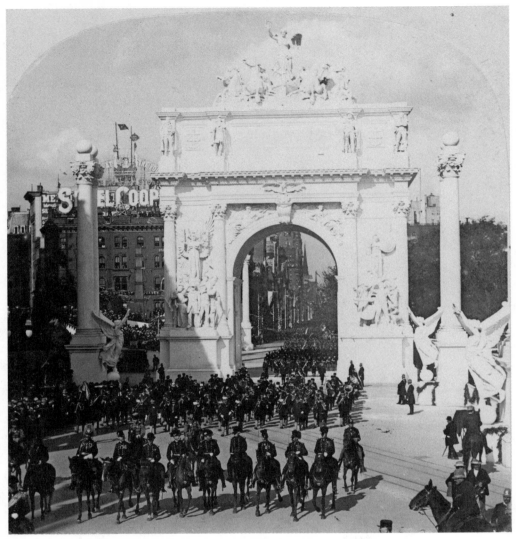

FIGURE 2.3. The parade in honor of George Dewey passes under the Dewey Arch on September 30, 1899. Right half of a stereoscopic image. Charles Lamb, principal sculptor; demolished. Courtesy of the Library of Congress.

he terms the *Progress of Civilization*."[29] In sum, American imperialism is presented as peaceful, positive, and progressive. America's Manifest Destiny is to dominate the Pacific, which not only benefits America but also the conquered.

Newspapers and the parade's souvenir booklet drew comparisons between Roman triumphs and Dewey's victory parade. "Surely no Roman general, surely no Roman emperor ever received such a tribute from the populace of the Eternal City!" gushed the *New York Times*.[30] Since imperialism was now "the dominant fact in our civilization," the architectural critic Lewis Mumford later explained, it was appropriate that Americans "should stamp the most important monuments and buildings with its image."[31] Roman imperial

propaganda was the pattern for these first monuments to the United States' new imperial reach. In the New York of 1899, America's acquisition of an empire was an event to celebrate.

The arch also imitates the practice of other imperial metropoles in erecting Roman triumphal arches to celebrate military victories. The designers of the arch were surely aware of the Arc de Triomphe and the Arc de Triomphe du Carrousel in Paris, commissioned in 1806 after the Emperor Napoleon I's victory at Austerlitz at the peak of his fortunes, and the Marble Arch and the Wellington Arch in London.[32] King George IV commissioned the arches in 1825 to commemorate Britain's victories in the Napoleonic Wars. John Nash based his design for the Marble Arch on the triumphal Arch of Constantine in Rome, and it too was made of Carrara marble.

Shortly before Dewey's victory parade, the new supercity of Greater New York had been ushered in with great ceremony on New Year's Eve, 1897. Thereafter, Manhattan, Brooklyn, Queens, Staten Island, and the Bronx were incorporated into a new megalopolis. The photographer and city booster Moses King classified New York as a cosmopolis, the peer of any city ancient or modern. According to King, New York was "the great mother-city of money," "the paramount city of the Western World, and the center of its commercial and financial activity."[33] Andrew Haswell Green, president of the Greater New York Commission, argued for incorporation, insisting that New York must recognize and accept its imperial destiny and status as a cosmopolis: "Cities are the crowns, the signs, the factors of empire," he said, and the imperial city "wins honorable renown throughout the world which all her colonies may proudly inherit."[34]

As the capital of American commerce and finance, New York's commercial buildings dramatized their functions through a celebratory and majestic Roman architecture. McKim, Mead & White's Bowery Savings Bank (1894) enshrined commercial banking in monumental Roman splendor; its temple front was framed with Corinthian columns, and it housed a grand "Roman" room, ringed with marble columns, its walls modeled with tabernacles and swags, that served as the main banking room.[35] Other banks imitated the Bowery Bank's classicism, though none matched its lavishness.[36]

New York's train stations were grand ceremonial gateways, signaling arrival in the city. Railroads were the vital arteries of commerce, and the railroad tracks rapidly spreading across the nation were the visible signs of economic conquest. British, French, and American architects of the railroad stations and terminals drew on Roman triumphal arches and Roman baths for their designs.[37] New York's train stations reflected the city's importance as the commercial capital of the nation, and a suitably bombastic rhetoric accompanied the opening of the new Grand Central Terminal in 1913. The promotional literature located its site as "the center of the city of New York, Metropolis of the Western Hemisphere, and in many respects the 'First City of the World.'"[38] The firms of Reed and Stem and of Warren and Wetmore, the terminal's engineers and architects, created an eclectic Roman style, one influenced by the ornate French neoclassicism popular at the time but that also drew directly on imperial Roman buildings for its inspiration.[39] The influence of imperial Roman baths is evident in both the main façade of the terminal station, which contains great arched windows flanked with Roman Doric columns, and the barrel-vaulted

ceiling of the main waiting room. Grand Central Terminal suggested the grandeur of imperial Rome. As one passenger put it, while in it "the traveller instinctively looks for white-robed priests and vestal virgins scattering flowers."[40] Its architecture was deemed magnificent, utilitarian, and inspirational—worthy of the great city it served: "It is the strangers' introduction to the great city whose heart-throbs are felt all over the civilized world, and this is a picture worthy of the frame that has been given to it."[41]

The jewel of the new railroad complexes that sprang up across the nation was McKim, Mead & White's stunning Pennsylvania Station, which was formally dedicated on August 1, 1910.[42] The great buildings of imperial Rome inspired Charles Follen McKim's design for the station; he had visited Rome in 1901 and photographed the Baths of Caracalla and the Colosseum, and the design of Pennsylvania Station reflects their influence. Like the Colosseum, the station had separate entrances and exits at different levels (Figure 2.4). The general waiting room was modeled on the *frigidarium*, and the concourse was modeled on the *natatio* of the Roman Baths of Caracalla. Like those baths (and other imperial Roman buildings), it was sheathed in travertine quarried from the Campagna district in Italy, where Romans had obtained materials for their buildings.[43] McKim not only took direct inspiration from the architecture of ancient Rome but, as King George IV had done for his triumphal arches in London eighty-five years earlier, even used bits of Italian marble to verify New York's inheritance of that architecture and all the cultural and imperial associations that came with it.

McKim put a steel and glazed concourse shell next to the grand waiting room, and the juxtaposition of the two spaces, one seemingly ancient and monumental, the other modern

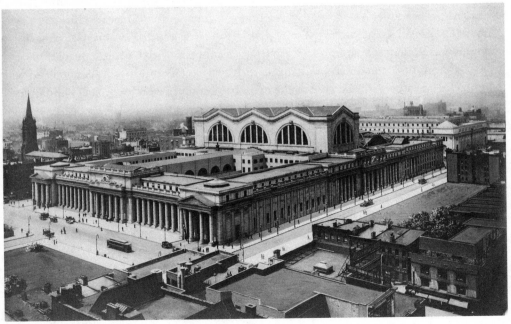

FIGURE 2.4. Pennsylvania Station, New York, as seen from Gimbels department store, ca. 1910. George Grantham Bain Collection.
Courtesy of the Library of Congress.

and utilitarian, highlighted the continuity of the classical form and its new uses in America.[44] One admirer enthused, "In catching or meeting a train at Pennsylvania Station one became part of a pageant—actions and movements gained significance while processing through such grand spaces."[45] Pennsylvania Station's magnificent architectural design and monumental spaces gave the act of meeting or taking a train an elevated meaning.

Symbolically, Roman references endowed the modern commercial metropolis with the importance and stature of imperial Rome. W. Symmes Richardson, who worked at the firm of McKim, Mead & White, commented on the appropriateness of Roman forms for American life at the turn of the century: "The conditions of modern American life, in which undertakings of great magnitude and scale are carried through, involving interests in all parts of the world, are more nearly akin to the life of the Roman Empire than that of any other civilization."[46] The plaster imperial city of the 1893 Chicago Exposition was now being translated into marble for the citizens of New York City, with the effect of reifying and perpetuating the claim to the inheritance of Rome's imperial grandeur.[47]

Some of the Gilded Age rich in New York and elsewhere made grand philanthropic use of their wealth and became patrons of the arts and learning. A number of America's wealthiest families endowed universities, orchestras, museums, libraries, and opera houses in New York and other metropolitan areas. Many of these new cultural institutions utilized the architectural language of Rome filtered through the Beaux-Arts movement. McKim, Mead & White's Pantheonic designs for the Low Library at Columbia University (1895–97) and the Gould Memorial Library at the Bronx Campus of New York University (1894–99) are particularly noteworthy examples of the influence of Roman models on New York's architecture, but that influence can also be seen in the architecture of the Metropolitan Museum of Art, the Brooklyn Institute of Arts and Sciences, the New York Public Library, and the New-York Historical Society.[48]

The taste for Roman-inspired architecture was both a gesture back to colonial and early republican uses of Rome in American architecture and part of a wave of progressive and nationalist fervor that viewed America as the heir to the great civilizations of antiquity and Europe. As Lawrence Levine has noted, this cultural identification with Europe marked a significant shift in American views of its cultural relationship to the Old World. For much of the nineteenth century, "Americans did not think of themselves as participants in a common Western civilization," but by the end of the century American architecture and art had incorporated images, symbols, and artifacts of other earlier cultures to assert precisely that.[49] The metaphorical power of architecture as a symbolic system helped bestow upon American culture a genealogy and legitimacy, placing it at the pinnacle of a trajectory that reached back through the more recent British and French empires to the Renaissance and ultimately to Greco-Roman antiquity.

Imperial Cornucopia

Wealthy elites, the middle classes, and the working classes could consume and enjoy imperial Rome in a variety of ways: in public buildings, commercial enterprises and mass

entertainments, and private homes. For example, New Yorkers gave Roman shape and form to a number of public facilities, including public baths.[50] Beginning in 1906, increasingly magnificent and lavish public baths were constructed for New York's citizens. Indoor plumbing was a rarity for much of the city's population, and public bathing facilities were a hygienic necessity.[51] However, these baths offered more than just bathing facilities: They included swimming pools, open and enclosed areas for games, meeting rooms, and steam rooms. Like ancient Roman baths (and Victorian baths in Great Britain), a number of New York public baths were designed as social centers as well as hygiene centers.

The Fleischman Baths (1908), located near the New York Public Library at Forty-Second Street and Sixth Avenue, was the most opulent and lavish of all the public baths in New York, and its design and decoration explicitly invoked the great imperial Roman baths. Fleischman's recreated the luxury and magnificence of ancient Roman baths for the enjoyment of well-to-do New Yorkers, and its publicity material cited the Baths of Diocletian as the model for its own magnificence:

> The people of ancient Rome lavished the revenues of the State in the construction of magnificent bathing institutions, which contained not only baths but also gymnasiums, libraries, and in some instances theaters. The Baths of Diocletian contained 3,200 marble seats for the use of bathers, and were adorned with exquisite mosaics, classic columns and the rarest pieces of statuary. The Fleischman Baths are a modern adaptation of the famous baths of imperial Rome.[52]

The cost for admission was one dollar, which was a hefty entrance fee: in 1910, the national average for a pound of butter was 36 cents, and the average yearly salary for all industry workers (excluding farm laborers) was 564 dollars.[53]

The inscription on the entrance or "antelarium" to the baths conflated Dante and imperial Rome: "Abandon care all ye who enter here and do as the Romans did." Fleischman's pampered its customers, who were surrounded by luxurious ways to indulge themselves. The "Roman" facilities included a *tepidarium*, a *caldarium*, a steam room, a *natatorium* or plunge pool, a shampooing room with marble compartments where bathers were scrubbed and scraped, gymnasiums, dressing rooms furnished with divans, a massage room for rubs with oils and perfumes, and pedicure and manicure departments.[54] The designers adorned the complex with marble pillars, mosaic floors, fountains, and replicas of classical statuary, and its walls were frescoed with Roman scenes. "The Diocletian Club Room," an exclusive club that provided valet service and round-the-clock services for those able to pay an extra annual fee, was located at the top of the building.

Members of the Diocletian Club (and other privileged elites) could, if they wished, continue their Roman experience into the evening and dine at Murray's Roman Gardens (1907), designed by Henry Erkins and located on Forty-Second Street between Seventh and Eighth Avenues in Manhattan.[55] The publicity material billed the Roman Gardens as a reproduction of a luxurious Pompeian villa (Pompeii was considered "the Newport of Rome") during the rule of Nero, the time of Rome's "greatest opulence and magnificence," and its promoters claimed that it was built "for the pleasure and delectation of the people in the one city in the new world, where such luxury and elegance are likely to find appre-

ciation."[56] The Manhattan Roman-themed restaurant anticipated Caesars Palace in Las Vegas in the lavish and meticulous attention it devoted to creating a sumptuous pleasure palace for imperial entertainments and ostentatious consumption.

Murray's "atrium," or interior court, served as the main dining area. Under a sky-blue ceiling lighted with electric stars and within walls festooned with vines and foliage, it contained as a centerpiece a huge fountain surmounted by a temple on a Roman barge. Fountains, palm trees, frescoes of views of the Bay of Naples and of the famous temple of Isis at Pompeii, Roman sculpture and statuary, and marble and mosaic pavements adorned the dining area. The Pompeian Garden contained palm trees, statuary, and two magnificent marble and mosaic fountains designed by Stanford White for the 1893 Columbian Exposition. Private dining rooms were located on the second floor, including one from "the period of Antony and Cleopatra" that contained a fresco of the Egyptian queen gazing from a balcony out over the landscape. As dinner guests were probably aware, Roman texts dwelt on the supposed decadence, luxury, and debauchery of Mark Antony and Cleopatra at the Egyptian Queen's palace in Alexandria.

At the Roman Gardens, patrons were "transported" to a sumptuous imperial Rome upon crossing the threshold. Erkins sought to recreate the Rome of the Caesars, the period when "Rome reached its zenith of wealth and luxury."[57] The restaurant created a villa, in the words of its publicity material, "such as a Roman general would build on return from his conquests, replete with various trophies of victories."[58] Murray's Roman Gardens was patronized by New York's wealthy elites, and it provided them a venue where they could enjoy emulating the imagined lifestyles of their imperial Roman predecessors or their British contemporaries. Murray's publicity advertised an environment that was "synonymous with artistic taste and unrivalled elegance, the storehouse for all that was precious and beautiful in the world that the Romans knew, conquered and plundered."[59] The Rome constructed at the simulated villa signifies and legitimates ancient and modern opulence, imperial conquest, and privilege.

Novi homines, or new men, in Rome and America loved display, glitter, and color. As the new men of Rome in Cicero's day plundered Egypt and Greece of their treasures, so the American plutocracy ransacked the palaces, churches, castles, and monasteries of Europe for paintings, statuary, rugs, wood carvings, and furniture for their New York palaces and Newport "cottages."[60] European tutors were imported to teach the new men, and their wives and children, etiquette, music, and appreciation of culture, much as Greek preceptors had served Roman families in the time of Cicero.[61] European artists designed and decorated for New York homes, as Greek artists had been commanded to decorate the homes of the newly rich in ancient Rome.

New York elites were well known for hosting dinners worthy of the ostentatious displays of wealth and consumption of Trimalchio, the freed slave of Petronius's *Satyricon*. At a dinner given by C. K. G. Billings in March 1903, known as the "Horseback Dinner," Sherry's restaurant in Manhattan refitted its grand ballroom for thirty-six guests and their horses.[62] The guests ate on horseback on miniature tables attached to the pommels of saddles and were served by waiters dressed as grooms at a hunting party. Saddle bags equipped with rubber tubes dispensed champagne, and elaborate oat-filled feeding troughs were set

out for the horses, which dined after their riders were finished. At another dinner party, guests dined near a thirty-foot-long ornamental pool containing four swans and discovered black pearls placed in their oysters. At still another party, human goldfish swam in ornamental pools, and chorus girls hopped out of pies. The diners occasionally made their identification with and emulation of the elites of the classical world explicit. In a photograph of a dinner given by or for Harrison Grey Fiske in the winter of 1900–1901, the black-tuxedoed dinner guests, shown relaxing after dinner with brandy and cigars, are crowned with laurel wreathes signifying their victorious status and privileged positions (Figure 2.5).[63]

The flamboyant life and career of the New York architect Stanford White is emblematic of the imperialist mood and the tastes and practices of the era. White designed numerous public buildings in Roman or Renaissance style, and he also designed homes and clubs for the Gilded Age rich, helping to translate vulgar capital into cultural capital. He shamelessly looted Europe to design palaces for the robber barons, "stripping Italian palazzi not only of their objects but their ceilings, their mosaics, their very door jambs and window frames."[64] Thinking of the Romans, Henry James referred to the loot as the "spoils" of civilization, and Thorstein Veblen called them "trophies."[65] White saw nothing wrong with this imperial process; with antiquity as his example, he claimed that it was the right of an ascendant nation to appropriate the treasures of civilization: "In the past

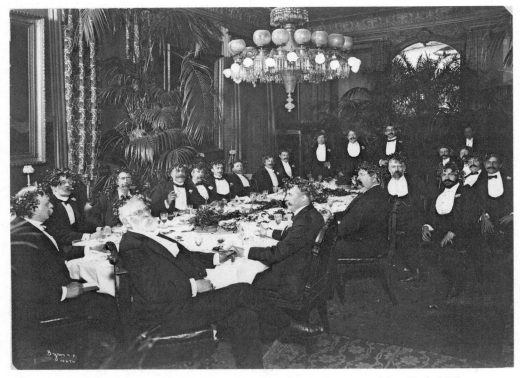

FIGURE 2.5. Harrison Grey Fiske Dinner, 1900–1901. Byron Company (New York, NY). Museum of the City of New York. 93.1.1.18338.

dominant nations had always plundered works of art from their predecessors. . . . America was taking a leading place among nations and had, therefore, the right to obtain art wherever she could."[66] White's obsession with collecting and incorporating the artifacts of other cultures into his architectural creations reflected the tastes of the age of empire.

White's acquisitive desire for beautiful objects was echoed in his desire to possess and consume women. His most notorious affair was with Evelyn Nesbit, a dancer and actress, who was sixteen when they first met. Family lore has it that White enjoyed acting out fantasies of Roman debauchery with Nesbit. According to Suzannah Lessard, White's great-granddaughter: "Sometimes when she and Stanford were in the loft with the red velvet swing Stanford would dress up in a toga and put Evelyn naked on his shoulder, pick up a big bunch of grapes, and then, looking at their image in the mirrors, march around the loft, singing at the top of his lungs."[67]

Bread and Circuses

While New York's elites indulged in private fantasies of Roman imperial pleasures and built neoclassical buildings to house art treasures from ancient and European cultures for their own enjoyment and the improvement of the populace, entertainment entrepreneurs like P. T. Barnum and Bolossy and Imre Kiralfy constructed spaces for the performance of events, loosely based on popular images of the imperial Roman world, for the pleasure of the working classes. For a small fee, thousands of New Yorkers enjoyed the supposed entertainments of the ancient Romans at the circus, at stage-spectacles, and at the amusement parks of Coney Island. These events offered patrons scenes of imperial cruelty and decadence and other forms of "Roman" entertainment, with no pretensions of moral improvement. Instead of uplift, the circuses and stage-spectacles created spaces for the performance of allegories of imperial power and dramatizations of colossal Roman excess.

Circuses capitalized on their distant link to Roman circuses. Many boasted that they were animating the Circus Maximus of ancient Rome; one circus poster boldly proclaimed: "Ancient Roman Hippodrome. A glorious picture of the Eternal City under the Caesars, reproducing with startling realism the sports, gladiatorial displays, and thrilling races of the Circus Maximus."[68] Madison Square Garden, once called the Great Roman Hippodrome, offered a variety of entertainments, including 160 light operas, romantic comedies, and P. T. Barnum's and John Ringling's circuses.[69] The "Roman" entertainments performed at these circuses included acts like the Octavian Troupe, sixteen Roman soldiers and athletes who performed "the sports, games, combats and tournaments of classic days. A historically correct representation of the thrilling scenes of the Caesarian period."[70] Chariot races, living-statue tableaux of mythological figures and events (such as Hercules, the Apollo Trio, the Seven Sapphos), gladiatorial combats, and acrobats dressed as ancient Romans juggling "Roman axes" were all popular circus acts (Figures 2.6–2.7).

Spectacular stage productions were one of the most popular forms of entertainment in late-nineteenth-century America. Enormous in scale and size, these productions featured

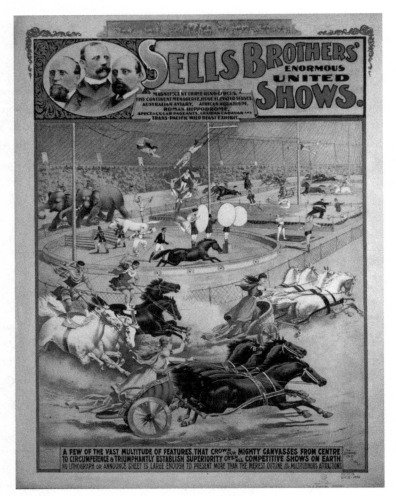

FIGURE 2.6. Sells Brothers circus poster featuring chariot races.

elaborate scenery and hundreds of singers, dancers, and actors in extravagant costume who mimed the drama to orchestral accompaniment. Imre and Bolossy Kiralfy produced the most successful stage-spectacles of the era.[71] The brothers understood the American immigrant audience's need for affordable entertainment, its desire for visual spectacle, and the advantages of mimed action, which solved the potential problem of the multiplicity of languages. In 1887, Imre Kiralfy built an outdoor theater on Staten Island where he staged his *Nero, or The Destruction of Rome*. *Nero* was produced on a lavish scale and was first performed to great acclaim in 1888.

The plot draws on the images of a cruel and decadent Rome prevalent in Victorian novels; in "toga" plays, popular from the 1880s on; and in Jean-Léon Gérôme's popular paintings of gladiators fighting and Christians martyred in Roman arenas. The performance featured gladiatorial combats, an imperial orgy, Nero's attempted seduction of an innocent Christian girl, Christians burned as human torches and thrown to wild beasts in the arena, and Nero's burning of Rome. The drama ends with Nero's death and the dawn-

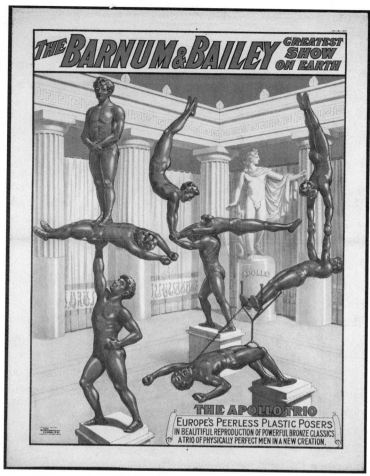

FIGURE 2.7. Barnum & Bailey circus poster advertising the Apollo Trio with the famous classical statue known as the *Apollo Belvedere* in the background.

ing of Christianity, signaled by angels appearing to transport the martyred Christians to heaven.

P. T. Barnum saw *Nero* and was so impressed that he immediately contacted Imre Kiralfy and asked him if he would be interested in shortening *Nero* into a "circus spec" and joining him with it on tour in London. Kiralfy's *Nero* became a part of Barnum and Bailey's "Greatest Show on Earth," and it reached hundreds of thousands of people, first on tour in London and then in New York and across America.

As early as 1889, the Barnum and Bailey circus referred to itself as "a stupendous mirror of departed empires."[72] Taking Roman emperors as models, circus entrepreneurs provided spectacular entertainments; they made the "pastimes of the Caesars" available to masses of people and offered "a millionaire vision for even the poorest child."[73] The Roman pastimes the entertainment entrepreneurs created for the pleasures of their audiences were based on those depicted in popular novels and paintings. Blood in the arena, the titillating

and decadent pastimes of the Roman elites, and the colossal material splendor of the Roman Empire fascinated Americans. The covers for many circus souvenir booklets and the advertising posters for *Nero* reproduced Jean-Léon Gérôme's paintings of Roman arena events. Circus attendees were not at all disturbed by any moral consideration of the events in the arena. Audiences could enjoy the spectacle without having to take a position on whether or not to condemn Nero.

In creating a miniature imperial Rome, some of the glory of that era devolved onto the circus and its modern re-creators; as Bailey said about his Greatest Show on Earth in the lavish souvenir program for the 1890 production:

> It is one of the nineteenth century's most colossal and magnificent achievements . . . to
> exhibit Rome, as she appeared in the zenith of her architectural, imperial, warlike,
> colossal, civic and festal splendors two thousand years ago. We do this, and with a
> majesty, perfection and superbness that would have amazed and captivated Nero
> himself.[74]

Circuses' lavish entertainments claimed to rival and even to supersede the imperial spectacles once provided by Roman emperors.

Similarly, Barnum employed a language of imperial power to describe the success of the circus's "victory" and "triumph" in London: "*Nero* the new, transcendent dramatic spectacle which reigned triumphant and resplendent in London for over two hundred performances."[75] One circus poster even has circus performers proceeding in triumph through the Dewey Arch (Figure 2.8)! Barnum boasted in a letter to his circus audiences that his show was so popular in London that he could "truthfully exclaim '*Veni, vidi, vici.*'"[76] Like Caesar (and later the film director Cecil B. DeMille), Barnum had the skills necessary to organize, supervise, and direct masses of people and animals. After all, it was no easy task to recreate imperial Rome under a circus tent. One circus fan said: "One is lost in admiration of the masterful generalship, the enormous labor, and the infinite care bestowed upon details . . . all going forward with the regularity and apparent ease of clockwork."[77] At a banquet given in Barnum's honor at the Hotel Victoria in London, the editor of the *Pall Mall Gazette* suggested that Barnum ranked with Caesar or even Alexander the Great. "After all, are not the great men of all ages showmen? Was not Julius Caesar, when he crossed the Rubicon . . . was not he a showman? Was not Alexander the Great a showman when he burned Persepolis, with a magnificent display of ten thousand additional lamps?"[78]

Not only did Barnum appropriate the language of imperial victory for himself and his circus; he also conflated his achievements with those of the American nation. He referred to himself as both a conqueror and a diplomatic envoy from America: he went to England, he said, "representing the Republic in amusement" and returned "triumphant to his native land," wearing "the brightest laurels the old world could bestow."[79] In Barnum's bombastic rhetoric, nationalism, patriotism, and the circus are conflated: "We went as Americans; we respectfully asked for recognition as Americans; and we won squarely on American merit."[80] The victory obtained was the recognition and admiration of the British public for the unsurpassable entertainments he and America provided the citizens of the Old

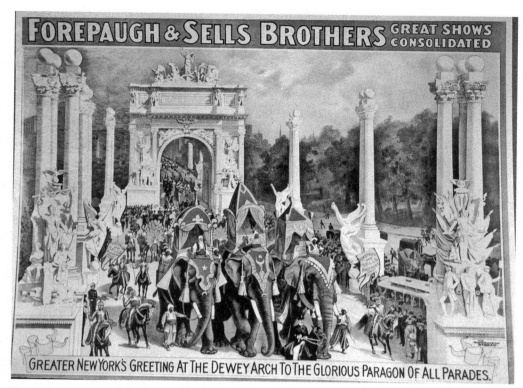

FIGURE 2.8. Forepaugh and Sells Brothers circus poster showing triumphal circus parade passing through the Dewey Arch.

World. Barnum's triumph in London demonstrated, he claimed, "a pretty fair sample of American progress, for it proves itself at least one hundred years ahead of the kind Europe can produce."[81] Americans had once again defeated the British and proved American superiority.

If Murray's Roman Gardens recreated the ritzy Pompeii of wealthy Romans for the enjoyment of New York elites, nearby at Manhattan Beach on Coney Island that same Pompeii was destroyed by a fiery cataclysm in nightly performances of James Pain's pyro-drama *The Last Days of Pompeii*. This was an abbreviated rendition of Edward Bulwer-Lytton's 1834 novel, and performances of it were held in July and August, where as many as ten thousand spectators gathered to watch it nightly. Bonfires and firework displays created the effect of an eruption, the flow of lava, and the burning of the city. Visitors to Coney Island could also experience the destruction of Pompeii at Dreamland. One of its buildings took the form of a classical temple, and its front was decorated with Charles Shean's fresco of the Bay of Naples, with the dormant volcano in the background. Inside, patrons could witness the eruption of Vesuvius, which was realized with scenic and mechanical equipment and an extraordinary electric display.

In Edward Bulwer-Lytton's popular novel, Pompeii and its luxury-loving citizens represented the dark side of empire, its decadent and oppressive face. Bulwer-Lytton had

criticized his own British aristocratic class by portraying the Roman ruling aristocratic elites of Pompeii as amoral pursuers of luxury and material display. The story is structured around two oppositions: pagans versus Christians and a noble, oppressed Greece versus a decadent, imperial Rome. Pompeii stands in for the Roman Empire; "Pompeii," Bulwer-Lytton told his readers early on in his novel, "was the miniature of the civilization of that age . . . a model of the whole empire."[82] The subject, the last days of the decadent city of Pompeii and the escape of (proto-) Christian Athenians from the doomed city, struck a chord with American hopes and fears during the Second Great Awakening, an era characterized by guilt over an increasing materialism and ascending consumerism and by anxiety over the social dislocation that had come about in the wake of territorial and commercial expansion.

Bulwer's novel was swiftly adapted into a play: J. B. Buckstone's *The Last Days of Pompeii; or, Seventeen Hundred Years Ago* ran for sixty-four nights in 1834 at the Adelphi Theatre in London. Soon after, the Bowery Theatre in New York put on an American version of Bulwer's text, credited at the time to the British-born playwright Louisa H. Medina, the wife of Thomas S. Hamblin, who managed the Bowery Theatre. However, Nicholas Daly has pointed out that "Medina's play is actually Buckstone's, down to the costume directions for the actors."[83] In any case, *The Last Days of Pompeii: A Dramatic Spectacle, Taken from Bulwer's Celebrated Novel of the Same Name* transformed Edward Bulwer-Lytton's 1834 novel into an apocalyptic melodramatic spectacle, which climaxed with the eruption of Vesuvius on stage. The play opened in February 1835 and received enthusiastic reviews; its initial twenty-nine performances constituted the longest run at that time in the history of the New York theater, and the play was frequently revived through the early 1850s.[84] According to Nick Yablon, the play "theatricalized, Americanized, and radicalized" Bulwer-Lytton's novel.[85] The melodrama draws an American/Roman analogy. The Roman villains of Pompeii stand in for parasitic factory owners, whose mechanized manufacturing was degrading skilled labor and reducing the wages of artisans, mechanics, and craftsmen, the very men who filled New York's Bowery Theatre. In Medina's adaptation, Yablon argues, Glaucus, the Athenian hero of Bulwer-Lytton's novel, embodies the honor and pride of the oppressed artisan-craftsmen.[86] *The Last Days of Pompeii* thus gives fiery expression to the resentment of working men against their masters. The play culminated with the punishment of the Roman villains: Vesuvius rained a fiery death upon the exploiters of the workingman. The destruction of the decadent city of Pompeii and its corrupt elites offered a satisfying allegory of the punishment of the capitalist entrepreneurs and the vindication of the artisan-craftsmen.

In 1879, James Pain brought his very popular pyro-drama *The Last Days of Pompeii* (also loosely adapted from Bulwer-Lytton's novel) from London's Crystal Palace to Brooklyn's Manhattan Beach at the southeastern tip of Coney Island. As with the circus spectacle *Nero, or The Destruction of Rome*, the narrative is frequently interrupted with various sideshow acts and attractions, as this *New York Times* review reveals:

Before the Temple stands an army of mail-clad warriors, with glittering weapons and armor, before whom passes a procession of priests, dancing girls, Senators, and slaves, all

in brilliant and fanciful costumes. . . . There are foot races, acrobatic performances, dancing by the fantastically attired girls, and then a confused combat, in the midst of which Vesuvius vomits forth a volume of lava; there is a tremendous earthquake, the buildings totter and fall, the populace rushes wildly about, and chaos is wrought in a very short order.[87]

In the circus extravaganzas, negative images of the decadence and cruelty of imperial Rome have been domesticated, losing their moralizing critique of the dangers of indulgence and materialism. In the 1880s, the contrast between the poverty of the working-class populations in their tenements and the imperial splendor of the civic architecture and the private mansions and retreats of the wealthy elites was even greater than it had been in the 1830s. Yet in Pain's pyro-drama and Barnum and Bailey's circuses, the conditions of metropolitan life were transformed into consumable goods, mass spectacles, and entertainments for the pleasure of the citizens of New York. In the hands of capitalist entertainment entrepreneurs, imperial Rome is exploited as a part of a new mass culture of commercialized entertainment that could be consumed across class, ethnic, linguistic, and gender lines.

Conclusion

Over the course of the 1880s and into the twentieth century, analogies drawn between the ancient Roman and modern American empires helped articulate and legitimate America's recent acquisition of an overseas empire. America, not Great Britain, was the modern successor to the ancient Roman Empire. New York, not London, was the new imperial metropolis. This is evident in the grand designs for civic architecture in New York and in popular entertainments that evoked the spirit of the Roman Colosseum and the Circus Maximus. With imperial arches, public baths, and even a restaurant called the Roman Gardens, New York clothed itself in imperial finery as it set about acquiring and then taking pleasure in its new empire. In contrast to contemporary British imperial politics, which are haunted by decline and fall, in America there is little fear of decline. Many members of the public now believed that the United States was historically unique and hence not subject to a trajectory of decline. America would not repeat Rome's fate (or contemporary Great Britain's), because Manifest Destiny made America's empire a virtuous, divinely guided one. Imperial pleasures were increasingly to be consumed, enjoyed, and displayed by all classes. All citizens could now enjoy the cornucopia of empire.

NOTES

1. This chapter uses, adapts, and expands material from Margaret Malamud, *Ancient Rome and Modern America* (Oxford: Wiley-Blackwell, 2009); and *"Translatio Imperii*: America as the New Rome c. 1900," in *Classics and Imperialism in the British Empire*, ed. Mark Bradley (Oxford: Oxford University Press, 2010), 249–83.

2. For the uses of classics in debates on imperialism in Great Britain, see the chapters in Bradley, ed., *Classics and Imperialism in the British Empire*.

3. The use of classical architectural models for American buildings was not new in the late nineteenth century. Thomas Jefferson's designs for the University of Virginia and the Virginia state capital are two examples of the early American interest in Roman architecture. Emulation of Rome had included a taste for its architecture. Jefferson and Federalist architects, however, admired and invoked the Roman Republic rather than imperial Rome.

4. See the discussion in Malamud, *Ancient Rome and Modern America*, 122–49.

5. Richard Morris Hunt designed the Administration Building; the firm of McKim, Mead & White did the Agricultural Building; Henry Van Brunt and Howe designed the Electricity Building; Adler and Sullivan did the Transportation Building; Charles Atwood designed the Terminal Station, the Fine Arts Building, and the Peristyle; Frederick Law Olmsted was in charge of landscape architecture; and Augustus Saint-Gaudens was the consultant for sculpture.

6. Quoted in Neil Harris, "Expository Expositions: Preparing for Theme Parks," in *Designing Disney's Theme Parks: The Architecture of Reassurance*, ed. Karla A. Marling (New York: Flammarion, 1997), 19.

7. Candace Wheeler, "The Dream City," *Harper's Monthly* 86 (1893): 836.

8. Charles Atwood's Peristyle featured a series of forty-eight Corinthian columns, one for each of America's states and territories, and an immense triumphal arch. On top of the arch was Columbus in a Roman chariot, and carved above the arch were the names of other conquerors and explorers of the New World. Corinthian columns flanked McKim, Mead & White's Agricultural Building, the dome was crowned with Augustus Saint-Gaudens's nineteen-foot statue of the Roman goddess *Diana*, and most of its sculpture and painted decoration were inspired by Roman references.

9. "There was no place in the modern world so magnificent, so imperial in its beauty." Barr Ferree, quoted in David F. Burg, *Chicago's White City of 1893* (Lexington: University of Kentucky Press, 1976), 396.

10. See the discussion in Richard W. Rydell, *All the World's a Fair: Visions of Empire at American International Expositions, 1876–1916* (Chicago: University of Chicago, 1984), 38–40.

11. Burnham, quoted in Lewis Mumford, *Sticks and Stones: A Study of American Architecture and Civilization*, 2nd rev. ed. (New York: Dover, 1955), 67.

12. Quoted in Harris, "Expository Exhibitions," 19.

13. Barbara M. Barker, "Imre Kiralfy's Patriotic Spectacles: Columbus, and the *Discovery of America* (1892–1892) and *America* (1893)," *Dance Chronicle* 17, no. 2 (1994): 173.

14. Mumford, *Sticks and Stones*, 60–61.

15. See the collection of essays in Brooklyn Museum, *The American Renaissance, 1876–1917* (New York: Pantheon, 1979). Also see Ritter's chapter in this volume.

16. See the discussion in Robert A. M. Stern, Gregory Gilmartin, and John M. Massengale, eds., *New York 1900: Metropolitan Architecture and Urbanism, 1890–1915* (New York: Rizzoli, 1983), 11–25.

17. The key characteristics of City Beautiful design plans included neoclassical architecture, grand avenues, green spaces, massive buildings and civic centers, and a unity of design and scale.

18. Elizabeth Macaulay-Lewis, "The Architecture of Memory and Commemoration: The Soldiers' and Sailors' Memorial Arch, Brooklyn, New York, and the Reception of Classical Architecture in New York City," *Classical Receptions Journal* 8, no. 4 (2016): 472.

19. Frederick Jackson Turner, *The Significance of the Frontier in American History* (1893; repr., Ann Arbor: University of Michigan, 1966).

20. Senator Cullom, quoted in Amaury de Riencourt, *The Coming Caesars* (New York: Coward-McCann, 1957), 194.

21. First published in *McClure's Magazine* 12, no. 4 (1899).

22. Plans for advertising the Exposition included "novel and attractive exhibits of the material resources, products, industries, manufactures, architecture, art, types of native people and

illustrations of the present state of the civilization of the islands of the sea recently acquired by the United States." Rydell, *All the World's a Fair*, 124.

23. Albert J. Beveridge, "Policy regarding the Philippines," *Congressional Record*, 56th Congress, 1st session, January 9, 1900, 704–12, http://social.chass.ncsu.edu/slatta/hi216/documents/imperialism.htm.

24. Triumphal Roman arches celebrating American heroes and military victories were among the earliest neoclassical structures built to adorn New York public spaces, and civic extravaganzas were organized to commemorate those heroes and events. The Washington Square Arch was erected in 1889 to mark the centennial of George Washington's inauguration. Stanford White designed an arch (1889–92) to replace this temporary arch. White also designed the Soldiers' and Sailors' Memorial Arch at Grand Army Plaza, Brooklyn (1889–92). See Elizabeth Macaulay-Lewis, "Triumphal Washington: New York City's First 'Roman' Arch," in *War as Spectacle: Ancient and Modern Perspectives on the Display of Armed Conflict*, ed. Anastasia Bakogianni and Valerie M. Hope (London: Bloomsbury Academic, 2015), 209–38; and Macaulay-Lewis, "The Architecture of Memory and Commemoration." My description of the Dewey Arch and Dewey's triumphal parade is based on Fred T. Alder and Harry C. Green, *Official Programme and Souvenir Reception of Admiral Dewey by the City of New York to Admiral Dewey September 29th and 30th, 1899* (New York: F. T. Alder and G. C. Green, 1899); Moses King, *The Dewey Reception in New York City* (New York: Prints and Photographs Division, New-York Historical Society, 1899); Stern et al., *New York 1900*, 20; and Michele H. Bogart, *Public Sculpture and the Civic Ideal in New York City, 1890–1930* (Chicago: University of Chicago Press, 1989), 98–106, 342.

25. Macaulay-Lewis, "Triumphal Washington," 222, fig. 12.3.

26. Alder and Green, *Official Programme*, 6.

27. Alder and Green, *Official Programme*, 7.

28. Bogart, *Public Sculpture and the Civic Ideal*, 104.

29. David Brody, *Visualizing American Empire: Orientalism and Imperialism in the Philippines* (Chicago: University of Chicago Press, 2010), 135.

30. "Two Millions Pay Tribute to Dewey," *New York Times*, October 1, 1899. In fact, the civic extravaganza was so popular that vandalism presented a threat: Many people wanted to take a piece of the arch home with them.

31. Mumford, *Sticks and Stones*, 61.

32. According to contemporary critics, the Dewey Arch's design follows the Arch of Titus and "the great Arch of Paris, the Arc de Triomphe." The article in the *Architects' and Builders' Magazine* also boasts, "This arch celebrates not only one of the greatest naval achievements of our age but it is also an artistic achievement of no small significance to American Art. New York has come to be recognized as the greatest Art Center of America . . . [and] there is no world center save Paris which takes a higher stand in Art matters, and has before it a future of greater promise." "The Dewey Arch," *Architects' and Builders' Magazine* 1, no. 1 (October 1899): 1.

33. Moses King, *New York: The American Cosmopolis, the Foremost City of the World* (Boston: M. King, 1894), 2.

34. Green, quoted in Edwin G. Burrows and Mike Wallace, *Gotham: A History of New York City to 1898* (New York: Oxford University Press, 1999), 1226.

35. The main banking room of "this lavishly detailed, nobly proportioned Roman room was surely one of the glories of the period." Stern et al., *New York 1900*, 178.

36. For example, the Franklin Savings Bank (1899), the Union Square Savings Bank (1907), and Mowbray & Uffinger's Dime Savings Bank in Brooklyn (1907) also employed classical references. See the description and discussion in Stern et al., *New York 1900*, 178–80.

37. See Janet DeLaine, "The *Romanitas* of the Railway Station," in *The Uses and Abuses of Antiquity*, ed. Maria Wyke and Michael Biddiss (Bern: Peter Lang, 1999), 145–66.

38. *The Center of the First City of the World: Concerning the New Grand Central Station, Forty-Second Street, New York* (New York: Rare Books Division of the Avery Architecture Library, Columbia University, 1904), 1. "Situated in the center of New York, the greatest city in America, the financial center of the world, and the most important commercial city on the globe, it occupies a unique position and is an ornament to its surroundings" (4–5). The New York Central and Hudson River Railroad Company, Passenger Department, produced this pamphlet.

39. "The three arched portals flanked by attached columns were clearly a repetition of the Arc du Triomphe du Carrousel . . . and served as a symbolic triumphal arch for the railroad," and "The main façade was one of the glories of the Modern French style in America." Stern et al., *New York 1900*, 37.

40. *The Center of the First City*, 3.

41. *The Center of the First City*, 19.

42. For Pennsylvania Station, see Steven Parissien, *Pennsylvania Station: McKim, Mead and White* (London: Phaidon, 1996); and Stern et al., *New York 1900*, 40–42. See also Gensheimer's chapter in this volume.

43. DeLaine, "*Romanitas* of the Railway Station," 153.

44. "Between the two spaces, one of modern materials, the other of (seemingly) ancient prototypes, McKim obviously intended for a dialogue to take place on the nature of American civilization." Richard G. Wilson, *McKim, Mead and White Architects* (New York: Rizzoli, 1983), 217.

45. Wilson, *McKim, Mead and White Architects*, 217.

46. William S. Richardson, "The Architectural Motif of the Pennsylvania Station," in *History of the Engineering Construction and Equipment of the Pennsylvania Railroad Company's New York Terminal and Approaches*, ed. W. Couper (New York: Isaac H. Blanchard Co., 1912), 77.

47. Technically not marble but travertine and granite.

48. For the classicism of these buildings, see the discussion in Stern et al., *New York 1900*, 88–98. Note also the acerbic comment of Lewis Mumford in 1924 about the classicism of these museums in New York and their contents: "If the imperial age was foreshadowed in the World's Fair, it has received its apotheosis in the museum . . . the imperial museum is essentially a loot-heap, a comprehensive repository for plunder." Mumford, *Sticks and Stones*, 148–49. For the Gould Memorial Library designed for the University Heights Campus of New York University in the Bronx by Stanford White, see Elizabeth Macaulay-Lewis's chapter in this volume.

49. Lawrence Levine, *The Opening of the American Mind: Canons, Culture, and History* (Boston: Beacon, 1996), 60.

50. See McDavid's chapter in this volume.

51. For New York public baths, see Stern et al., *New York 1900*, 137–41.

52. *The Fleischman Baths: Bryant Park Building, Forty-Second St. & Sixth Ave., New York City* (New York: Gudé-Bayer Co., 1908). All quotations are from this advertising pamphlet, which is unpaginated.

53. Scott Derks, *The Value of a Dollar: Price and Incomes in the United States, 1860–2004*, 3rd ed. (Millerton, NY: Grey House, 2004).

54. There were also barber and hairdressing salons; a solarium, which contained a tropical garden with trees, plants, flowers, statuary, and birds; a restaurant; and a grill. The baths also offered pool and billiard games, a bowling alley, and boxing matches in the gymnasium.

55. My description of Murray's is based on Charles R. Bevington, *New York Plaisance—An Illustrated Series of New York Places of Amusement*, vol. 1 (New York: New York Plaisance, 1908); and Henry Erkins, "Murray's Roman Gardens," *Architects' and Builders' Magazine* 8 (1907): 574–49. Brief discussions of the Roman Gardens can also be found in Stern et al., *New York 1900*, 224–25; and Rem Koolhaas, *Delirious New York: A Retroactive Manifesto for Manhattan* (New York: Monicelli, 1994), 101–3.

56. Bevington, *New York Plaisance*, n.p.

57. Bevington, *New York Plaisance*, n.p.

58. Bevington, *New York Plaisance*, n.p.

59. Bevington, *New York Plaisance*, n.p. Compare these boasts with the disdainful comment of Lewis Mumford on the "plunder" and "loot" of the "imperial museums" in New York in note 48.

60. See Figure 3.1 in Bartman's chapter, in this volume.

61. On the role of ancient art in elite education, see Caroline Winterer, *The Culture of Classicism: Ancient Greece and Rome in American Intellectual Life, 1780–1910* (Baltimore, MD: Johns Hopkins University Press, 2002), 125–30.

62. For this dinner, see Grace M. Mayer, *Once upon a City: New York from 1890 to 1910 as Photographed by Byron and Described by Grace M. Mayer* (New York: Macmillan, 1958), 224–25.

63. The photograph is in Mayer, *Once upon a City*, 222–23. Mayer was unable to identify the precise occasion for the dinner.

64. Suzannah Lessard, *Architect of Desire: Beauty and Danger in the Stanford White Family* (New York: Dial, 1996), 115.

65. James and Veblen, quoted in Matthew Josephson, *The Robber Baron: The Great American Capitalists, 1861–1901* (1934; repr., New York: Harcourt, Brace and Co., 1962), 341.

66. White, quoted in Brooklyn Museum, *American Renaissance*, 15.

67. Lessard, *Architect of Desire*, 285. Nesbit's husband, Harry Thaw, a wealthy Pittsburgh industrialist, later shot and killed White at a rooftop garden of a restaurant White had designed in Manhattan.

68. Charles P. Fox and Tom Parkinson, *Billers, Banners, and Bombast: The Story of Circus Advertising* (Boulder: University of Colorado Press, 1985), 160.

69. In 1873, P. T. Barnum leased, from the Vanderbilt family, the New York and Harlem Rail Road shed, which took up an entire square block bounded by Madison and Fourth Avenues and by Twenty-Sixth and Twenty-Seventh Streets. Barnum remodeled it as the Great Roman Hippodrome and put on performances of the world's first three-ring circus. After Barnum gave up the lease in 1879, Vanderbilt renamed it Madison Square Garden. In 1885, Vanderbilt razed the building and sold the site to a group of millionaires, including Andrew Carnegie and J. P. Morgan, who hired Stanford White to design the new Madison Square Garden. John Culhane, *The American Circus: An Illustrated History* (New York: Holt, 1990), 104–5.

70. Forepaugh-Sells Company, *Official Route Book of the Circuses* (Circus File, Billy Rose Theatre Collection, New York Public Library, 1898).

71. For Bolossy Kiralfy, see Bolossy Kiralfy, *Bolossy Kiralfy, Creator of Great Musical Spectacles: An Autobiography*, ed. B. Barker (Ann Arbor: University of Michigan Press, 1988). For Imre Kiralfy, see Barker, "Imre Kiralfy's Patriotic Spectacles."

72. Bluford Adams, *E Pluribus Barnum: The Great Showman and the Making of United States Popular Culture* (Minneapolis: University of Minnesota Press, 1997), 188.

73. A claim asserted in a poster for "The Great Barnum and Forepaugh Combination," located in the Circus File at the Museum of the City of New York.

74. Phineas Taylor Barnum, *Nero, or The Destruction of Rome Souvenir Program* (Circus File, City Museum of New York, 1890).

75. Barnum, *Nero*.

76. Barnum, *Nero*.

77. Barnum, *Nero*.

78. Barnum, *Nero*.

79. Barnum, *Nero*.

80. Barnum, *Nero*.

81. Barnum, *Nero*.

82. Edward Bulwer-Lytton, *The Last Days of Pompeii* (1834; repr., Garden City, NY: Doubleday, 1946), 9.

83. Nicholas Daly, "The Volcanic Disaster Narrative: From Pleasure Garden to Canvas, Page, and Stage," *Victorian Studies* 53, no. 2 (Winter 2011): 275. Thanks to Elizabeth Macaulay-Lewis for bringing this article to my attention.

84. There were new productions in 1836, 1840, and 1843.

85. Nick Yablon, "'A Picture Painted in Fire': Pain's Reenactments of *The Last Days of Pompeii, 1879–1914*," in *Antiquity Recovered: The Legacy of Pompeii and Herculaneum*, ed. Victoria Gardner Coats and Jon L. Sedyl (Los Angeles: J. Paul Getty Museum, 2007), 193.

86. Yablon, "'A Picture Painted in Fire.'"

87. Quoted in Daly, "The Volcanic Disaster Narrative," 277.

Archaeology versus Aesthetics: The Metropolitan Museum of Art's Classical Collection in Its Early Years

Elizabeth Bartman

The classical collection of the Metropolitan Museum of Art (the Met) in New York is arguably the finest in the United States today.[1] Between its founding in 1870 and just before World War II, the Met acquired thousands of objects, from prehistoric potsherds to monumental architecture. In between were Greek pots, coins, terracottas, fragments of glass, Cypriot statues, Etruscan bronzes, Roman marbles, and frescoes. This range of objects from diverse ancient Mediterranean cultures befits a museum that from its near beginnings had the ambitious goal of being an encyclopedic, or universal, museum and the "greatest" in America.[2]

In many respects, the early history of the museum mirrors that of other public cultural institutions founded in the so-called Gilded Age of the latter nineteenth century.[3] Flush with new wealth, the Met, like its counterparts in Boston, Baltimore, and elsewhere, was conceived as a temple of art where visitors would be educated, elevated, and inspired. Americans were traveling abroad and hosting world's fairs; buying foreign art treasures for their home cities was a logical next step, reflecting not only their new internationalism but also their sense of Manifest Destiny.[4] However, being located in New York—not just a city but a nascent metropolis of unmatched power—the Metropolitan aimed higher than other American museums as it sought world-class status on a par with the Louvre or the British Museum.

Today a little-noticed plaque near the Metropolitan's entrance salutes its trustee, benefactor, and president John Pierpont Morgan with a single eloquent sentence: "He helped to make New York the true metropolis of America" (Figure 3.1). Indeed, from hiring

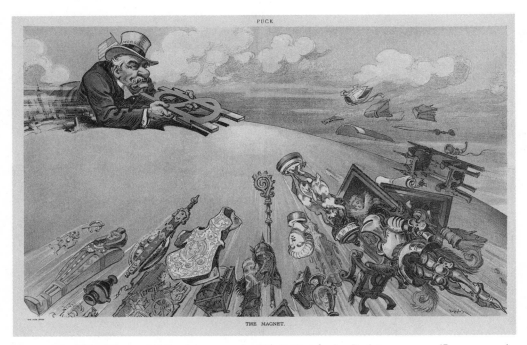

FIGURE 3.1. "The Magnet." Editorial cartoon by Udo J. Keppler Jr., *Puck* 69, no. 1790 (June 21, 1911). Courtesy of the Morgan Library and Museum. ARC 2650.

specialist curators to systematizing displays, Morgan was a pivotal figure in shaping both the Met and smaller museums that followed its lead.[5] Although the classical collection was but one part of an institution he transformed, its role in bringing Greco-Roman classicism to the city of New York was no less powerful than the classically informed buildings that feature in several other chapters in this volume. Like them, the Met's collection presented a vision of antiquity that was highly selective, curated, and filtered through the sensibilities of its leaders.

The history of the Met's classical collection, as well as of the museum itself, begins with the Cesnola collection. In 1870, the fledging Metropolitan had money and a mission but as yet few artworks. Luigi Palma di Cesnola, an American Civil War officer who had served as US consul on Cyprus, possessed just the collection to launch the museum as a serious collecting institution.[6] Over the course of several years, the charismatic Cesnola sold the museum some 35,000 works (mainly Cypriot statues but also vases, gems, and other artifacts) that he had dug up on the island (Figure 3.2).

Cesnola also managed to get himself hired as the museum's first director in 1879, a post he held until his death in 1905. That Cesnola's antiquities were virtually synonymous with the museum is shown by a fictional passage of Edith Wharton, who chronicled New York society of the early twentieth century:

> Newland Archer sat at the writing-table in his library in East Thirty-ninth Street.
> He had just got back from a big official reception for the inauguration of the new galleries at the Metropolitan Museum, and the spectacle of those great spaces crowded

FIGURE 3.2. H. R. Ogden composite drawing of the Metropolitan Museum of Art.
Frank Leslie's Illustrated Newspaper, April 10, 1880.

with the spoils of the ages, where the throng of fashion circulated through a series of scientifically catalogued treasures, had suddenly pressed on a rusted spring of memory.

"Why, this used to be one of the old Cesnola rooms," he heard some one say; and instantly everything about him vanished, and he was sitting alone on a hard leather divan against a radiator, while a slight figure in a long sealskin cloak moved away down the meagrely-fitted vista of the old Museum.[7]

But the Cesnola purchase, which was expensive for the time, quickly disappointed: A number of statues were accused of being pastiches cobbled together from different sources,[8] while thousands of them were classified as "duplicates" that the museum eventually sold off.[9] By 1887, the trustees were publicly fretting about the quality of the objects in the galleries.[10]

Even worse, works that were for many museumgoers the first "classical" Mediterranean antiquities they had ever seen turned out to be not so classical after all. Alas, Cyprus was not Athens, and although the works found by Cesnola had aspects in common with Greek art, they could hardly be termed mainstream Greek.[11] It would appear that by painting his statues with limewash to mask their bright polychromy, as was later discovered,[12] Cesnola attempted to make them look more Greek. Their non-Greekness posed a problem, for by the late nineteenth century, Greek art was widely regarded as the artistic high point of antiquity. Influential scholars such as Percy Gardner, Henry Chase, and the Met's own curators all trumpeted its virtues.

Cesnola's Cypriot antiquities had little status in the narrative of Western art emerging at the time of the Met's founding. As Ralph Cram, the Gothic Revivalist architect (and one-time colleague of Bertram G. Goodhue),[13] wrote, "Forget the archaeology of Babylonia, Crete, Egypt. Realize that the great sequence is from Greece to Rome, to Byzantine, Gothic, Early Renaissance and the Pagan Renaissance."[14] In the study of history as well, ancient cultures other than Greece and Rome were increasingly marginalized.[15] In its aspirations to be a universal museum like the Louvre, the Met could not subscribe wholeheartedly to views such as Cram's and ignore earlier civilizations in Egypt and Assyria. But Cram's location of Greece (and Rome) as the foundation of all Western art cannot but have fortified a new classical department competing for museum space, funding, and resources. It is no accident that Greek and Roman art has always occupied prime real estate on the museum's first floor.[16]

During the very years in which the Metropolitan was establishing itself as a treasury of ancient monuments, spectacular archaeological discoveries from such renowned places as Troy, Mycenae, and, later, Ur and Luxor enthralled the public and expanded the corpus of collectible antiquities. In the sphere of archaeology, Americans had been outpaced by the Europeans for decades; nonetheless, archaeology's merits for gaining both knowledge and artifacts were obvious. As an officer of the newly founded Archaeological Institute of America wrote, "America should not lose its share . . . for lack of enterprise."[17] The Met took up the challenge, launching long-term field projects in Egypt in 1906[18] as well as more limited excavations in Ctesiphon, Nishapur, and elsewhere in the Near East during the 1930s.

Yet, classical archaeology—the archaeology of ancient Greece and Rome—never became central to the Metropolitan's mission. To be sure, its most influential curators during

these years—Edward Robinson (1858–1931) and Gisela Richter (1882–1972)[19]—described themselves as archaeologists, but their use of the term reflected the late-nineteenth-century tradition in which they were trained rather than today's definition of an archaeologist as a person who excavates ancient sites. After an undergraduate education at Harvard that included digging at Assos in modern-day Turkey, Robinson (Figure 3.3)[20] studied in Germany and Greece; Richter took an undergraduate degree at Girton College, Cambridge, before a stint at the British School in Athens.[21] Although both approached their subject scientifically by applying a scholarly rigor grounded in chronology, typology, and other taxonometric criteria, their methodologies align more with what today we would call art history, and neither seems to have undertaken any fieldwork as mature scholars.[22] More critically for the Metropolitan's collecting, neither appears to have advocated excavation as a way to acquire exhibit-worthy objects to fill the classical rooms in the new museum. As we shall see, the tension between archaeology and aesthetics—by which I mean a concern for physical appearance and, ideally, beauty—recurs throughout the history of the Greek and Roman Department's collecting and other curatorial activities.

Ironically, an aversion to classical archaeology in the Greek and Roman Department was one of the legacies of Cesnola. By Cesnola's death in 1905, the Metropolitan had learned a hard lesson about archaeology. First, all those inevitable duplicates took up space and other scant museum resources. Multiples, obviously, are neither ideal nor necessary for advancing the mission of the universal museum. Second, and more importantly, the randomness intrinsic to archaeology was fundamentally at odds with filling a universal museum. Notwithstanding the surveys and reconnaissance, serendipity always plays a role in digging—archaeology can guarantee neither the nature nor quality of the works that emerge. The museum's *Bulletin* of 1906 states the problem succinctly: Commenting on the vases that were part of the Cesnola purchase, the unnamed writer notes that they "were necessarily what had come to hand in the excavations, rather than what might have been chosen with forethought."[23]

Although it does not say so outright, the *Bulletin* provides the rationale for hiring Robinson away from the rival Museum of Fine Arts, Boston, in 1905 and then John Marshall as its exclusive purchasing agent in 1906.[24] If the goal was obtaining masterpieces, as it clearly was, hiring an agent to make targeted purchases was obviously more expedient than any archaeological endeavor. In Marshall, who had formed part of the circle around Edward Perry Warren at Lewes House in Sussex, England,[25] the Metropolitan found a savvy, well-connected agent who also had a very good eye. Indeed, most of the museum's finest ancient works came through Marshall over the more than two decades in which he was employed by the Met: Among them were the statue of the falling Protesilaos, that of the Old Market Woman, and a gigantic Geometric krater.[26] The latter work suggests that although Marshall was based in Italy he had good connections in Greece as well.[27]

Of course, as purchasing agent Marshall was but one factor—along with money and vision—in the transformation of the Met's classical collection in the first two decades of the twentieth century. The funding came largely from the multi-million-dollar legacy of Jacob S. Rogers in 1901; as this gift was unrestricted, credit for the generous allocations to the classical collection must go to the persuasive power of the museum's assistant

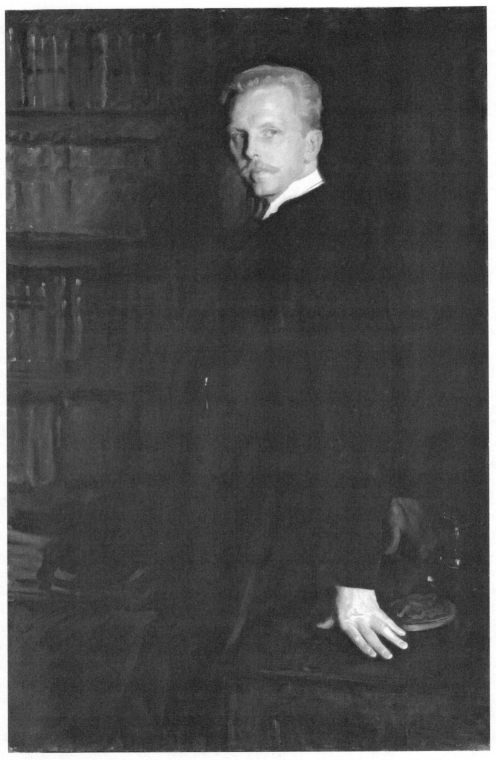

FIGURE 3.3. Portrait of *Edward Robinson*, 1903, by John Singer Sargent (1856–1925). Oil on canvas, 56½ × 36¼ in. (143.5 × 92.1 cm). The Metropolitan Museum of Art, Gift of Mrs. Edward Robinson, 1931 (31.60).

OASC, www.metmuseum.org.

director Robinson as well as to the support of President Morgan. No doubt financial support was explicitly promised to Robinson when the Metropolitan hired him away from Boston's Museum of Fine Arts in 1905, as he brought Marshall with him.[28] Their joint departure from Boston was considered a coup, and it spelled the end of the Museum of Fine Arts' several decades of dominance in antiquities collecting in America.[29]

Marshall sent yearly consignments of his European purchases to the museum, but unfortunately we don't really know what, if any, guidance the department provided; that is, to what extent was he a free agent with sole responsibility for acquisitions decisions? Marshall's primary contact during this period was Robinson, who is known to have visited Italy regularly and met with Marshall there. Little of their conversation is recorded— indeed, their correspondence often specifically delays the discussion of issues "until we see each other in person."[30]

Of course, reliance on a single agent had its dangers, for no one individual possesses in-fallible critical judgment, expertise, or necessarily the appropriate network to collect for the universal museum. The fiasco of the Etruscan warriors, the colossal terracotta figures pur-chased by Marshall in the 1910s and exposed as forgeries decades later, is the most dramatic example of an error of judgment, but Marshall purchased other fakes as well.[31]

Early in his relationship with the Metropolitan, Marshall steered the museum away from acquisitions that he deemed too "archaeological."[32] He seems likely to be responding to direc-tives from the museum, specifically from Robinson; in early 1907, Robinson wrote in the Met's *Bulletin* of his aim of "developing the Museum's collection of classical art along system-atic lines, strengthening it where it is weak, rounding it out as a whole, maintaining . . . a high standard of artistic excellence."[33] Robinson's stated mission would have had several drivers. As Robinson's successor Gisela Richter publicly stated decades later, "before 1905 the Museum owned only a few pieces of importance."[34] In fact, most of the museum's classical holdings in its early decades consisted of works belonging to the "minor arts," that is, engraved gems and sealstones, glass, and coins; such artifacts had belonged to private collections—typically consisting of a single artifact type—donated to the museum by the collectors (often trustees) or others.[35] Although such works could manifest the "Greek ge-nius,"[36] the fact remained that the museum was deficient in works from the so-called major arts of architecture, sculpture, or painting (Figure 3.4). This lack obviously posed a problem for the universal museum. In addition, little in the Met's collection was Greek and thus repre-sentative of what Robinson and his contemporaries regarded as the pinnacle of ancient artistic production. And without a full roster of Greek sculpture, the museum was hard-pressed to advance the then emerging theories of artistic progress (through naturalism)[37] and the very achievement that for many made it an anchor in the development of Western art as a whole.

Notwithstanding official restrictions on export, countless antiquities left Italy and other source countries during the decades of Marshall's collecting. Like other museums, the Metropolitan frequently benefitted from the lax oversight and even outright corrup-tion of the local authorities.[38] In fact, the Imperial Museum opened in Istanbul in 1870,[39] the same year that Abdo Debbas, the US vice consul at Tarsus, bestowed a Roman sar-cophagus on the Metropolitan.[40] In view of Italy's legal position, the museum was typi-cally reticent about a newly acquired object's provenance; either no information at all was

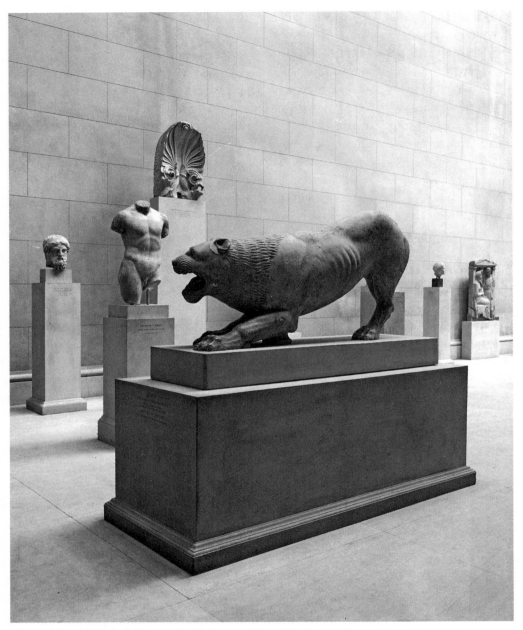

FIGURE 3.4. Greek and Roman Art Galleries (Wing J Gallery), Metropolitan Museum of Art, view looking southeast. Photographed on April 12, 1921.
© The Metropolitan Museum of Art. Image source: Art Resource, NY.

published, or, in a nod to the certainty of archaeological discovery, a work was "said to be from *x*" when in fact there was no irrefutable information about provenance.[41]

But while Italy and Greece largely prohibited foreigners from exporting antiquities and excavating in their territory, countries on the fringes of the Mediterranean basin offered ample opportunity for legally acquiring major works of the highest quality through

purchase and archaeological fieldwork. Hence Mikhael Rostovzeff dug at Dura Europos under the auspices of Yale; teams from the Museum of the University of Pennsylvania worked at Bet Shean in present-day Israel, at Kourion on Cyprus, at Vrokastro on Crete, and at Minturnae in Italy (not to mention Ur); and Francis Kelsey from the University of Michigan dug at Carthage, Seleucia on the Tigris, Sepphoris, and several sites in Egypt.[42] What distinguishes these institutions, of course, is that they are all academic: Acquiring beautiful objects is unlikely to have been their primary aim but rather the acquisition of research material and historical knowledge as well as the training of students. Indeed, the Penn Museum was fashioned as a museum of "archaeology" from its beginnings in 1887, and Kelsey's first purchases in 1893 were inspired by their educational value for students. In his work at Karanis in Egypt, Kelsey adopted a "modern" archaeological approach that aimed "not only to recover new documentary and literary papyri . . . but also to extract and record every trace of other kinds of archaeological material by which a reconstruction of the inhabitants' lives might be achieved."[43]

The excavations conducted at Antioch-on-the-Orontes in the 1930s, however, present a notable exception to the museum/university dichotomy I have just noted.[44] Syria had granted the French National Museums a concession to dig the site, an eastern capital of the late Roman Empire whose lost architectural glories were tantalizingly described by ancient writers. The French were looking for American partners to finance 25 percent of the costs of the dig, and an enthusiastic Charles Rufus Morey of Princeton hoped to enlist four other American institutions to commit to an annual contribution of $6,000 for five years.[45] In exchange, the Americans would get a quarter of the finds. Like all excavations, there were of course no guarantees, but putting two thousand men to work digging a site renowned in antiquity for its wealth and luxury made it likely that important discoveries would be made at Antioch.

First on the list of museums to be approached, the Metropolitan declined to participate. Why? Admittedly, the country was in the midst of the Depression, but obviously that was no deterrent to Baltimore's Walters Art Gallery, the Worcester Art Museum, Princeton, or to Harvard University's Fogg Museum and Dumbarton Oaks, both of which belatedly opted in. And the Metropolitan continued to buy actively during the decade. Hence we may speculate that the intellectual biases of Gisela Richter, newly appointed head of the department, played a role.[46] (On the death of Marshall in 1928, Richter had also become the Met's purchasing agent.) An impassioned advocate for Greek art, Richter frequently disparaged Roman art in her writing.[47] Having the benefit of hindsight, we are able to consider the department's acquisitions during the decade in which it declined to participate in the Antioch excavations. There is no doubt that during those years Richter made some spectacular purchases of Greek art—foremost among them are the archaic male nude now known as the New York kouros and a late-sixth-century grave stele.[48] She also seems to have persuaded trustee John D. Rockefeller to buy a celebrated Amazon, widely regarded as a Roman copy of a lost mid-fifth-century Greek work, at the Lansdowne collection sale in London in 1932.[49] She also bought a number of less impressive Greek works.

Meanwhile, mosaics, now generally regarded as among the most brilliant achievements of Roman art, are barely attested in the collection; to my knowledge, the Met's Greek and

Roman Department possesses only one distinctive mosaic, a fragment purchased from Baltimore, who had obtained it from their Antioch distribution.[50] In contrast, thanks to their excavation support, Princeton and Baltimore are awash in mosaics,[51] and the Worcester Museum received the prize of the Great Hunt mosaic, probably the finest Roman mosaic in all of America and said to have represented an astonishing return on investment.[52]

In declining to support the Antioch excavations—and it was not alone in doing so[53]—the Metropolitan clearly asserted its collecting priorities: masterpieces over scientific knowledge, aesthetics over archaeology. Given the museum's decades-long support of archaeological fieldwork in Egypt and the Near East, however, it is clear that this attitude was particular to the classical realm rather than representative of the institution in its entirety. In the museum's dominant narrative, however, Greece was regarded as the *fons et origo* of Western art, but only Greek art of a certain kind was collectible. If it did not have the "inherent beauty" for which Greek art was lionized by Robinson, Richter, and others, it was not of interest. Hence the collection grew through selective purchases rather than the vagaries of the spade.

But even if the Met's Greek and Roman Department did not financially support archaeological work, it could not ignore archaeology entirely. Archaeology had played a critical role in the Cesnola affair. For example, when accusations of fraud surfaced about Cesnola's antiquities, experts looked to documented excavations to help determine authenticity.[54] Fortunately, Cesnola's successors on Cyprus were motivated more by scientific knowledge than treasure hunting, and their excavations helped give context to the thousands of artifacts that Cesnola's undocumented digging had unearthed.[55]

Through didactic photographs, plans, and casts of the great monuments that remained in Greece and Italy, the museum's displays acknowledged that a work of art needed context in order to be fully understood (Figure 3.5). In fact, one of the early handbooks of the collection published in 1927 explicitly noted archaeology's role in documenting prehistoric Greek art at such sites as Mycenae, Tiryns, Knossos, and Phaistos.[56] And works that came from scientifically run excavations were proudly advertised as such: Richter's memoir of 1970 notes the presentation of a column and architectural fragments by the American Society for the Excavation of Sardis in 1926 as well as a bequest of Minoan objects from the excavator Richard Seager in that same year.[57] The museum also obtained prehistoric pottery from Gournia, where Richter's college friend Harriet Boyd Hawes dug in the early twentieth century.[58]

Beyond issues of provenance and authenticity, archaeology had the potential of answering the questions about the past that early visitors to the Metropolitan increasingly asked. The museum had been founded with the noble aim of improving public taste, but many crossing the threshold had less elevated goals—they wanted to know how ancient people had lived (and in some cases, died). If the Greeks represented, as claimed, the start of Western civilization, viewers wondered how their personal lives mirrored those of moderns—what kind of table utensils did they use for dining? Were their beds comfortable? Shifting the focus from monuments to people, books such as Sir William Gell's popular volumes on Pompeii had first addressed these issues in the early nineteenth century,[59] but twentieth-century New Yorkers turned to museums like the Metropolitan

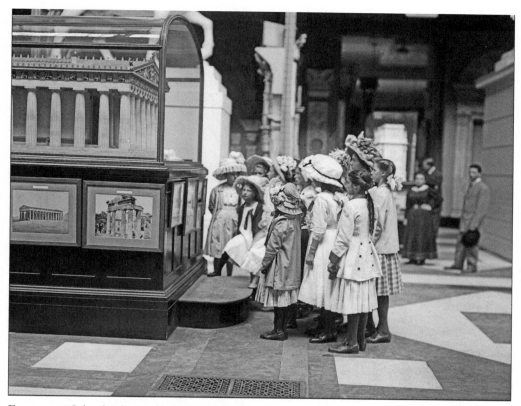

FIGURE 3.5. Schoolgirls viewing the model of the Parthenon in the Cast Collection Galleries, Metropolitan Museum of Art, ca. 1910.
© The Metropolitan Museum of Art. Image source: Art Resource, NY.

to "form a mental picture of . . . [ancient] people and their surroundings."[60] For a time the Metropolitan provided answers to such questions in its Gallery of Greek and Roman Daily Life, but this room appears to have lasted only about a decade and was located in the basement.[61] In 1941, some quotidian objects were displayed in cases in one of the galleries on the main floor, while others were integrated into the primary displays.[62] Not surprisingly, such fundamental issues as sex and toilets were off-limits. Personal hygiene, for example, was limited to mirrors, perfumes, razors, a tweezer; a vase showing Ganymede with a cock was filed under "pets." Today many of these objects have entirely disappeared from view.

Contextualizing ancient art did find one permanent manifestation at the museum during these years, however, in the making of the Roman court. The final element of the master plan, the court was conceived by Director Robinson "as a Greek or Pompeian peristyle, with a garden in the center, in which sculpture and other works of classical art would be exhibited with some suggestion of their original surroundings and atmosphere."[63] In 1912, he enlisted fellows at the American Academy in Rome to make architectural designs, but the court was delayed for more than a decade and only finally executed in 1926 by the Beaux-Arts architectural firm McKim, Mead & White (Figures 3.6–3.7). In its columns with their lower parts painted red and left unfluted, the court was inspired by such Pompeian houses as the House

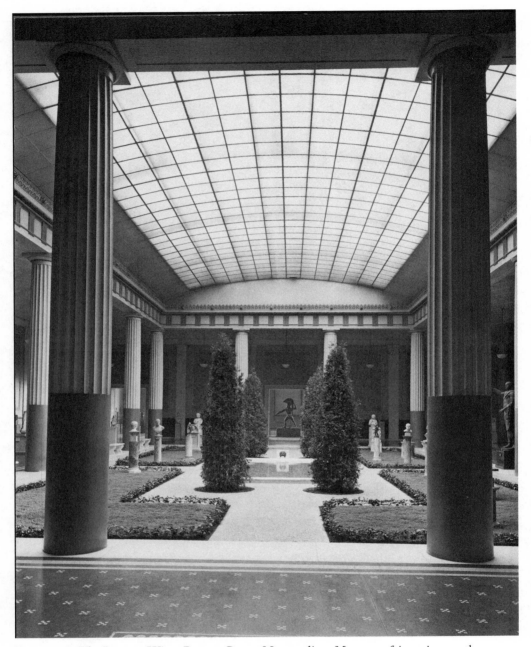

FIGURE 3.6. The Lamont Wing, Roman Court, Metropolitan Museum of Art, view south, 1939.
© The Metropolitan Museum of Art. Image source: Art Resource, NY.

of the Gilded Cupids and the House of Venus. It lasted until 1941, when a new director intent on modernizing converted the space into a public restaurant.[64]

Another aspect of the museum's early history that reveals the tension between aesthetics and archaeology is the issue of casts. Plaster casts were among the museum's earliest acquisitions, and many of the most important discoveries made in Italy and Greece—

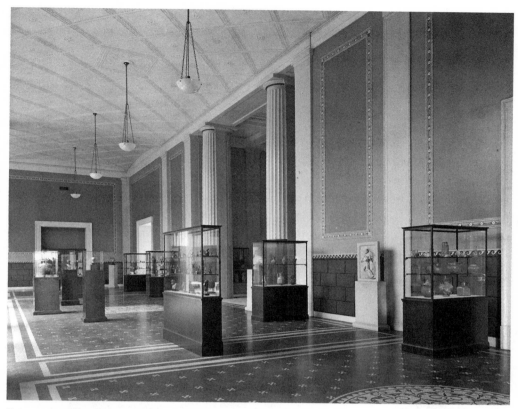

FIGURE 3.7. The Lamont Wing, Roman Court, Metropolitan Museum of Art. Photographed on April 8, 1926.

for example, the Charioteer from Delphi found in 1897—were copied almost immediately for wide distribution to American and European cast collections. Richter attributes the Met's many copies (both plaster casts of sculpture and painted facsimiles) of the spectacular Bronze Age finds by Sir Arthur Evans and others on Crete and in mainland Greece to the impossibility of obtaining prehistoric Greek originals, but they were but a fraction of the eventual several thousand casts that the Metropolitan came to own.[65] By the 1880s, substantial sums were devoted to buying casts, and an entire department and special committees were formed to provide administrative oversight.[66] But the entire project was doomed, for just as the Met initiated its heavy investment, casts fell out of fashion.[67] Although regarded by some as superior to original sculptures for drawing, the cast was demoted when the very practice of "drawing after the antique," for which casts had been used for centuries, came under fire as an outdated, academic exercise. Photography, a relatively new invention, was regarded as the modern means of studying art, and its advocates touted its ability to capture the texture and surface of an ancient work.[68] By the 1920s, progressive museums had embraced the cult of the original work of art and banished casts from the public galleries and eventually from the museum entirely.[69] The Met's

attitude, along with that of other museums, was paradoxical. Although the Greek and Roman Department had largely rejected archaeology in its mission, when it came to collecting statues it favored a battered "original" surface—one that proclaimed its post-antique history if not actually its archaeological context—over an aestheticized version in pure white plaster.[70]

Notwithstanding their disfavor, numerous casts appeared in the special exhibition mounted by the museum in early 1939 to celebrate the bimillennium of the birth of Rome's first emperor, Augustus (Figures 3.8–3.9).[71] In addition to the casts lent by Italy, the Metropolitan displayed loans from the Louvre and the Boston Museum of Fine Arts, along with several other institutions and private lenders. The Met's show followed on the heels of an enormous exhibition held in Rome the previous year, intended to celebrate Augustus but also to showcase the archaeological work carried out by the Fascist regime in Italy and abroad.[72] In contrast to Mussolini's clear equation of his own regime with that of Rome's first emperor, the Metropolitan pointedly eschewed "any real similarity between the political situation of our own time and that of the Augustan age."[73] But if the Fascist production was pure propaganda, the Met's small and short-lived exhibition stripped Augustan art of any political aspect whatsoever. Largely devoid of history, it focused on

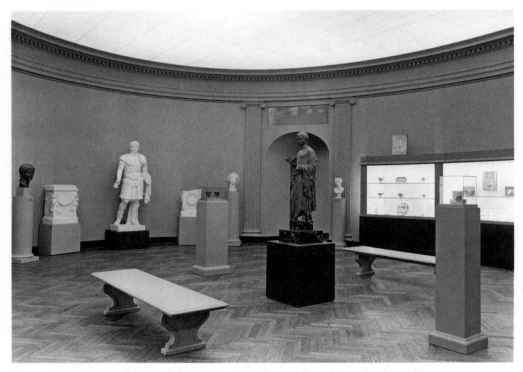

FIGURE 3.8. Special exhibition of Augustan art, Metropolitan Museum of Art, January 4–February 19, 1939, Gallery of Special Exhibitions (D6 Room 2), Floor II, view looking northwest.

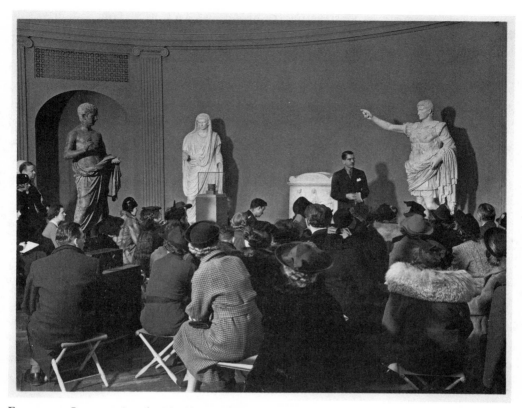

FIGURE 3.9. Lecture given by Mr. Shaw at the special exhibition of Augustan art, Metropolitan Museum of Art, January 4–February 19, 1939, Gallery of Special Exhibitions (D6 Room 2), Floor II.

© The Metropolitan Museum of Art. Image source: Art Resource, NY.

the works' aesthetic character, which was approvingly described as "restrained classicism," "elegance," and "sobriety."[74] This was Roman art as the Met liked it: "directly in the tradition of Greek art."[75]

Conclusion

The most prolific curator in the history of the department, Richter wrote the Augustan exhibition catalogue, just as she wrote scores of books and articles on works in the museum's collection.[76] Indeed, it is fair to say that from her first job at the museum cataloguing Attic vases until the end of her life, that is, over a period of close to seventy years, Richter's writings enhanced the museum's stature and reputation. As an outspoken proponent of Greek art, however, Richter was a convenient target for those who challenged her opinions. Her most virulent assailant—at least in public—was her museum colleague William Ivins, the founding curator of the Department of Prints and Drawings. Ivins attacked Richter—and virtually all students of classical art—for their use of unprovenanced

and undated fragments in constructing the history of Greek art.[77] (Ivins also dismissed Greek philosophy for its basis in fragments.) To be sure, Ivins was widely regarded as a difficult personality—after two years as acting director, he was passed over for the permanent directorship of the museum in 1940—but his views about art inevitably put him on a collision course with Richter. From an interest in the history of ideas and social history to an appreciation of decidedly unbeautiful artworks such as the prints of Francisco de Goya, Ivins diverged in perspective from Richter, whose philhellenism and equation of Greek art with ideal beauty were unshakeable. To what extent Ivins's anti-Greek attitudes[78] found an audience is unknown, but unquestionably the arrival of Henry Francis Taylor as director in 1940 marked a shift in the museum's priorities and a dethroning of classical art.[79]

Decades later in 1968, near the end of her life, Gisela Richter received the Archaeological Institute of America's highest honor, the Gold Medal for Distinguished Archaeological Achievement. Among the accomplishments noted in the published citation was her "indefatigable pursuit of masterpieces."[80] This goal—pursued by Richter as well as other Met curators both before and after—has resulted in the present collection, a museological triumph thanks to its many exquisite works. At the same time, the focus on masterpieces has created the collection's fundamental shortcoming: a dearth of contextual information that would enable viewers and scholars alike to understand more fully what they are admiring. Rich as the present collection is, its early decades—with lost opportunities as well as triumphs—have irreversibly shaped the image of classical antiquity it conveys.

NOTES

1. Thanks to Elizabeth Macaulay-Lewis and Matthew McGowan, who encouraged this chapter and offered astute criticisms, as well as to the two anonymous reviewers whose comments helped sharpen my arguments. I am indebted to Melissa Bowling and Julie Zeftel of the Metropolitan Museum for their assistance in my use of the Metropolitan's archival materials and to Mackenzie Mallon for information relating to John Marshall. Larissa Bonfante, Richard Brilliant, and Anne Laidlaw kindly shared reminiscences of Gisela Richter, and Iris Carulli, Robert Cohon, and Katherine Geffcken filled in many historical details. I thank the audience at the Archaeological Institute of America's 2016 annual meeting for their comments on an earlier version of this paper.

2. Report from McKim, Mead & White to the Board of Trustees in 1908, quoted in Morrison Heckscher, "The Metropolitan Museum of Art: An Architectural History," *Bulletin of the Metropolitan Museum of Art* 53, no. 1 (Summer 1995): 42.

3. For a general overview, see Carlos Picón, "A History of the Department of Greek and Roman Art," in *Art of the Classical World in the Metropolitan Museum of Art: Greece, Cyprus, Etruria, Rome,* ed. Carlos Picón et al. (New York: Metropolitan Museum of Art, 2007), 3–23; and Joan Mertens, *The Metropolitan Museum of Art: Greece and Rome* (New York: Metropolitan Museum of Art, 1987). For a more critical approach, see Calvin Tompkins, *Merchants and Masterpieces: The Story of the Metropolitan Museum of Art,* rev. ed. (New York: Dutton, 1989); and Stephen Dyson, *Ancient Marbles to American Shores: Classical Archaeology in the United States* (Philadelphia: University of Pennsylvania Press, 1998), 129–39.

4. See Malamud's chapter in this volume.

5. Morgan served the museum from 1871 to 1913 and was its president from 1904 to 1913. Under his leadership, the Met witnessed major changes as the museum shifted from a "collection

of unrelated curios" to an organized assemblage of "masterpieces" arranged by country and period. The latter embodied what Kathleen Curran and others have called *Kulturgeschichte*, a museological concept that developed in Germany in the mid–nineteenth century. Kathleen Curran, *The Invention of the American Art Museum: From Craft to Kulturgeschichte, 1870–1930* (Los Angeles: Getty Research Institute, 2016), 82. For Morgan, see Jean Strouse, *Morgan, American Financier* (New York: Random House, 1999), 494–501; Jean Strouse, "J. Pierpont Morgan, Financier and Collector," *Bulletin of the Metropolitan Museum of Art* 57, no. 3 (Winter 2000).

6. In a letter to John Taylor Johnson, the Metropolitan's first president, Cesnola described his collection as "the most valuable and richest private collection of antiquities existing in the world, which is the result of six years' labor, in this famous island [Cyprus], and of a great outlay of money." Quoted in Winifred Howe, *A History of the Metropolitan Museum of Art* (New York 1913), 2:153–54. Cesnola has been the subject of many studies, some scurrilous; see Elizabeth McFadden, *The Glitter and the Gold: A Spirited Account of the Metropolitan Museum of Art's First Director, the Audacious and High-Handed Luigi Palma de Cesnola* (New York: Dial, 1971); and Tompkins, *Merchants*, 49–68. See also Vassos Karageorghis with Joan Mertens and Marice Rose, *Ancient Art from Cyprus: The Cesnola Collection in the Metropolitan Museum of Art* (New York: Metropolitan Museum of Art, 2000).

7. Edith Wharton, *The Age of Innocence* (New York: Collier, 1987), 344.

8. A critique by the art critic Gaston Feuardent triggered a formal inquiry by the museum that largely exonerated Cesnola in 1881 (although some restorations were removed); Cesnola won his 1884 lawsuit against Feuardent for libel. Howe, *A History of the Metropolitan Museum of Art*, 222–23. Pamela Gaber's review of Antoine Hermary and Joan Mertens, *The Cesnola Collection of Cypriot Art: Stone Sculpture* (New York: Metropolitan Museum of Art, 2014), in *Bryn Mawr Classical Review* (February 15, 2016), mentions "lawsuits" (n1) in the plural.

9. Hermary and Mertens, *The Cesnola Collection*, 21–22. Duplicate terracottas were sold off as early as 1896.

10. Howe, *A History of the Metropolitan Museum of Art*, 120–21.

11. Dyson, *Ancient Marbles*, 132, speaks of "bastard pieces."

12. "A thin coating of stone-wash" was noted by John Myres, the University of Liverpool expert hired to assess the Cesnola works. John L. Myres, "The Cesnola Collection: Preliminary Note," *Bulletin of the Metropolitan Museum of Art* 4, no. 6 (June 1909): 96.

13. See McGowan's chapter in this volume.

14. R. Cram, "The Place of the Fine Arts in Higher Education," *Bulletin of the College Art Association of America* 4 (1918): 133–34.

15. In 1872, the study of ancient history at Oxford shifted to an exclusive focus on Greece and Rome after the Egyptians and Assyrians were removed from the curriculum. "In the nineteenth century the ancient world began to shrink under the combined effects of secularism, imperialism and anti-Semitism": J. C. Quinn, review of M. Scott, *Ancient Worlds: An Epic History of East and West*, in *Times Literary Supplement* (January 6, 2017). I. Jenkins, *Archaeologists and Aesthetes in the Sculpture Galleries of the British Museum 1800–1939* (London: British Museum, 1992), esp. 56–74, 140–67, discusses how these tensions played out in the museum context, albeit prior to the Metropolitan's founding.

16. Heckscher, "The Metropolitan Museum of Art: An Architectural History," shows early installations. For most of its history, the ancient collection has occupied the southern part of the main galleries running parallel to Fifth Avenue (Wings J and K in the Master Plan of McKim, Mead & White begun in 1914). Ibid., 51.

17. Martin Brimmer, quoted in Caroline Winterer, *The Culture of Classicism: Ancient Greece and Rome in American Intellectual Life, 1780–1910* (Baltimore, MD: Johns Hopkins University Press, 2002), 160. The Archaeological Institute was founded in 1879.

18. http://www.metmuseum.org/about-the-museum/museum-departments/curatorial
-departments/egyptian-art; Howe, *A History of the Metropolitan Museum of Art*, 313. Supported by
William Laffan and Morgan, the Egyptian Expedition divided finds equally between the
Metropolitan Museum and the Cairo Museum.

19. Robinson served as assistant director (1905–10) and then director of the museum (1910–30)
while he was at the same time curator of the classical collection. After decades in the department,
Richter succeeded Robinson as curator only on his death in 1931.

20. Robinson has received little attention: https://dictionaryofarthistorians.org/robinsone
.htm; *Bulletin of the Metropolitan Museum of Art* 26, no. 5 (May 1931): 111–12; Dyson, *Ancient
Marbles*, 133, 139, 142; Tompkins, *Merchants and Masterpieces*. Despite study at the University of
Berlin, he seems not to have received a PhD in classical archaeology but rather an LLD from the
University of Aberdeen. "American Director for Art Museum," *New York Times* (November 1,
1910). The portrait in Figure 3.3 is now in the Metropolitan Museum of Art. Richard Ormond
and Elaine Kilmurray, *John Singer Sargent: The Later Portraits: Complete Paintings* (New Haven,
CT: Yale University Press, 2003) 3:291–92, no. 450.

21. Richter's self-definition as an archaeologist is clearly shown in the title of her memoir *My
Memoirs: Recollections of an Archaeologist's Life* (Rome: privately published, 1970).

22. Stephen Dyson, *In Pursuit of Ancient Pasts: A History of Classical Archaeology in the Nine-
teenth and Twentieth Centuries* (New Haven, CT: Yale University Press, 2006), 153–55, discusses
the bars to women like Richter undertaking fieldwork during these years.

23. *Bulletin of the Metropolitan Museum of Art* 1, no. 3 (February 1906): 47.

24. Before Marshall came on the scene, Arthur Lincoln Frothingham, a Princeton University
professor, bought a number of Etruscan works for the Metropolitan as he did for other museums.

25. Warren is only now beginning to receive serious study. For a basic biography, see David
Sox, *Bachelors of Art: Edward Perry Warren and the Lewes House Brotherhood* (London: Fourth
Estate, 1991). For Warren's donations of antiquities to various US collections, see James Murley,
"The Impact of Edward Perry Warren on the Study and Collections of Greek and Roman
Antiquities in American Academia." PhD diss., University of Louisville, 2012.

26. Protesilaos: MMA 25.116 Picón 432–33 no. 140; Old Market Woman: MMA 09.39 Picón
490 no. 432; krater: MMA 14.130.14 Picón 413 no. 29.

27. The current John Marshall Archive Research Project of the British School at Rome promises
to expand our knowledge of Marshall's collecting considerably. Unfortunately, the Metropolitan has
declined to participate, and most of its Marshall papers—especially the accession materials—are
closed to outside researchers.

28. He also brought the young Gisela Richter, who in 1931 succeeded him as head of what had
been renamed the Greek and Roman Department.

29. Boston's shifting financial priorities ended its active collecting of antiquities (Dyson,
Ancient Marbles, 139), but the Met faced fierce competition from other collectors, such as Carl
Jacobsen in Copenhagen. On the cutthroat atmosphere, see Katherine Geffcken, "The History of
the Collection," in *The Collection of Antiquities in the American Academy in Rome*, ed. Larissa
Bonfante and Helen Nagy with the collaboration of Jacquelyn Collins-Clinton, *Memoirs of the
American Academy in Rome* Supplement 11 (2015): 21–78. Moltesen describes Marshall and Perry
as "more selective" than Jacobsen. Mette Moltesen, *Perfect Partners: The Collaboration between Carl
Jacobsen and His Agent in Rome Wolfgang Helbig in the Formation of the Ny Carlsberg Glyptotek,
1887–1914* (Copenhagen: Ny Carlsberg Glyptotek, 2012), 155.

30. Richard De Puma, personal communication, January 2016.

31. The case was not closed until the 1950s. Dietrich von Bothmer and Joseph Noble, "An
Inquiry into the Forgery of the Etruscan Terracotta Warriors in the Metropolitan Museum of
Art," *Metropolitan Museum of Art Papers* 11 (1961); Richard De Puma, *Etruscan Art in the Metro-
politan Museum of Art* (New York: Metropolitan Museum of Art, 2013), 9–10. Marshall also

purchased fake Etruscan terracotta reliefs (De Puma, *Etruscan Art*, 293) and a fake Greek archaic statuette for the museum in 1926 (Cleveland Museum of Art Archives, Records of the Director's Office: Frederic Allen Whiting, letter from Howard Parsons to Rossiter Howard, October 9, 1927. I thank Mackenzie Mallon for this reference.)

32. The acquisition in question was an Etruscan tomb group from Corneto (Tarquinia) apparently containing various bronze objects. In his letter to Robinson of February 8, 1909, Marshall says: "The things were much too archaeological for my taste." R. De Puma, personal communication, January 2016.

33. Edward Robinson, *Bulletin of the Metropolitan Museum of Art* 2, no. 1 (January 1907): 5.

34. Gisela Richter, *Handbook of the Classical Collection*, 5th ed. (New York: Metropolitan Museum, 1927), xiii. This assessment ignores the colossal statue of Trebonianus Gallus, one of the finest Roman bronzes in America (MMA 05.30; Picón 497–98 no. 471).

35. Important early donations included founding trustee John Taylor Johnston's gift of Etruscan and Roman gems in 1881, trustee and collector Henry Marquand's donation of bronzes and glass (ex Charvet) in 1897 (on Marquand see the chapter by Danielle Castaldo in this volume), and Morgan's donation in 1906 of the coins collected by Englishman John Ward. *Bulletin of the Metropolitan Museum of Art* 1, no. 3 (February 1906): 42. Morgan made numerous generous gifts during his lifetime, and his son bequeathed many objects in 1917, several years after his father's death.

36. In the passage cited in note 33, Robinson goes on to mention "all forms of the larger and the smaller arts in which the Greek genius found expression." *Bulletin of the Metropolitan Museum of Art* 2, no. 1 (January 1907).

37. See Kenneth Lapatin, *Luxus: The Sumptuous Arts of Greece and Rome* (Los Angeles: J. Paul Getty Museum, 2015) 12, 15; and the review by Sam Leith, *Times Literary Supplement* no. 5896 (April 1, 2016): 5.

38. On this sad history, see R. Nucci, "Alle origini della tutela," in *Rovine e rinascite dell'arte in Italia*, ed. Elena Cagiano de Azevedo and Roberta Nucci (Milan: Electa, 2008): 22–24.

39. Edhem Eldem, *Mendel-Sebah. Müze-i Hümauyan'u Belgelemek. Documenting the Imperial Museum* (Istanbul: Hamidiye Mahallesi 2014). The year 1870 also saw the inauguration of the Royal Egyptian and Etruscan Museum in Florence, underscoring how safeguarding archaeological heritage and making museums had become global cultural phenomena of the period.

40. MMA 70.1; http://www.metmuseum.org/blogs/now-at-the-met/features/2010/this-weekend-in-met-history-november-21.

41. On this practice, see Elizabeth Marlowe, "Said to Be or Not Said to Be: The Findspot of the So-Called Trebonianus Gallus Statue at the Metropolitan Museum in New York," *Journal of the History of Collections* 27 (2014): 147–57.

42. Yale: Michael Rostovtzeff et al., *The Excavations at Dura-Europos, Preliminary and Final Reports* (New Haven, CT: Yale University Press; Los Angeles: University of California Press; Ann Arbor: University of Michigan Press, 1929–2001). University of Pennsylvania: www.sas.upenn.edu/aamw/resources/museum; Kelsey: John G. Pedley, *Life and Work of Francis Willey Kelsey: Archaeology, Antiquity, and the Arts* (Ann Arbor: University of Michigan, 2012).

43. Steven Ostrow, review of Pedley, *Life and Work of Francis Willey Kelsey, Journal of Roman Archaeology* 25 (2012): 1001.

44. On the history of the excavations, see Scott Redford, ed., *Antioch on the Orontes: Early Explorations in the City of Mosaics* (Istanbul: Koç Üniversitesi Yayinlari, 2014); and the review by Andrea U. De Giorgi, *Journal of Roman Archaeology* 28 (2015): 873–76.

45. Charles Rufus Morey to Miss Baker (departmental secretary at Princeton), March 15, 1930. Charles Rufus Morey Papers, Princeton University Library.

46. Richter's career has been little analyzed, partly because the Greek and Roman Department's archival records remain essentially closed to outside researchers. I. Edlund, A. McCann,

and C. Richter Sherman, "Gisela Marie Augusta Richter (1882–1972): Scholar of Classical Art and Museum Archaeologist," in *Women as Interpreters of the Visual Arts, 1820–1879*, ed. C. Richter Sherman and A. Holcomb (Westport, CT: Greenwood, 1981), 275–300, relies heavily upon Richter's own writings. Dyson, *Ancient Marbles*, 152–55, discusses her collecting.

47. Some sample writings: "The chief value of Greek art . . . lies in its inherent beauty. The Greeks were the most artistic people the world has known and there is no better way for the training of eye and taste than to spend some time in their company." G. Richter, *The Metropolitan Museum of Art: Handbook of the Classical Collection*, new ed. (New York: Metropolitan Museum of Art, 1930), xx. In contrast, the Romans "did not excel . . . in artistic imagination." *Handbook* (1927), 286. Not surprisingly, fewer than fifty out of 334 pages of text in the 1927 *Handbook* are devoted to Roman art. In his obituary of Richter, Cornelius Vermeule wrote, "Miss Richter was the museum world's most constant phil-Hellene, not only in the type and quality of her acquisitions in New York but also in the message coming through from every one of her books." *Burlington Magazine* 115 (1973): 329.

48. Kouros: MMA 32.11.1, Picón 419 no. 67; stele: MMA 38.11.131.185, Picón 419 no. 68. Vermeule in his obituary of Richter comments that many archaic sculptures were coming out of Attica in the 1930s. Dyson has compiled statistics showing a surge in acquisitions between 1900 and 1939. Stephen Dyson, "Temple of Beauty & Learning. The New Greek and Roman Galleries at the Metropolitan Museum of Art," *Apollo* 165 (May 2007): 40. Of these, very few purchases after Richter assumed responsibility for buying were Roman. I note but two marble portrait heads and two cameos in Picón, "A History of the Department of Greek and Roman Art," 317–405.

49. MMA 32.11.4, Picón 430 no. 128.

50. MMA 38.11.12, Picón 489 no. 428. The Byzantine Department also has at least one Antioch mosaic, presumably also bought from one of the original participating institutions (MMA 40.185, dated 537/38 CE).

51. Frances Jones, "Antioch Mosaics in Princeton," *Record of the Art Museum, Princeton University* 40, no. 2 (1981): 2–26.

52. Worcester Art Museum 1936.30; C. Kondoleon, *Antioch: The Lost Ancient City* (Princeton, NJ: Princeton University Press, 2001), 68, fig. 2. Worcester secured this mosaic when its director Francis Henry Taylor personally visited Syria. Janet Tassel, "Antioch Revealed," *Harvard Magazine* (November 1, 2000), http://harvardmagazine.com/2000/11/antioch-revealed .html.

53. The Art Institute in Chicago, Ny Carlsberg Glyptotek in Copenhagen, and, initially, the Fogg Museum of Harvard University declined. Charles Rufus Morey to Fiske Kimball, June 29, 1930. Charles Rufus Morey Papers, Princeton University Library.

54. Myres's evaluation of the Cesnola collection was described as "based on the results of the most recent investigations in Cypriote archaeology." *Bulletin of the Metropolitan Museum of Art* 5, no. 3 (March 1910): 57; see above, n. 12.

55. Scientific excavation on Cyprus commenced with the arrival of the British in 1878 and the formation of the Cyprus Exploration Fund in 1887.

56. Richter, *Handbook* (1927), 3–6: "Our knowledge of this earlier Greek civilization we owe almost entirely to the work of the archaeologist."

57. Gisela Richter, "The Department of Greek and Roman Art: Triumphs and Tribulations," *Metropolitan Museum Journal* 3 (1970): esp. 90–91.

58. Harriet B. Hawes et al., *Gournia, Vasiliki, and Other Prehistoric Sites in the Isthmus of Hierapetra, Crete: Excavation of the Wells-Houston-Cramp Expeditions, 1901, 1903, 1904* (repr., Philadelphia: INSTAP, 2014). For Hawes's life and career, see Yasso Foutou and Ann Brown, "Harriet Boyd Hawes, 1871–1945," in *Breaking Ground: Pioneering Women Archaeologists*, ed. Getzel M. Cohen and Martha Sharp Joukowsky (Ann Arbor: University of Michigan Press, 2004): 198–203.

59. William Gell, *Pompeiana: The Topography, Edifices, and Ornaments of Pompeii* (London: Rodwell and Martin, 1817–19); William Gell, *Pompeiana: The Topography, Edifices, and Ornaments of Pompeii, the Result of Excavations since 1819* (London: Jennings and Chaplin, 1832); Rebecca Sweet, "William Gell and *Pompeiana* (1817–19 and 1832)," *Papers of the British School at Rome* 83 (2015): 245–81.

60. Helen McClees, *The Daily Life of the Greeks and Romans as Illustrated in the Collections* (New York: Metropolitan Museum of Art, 1941), xviii. Referencing the "museum" in its title, Levi Yaggy and Thomas Haines, *Museum of Antiquity—A Description of Ancient Life: The Employments, Amusements, Customs and Habits, The Cities, Palaces, Monuments and Tombs, The Literature and Fine Arts of 3,000 Years Ago* (Chicago: Western Publishing House, 1882), underscores how the museum had become a site for documenting ancient quotidian details.

61. Picón, "A History of the Department of Greek and Roman Art," 12.

62. McClees, *The Daily Life of the Greeks and Romans.*

63. Letter of April 1912, quoted in Heckscher, "The Metropolitan Museum of Art: An Architectural History," 52.

64. Francis Henry Taylor, newly arrived from the Worcester Museum of Art, regarded the Greek and Roman collection as old-fashioned and boring. See Picón, "A History of the Department of Greek and Roman Art," 15; and Heckscher, "The Metropolitan Museum of Art: An Architectural History," 62.

65. *Catalogue of the Collection of Casts*, 2nd ed. (New York: Metropolitan Museum of Art, 1910). An informal count of the numbers shows that circa 1,150 casts reproduced Greek and Roman objects, versus one hundred Egyptian and circa 1,200 early Christian and French, German, Italian up until the nineteenth century combined. For a view of the cast gallery, see Heckscher, "The Metropolitan Museum of Art: An Architectural History," fig. 37.

66. In 1886, the Met trustee Henry Marquand provided funds for casts, stating that they were the museum's "greatest need" (*Catalogue of . . . Casts*, vii).

67. Beard dates the shift to the 1870s. Mary Beard, "Cast: Between Art and Science," in *Les moulages de sculptures antiques et l'histoire de l'archéologie. Actes du colloque international, Paris, 24 Octobre 1997*, ed. Henri Lavagne and François Queyrel (Geneva: Droz, 2000), 159.

68. Edward Forbes, "The Art Museum and the Teaching of the Fine Arts," *Bulletin of the College Art Association* 4 (1918): 123.

69. On the general phenomenon, see Stephen Dyson, "Cast Collecting in the United States," in *Plaster Casts: Making, Collecting, and Displaying from Classical Antiquity to the Present*, ed. Rune Frederiksen and Eckart Marchand, Transformationen der Antike 18 (Berlin: Walter de Gruyter, 2010), 556–75. According to Dyson, *Ancient Marbles*, 142, the Met faced public protests when it tried to remove casts from its galleries in 1924.

70. Hima Mallampati Gleason, "Collecting in Early America," in *The Oxford Handbook of Roman Sculpture*, ed. Elise Friedland and Melanie Grunow Sbocinski, with the assistance of Elaine Gazda (Oxford: Oxford University Press, 2015), 46, speaks of the cast's "highlighting of form over other issues."

71. Gisela Richter with Christine Alexander, *Augustan Art: An Exhibition Commemorating the Bimillennium of the Birth of Augustus* (New York: Metropolitan Museum of Art, 1939).

72. *Mostra Augustea della Romanità. Catalogo*, 4th ed. (Rome: Casa Editrice C. Colombo, 1937). For pictures of the exhibition, see Massimo Pallottino, "La Mostra della Rivoluzione Fascista a Valle Giulia," *Capitolium* 12 (1937): 513–28. Many of the casts made for the Mostra can still be seen today in Rome's Museo della Civiltà Romana.

73. Museum Director H. [Herbert] E. Winlock, writing in the catalogue's preface.

74. Richter, *Augustan Art*, 3.

75. Richter, *Augustan Art*, 17. For an expression of the same view in a current exhibition nearly eighty years later, see Paul Zanker, "Greek Art in Rome: A New Center in the First

Century BC," in *Pergamon and the Hellenistic Kingdoms of the Ancient World*, ed. Carlos Picón and Seán Hemingway (New York: Metropolitan Museum of Art, 2016) 92–99.

76. Her bibliography includes hundreds of items. See Joan R. Mertens, "The Publications of Gisela M. A. Richter: A Bibliography," *Metropolitan Museum Journal* 17 (1984): 119–32.

77. Peter Parshall, "The Education of a Curator: William Mills Ivins Jr.," in *The Power of Prints: The Legacy of William M. Ivins and A. Hyatt Mayor*, ed. Freyda Spira and Peter Parshall (New York: Metropolitan Museum of Art, 2016): 21–22. It is not clear to what extent Ivins's rancor extended beyond the intellectual into the personal realm.

78. These found their widest circulation in a series of articles published in *Harper's* in the 1940s; see Parshall, "The Education of a Curator," n28, as well as Ivins's influential *Prints and Visual Communication* (Cambridge, MA: MIT Press, 1953), 4, 7, 10.

79. Taylor's conversion of the Roman court into a restaurant has already been mentioned; Picón, "A History of the Department of Greek and Roman Art," 15, notes the reduction of floor space allocated to the department.

80. *American Journal of Archaeology* 73 (1969): 230. Several obituary writers echoed these sentiments: Frank Brown, "Gisela Marie Augusta Richter," *Studi Etruschi* 41 (1973): 597–600; Homer Thompson, "Gisela M. A. Richter (1882–1972)," *American Philosophical Society Yearbook* (1973): 144–50; and Vermeule, "Gisela M. A. Richter."

The Gould Memorial Library and Hall of Fame:
Reinterpreting the Pantheon in the Bronx

Elizabeth Macaulay-Lewis

The Gould Memorial Library, designed by Stanford White for the University Heights Campus of New York University (NYU), in the Bronx, is perhaps New York's greatest forgotten architectural masterpiece (Figure 4.1).[1] The library, now on the campus of Bronx Community College, part of the City University of New York, was landmarked in 1966.[2] Although in 2005 it was the focus of a comprehensive buildings-conservation study funded by the Getty Trust,[3] the library has never been the subject of a detailed architectural study,[4] nor has it been considered as an example of classical reception. The architecture of the classical world, like its art, literature, and history, offered the late-nineteenth-century American patron a bevy of options, models, and symbols that could be deployed to create architecture with powerful contemporary cultural resonances.[5]

The Pantheon, mediated through the lens of European and American architecture, served as Stanford White's inspiration for the Gould Memorial Library.[6] By the late nineteenth century, classical culture had become a symbol of elite, high culture.[7] The library was the architectural embodiment of Chancellor Henry Mitchell MacCracken's ambitions for NYU to be New York City's leader in higher education. The neoclassical architecture of the Gould Memorial Library helped transform a country estate into a new campus for academic learning and intellectual achievement.

The Hall of Fame for Great Americans, a porticoed ambulatory, was erected around the southern, eastern, and northern sides of the Gould Memorial Library to celebrate, as its name suggests, "Great Americans." Through its architectural and intellectual conception, which evoked the porticoes of antiquity, the Renaissance, and eighteenth- and

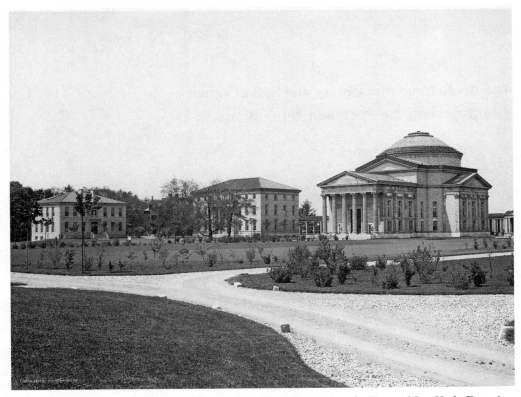

FIGURE 4.1. The Gould Memorial Library, New York University, the Bronx, New York. Detroit Publishing Co., no. 18537.
Courtesy of the Library of Congress.

nineteenth-century Europe, the Hall of Fame also contributed to the scholarly air of NYU's new campus. The Gould Memorial Library and the Hall of Fame are potent examples of classical reception in late-nineteenth-century New York.

MacCracken's Ambitions for the University of the City of New York

The decision to construct the library and the University Heights Campus was informed by the challenges facing the University of the City of New York (renamed New York University in 1896) in the late nineteenth century.[8] The University of the City of New York was not well endowed and required financial support from the small community of wealthy New York philanthropists.[9] The school also needed to increase tuition revenue.[10] The university responded to these obstacles by hiring Henry Mitchell MacCracken as chancellor in 1891. Upon his appointment, MacCracken focused his energies on creating a new uptown campus. He believed the university needed a calm, reflective environment for its students to thrive. Washington Square, where the University of the City of New York was located, was increasingly dominated by commercial lofts that served the textile and garment industries and thus was unsuitable for academic pursuits. MacCracken identified the Mali

estate, which was situated on a high bluff overlooking the Harlem River about ten miles north of Washington Square, as the location for his new University Heights Campus. Certain departments—law, pedagogy, and the graduate division—were to stay at Washington Square Park.

MacCracken now needed an architect to mastermind his ambitious project. Stanford White was an obvious candidate. Not only was he a leading architect of the day, but his father, Richard Grant White, had attended the University of the City of New York and considered teaching there. Richard White had successfully petitioned Dr. Howard Crosby, who was chancellor from 1870 to 1881, to grant Stanford an honorary degree.[11] McKim, Mead & White had also completed several commissions for individuals with strong ties to the University of the City of New York.[12] Through family connections, MacCracken approached White in 1891 and asked him to design the campus out of respect for his father's memory rather than for a fee, a request to which White agreed.[13]

White, who was interested in the preservation of early-nineteenth-century New York architecture, wanted to move NYU's main building, which was designed by Town & Davis, from the Washington Square Campus and reconstruct it in the Bronx,[14] but this was too expensive. Undoubtedly, the opportunity to erect a new campus with his intellectual imprint also appealed to MacCracken.[15] In 1894, White submitted plans to MacCracken for the campus.[16] It was planned around an inward-looking quad, which was intended to allow students to focus on their studies. The old campus and the preexisting buildings on the Mali estate were to be used until funds could be raised to finance the construction of the University Heights Campus.

The first building erected was the Hall of Languages, which was originally used as a dormitory. In the winter of 1894–95, White designed a domed library, the center of the campus, to sit atop a bluff of an escarpment overlooking the Harlem River. The elevated position of the library ensured that it was highly visible within New York City and from New Jersey (Figure 4.2).[17]

From the beginning, there was tension between White and MacCracken over the design of the library. The original plan for the library was similar to its final form: a dome over a Greek cross. When this design was submitted to the university's executive committee for review, White described the style of the library to MacCracken as "severely classic, but the play of the parts caused by the four wings and the prolongation of the front wings, and the transition of the octagon to the arches will give the building a picturesque effect."[18] White framed the building as a classical monument, but one modified to suit the larger landscape in which it was situated.

MacCracken and the executive committee of the university did not like the initial design,[19] although the exact reasons why are unclear. The executive committee reportedly decided to hold a design competition for the library, to which White, George B. Post, Henry Hardenburgh, and Richard Morris Hunt were invited to submit designs.[20] They do not appear to have done so, suggesting that the competition may never have been held. Alternatively, other sources report that the dispute between White and MacCracken over the design was mediated by Richard Morris Hunt, who backed White; thanks to Hunt, White continued as the project's architect.[21]

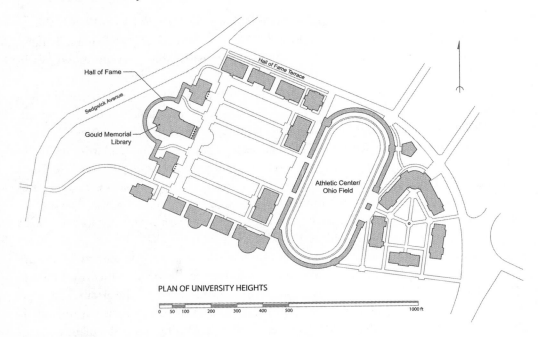

FIGURE 4.2. The proposed campus plan with the Gould Library and Hall of Fame.
J. Burden and J. Montgomery, *Building History Project*, after proposed plan. Bobst Library Archive, New York University.

In an 1896 letter to White, MacCracken expressed his concerns over the form and function of the library's design:

> I am still dissatisfied with the reading room which I fear will have a barn-like rotunda, dimly lighted, never warm in the coldest weather—Then we do not get interior richness with 24 sham marble columns. I should have esthetic pangs every time I saw them. Domes, although imposing are dreary things to live in—Therefore can you not give us an attractive sketch, embodying features which would enable me conscientiously to advocate the experience. . . . I enclose a sketch embodying my suggestions. I realize that visitors will expect to find an interior rotunda, but better a little disappointment of that kind, then great failure to meet practical aims.[22]

MacCracken's concerns about the functionality of round libraries were well founded. Round libraries often lack good sources of natural light. Their form can impede the circulation of books; it is difficult to house books in rectilinear bookcases within a round space. MacCracken's own modifications to the design of the Gould Memorial Library, as enumerated in a 1901 letter to White, included the enlargement of the dome's oculus from thirteen to twenty-three feet, which MacCracken viewed as having saved the library from being "an utter failure for library purposes."[23] Thus, the final design of the building was a result of the artistically lively, though tense, exchange between White and MacCracken.[24] Construction of the library began in 1897, when Helen Miller Gould donated funds to name the library in honor of her father, Jay Gould, the financier and railroad tycoon. It

was completed in 1899. Despite MacCracken's concerns over its circular form, the Gould Memorial Library functioned relatively well, serving as a library until 1969.[25]

The Pantheon as an Architectural Palimpsest

The Gould Memorial Library is a reconceptualization of the Pantheon, influenced by earlier European and American architectural interpretations of one of ancient Rome's most iconic structures. It is also White's original, American contribution to the long tradition of the architectural reception of the Pantheon.

The Pantheon is considered to be among the greatest Roman buildings ever erected.[26] Marcus Agrippa (d. 12 BCE) built the original Pantheon during Augustus's reign in the late first century BCE. The purpose of the building is unclear. It was not a typical temple, and it may have housed statues of the imperial family and certain gods.[27] The building was rebuilt and repaired several times in antiquity because it was severely damaged by fire. The most significant reconstructions are those of the emperors Domitian, Trajan and Hadrian, and Septimius Severus and his son Caracalla. The construction on the extant structure started under Trajan in the early second century CE and was completed under Hadrian by about 126 CE.[28] The lofty interior was dominated by a vast dome, composed around a perfect circle with a diameter of 150 Roman feet. Its interior had elaborate *opus sectile* flooring and wall decoration, made of marble and other stones from across the Roman Empire (Figure 4.3).

The Pantheon's main entrance was composed of a porch with a pediment and the outline of a taller pediment, creating the visual effect of a double pediment (Figure 4.4). This double pediment may have resulted from a design change or from the failure of columns that were sixty Roman feet tall to arrive to support the higher pediment.[29] While scholars still debate the origin and meaning of the double pediment as well as the date and construction techniques of the Pantheon,[30] these academic concerns were not of primary importance to later architects, who viewed the Pantheon as the quintessential Roman building and as an architectural palimpsest to be reinterpreted.

As early as the sixteenth century, Italian architects were experimenting with the form of the Pantheon for their architectural creations. Most notably, Andrea Palladio used it as the model for the Villa Almerico-Valmarana, the so-called Villa Rotonda or Villa Capra (begun ca. 1565–66), near Vicenza, Italy.[31] At the center of the Villa Rotonda was a circular room with a dome based on the Pantheon. Vincenzo Scamozzi, who oversaw the erection of the building, modified the dome to make it shallower.[32] The double pediment and porch were elements that were often retained in later interpretations, although the number of columns and their order, as well as the depth of the porch, varied. The double pediment may have been faithfully replicated in later interpretations of the Pantheon because it—more than a dome—is immediately recognizable and identifies the Pantheon as the architectural inspiration behind the building in question.

The Pantheon came to the architects of northern Europe through its Italian interpreters, specifically Palladio. Inigo Jones visited Italy in 1613–14, met Scamozzi, and

acquired a large number of Palladio's drawings.[33] He was the first English architect to interpret Palladio, and others soon followed. In his design for the library at Trinity College, Cambridge (1695), Sir Christopher Wren included a round reading room, although this was not retained in the final form.[34] There were other round libraries constructed in the eighteenth and nineteenth centuries, such as the Radcliffe Camera in Oxford and the great circular reading room of the old British Library, which was constructed in the central quadrangle of the British Museum. The Radcliffe Camera, which was finished by James Gibbs in 1737–48,[35] owes a great deal to the plan first presented by Nicholas Hawksmoor in 1720, which vaguely evoked the tomb of Cecilia Metella[36] rather than the Pantheon. The reading room of the old British Library was designed by the librarian Sir Anthony Panizzi (1797–1879) and completed in 1857.[37] Panizzi's inspiration for the reading room was the Pantheon.[38]

In the United States, Thomas Jefferson was the first to repurpose the Pantheon's architecture for his residence, Monticello. Drawing upon the 1742 edition of *The Architecture of A. Palladio* by James Leoni, Jefferson began designing Monticello in 1768,[39] and it was constructed in two phases (1770–84 and 1796–1809). Jefferson's Monticello clearly evokes the Pantheon with its frontal pediment and dome, although it has an octagonal plan.

The Rotunda, the Jefferson-designed library erected at the center of the University of Virginia's campus between 1823 and 1832, was also modeled on the Pantheon.[40] The proportions of the Pantheon were reduced by half for the Rotunda.[41] On October 27, 1895, the library almost entirely burned down. On January 18, 1896, more than a full year after he began work on the designs for the Gould Memorial Library in the Bronx, Stanford White was invited to oversee the University of Virginia's restoration program. His work on the Rotunda remains highly controversial,[42] but it does not appear to have influenced his designs for the Gould Memorial Library.[43]

In the nineteenth century, not all circular American libraries were modeled on the Pantheon. The first independent building of the Library of Congress, the Thomas Jefferson Building, had an octagonal—not circular—plan. It was modeled on the Paris Opera house and also owed an artistic debt to the Italian Renaissance.[44] The Pantheon, however, remained an important model.

As a principal of the legendary architectural firm McKim, Mead & White, Stanford White was at the forefront of late-nineteenth-century American architecture. Having traveled for a year in Europe in 1878, he was well versed in various European architectural forms and styles. Depending on what he was designing—a country residence, a gentlemen's club, church, or a university library—White used different forms of European architecture, which, with their long histories and pedigrees, bestowed cultural authority and prestige upon both project and patron.[45]

Although White did not articulate why he selected the Pantheon in any surviving document, his choice must have been deliberate. A few years earlier, he had interpreted the form of the Roman triumphal arch when designing arches to honor Washington and the Civil War veterans from Brooklyn.[46] He deemed the arch an eminently appropriate form for such a memorial.[47] This indicates that White gave considerable thought to the selection of

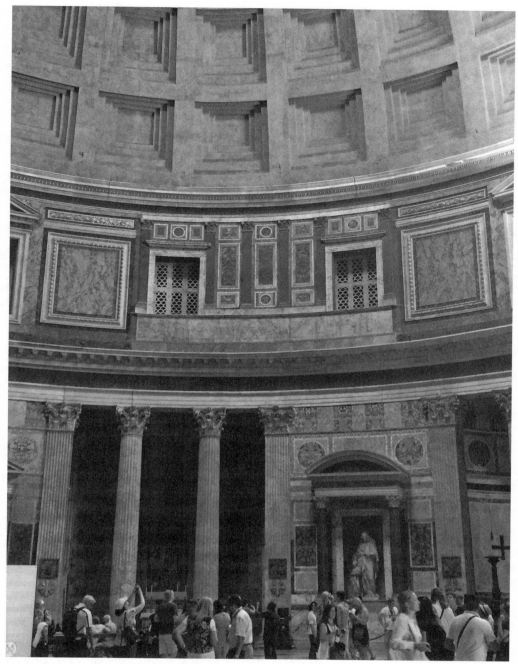

FIGURE 4.3. Interior of the Pantheon, Rome.
D. Mladenović.

forms and models for his buildings. It was not just any classical form that would do for this library; a specific one was necessary.

The Pantheon was a potent symbol of classical culture. Because of Palladio's and Panizzi's earlier interpretations of the Pantheon, the Gould Memorial Library and NYU's new

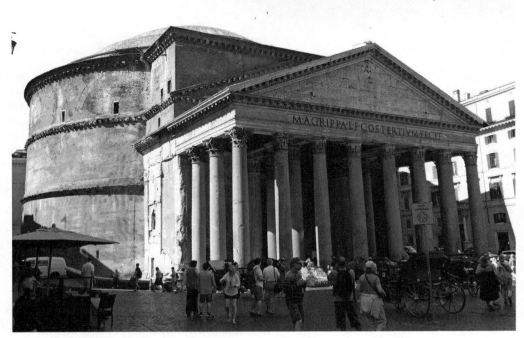

FIGURE 4.4. Porch of the Pantheon.
D. Mladenović.

campus were also imbued with a sophisticated air of contemporary European culture. The literary associations of the rotunda or Pantheon-inspired form were already established by such august institutions as the University of Oxford and the University of Virginia. Thus, a Pantheon-like library bestowed architectural and academic prestige. For a university with NYU's lofty ambitions, only a rotunda would be suitable. The presence of such a grand building on its campus demonstrated that New York University was architecturally and intellectually a peer of elite institutions such as Oxford and Virginia. The form of the Pantheon may have had one other key appeal: The Gould Memorial would be the first Pantheon-like building in New York City.

The Gould Memorial Library

By examining the form, architectural elements, and details of the Gould Memorial Library, we can understand how White transformed the Pantheon to create the library.[48] The use of a Greek-cross plan with a central dome rather than a circular plan with a porch (as in the Pantheon) resolved the issue of how to connect rectilinear spaces to the circular core of the library in an attractive fashion (Figure 4.5).

The building has a grand hexastyle porch, an entrance in the east façade, and rectangular, projecting wings with triangular pediments on the north, south, and west sides. On each

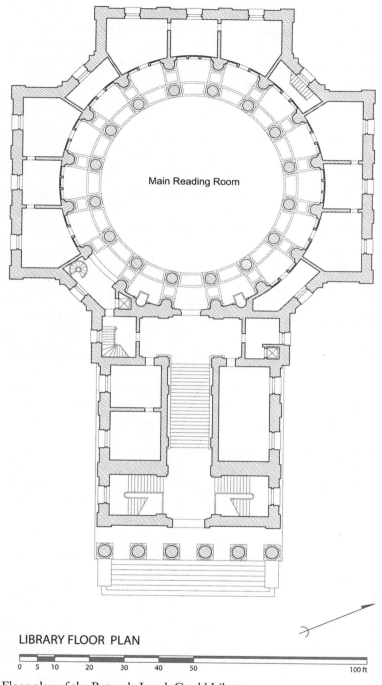

Main Reading Room

LIBRARY FLOOR PLAN

0 5 10 20 30 40 50 100 ft

FIGURE 4.5. Floor plan of the Rotunda Level, Gould Library.

J. Burden and J. Montgomery, *Building History Project,* after Easton Architects, *Conservation Master Plan,*
III-A, 57, A104.

façade of the Gould Memorial Library is a visually attractive stacking of the different architectural elements: the triangular pediment, the rectangular wing, and the curve of the dome. The library has two primary façades: the east with its grand porch, which looks toward the campus, and the west wing, which was highly visible from northern Manhattan.

EXTERIOR

The eastern façade of the library has a deep classical-style porch with a double triangular pediment, a clear evocation of the Pantheon's porch (Figure 4.6). The lower limestone pediment has no sculpture and is only decorated with dentils along the ridge of the triangular pediment and its base. The upper pediment, like the bulk of the building, is made of yellow and buff "Roman brick," which was very popular at the time.[49] This pediment is also undecorated except for its edge of small dentils. The upper pediment is topped by a raking cornice with a palmette design.

At the apex of the upper pediment is an acroterion, the head of a helmeted female figure who has the appearance of Minerva or Athena, the Roman or Greek goddess of wisdom, respectively (Figure 4.7), although the figure is not specifically identified as such in any source. Such specificity may not have been necessary; rather, simply the presence of a generic, classical goddess of learning and wisdom as a symbol of elite learning may have mattered. From her position at the top of the upper pediment, she watches over campus as the guardian of knowledge and learning.

The library is accessed through the deep hexastyle porch with fluted columns composed of multiple limestone drums, topped by Corinthian capitals. There are two inscriptions on the porch. The entablature contains the inscription:

LIBRARY OF NEW YORK UNIVERSITY MDCCCIC (1899).

The inscription on the rear wall of the porch, just above the top of the door, is an abridged quotation from Francis Bacon. It is divided into two lines on both sides of the door and reads:

Libraries are as the shrines/where all the relics of the/
(*to the left side of the door*)
Ancient saints full of true vir/tue are preserved and reposed
(*to the right side of the door*).

This quotation[50] sets the stage for entering the building by identifying the library as a site of learning and knowledge. The Bacon quotation was very well known, having appeared in many popular books of quotations, such as *The Cyclopædia of Practical Quotations*, which was in its eleventh edition by 1890.[51] The inscription reminds us that the Gould Memorial Library, like the Pantheon, is a temple or shrine—in this case, to (ancient) knowledge. The use of such a quotation also associates the building with long, well-established traditions of European learning; therefore, the Bacon quotation seems to parallel White's reception of the Pantheon through Palladio. The position of the inscription also speaks to the question of audience. While many could see the library, this quotation is only visible when

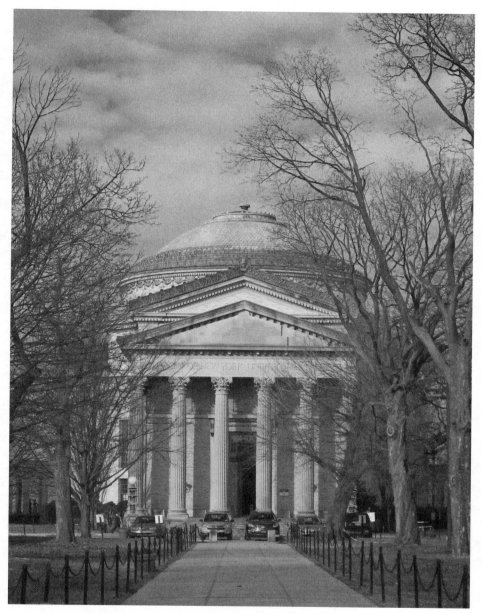

FIGURE 4.6. The main (east) façade of the Gould Memorial Library.
E. Macaulay-Lewis.

one is about to enter, suggesting that such details were intended for the students and faculty using the library.

The porch is significantly deeper than that of the Pantheon because it accommodates a long internal staircase, flanked by rooms. The details along the porch's roofline are similar to the rest of the building; the roofline also has projecting decorative palmette antefixes. Identical ones also appear on the roof of the Hall of Fame and on the dome. There are dentils below the porch's roofline.

FIGURE 4.7. The helmeted female head, either of Minerva or Athena, on the upper pediment of the main (east) façade of the Gould Memorial Library.
E. Macaulay-Lewis.

The main entrance to the library is through the doors that commemorate the life and work of Stanford White, who had been murdered by the jealous husband of his ex-lover Evelyn Nesbit. Commissioned by his family and friends and designed by his son, these large bronze doors are executed in a Renaissance style, reminiscent of the great doors of Tuscan churches and baptisteries. A simple inscription, which commemorated the dedication on December 10, 1921, states:

> These doors were given in memory of / Stanford White / Architect by his friends MCMXXI.

The doors, created by A. A. Weinmann and Philip Martney,[52] are decorated with eight female "muses," which represent Generosity, Architecture, Sculpture, and Drama (on the left door), and Inspiration, Decoration, Painting, and Music (on the right door).[53] The inclusion of such doors, whose inspiration was not classical, also reminds us that buildings such as the Gould Library were not slavish copies of ancient buildings but highly considered original structures that strategically deployed previous architectural forms. In this way, the library embodied the late-nineteenth-century trend toward bricolage and eclecticism, which Katharine von Stackelberg and I have identified as being a "Neo-Antique"[54] type of building, where neoclassical architecture was creatively combined with the architecture of other eras.

In his dedicatory address, Thomas Hastings, whose firm had designed the New York Public Library, said of White, "Stanford White always consistently adhered to classic principles and saw no logical or historical reason for a revival of the medievalism of his predecessor. With these strong convictions his work was always personal with a most unusual inborn sense of beauty."[55] Hastings's observation about White affirms that architectural classicism, broadly defined, was central to White's architectural practice. The selection of the Gould Memorial Library as the site of the memorial doors to Stanford White is

significant—it identifies the library as one of his most important and artistically success-
ful commissions.

THE EXTERIOR OF THE DOME

Composed of Roman bricks set in a steel frame, the dome projects upward from the cen-
ter of the Greek plan. The drum of the dome is decorated with a series of carved garlands
and dentils, which are consistent with the classical details found on the porch and on the
copper roof of the Hall of Fame. At the spring of the dome, there are four circular stepped
bands topped with palmettes. These echo the Pantheon's roofline, which had a series of
step rings that lightened the load of the dome at its haunch. Above the four step rings, the
roof is decorated with a leaf pattern.[56] The scale pattern terminates with a Mycenaean wave,
from which a lantern roof, with clerestory windows[57] covering an oculus, projects upward.

The roofed oculus allows in light but prevents the elements from entering. As in the
Pantheon, this is a clever solution to resolve structural problems posed by the weakest part
of any dome, its peak. It also allows more natural light into the circular reading room,
thereby addressing one of MacCracken's early concerns about the library's design. The
detailing is primarily Roman; the panes of window glass are set into Roman-style steel
window frames. The roof of the oculus is decorated with the same individual palmettes
that are visible on the side of porch and in the Hall of Fame's colonnade, bringing archi-
tectural cohesion to the building.

MacCracken wanted a large statue of Victory, preferably with wings, erected atop the
lantern.[58] Although White determined costs for such a statue and suggested the sculptor
Frederick MacMonnies for the work,[59] the statue was not commissioned, likely due to ex-
pense.[60] The discussion to include a Victory suggests that classical art and architecture
was as much a part of MacCracken's artistic vocabulary as it was White's.

THE INTERIORS

The interior of the library is composed of the circular reading room and adjoining rooms
and offices. Below the library is an auditorium. The elevated position of the main reading
room meant that both the library and auditorium received natural light, filtered through
Tiffany glass windows. The main reading room was accessed via staircase. White modeled
the staircase and its stucco-coffered ceiling on the Golden Staircase in the Ducal Palace in
Venice and the Great Staircase in the Vatican.[61] Other aspects of European architecture
were used in the creation of the library, underscoring that the building did not merely imi-
tate an ancient monument but was an architectural masterpiece combining diverse elements
to create a striking new building.

The axiality of the staircase focuses one's view toward the entranceway and two green
Connemara marble columns, thereby creating an aura of excitement to see what lies ahead.
Yet from this elegant, steep staircase that leads from a relatively unadorned foyer, one can
scarcely anticipate the vast, domed reading room that lay beyond the landing atop the stairs.

The Main Reading Room

The lofty dome, spanning seventy feet,[62] creates an ethereal interior (Figure 4.8). The stucco dome is gilded with Dutch metal, which gives it a golden appearance. The dome is composed of six levels of coffered rosettes set in diamonds that decrease in size as they

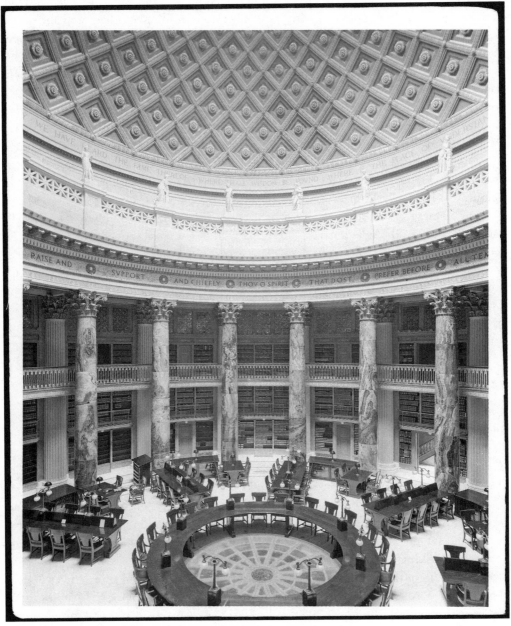

FIGURE 4.8. View of the main reading room, Gould Memorial Library, from the east, as one enters. Courtesy of the Museum of the City of New York.

approach the oculus, which was originally composed of Tiffany glass. The decorative stucco was built directly into the Guastavino tiles, which structurally support the dome.[63] The oculus was filled in during the late twentieth century, and sixteen harsh gym lights, affixed to it, are now the main light source for the rotunda.

At the foot of the dome is a balcony with sixteen plaster statues. Each was based on an ancient prototype and represents one of four female personifications associated with learning. Each statue appears four times. These statues are not identified in any of the archival material, but they are listed as types A through D in the Getty conservation plan.[64] They can be identified by their attributes and through comparisons to ancient sculpture. Statue type A is likely Polyhymnia, the muse of sacred poetry, and statue type D is probably Mnemosyne, or the personification of Memory, technically the mother of the muses, because these statues are close copies of known ancient prototypes.[65] Statue type B may be Calliope, the muse of epic poetry, because she is holding a tablet, Calliope's attribute. Statue type C appears to hold a globe in her left hand and a compass in her right hand, suggesting that she may be Urania, the muse of astronomy. She would be a highly suitable inclusion, as she would represent the sciences in this Pantheon of learning. Despite being only four feet tall, they appear life-sized from below. Like the classical goddess of wisdom located atop the upper pediment of the east porch, these muses are meant to inspire the students below. Their pediments also have classical details, including a meander pattern and reflective tesserae that shimmer in the light.

Behind the muses was an abridged quotation from the book of Job 28:12–14 and 28:22, from Webster's translation of the Bible, inscribed on the haunch of the dome. It reads:

> But where shall wisdom be found [and] where is the place of understanding.
> Man knoweth not the price of it[;] neither is it found in the land of the living.
> The depth saith, It is not in me: and the sea saith, It is not with me . . .
> Destruction and Death say we have heard the fame thereof [with our ears].

The word "wisdom" is on axis with the main entrance into the reading room and is thus visually prominent upon entering the library. These words in the reading room are on axis with the Athena/Minerva figure on the exterior. Thus, the inscriptions and sculpture on the library's interior and exterior emphasize that it is a place of wisdom and learning.

Sixteen Connemara marble columns with Corinthian capitals, also gilded with Dutch metal, line the circular reading room. MacCracken was insistent that these columns, rather than plain or plaster columns with steel structures, be used. The polished green marble reflects light, as does the gold of the dome, the inscriptions, and capitals, creating a textured interplay of luminosity and color.

The entablature supported by the Connemara columns is inscribed with an abridged and adapted quotation from the beginning of Milton's *Paradise Lost*, 1.18–19, 22–23:

> And chiefly thou o spirit that dost prefer before all temples that upright heart and pure.
> Instruct me for thou knowest . . . what in me is dark Illumine, what is low raise and support.[66]

Wreaths, a symbol of civic achievement in the classical world, are interspersed between the words of this inscription. The position of the inscription is well considered. One

enters the reading room through the main entrance and immediately sees "thou o spirit," directly below the word "wisdom." Together these words should lift the spirits of young students to lofty heights of wisdom. The oculus would literally help illumine students' minds with light, just as the inscription exhorted them to learn. Thus the inscription and architecture yet again convey a unified message to the library's users and help create a rarified atmosphere of erudite learning.

The interior inscriptions are gilded. White informed MacCracken that "the classics gilded their inscriptions . . . as in all or nearly all the classic buildings the stone work was painted in color, and with bright polychromatic ornament; and for this reason it is perfectly good practice to gild interior inscriptions."[67] White warned against gilding the exterior inscriptions; this was done with commercial buildings, and thus the use of exterior gilding would not be, in White's words, "dignified."[68] Again, these choices reflect White's deep knowledge of classical buildings and epigraphic traditions as well as his desire to use them thoughtfully to enhance the appearance of his building.

Along the walls behind the colonnade, there are inscriptions with the names of great writers, scholars, poets, philosophers, scientists, and jurists[69] whose achievements were meant to encourage the students to excel. Behind these walls were bookcases and hidden doors.[70] The original book call desk remains and is inscribed with a gilded Latin inscription that reads "MVLTOQVE SATIVS EST PAVCIS TE AVCTORIBVS TRADERE QVAM ERRARE PER MVLTOS" (It is much better to surrender yourself to a few authors than to wander through many),[71] a quotation from Seneca the Younger's *De Tranquillitate Animi* IX.9.4. Such a quotation promotes deep and profound learning. Above the center of the call desk area is the Latin inscription "PERSTARE ET PRAESTARE," NYU's motto, "to persevere and to excel." These inscriptions continued the aspirational and inspirational message of the large-scale, interior inscriptions. The choice of Latin is another example of the use of the classical past for the purposes of the present. Latin bestowed cultural and academic authority upon the library and the university.

Latin and English were used for the inscriptions. Latin was still widely being used in inscriptions in New York City at this time,[72] but there was and still is a strong epigraphic tradition using the English language. The nature of the texts inscribed on the Gould Library may have dictated the language used. Bacon and Milton were Anglophone authors who wrote in English. The Bible, which is also quoted, would have been known to many of the students and faculty who passed through the library in its English translations rather than in the Hebrew or Greek original or Latin Vulgate. Furthermore, at this moment in US history, classics, specifically the teaching of Latin and Greek, was becoming less central to American education.[73] While some of the NYU students would have studied both Latin and Greek, many likely did not.

There is also a small, elevated walkway between the rear walls and the Connemara columns. Along the walls are sixteen engaged columns, directly behind the Connemara columns. These engaged columns are made of plaster around a steel core. Many of White's buildings did this, a reflection of how he designed and what type of architecture his clients desired.[74]

The study rooms—now offices—and stacks were carefully hidden behind the doors and fake walls of the circular reading room. These study rooms and stacks made use of awkward spaces. The reading and study rooms are primarily on the ground floor; the upper floors have stacks and certain special study rooms, such as the maps room.

The windows in the Gould Memorial Library are composed of Tiffany glass,[75] including green, red, and yellow colored glass, whose hues vary from orange to ruddy brown depending on the light. The colored glass compliments the greens in the marble, the golden hues of the dome, and the red in the marble of the inlaid floor, creating a dynamic interior.

The majority of the floor is composed of monochrome white mosaic. Between the green marble columns are inlaid rectangles of green, yellow, and red marble, perhaps a direct reference to the Pantheon's flooring. At the floor's center was a second glass oculus that allowed natural light into the lower auditorium. This oculus was destroyed on April 17, 1969, when the basement auditorium of the library was firebombed with a Molotov cocktail.[76]

The basement auditorium of the library was extensively damaged by the fire caused by the Molotov cocktail; however, the three hundred thousand books and the Hall of Fame busts were not damaged.[77] There was no claim of responsibility nor any indication of who bombed the library. In October 1968, the campus had been damaged when two bombs exploded; fire hoses and telephone lines had also been cut. These actions were connected to protests over the dismissal of John F. Hatchett, the director of the Afro-American Student Center. The choice to target the Gould Library may stem from the fact it symbolized the establishment and patriarchal forces that many students opposed and actively protested in the 1960s.

Like the Pantheon, the library's interior was a true architectural achievement, an inspiring place where architecture encouraged students to reach their greatest academic and intellectual heights. But access to this remarkable interior was restricted. Only NYU's students and faculty could use the library.[78] Non-NYU students were granted access only under specific circumstances. In a letter to Chancellor E. E. Brown, dated June 3, 1919, Miss Belle Corwin, the librarian at the Gould Memorial Library, states that she could accommodate the students from the Church of God, Missionary to Home, to use the library for reference and research.[79] In this letter, she also gives the statistics for the average daily attendance in the reading room during March (302), April (376), and May (395) of 1922, demonstrating use of the library by a relatively large number of students.[80]

The Gould Memorial Library commemorated Jay Gould. Gould was in talks with Mac-Cracken to donate funds to support engineering at NYU, but these plans were not finalized when Gould died. Helen Gould, his daughter, was a graduate of NYU's law school. Her decision to fund and name the library in memory of her father appears to have been an attempt to rehabilitate his public image.[81] The grand, opulent, and evocative architecture of the classical past and European culture would have been a suitable memorial for Gould, who was buried in a neoclassical Ionic temple tomb, modeled on the Erechtheion, in Woodlawn Cemetery in the Bronx, roughly three miles on foot from the library itself.[82]

The Hall of Fame for Great Americans

Like the library, the Hall of Fame sought to inspire students (Figure 4.9). Built in 1901, the Hall of Fame is an elegant curvilinear portico over 630 feet long[83] that frames the library on its west side and flanks the library and the Halls of Philosophy and Languages on its north and south sides, respectively. Architecturally, the Hall of Fame was also a clever solution to mask the massive retaining wall that was constructed to support the Gould Memorial Library.[84] Underneath the colonnade inside the retaining wall was a museum composed of six galleries with exhibits about the individuals in the Hall of Fame.

In the Hall of Fame, busts of "America's immortals,"[85] as the official guidebook calls them, from the sciences, arts, industry, agriculture, education, politics, and armed forces were displayed with plaques detailing their achievements.[86] These Americans, who had to have been born in the United States to be selected for the Hall of Fame, were nominated according to a specific set of criteria and then chosen by a group of electors.[87] White designed the Hall of Fame, but the concept seems to have originated with MacCracken.[88]

The Hall of Fame was closely connected to European buildings that celebrated the great men of a specific region or county. MacCracken identified the Galleries of the Immortals at the nineteenth-century Ruhmeshalle in Munich, Germany,[89] as a model, where sixty-four busts of famous individuals sit on bases along the walls, in honor of Ludwig I.

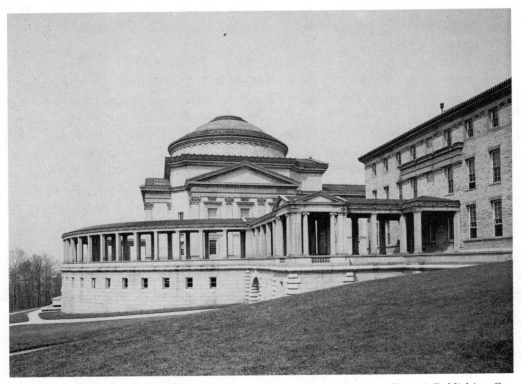

FIGURE 4.9. The Hall of Fame of Great Americans, New York University. Detroit Publishing Co. Courtesy of the Library of Congress.

MacCracken also identifies Westminster Abbey and the Pantheon in Paris as precursors to the Hall of Fame.[90] While the architectural inspiration for the Ruhmeshalle is clearly the Pergamon altar, a single ancient architectural source for NYU's Hall of Fame is not immediately recognizable. These modern structures tap into the universal idea that great men and women should be celebrated and honored.

The Hall of Fame is an American manifestation of these intellectual and architectural traditions. While rooted in the celebration of great individuals from antiquity that continued into eighteenth- and nineteenth-century Europe, the Hall of Fame was seen by MacCracken as different and uniquely American because "admission to this Hall of Fame should be controlled by a national body of electors, who might, as nearly as possible, represent the wisdom of the American people."[91] Like the Gould Memorial Library, the Hall of Fame, the first of its kind in the United States, was framed as a continuation of European and classical traditions of architecture and commemoration, and at the same time the Hall of Fame was different and superior from its predecessors because its process was democratic. MacCracken argued that the American drew upon the open-ended concept of liberty "to adopt new and broad rules to govern him, even when following on the track of his Old-World ancestors."[92]

THE HALL OF FAME'S ARCHITECTURE AND POSITION IN THE LANDSCAPE

The Hall of Fame is asymmetrical, but this is not apparent when viewing the Gould Memorial Library from the quad, as the curve of the Hall of Fame is visible but the entrances to the ambulatory are not. It is only noticeable when one looks toward the west side of the Gould Memorial Library and the Hall of Fame from an inferior position on the hill or from Upper Manhattan. The asymmetry is not visually disruptive, especially if the Hall of Fame is viewed from an oblique angle. Again, this is a feature of classical and Beaux-Arts architecture, where the appearance of symmetry was more important than the architecture's actual symmetry.

The retaining wall was built of thick rusticated blocks, typical of many Roman buildings, but the design cannot be intentionally linked to an ancient predecessor. This wall was covered by ivy at various points during the history of the building. The roof has decorative motifs in keeping with the rest of the building, including palmettes like those used on the roof and pediments of the library. There are also small lion heads on one gutter.

On the center of the retaining wall, directly below the library, there was an inscription. Set in front of this inscription was a large fountain. Together they mark another example of White's artful reception of classical artistic and epigraphic traditions. The inscription reads:

NEW YORK VNIVERSITY CHARTERED MDCCCXXXI
VNIVERSITY HEIGHTS PVRCHASED MDCCCXCI
VNIVERSITY COLLEGE REMOVED MDCCCXCIV
THIS HALL OF FAME WAS COMPLETED MCM
IN HONOR OF GREAT AMERICANS.

The use of "V" for "U" is an adoption of the Roman way of writing a "U."

A strigilated sarcophagus served as the basin for the fountain and was decorated with NYU's emblem, which White also designed. Above the fountain are stone-carved garlands that connect three tondi with lion heads, similar to those on the gutters of the Hall of Fame. These lions served as spigots, thereby linking the building and fountain. The fountain monumentalizes the retaining wall, breaking up the visual monotony of the wall. Its position directly underneath the triangular pediments and dome creates a strong vertical line that draws the eye up to the dome.

INSCRIPTIONS

The Hall of Fame has several inscriptions, two of which were drawn from the Bible. "Mighty men were of old, Men of Renown" (Genesis 6.4) is inscribed over the northern entrance. On the colonnade, there is a selection of verses from Ecclesiasticus 44 (44.7, 44.10, and 44.11):

> All those honored in their generations, and were the glory of their times . . . Yea, they were men of mercy, Whose righteous deeds have not been forgotten. . . . Their bodies are buried in peace, but their names live forever.

Above the south gate, the short phrase "Take note of Wisdom, Beauty, Power" is inscribed. These quotations, like those from the Bible and Milton on the library's interior, serve to remind the visitor that they are in the presence of great individuals whose achievements should be noted and celebrated. The font for the inscriptions in the Hall of Fame and in the Gould Memorial Library was modeled on the letters from the Forum of Trajan, again demonstrating White's deep awareness of Roman architectural and epigraphic traditions.[93]

THE HALL OF FAME AS A DIDACTIC MONUMENT

The Hall of Fame is a didactic monument. The busts are located in the intercolumniations at eye level. Each bust's plaque informs the reader about the achievements of these "Great Americans." As Mosette Broderick notes, "The pitch [of the Hall of Fame] was that students who studied at the university and sat among the greats would go on to achieve magnificent achievements after college."[94] The staged photographs of students sitting or walking contemplatively through the colonnade appeared in NYU's promotional materials in the late nineteenth and early twentieth centuries and highlighted how White and MacCracken envisaged students walking and moving through the space in thoughtful reflection about how they might join this august pantheon of American luminaries.[95]

The colonnade is both a dynamic space for movement and a performative stage where students and professors performed the rituals of academia. Many campus-wide processions, including parts of the commencement ceremonies, utilized the Hall of Fame for faculty and graduates to process (Figure 4.10). The marching of graduates through the Hall of

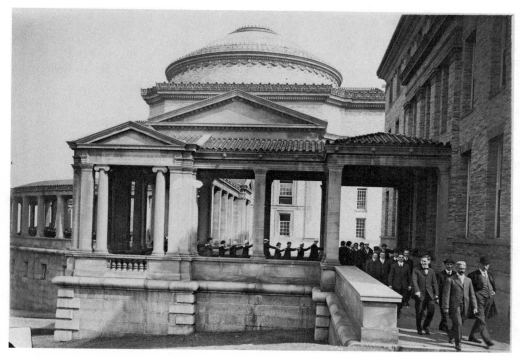

FIGURE 4.10. A procession through the Hall of Fame, New York University, the Bronx, New York. Courtesy of the Museum of the City of New York.

Fame is symbolic of their transition into the world. Having been educated in the hallowed reading room and study rooms of the Gould Memorial Library, they are ready to venture forth toward greatness.

The position of the Gould Memorial Library and the Hall of Fame literally transformed NYU into the university on the hill. Simply put, the library and colonnade dominated the views from the Bronx, Harlem River, Upper Manhattan, and even New Jersey. The curvilinear design of the colonnade unified the library and the Halls of Philosophy and Languages and maximized the natural curves of the landscape. Most historical photographs or postcards of the library were taken from below the Hall of Fame and library, making them appear more imposing.

The Hall of Fame, unlike the library, was conceived as a public monument intended to educate the population of New York City about the achievements of outstanding Americans. NYU produced annual handbooks, starting in 1920, which detailed the conception of the Hall of Fame, the election process, the biographies of those elected, and how to visit the Hall of Fame. Directions via public transportation and automobile were included. The handbooks also note that guides gave tours on Saturday and Sunday afternoons.[96] NYU's promotion of its Hall of Fame can be seen as an appropriation of these great Americans for the university's benefit. Through the Hall of Fame, NYU positioned itself as an arbiter of cultural, artistic, intellectual, and scientific achievements and as an educator of the broader population.

Dueling Pantheons in New York City

As noted earlier, by the 1890s the domed library was highly potent as a symbol of academic learning and intellectual achievements. Almost simultaneously, Charles Follen McKim, White's partner and rival, designed the Low Library at Columbia University.[97] Seth Low, the ambitious president of Columbia who would later become mayor of the newly incorporated New York City, underwrote the construction costs and dedicated the library in honor of his father.

Low and Columbia were in direct competition with MacCracken and NYU for academic prestige, students, and donors. Like MacCracken, Low risked his reputation on the successful migration of Columbia from Midtown Manhattan to a new campus in Morningside Heights. McKim had been involved in Columbia's architectural school, where he had endowed a traveling fellowship, and so it was unsurprising that he won the commission to design Columbia's new library. While the construction on the library did not start until 1895, there were plans for it in 1894,[98] so the Gould and Low Libraries effectively started at the same time.

The fact that business partners White and McKim were designing similar libraries for rival institutions speaks to their influence in New York City. They were not merely architects but cultural authorities who shaped the artistic, design, and architectural tastes of New York and the United States through their work at the Chicago World's Fair and their commissions in other major cities and cultural hubs.

Like MacCracken and White, Low and McKim felt that they were designing for history and their own legacies. The Low Library was also to symbolize Columbia's position as a premier educational institution, not just function as a working library.[99] Just as the Gould Memorial Library was located at the center of NYU's campus and had commanding views over Upper Manhattan, the Low Library was centrally located in Columbia's campus, atop an elevated platform, imposingly sitting above Manhattan (Figure 4.11).[100] Both libraries are conceptualized as memorials for deceased men and serve as the focal point of academic campuses, and both are situated atop the hill, far above the uncouth and ill-educated city.

The Low Library marks a more eclectic approach to the reception of the Pantheon. The Pantheon's dome was deployed alongside the architecture of Roman porticos and public baths, a combination that may result from the influence of the World's Columbia Exhibition in 1893, also known as the Chicago World's Fair.[101] The façade is composed of a wide decastyle portico, which allows for a large entablature where an inscription details Columbia's long history. A statue of a seated, robed woman, *Alma Mater*, is located in front of the library, another appropriation of classical ideals and sculpture.

The interior was built on a Greek-cross plan with a central rotunda that served as the great reading room. Rather than having a singular oculus as the primary source of light, four large, Roman bath–style windows allow natural light to pour into the interior. McKim painted the ceiling blue, like the night sky, and hung a globe to emulate the moon. The rotunda was to have sixteen figures to inspire the scholars of the future, but only four were erected. The interior of the Low Library, which uses a mute blue and gray palette, is far less vibrant than the rich gold and green of the Gould Library's reading room.

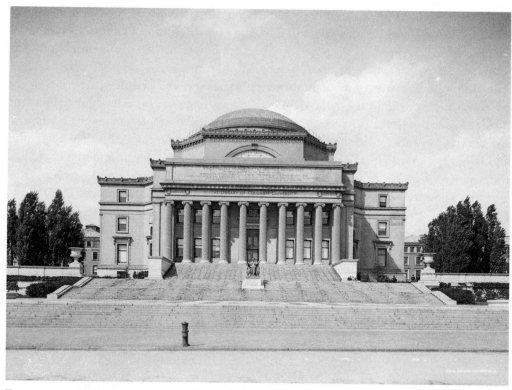

FIGURE 4.11. The Low Library, Columbia University, New York. Detroit Publishing Co. Courtesy of the Library of Congress.

The Low Library worked poorly for its purpose. As Lewis Mumford noted, it has "ample space for everything except books."[102] By the 1920s, the new Butler Library was erected across the quad to serve as Columbia's primary library. The symbolic academic center of Columbia was denuded of books and transformed into an event space. While the Low Library may have paled both functionally and aesthetically as a library when compared to the Gould Memorial Library, Low's gamble on Columbia's move to Morningside Heights was much better than MacCracken's bet on the Bronx. In 1973, NYU was forced to sell the uptown campus due to financial difficulties. The exhortation to "Take note of Wisdom, Beauty, Power," which adorns the entrance to the Hall of Fame, now seems quite ironic, and this great library building, perhaps, a folly.

Conclusion

The Gould Memorial Library is an American Pantheon. It is a testament to the greatness of White as an architect; the status of Helen Miller Gould and her late father, Jay Gould; and the ambitions of MacCracken for New York University. The colonnade of the Hall of Fame and rounded dome of the library draw upon the architectural traditions of Europe

and ancient Rome. The use of the Pantheon as a prototype for both the Gould Memorial Library and the Low Library testifies to the lasting power of Roman architecture as a suitable model for the grand educational architecture of late-nineteenth-century America. Through the redeployment of Roman architectural forms, the Gould Memorial Library accorded cultural status to its commissioner, benefactor, and architect. The use of the Pantheon as a model for the Gould Memorial Library and the Low Library also shows the dynamic ability of Roman architecture to be reinterpreted to create a monumental impressive library. The form of the Gould Memorial and Low Libraries, as well as their epigraphic and artistic programs, demonstrates that classical architecture, specifically the Pantheon, was deployed to create a cultured atmosphere of erudition, scholarship, and wisdom.

Throughout the first half of the twentieth century, the Gould Memorial Library and Hall of Fame were regularly reproduced on postcards. The dissemination of this image promoted a specific vision of NYU to New York City and beyond: that of an esteemed institution of higher learning.

The Pantheon remained a potent architectural form. The Thomas Jefferson Memorial, designed by John Russell Pope for the National Mall in Washington, DC, and dedicated on April 13, 1943, was also modeled after the Pantheon.[103] The Gould Memorial Library, forgotten to all but the most enthusiastic architectural historians, still has potency as a building: It influenced the design of the North Hall and new library on the campus of Bronx Community College, which now occupies the old NYU campus. Designed by Robert A. M. Stern Architects and completed in 2012, the North Hall and new library were modeled on the Bibliothèque Ste.-Geneviève in Paris by Henri Labrouste.[104] However, the materials, Roman brick and limestone, as well as the metal detailing, including palmettes, were in keeping with the Gould Memorial Library. The architecture of the North Hall is another layer of classical reception on the campus. This new library, like its predecessor, contributes to the creation of an atmosphere of learning and scholarship to inspire the students of Bronx Community College.

While the Gould Memorial Library continues to impress visitors in the early twenty-first century, the legacy of the Hall of Fame is more complex. The luminaries of America's past do not have the same resonance with the diverse students of Bronx Community College, who may not be able to relate to many of the individuals represented as readily as their early-twentieth-century predecessors.[105] The library is in a dire condition and needs tens of millions of dollars of renovation to ensure the long-term survival of the building. As the Bronx sees economic rejuvenation and increased investment, one can only hope that White's Pantheon can attract the interest and financial support it needs to recapture its former glory not only as the architectural centerpiece of a college but also as an architectural anchor for the University Heights neighborhood.

NOTES

1. The author would like to thank Remo Constantino, Wendall Jenner, Matthew McGowan, Dragana Mladenović, David Sider, and Jared Simard. Many thanks are owed to the librarians and archivists at the New York University Archive, the New-York Historical Society, Bronx Community College, and Avery Library at Columbia. The comments of the audience at the 2015 New

York Classical Club conference were particularly insightful, as were the comments of the anonymous reviewers.

2. The exterior was landmarked in 1966, and the ground-floor interior was landmarked in 1981. See Landmarks Preservation Commission, "Gould Memorial Library—Landmarks Preservation Commission February 15, 1966, Number 3, LP-0112," http://www .neighborhoodpreservationcenter.org/db/bb_files/66-GOULD-LIBARY.pdf; and Andrew S. Dolkart, "Gould Memorial Library, Ground Floor Interior—Landmarks Preservation Commission, August 11, 1981, Designation List 146, LP-1087," Landmarks Commission Report, http://www .neighborhoodpreservationcenter.org/db/bb_files/81-GOULD-LIB-INT.pdf.

3. Easton Architects, *Conservation Master Plan for the Stanford White Complex Located on the Campus of Bronx Community College of the City University of New York*, 3 vols. (2005), http://www .campusheritage.org/page/bronx-community-college.html.

4. An excellent website focuses on the campus. See Catriona Schosser, "The College on a Hill," http://www.nyuuniversityheights.com/.

5. Caroline Winterer, *The Culture of Classicism: Ancient Greece and Rome in American Intellectual Life, 1780–1910* (Baltimore, MD: Johns Hopkins University Press, 2002), 143.

6. Easton Architects, *Conservation Master Plan*, III-B, 1.

7. Winterer, *The Culture of Classicism*, 1.

8. On NYU's history, see Thomas J. Frusciano and Marilyn H. Pettit, *New York University and the City: An Illustrated History* (New Brunswick, NJ: Rutgers University Press, 1997); Joan Marans Dim and Nancy Murphy Cricco, *The Miracle on Washington Square: New York University* (Lanham, MD: Lexington, 2001), 34–37. Columbia faced an identical set of challenges and responded in virtually the same way. See Mosette Glaser Broderick, *Triumvirate: McKim, Mead, and White: Art, Architecture, Scandal, and Class in America's Gilded Age* (New York: Knopf, 2011), 385–400.

9. Broderick, *Triumvirate*, 385. On NYU's problems, see Dim and Cricco, *The Miracle on Washington Square*, 34–37.

10. Broderick, *Triumvirate*, 385–86.

11. Dolkart, "Gould Memorial Library," 2; Broderick, *Triumvirate*, 387.

12. Broderick, *Triumvirate*, 387.

13. Broderick, *Triumvirate*, 387.

14. Dolkart, "Gould Memorial Library," 3; Broderick, *Triumvirate*, 388.

15. Broderick, *Triumvirate*, 388.

16. Dolkart, "Gould Memorial Library," 3.

17. Broderick, *Triumvirate*, 388.

18. Quoted in Dolkart, "Gould Memorial Library," 4.

19. Dolkart, "Gould Memorial Library," 4; Broderick, *Triumvirate*, 389.

20. Dolkart, "Gould Memorial Library," 4.

21. Broderick, *Triumvirate*, 389.

22. Letter dated September 3, 1896, MacCracken to White, in the McKim, Mead & White Papers, quoted in Dolkart, "Gould Memorial Library," 4–5. It was not possible to locate this original letter in any of the archives consulted.

23. Letter from MacCracken to White, October 17, 1901, Records of the Office of the Chancellor (Henry MacCracken); RG 3.0.3, box 19, folder 3; New York University Archives, New York University Libraries. Hereafter "Records of the Office of the Chancellor."

24. Dolkart, "Gould Memorial Library," 4.

25. Easton Architects, *Conservation Master Plan*, II, 3.

26. For a concise introduction, see Amanda Claridge, *Rome: An Oxford Archaeological Guide*, rev. ed. (Oxford: Oxford University Press, 2010), 226–32. On the Pantheon's architectural greatness, see Spiro Kostof, *A History of Architecture: Settings and Rituals*, 2nd ed. (Oxford: Oxford

University Press, 1995), 217; Edmund Thomas, "The Architectural History of the Pantheon from Agrippa to Septimius Severus via Hadrian," *Hephaistos* 15 (1997): 163.

27. Thomas, "The Architectural History of the Pantheon," 171–74.

28. Lise M. Hetland, "Dating the Pantheon," *Journal of Roman Archaeology* 20 (2007): 95–112.

29. Paul Davies, David Hemsoll, and Mark Wilson Jones, "The Pantheon: Triumph of Rome or Triumph of Compromise?" *Art History* 10 (1987): 133–53; Mark Wilson Jones, *Principles of Roman Architecture* (New Haven, CT: Yale University Press, 2000), 177–213.

30. Paul Davies et al., "The Pantheon," 133–53; Jones, *Principles of Roman Architecture*, 177–213.

31. Andreas Beyer, "Palladio, Andrea," Grove Art Online, Oxford Art Online, http://www .oxfordartonline.com/subscriber/article/grove/art/T064879.

32. Beyer, "Palladio, Andrea."

33. Beyer, "Palladio, Andrea."

34. Dolkart, "Gould Memorial Library," 5, 13n21.

35. Roger White, "Gibbs, James," Grove Art Online, Oxford Art Online, http://www .oxfordartonline.com/subscriber/article/grove/art/T032107.

36. H. M. Colvin, "Architecture," in *The History of the University of Oxford*, vol. 6: *The Eighteenth Century*, ed. L. S. Sutherland and L. G. Mitchell (Oxford: Oxford University Press, 1986), 846–47; Estate Services, "The Radcliffe Camera Conservation Plan," first draft, March 2012, 16n5, 17n9, http://www.admin.ox.ac.uk/media/global/wwwadminoxacuk/localsites/ estatesservices/documents/conservation/Radcliffe_Camera.pdf.

37. Louis Fagan, *The Life of Sir Anthony Panizzi: K. C. B., Late Principal Librarian of the British Museum, Senator of Italy, &c., &c*, vol. 2. (London: Remington & Company, 1880), 24; David Rodgers, "London, British Museum," in *The Oxford Companion to Western Art*, Oxford Art Online, http://www.oxfordartonline.com/subscriber/article/opr/t118/e1500.

38. "The Reading Room," http://www.britishmuseum.org/about_us/the_museums_story/ architecture/reading_room.aspx.

39. William L. Beiswanger, "Monticello," Grove Art Online, Oxford Art Online, http://www .oxfordartonline.com/subscriber/article/grove/art/T059356.

40. Frederick D. Nichols, "Jefferson, Thomas," Grove Art Online, Oxford Art Online, http://www.oxfordartonline.com/subscriber/article/grove/art/T044540.

41. Nichols, "Jefferson, Thomas."

42. George Humphrey Yetter, "Stanford White at the University of Virginia: Some New Light on an Old Question," *Journal of the Society of Architectural Historians* 40, no. 4 (December 1981): 320–25.

43. Dolkart, "Gould Memorial Library," 13, 23.

44. Architect of the Capitol, "Thomas Jefferson Library," http://www.aoc.gov/capitol -buildings/thomas-jefferson-building.

45. Broderick, *Triumvirate*, 10.

46. Elizabeth Macaulay-Lewis, "The Architecture of Memory and Commemoration: The Soldiers' and Sailors' Memorial Arch Brooklyn, New York, and the Reception of Classical Architecture," *Classical Receptions Journal* 8, no. 4 (2016): 447–78.

47. Elizabeth Macaulay-Lewis, "Triumphal Washington: New York City's 'Roman' Arch," in *War as Spectacle: Ancient and Modern Perspectives on the Display of Armed Conflict*, ed. Anastasia Bakogianni and Valerie Hope (London: Bloomsbury Academic, 2015), 223.

48. David Lowe, *Stanford White's New York* (New York: Doubleday, 1992), 173–74; Broderick, *Triumvirate*, xxi.

49. Easton Architects, *Conservation Master Plan*, III-A, 1.

50. Francis Bacon, *The Advancement of Learning*, ed. Henry Morley (London: Cassell and Company, 1893), bk. 2, 5.

51. Thanks to Matthew McGowan for this reference.

52. The New-York Historical Society Department of Prints, Photographs, and Architectural Collections, PR 042, McKim, Mead & White Collection—Correspondence Files, box 516. See Simard's discussion of Prometheus, also created by Martney, in this volume.

53. The New-York Historical Society Department of Prints, Photographs, and Architectural Collections, PR 042, McKim, Mead & White Collection—Correspondence Files, box 516.

54. K. von Stackelberg and E. Macaulay-Lewis, "Introduction: Architectural Reception and the Neo-Antique," in *Housing New Romans: Architectural Reception and Classical Style in the Modern World*, ed. K. von Stackelberg and E. Macaulay-Lewis (Oxford: Oxford University Press, 2017), 1–23.

55. Privately published pamphlet from the dedication on December 10, 1921, 7, New-York Historical Society Department of Prints, Photographs, and Architectural Collections, PR 042, McKim, Mead & White Collection—Correspondence Files, box 516.

56. Easton Architects, *Conservation Master Plan*, III-A, 27.

57. Easton Architects, *Conservation Master Plan*, III-A, 233.

58. Letter from MacCracken to White, January 13, 1898, Records of the Office of the Chancellor (Henry MacCracken), RG 3.0.3, box 19, folder 3.

59. Letter from White to MacCracken, April 13, 1898, Records of the Office of the Chancellor (Henry MacCracken), RG 3.0.3, box 19, folder 3.

60. Letter from White to MacCracken, April 13, 1898, Records of the Office of the Chancellor (Henry MacCracken), RG 3.0.3, box 19, folder 3.

61. Letter dated May 2, 1898, from White to MacCracken; Letter, October 17, 1901, Records of the Office of the Chancellor (Henry MacCracken), RG 3.0.3, box 19, folder 3.

62. Easton Architects, *Conservation Master Plan*, II, 9.

63. Easton Architects, *Conservation Master Plan*, III-A, 72.

64. Easton Architects, *Conservation Master Plan*, III-A, 198–99.

65. For example, see the sculptures of Mnemosyne and Polyhymnia at the House of Octavius Quartio / House of M. Loreius Tiburtinus (II.ii.2): Wilhelmina Jashemski, *Gardens of Pompeii, Herculaneum, and the Villas Destroyed by Vesuvius* (New Rochelle, NY: Caratzas Brothers, 1993), 80, figs. 84–85.

66. The spelling in the inscription has been changed from Milton's original.

67. Letter from White to MacCracken, October 30, 1900, Records of the Office of the Chancellor (Henry MacCracken), RG 3.0.3, box 19, folder 3.

68. Letter from White to MacCracken, October 30, 1900, Records of the Office of the Chancellor (Henry MacCracken), RG 3.0.3, box 19, folder 3.

69. Easton Architects, *Conservation Master Plan*, III-A, 210.

70. Easton Architects, *Conservation Master Plan*, II, 5, fig. II-17.

71. Seneca the Younger, *Moral Essays*, vol. 2: *De Consolatione ad Marciam. De Vita Beata. De Otio. De Tranquillitate Animi. De Brevitate Vitae. De Consolatione ad Polybium. De Consolatione ad Helviam*, trans. John W. Basore (Cambridge, MA: Harvard University Press, 1932).

72. See McGowan's chapter in this volume.

73. Winterer, *Culture of Classicism*, 119.

74. This was also done at Pennsylvania Station. See Gensheimer's chapter in this volume.

75. For more information about the Tiffany glass, its condition, production, and proposed restoration method, see Easton Architects, *Conservation Master Plan*, III-A, 211–23.

76. Easton Architects, *Conservation Master Plan*, II, 3.

77. "Fire Damages NYU's Gould Library," *New York Times*, April 18, 1969.

78. The inside cover of *The Handbook of the Gould Memorial Library New York University*, from 1966, states that "All members of the University community—students, staff, and faculty—are eligible to use the library." Records of the John Frost Library Collection, Series I: Library

Administration, Group no. 38.0, Series no. I, box 2, folder, "Gould Memorial Library—1966—box 2, folder 2—RG 38.0, Series I," in Bobst Library, New York University. The 1952–1953 New York University Bulletin also confirms this admissions policy.

79. Letter dated June 3, 1919, from Belle Corwin, the librarian, to Chancellor E. E. Brown, New York University Archives, Office of the President, Elmer Ellsworth Brown Administration, Administrative Files, League to Enforce Peace to Library, University Heights, Group no. 3.0.4., Series no. I, box 37, Library University Heights—Gould Memorial Library—1912–1922, EE Brown Papers box 37/folder 12, Bobst Library.

80. In 1917, there were 789 students, a number that dropped to 238 by October 1918 because of World War I. See "175 Facts about NYU," http://www.nyu.edu/library/bobst/research/arch/175/facts5.htm.

81. Broderick, *Triumvirate*, 389.

82. Elizabeth Macaulay-Lewis, "Entombing Antiquity: A New Consideration of Classical and Egyptian Appropriation in the Funerary Architecture of Woodlawn Cemetery, New York City," in *Housing New Romans: Architectural Reception and Classical Style in the Modern World*, ed. K. von Stackelberg and E. Macaulay Lewis (Oxford: Oxford University Press, 2017), 190–231.

83. Jerry Grundfest, *Great Americans: A Guide to the Hall of Fame for Great Americans* (New York: New York University, 1977), 9.

84. Henry MacCracken, "The Hall of Fame," *American Monthly Review of Reviews* 22 (July–December 1900), 563.

85. Jerry Grundfest, *Great Americans*, 9.

86. For an official history of the Hall of Fame and its conception, see Henry Mitchell MacCracken, *The Hall of Fame: Official Book* (New York: G. P. Putnam/Knickerbocker Press, 1901). Also see Easton Architects, *Conservation Master Plan*, II, 14–17.

87. On the process of election, see MacCracken, "The Hall of Fame," 563–70.

88. Jerry Grundfest, *Great Americans*, 10; Easton Architects, *Conservation Master Plan*, II, 11; Broderick, *Triumvirate*, 390.

89. MacCracken, "The Hall of Fame," 563.

90. MacCracken, "The Hall of Fame," 563.

91. MacCracken, "The Hall of Fame," 563.

92. MacCracken, "The Hall of Fame," 563.

93. Letter from White to MacCracken Bobst, November 23, 1900, box 19, folder 3 (Group no. 3.0.3, Series III, box 19). In this letter, White notes that MacCracken intended to change the font without discussing it.

94. Broderick, *Triumvirate*, 389.

95. An example of such a scene is held in the Irma and Paul Milstein Division of United States History, Local History and Genealogy, New York Public Library, "Bronx: Hall of Fame," New York Public Library Digital Collections, http://digitalcollections.nypl.org/items/510d47dc-a9dd-a3d9-e040-e00a18064a99.

96. Handbooks from various years from 1920 through 1956 are held in New York University Archives, Hall of Fame for Great Americans, Handbook of the Hall of Fame (1920–1956) Group no. 42.2, Series no. 7, box 4.

97. Broderick, *Triumvirate*, 394.

98. Broderick, *Triumvirate*, 395.

99. Broderick, *Triumvirate*, 395.

100. Broderick, *Triumvirate*, 395.

101. Broderick, *Triumvirate*, 395.

102. Lewis Mumford, *Sticks and Stones* (New York: Dover, 1955), 64.

103. "Thomas Jefferson," http://www.nps.gov/thje/learn/historyculture/index.htm. It does not seem that the Gould Library was influential upon its design.

104. Karen W. Anderson, "Regilding a Bronx Landmark; Getty Gives Community College a $228,000 Architectural Grant," *New York Times*, July 30, 2004, http://www.nytimes.com/2004/07 /30/nyregion/regilding-bronx-landmark-getty-gives-community-college-228000-architectural .html.

105. Sam Dolink, "A Hall of Fame, Forgotten and Forlorn," *New York Times*, December 4, 2009, http://www.nytimes.com/2009/12/05/nyregion/05metjournal.html.

The Expression of Civic Life:
Civic Centers and the City Beautiful in New York City

Jon Ritter

Classical New York is all around us—in our houses, public buildings, cultural institutions, public parks, and infrastructure. From colonial times to the present, architects, builders, patrons, and planners have incorporated columns, arches, pediments, cornices, moldings, and myriad other classical elements into the fabric of New York, to demonstrate permanence, prestige, culture, and authority. This chapter examines a particularly productive period of classicizing building in New York, the years just after 1900. During this time, the architecture and public spaces of ancient cities inspired architects and planners to reconsider the forms and spaces of the city. Here I examine what came to be called the City Beautiful movement, with particular focus on the New York Civic Center at Foley Square in Manhattan. Around 1900, New York architects and intellectuals helped define the City Beautiful as a national movement aiming to reform and reorient American cities around classically inspired buildings and monumental plans emphasizing civic identity and public life.

Analysis of the civic center as a key element of City Beautiful plans reveals how architects, civic leaders, and Progressive political reformers understood the space of the Greek agora and the Roman forum in the modern world. After introducing the origin of the civic center concept and early examples from Cleveland and San Francisco, my examination turns to the Foley Square project, especially the first building proposed and built there, the New York County Courthouse—now the New York Supreme Court—by the Boston architect Guy Lowell. Lowell's innovative plan for a circular building "like the Coliseum [*sic*]"[1] proposed a neo-Roman urban form while accommodating new municipal functions. I conclude with an assessment of New York City's role in national efforts to classicize

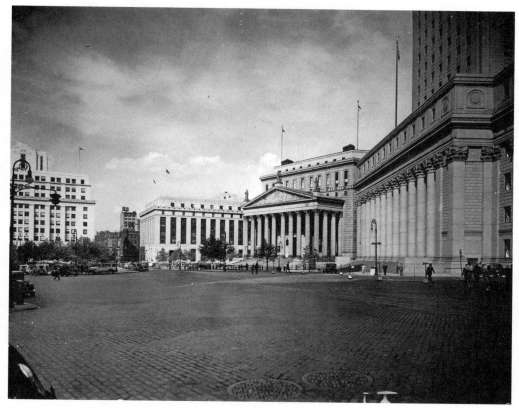

FIGURE 5.1. New York Civic Center at Foley Square, 1936 photograph by WPA Federal Writers Project. *From left to right*, Board of Health Building, New York State Building, New York County Courthouse, Federal Court Building.

Milstein Division of United States History, Local History, and Genealogy, The New York Public Library, Astor, Lenox, and Tilden Foundations.

American cities, identifying key differences between the ways that architecture and urbanism can fulfill the promise of classical references.

Today the New York Civic Center consists of public buildings surrounding the irregularly shaped Foley Square (Figures 5.1–5.3). Lowell's courthouse at 60 Centre Street, planned and built between 1913 and 1927, clearly presents a classical image with its projecting, decastyle Corinthian porch, pedimented roof, peripteral Corinthian pilasters, and its continuous, denticulated cornice. In 1935, the City and State of New York amplified the neoclassical presence in this area with the Department of Health Building (Charles B. Myers) and the New York State Building (William E. Haugaard and Sullivan W. Jones).[2] The federal government added the colonnaded US Courthouse and Federal Office Building in 1936, designed by the architect Cass Gilbert, most famous for his 1913 Woolworth Building, a few blocks away. After World War II, the Javits Federal Office Building and Court of International Trade (Alfred Easton Poor, Kahn & Jacobs, and Eggers & Higgins) opened in 1969, expanding the federal presence in the area, filling the lots opposite the County Courthouse. We will return to examine these buildings more

closely after considering the political and urban contexts under which they developed as a civic center during the early twentieth century.

Classicism, the American Renaissance, and the City Beautiful

The idea of creating a civic center for New York originated in the early twentieth century as a self-conscious way to evoke a classical identity for the growing city. The project and its origins can be understood to be part of the national City Beautiful movement, proponents of which sought to unify and aggrandize American cities through architectural and infrastructural projects. The forms and spaces of the City Beautiful appropriated classical models to embody the ideals of the civic leaders, professionals, and reformers who sponsored this movement.

The Chicago architect Daniel Burnham and the journalist, writer, and planner Charles Mulford Robinson led this movement through their work and writing from the late nineteenth century through the first two decades of the twentieth century. Robinson was in many ways the propagandist of the movement, promoting civic art, municipal planning, and civic centers in popular books, articles, and city plans.[3] Burnham introduced the most influential example for this planning ideal as Director of Works for the 1893 Chicago's World's Columbian Exposition.[4] Under Burnham's leadership, some of America's most prominent architects collaborated to build the Court of Honor, an architecturally coordinated group of uniformly white buildings sharing a Renaissance-Roman idiom and a common cornice line, at the center of the Exposition (see Figures 2.1, 5.4).

The classical image of this place exerted a strong influence on both the general public and on professionals and elites who would go on to promote civic center plans for American cities.[5] The "White City" was so named for the buildings' façades, which were made of a mixture of plaster, cement, and staff and painted white. At the same time, the name suggested the possibility of actively planning an alternative to Chicago's "Black City," characterized by chaotic commercial development and slum housing.[6] The spatial form of the Court of Honor provided an urban model for municipal civic centers as architecturally coordinated, axially oriented complexes of administrative and cultural buildings surrounding naturalized open spaces. Following on his success in Chicago, Burnham led Senator James McMillan's commission to restore the original monumental plan of Washington, DC, particularly its axial Mall.[7] This project provided another major example of coordinated spatial planning serving government representation for the incipient City Beautiful movement.

By the early twentieth century, architects and planners routinely adopted classical forms for public buildings and urban projects across the country. Like many American artists trained at the École des Beaux-Arts in Paris and at the American Academy in Rome (est. 1894), these designers favored an eclectic, neoclassical style that was known at the time as the American Renaissance. The American Renaissance featured a mixture of classical elements, usually incorporating Renaissance and Roman motifs, with rich ornamental and sculptural programs derived from seventeenth- and eighteenth-century French architecture.[8] "Renaissance" refers not only to these formal traits but also to the collaboration of

FIGURE 5.2. New York Civic Center with triangular Foley Square Plaza at center. The New York County Courthouse (now the New York Supreme Court) is the hexagonal building to the left. Clockwise from the County Courthouse: United States Federal Building, Municipal Building, two commercial buildings, World Court of Trade, Federal Building, and in foreground with square courts, the New York Board of Health and the New York State Building.

Daniel Acker, Getty Images.

FIGURE 5.3. The civic center as built, from *Manhattan Land Book*, G. W. Bromley and Co., 1955, plate 8.

The New York Public Library, http://digitalcollections.nypl.org/items/4f7a3120-4672-0132-79d8-58d385a7bbd0.

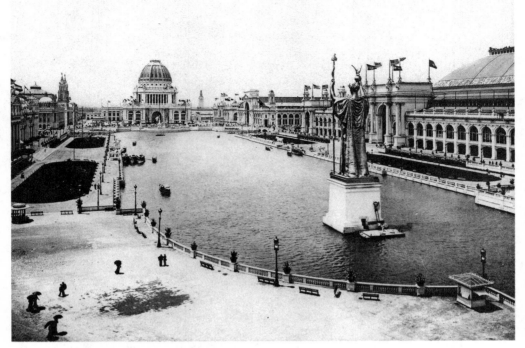

FIGURE 5.4. Court of Honor, World's Columbian Exposition, Chicago, 1893, looking east from the Lake Michigan Water Gate.
Project Gutenberg.

architects, painters, and sculptors on these projects and to the urban quality of the works.[9] Many today refer to this style as the "Beaux-Arts," for its relationship with the Parisian academy, but this chapter avoids that term because its identification with historicist practice does not account for the diversity of approaches taught at the École des Beaux-Arts, including structural rationalism.[10]

American Renaissance designers believed that Greek and Roman architectural forms held moral and political meaning, and they deployed them to establish cultural and political legitimacy for a nation emerging as an economic and military world leader.[11] As supervising architect of the US Treasury from 1897 to 1912, James Knox-Taylor promoted American Renaissance classicism as the exclusive architectural idiom for public buildings.[12] For Knox-Taylor and others commissioning public architecture, classical forms served an operative rather than merely representational purpose. Classicism had often symbolized democratic institutions for American builders, but Knox-Taylor and other American Renaissance architects argued that these forms could acculturate new generations of Americans. Regarding the power of the hundreds of neoclassical buildings under his supervision, Knox-Taylor wrote:

> If the . . . immigrant sees a public building in the town he has chosen for his home and the Stars and Stripes fluttering in the . . . wind, he has respect and not contempt for his

new allegiance and that is what is needed in this republic—respect for the law and lawmakers, respect for court and judges, and respect for all rightful authority.[13]

In New York, the Municipal Art Society (MAS) Committee on Civic Centers also argued that "adequate, dignified, beautiful governmental buildings will produce an effect on the governed which mere holders of office as individuals cannot do."[14] For the MAS, as for Knox-Taylor, "dignified" and "beautiful" were synonymous with American Renaissance classicism.

The urban extension of American Renaissance architecture came to be known as the City Beautiful.[15] For designers and patrons educated on Grand Tours of European capitals, broad avenues punctuated by monuments and arches, public squares filled with allegorical statuary, and uniform, classicizing street façades invoked permanence, authority, and stability. At the urban scale, stylistic uniformity implied the civic order and harmony that many wished to install in American cities. Building on the architectural form of the Court of Honor at the World's Columbian Exposition, American Renaissance architects developed a model of monumental urbanism.[16]

In New York, the City Beautiful offered an image of order and control against what many saw as a chaotic and ill-defined city. The American novelist Henry James (b. 1843) expressed this view when he described the "provisional"[17] character of New York upon his return to the city from Europe in 1904. James took the residential and commercial dislocations of the nineteenth century to be perpetual. Whereas Paris and London planned and built permanent improvements, for James, New York remained formless and shifting. In his estimation, "the city is, of all great cities, the least endowed with any blest item of stately square or goodly garden."[18] Unlike those who would propose the City Beautiful, James concluded that this impermanence was a virtue and that "the very sign of its energy is that it doesn't believe in itself; it fails to succeed even at a cost of millions in persuading you that it does."[19] Against this formlessness of undistinguished American cities, the City Beautiful movement proposed monumental city plans to highlight focal places and institutions.

The classicizing architectural harmony and spatial unity of the City Beautiful can be understood as a critique of the American free-market urban development admired by James. Many of the movement's leaders criticized American private-property rights, proposing instead to make collective identity more evident through classically inspired monumental urban plans. For example, John Brisben Walker, editor of *The Cosmopolitan*, believed competition among builders vying for attention and prestige created "freaks of individuality" rather than cooperative "harmony."[20] Comparing the classically inspired 1901 Buffalo Pan-American Exhibition to the City of Buffalo, Walker expressed the City Beautiful critique of laissez-faire economic development:

> One represents human effort disastrously expended under individual guidance in the competitive system which takes no thought of neighbor. The other represents organization intended for the best enjoyment of all. One stands as the remnant of a barbarism handed down through the centuries. The other stands for the aspiration of the human mind under the unfolding intelligence of an advancing civilization. In the light of this new city the old seems almost as much of an anachronism as the walled city of the Middle Ages with its turrets and donjon and drawbridge and portcullis.[21]

Here Walker suggests that coordinated ensembles of buildings and monumental vistas implied shared social values. For him, the individualism inherent in American economic principles clashed with the broad collectivism of the City Beautiful. The New York architect Charles R. Lamb offered a similar critique, comparing the competitive impulse shaping Manhattan's skyline to the individual defensive needs that created the medieval towers of the Italian hill town of San Gimignano.[22] For Lamb, individualism created chaotic cityscapes; he and fellow City Beautiful planners proposed instead an alternative urban form based on the Court of Honor model. For reformers like Walker and Lamb, a shared classical architectural idiom, buildings of uniform height, and generous public spaces exemplified common American identity. City Beautiful plans offered the classical image of unity to create a civic identity that was cooperative and harmonious rather than individualistic and competitive. If, according to the City Beautiful economic critique, unregulated commercial development destroyed places promoting public life, then monumental planning would reimpose a public, or civic, hierarchy.

Many scholars interpret these aspirations to civic representation as a strategy of social control with a prescriptive ethical agenda.[23] Indeed, many City Beautiful proponents advanced public works as moral agents to instruct citizens and immigrants.[24] For the New York muralist Edwin Blashfield, public buildings could "celebrate patriotism, inculcate morals, and stand as the visible concrete symbol of high endeavor."[25] The MAS concurred, proclaiming, "municipal art leads to a better conception of the duties of citizenship."[26] Some see these invocations of "patriotism" and "citizenship" to be directed toward workers and immigrants, whose values were uncertain and possibly dangerous to elite City Beautiful leaders.[27] This interpretation certainly recalls Knox-Taylor's enthusiasm for the power of classical forms to construct citizenship. Some even used the Latin term for citizens, *cives*, when referring to the public anticipated for civic centers.[28] This reference to Roman citizenship reflects the ambition reformers held for their urban projects. If understood in conjunction with other Progressive socialization programs, such as education and instruction at settlement houses or organized recreation in city parks, reformers' citizenship agenda might be compared with ancient precedents regarding identity and public comportment.[29]

Whether the City Beautiful movement was a strategy for social control or a reflection of broader patriotic attitudes, many at the time saw great promise in the potential for civic improvement and environmental reform to promote social harmony. Historians commonly identify in this attitude an alliance or even an identity between the City Beautiful movement and Progressive political reform.[30] Many Progressives worked in both politics and planning, and contemporaries often conflated the two movements. Progressives and City Beautiful proponents shared many goals, such as regulating commerce, reforming professional and administrative practices, centralizing authority, promoting expert advisers, and establishing local political autonomy. Progressives shared with civic center supporters an interest in strong municipal government to achieve these goals. The City Beautiful advocates argued for controls over private building, reformers urged regulatory power over private enterprise and independence from state and machine control, and civic centers appealed to both as the physical manifestation of strong municipal power. Many scholars

have therefore understood municipal civic centers as symbols of Progressive regulatory ambition.[31] According to this reading, monumental architectural ensembles stand for the growing role of Progressive municipal government. One recent interpretation, for example, associates civic centers with "the hopes of urban progressives to give evocative form to their citizenship ideal."[32]

Origin of the Civic Center

The idea of a civic center as a Roman forum-like space emerged early in the City Beautiful as a way to promote a collective vision for cities focused on architecturally coordinated spaces and monumental vistas.[33] As the City Beautiful unfolded through dozens of city plans across the first decade of the twentieth century, architects and planners developed the civic center into a key element of urban design.[34]

The New York lawyer and reformer John Dewitt Warner coined the term "civic center" in 1902 to refer to a "common focus . . . about which should be grouped the more important buildings" of a city.[35] That he introduced this term in *Municipal Affairs*, the journal of the Reform Club of New York,[36] indicates the relationship between civic centers and Progressivism. Warner cited historic precedents, from ancient Mesopotamia to nineteenth-century Vienna and Paris, concluding that American cities should create such places to be the "expression of . . . civic life."[37] He considered the Roman Forum to be the most "characteristic example . . . the centre of Rome's civic life where the people most frequently gathered."[38] Warner urged Americans to build modern equivalents of ancient Roman fora and Greek agorai and to create public gathering places for American democratic life. As physical representations of the state, civic centers would become the places to present most clearly the values of the City Beautiful.[39]

While scholars credit Warner's article as the origin of the term, there are other possible origins. Archaeologists had referred to certain ancient city sites as "civic centres" as early as the 1880s, and it is possible that Warner adapted this concept from these sources. In 1887, the American classicist J. H. Wright described the Greek-era *temenos* at Naukratis, excavated by the Egyptologist W. M. Flinders Petrie, as having been "a place of assembly for deliberation, . . . the civic centre of authority."[40] Arthur Frothingham, another American art historian and archaeologist, also used the term "civic centre" in several reports of archaeological news for the *American Journal of Archaeology* in the 1890s. In 1896, for example, he cited the term "civic centre" three times in a report on Cretan excavations by the archaeologist Arthur J. Evans.[41] Evans himself referred to Cretan "Miletus" (*sic*) as a "civic centre" in a British journal article in 1897, and he would later refer to the palace at Knossos as a "civic centre" in his publications of the 1920s and 1930s.[42] Today it is common for archaeologists and historians to use the term in reference to political and social centers of ancient cities.[43] These examples suggest that Warner might have been aware of the term, but, because we have no hard evidence that he knew these sources, and because he did not refer to Naukratis, Crete, or Knossos, this must remain a speculative etymological possibility.

First Civic Center Projects

Whatever the origin of the term, the civic center became a common element of city plans very quickly after the turn of the century. By the 1920s, more than seventy American cities had approved official plans for civic centers, although few completed them as intended.[44] Building on the model of the Court of Honor and the Washington Mall, Burnham worked with other American Renaissance architects to design plans for Cleveland and San Francisco, both of which feature prominent civic centers.

The Cleveland and San Francisco projects were, respectively, the first and the most completely built civic center projects of this period. Both proposed clear images of the Roman-Renaissance urbanism favored by the City Beautiful, and reformers promoted them as examples of Progressive municipal planning. The buildings anticipated for the Cleveland Group Plan, as this complex is called, shared uniform colonnades, continuous cornices, and carved stone façades, forming an axial court or mall, clearly derived from the Chicago Court of Honor, to create a modern-day Roman Forum for this civic precinct (Figure 5.5).[45] The plan, designed by Burnham with the New York architects John Carrère and Arnold W. Brunner, specified that the buildings be "derived from the historic motives [*sic*] of the classic architecture of Rome."[46] Burnham, Carrère, and Brunner established a uniform cornice height and stylistic guidelines for all the buildings in the area, based largely on Brunner's previous design for the Cleveland Federal Building.[47] Figure 5.5 shows their 1903 plan for a civic center extending south from Lake Erie, unseen in the foreground, toward the city's historic commercial center at Public Square in the upper right. The

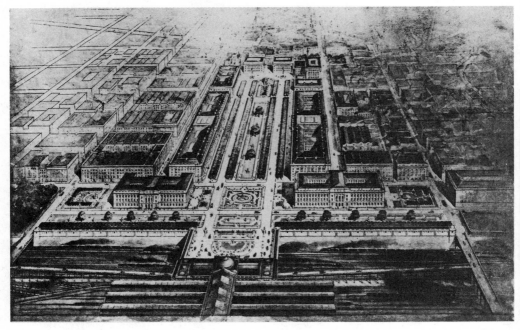

FIGURE 5.5. View of the Cleveland civic center, from *The Group Plan of the Public Buildings of the City of Cleveland* (1903).

buildings proposed include a new railroad station in the foreground and, clockwise from the station, new buildings for the Cuyahoga County Courthouse (Lehmann and Schmitt, 1912), the Public Auditorium (J. Harold McDowell and Frank Walker, 1922), Board of Education (Walker and Weeks, 1931), Public Library (Walker and Weeks, 1925), Federal Building (Arnold W. Brunner, 1910), Grand Army of the Republic (unbuilt), Municipal Office Building (unbuilt), and City Hall (J. Milton Dyer, 1916). Much of the east and south sides of this complex have been built as shown over the twentieth century. The rail station was built in the 1920s on the Public Square as part of the Terminal Tower (Graham, Anderson, Probst, and White).

The location of the Group Plan is significant as a product of contestation and negotiation between civic reformers, who wanted a prominent site in the commercial center of the city at the Public Square, and business interests, led by the Chamber of Commerce, who proposed a remote location on the banks of Lake Erie.[48] Cleveland's Progressive mayor Tom L. Johnson secured a compromise location on the blocks between the Public Square and the lake,[49] which both amplifies and undermines the classical ideal of the civic center. On the one hand, this location enhances civic identity by featuring public buildings within a forum-like space, removed from the competing buildings of the commercial district. On the other hand, the Group Plan remains somewhat lifeless because it is isolated from the life of the city's commercial core. Whereas Roman fora typically occupied sites at the center of towns and enjoyed the vibrant life of mixed uses there, the Cleveland Group Plan is marginalized by both its location and its exclusively civic functions.

The San Francisco Civic Center similarly presents a strong classical image of city government that is also compromised by its location and functions (Figure 5.6). A local civic group, the Association for the Adornment and Improvement of San Francisco, commissioned Burnham to create a comprehensive plan for the city, and his 1905 report calls for a civic center in which "the column should be freely used as a governing motif."[50] Burnham's plan and several others proposed around this time envisioned the civic center at the center of a newly organized city.[51] As in Cleveland, however, business and commercial leaders opposed a central location for the civic center, and Mayor James Rolph approved a site several blocks off the city's central commercial artery, Market Street, in 1912.[52]

As built, its combination of American Renaissance buildings, spatial enclosure, monumental axiality, and an internal focus on open space creates civic identity and distinction from the rest of the city. The architect Arthur Brown Jr.'s 1912 City Hall defines the group with an American Renaissance block surmounted by a monumental dome.[53] The other buildings of the group conform generally with the city hall in size, scale, and detailing, defining the space of an interior court. Figure 5.6 shows (1) the long, low blocks of the triple-arched, domed Civic Auditorium (Howard, Meyer, and Reid, 1915); (2) the Board of Health Building (Samuel Heiman, 1932); (3) City Hall; (4) the War Memorial Opera House (Arthur Brown Jr., 1932); (5) the Veterans Building/Herbst Theatre (Arthur Brown Jr., 1915); (6) the Federal Building (Arthur Brown Jr., 1936); (7) the Public Library/Asian Art Museum (George Kelham, 1914–1916 / Gae Aulenti, 2003); and (8) the California

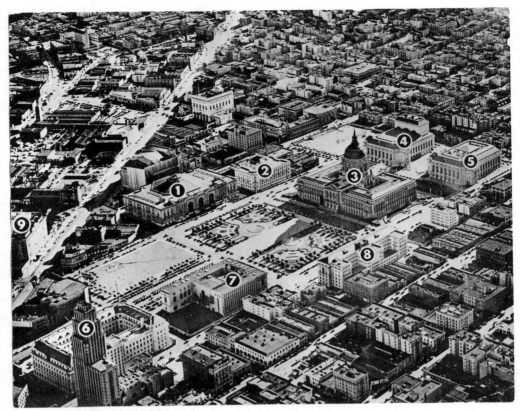

FIGURE 5.6. San Francisco Civic Center, 1945, showing (1) Civic Auditorium with dome and triple arch entry, (2) Board of Health Building, (3) City Hall, (4) War Memorial Opera House, (5) Veterans Building/Herbst Theatre, (7) San Francisco Public Library (now Asian Art Museum), and (8) California State Building.

San Francisco History Center, San Francisco Public Library; © Moulin Archive

State Office Building (Bliss and Faville, 1926). The Public Library now occupies a 1997 building designed by James Ingo Freed on the site of the empty lot to the left of (7). Market Street, the city's main commercial artery, runs diagonally to the left of the civic center.

As in Cleveland, functional exclusivity reinforces architectural and spatial unity: Only government and cultural buildings stand in the civic center, which lies several blocks away from the city's commercial center on Market Street. These architectural, spatial, and functional factors combine to create a distinct sense of place in the civic center, which is different from the linear, gridded streets and individuated buildings of the commercial and residential areas. But this place is also less active than the lively commercial center on Market Street, from which it is removed by several blocks.

In New York during these years, architects, politicians, and civic organizations proposed several forum-like civic centers for the area around City Hall Park. The project emerged from the demand for more office space as administrative and bureaucratic needs

grew after consolidation of the five boroughs into Greater New York in 1898.[54] By the turn of the century, great debate arose about where to build, however. Some proposed to build cheaply in City Hall Park; others advocated other sites across the city.[55] In 1899, the city began constructing a new Hall of Records, on the north side of Chambers Street, and in 1902 the state chartered a New York County Courthouse Commission to plan and build the courthouse that would eventually anchor the civic center at Foley Square.[56] In the following year, the MAS Committee on Civic Centres, chaired by Warner, made the first proposal for a New York civic center, a coordinated ensemble of municipal buildings conforming with the Northern Renaissance style of the Hall of Records, on the north side of Chambers Street, axially related to City Hall.[57] The MAS sought to highlight further the municipal presence by clearing all buildings except City Hall from City Hall Park.[58] This plan therefore envisioned City Hall Park as a forum- or agora-like place surrounded by government buildings, "which, through their use by the public, become a centre of civic life."[59] The location proposed for this civic center contributed significantly to the public life the MAS envisioned there. By locating the project adjacent to both City Hall Park and to the commercial activity of Broadway, the MAS aspired to build a civic center that would house a Progressive government and form an active part of the city's daily life, like the initial proposals for Cleveland and San Francisco.

The MAS proposal reflected contemporary criticism of the encroachment on public space at City Hall Park, and it gained broad support from professional and reform groups.[60] Civic leaders particularly disdained the largest buildings in the park, the Tweed Courthouse and the Federal Building (or Mullett Post Office), on political, aesthetic, and practical grounds. Many resented the courthouse because of its associations with Tammany Hall corruption, its outdated Palladian classicism, and its large footprint within the park.[61] Civic activists opposed the Federal Building on similar grounds, as a symbol of federal intervention and *retardataire* Second Empire aesthetics.[62] The cutting of Mail Street through the park, behind the post office, and the construction of loading docks facing City Hall especially offended those seeking a unified civic presence.[63]

Many supported building the new courthouse in City Hall Park, despite objections about encumbering its park space, and in 1910 the Courthouse Commission recommended erecting its new building there. Their report also introduced the eventual site of the civic center as an alternative, and this became the compromise location in the years that followed.[64] Given the opposition from civic and professional groups to building in the park, the site that would become Foley Square emerged as a place to build a civic center that reformers hoped could embody their collectivist ideals.

60 Centre Street: The New York County Courthouse

Manhattan Borough President George McAneny led the effort to secure this site and to build a civic center for New York, which lacked an overall plan like the ones in Cleveland or San Francisco. McAneny acted as the planner of the project, envisioning a civic precinct and then organizing the municipal acquisition of the area that would become the

FIGURE 5.7. The approved New York County Courthouse, as published in Moses King, *King's Views of New York* (1915), 47.
Picture Collection, The New York Public Library, Astor, Lenox, and Tilden Foundations.

civic center by accretion. McAneny was a Progressive who promoted a wider role for municipal government in areas such as civil service reform, zoning regulation, and historic preservation;[65] he championed a civic center to physically embody robust state power. In 1911 and 1912, McAneny worked as president of the Board of Estimate (BOE) to establish the site, as support slowly coalesced around the compromise location.[66] In January 1912, the BOE approved the site plan for a new courthouse on Centre Street, with sidewalks and trolleys running underneath,[67] and McAneny and the courthouse commission immediately began planning the project.[68] The Courthouse Commission took responsibility for the building, initiating an architectural competition in May 1912, as the BOE began acquiring land and preparing the ground. The BOE's authority extended only to the site for the courthouse, but McAneny subtly reserved space for other buildings he anticipated to rise in a future civic center.[69] By reorganizing the street pattern and including in the plan many plots to be acquired later, McAneny's BOE plan preserved the possibility for comprehensive civic development in the area.[70]

In April 1913, the Courthouse Commission announced Lowell the winner of the competition, with a striking, circular design that the *New York Times* likened to the Roman Colosseum (Figures 5.7–5.8).[71] Lowell proposed a massive building, five hundred feet wide and two hundred feet tall, with four Corinthian porticoes and eighty Doric pillars encircling the façade.[72] The plan featured concentric rings of courtrooms, administrative offices, and public and private spaces, sited atop the intersection of Centre and Worth Streets.

FIGURE 5.8. Image of unbuilt civic center, as published in *The San Francisco Call*, June 15, 1913.

Lowell's building, together with the site assembled by McAneny, promised to produce an impressive civic center.

Lowell emphasized the Roman qualities of the building, claiming that many antique buildings took this form, for which he claimed efficiency.[73] Round walls, he believed, allowed more internal space at lower cost than rectilinear forms, and they promised better circulatory organization. He also emphasized the traditional, Roman character of his design for a twentieth-century civic building. Referring to the recently closed Armory Show of 1913, which had shocked the American public with works by Van Gogh, Gauguin, Cezanne, Picasso, and Matisse, Lowell told the *New York Times* that he "thought of placing over my porticoes the inscription: "A bas les Cubistes!" (Down with the Cubists!).[74] Here he humorously highlights the roundness of his own building, while repudiating the modernity of the avant-garde European forms causing a sensation uptown.

Lowell never addressed the symbolic meaning of using the Roman amphitheater type to represent legal authority, though this may strike the observer today as an odd choice. The *New York Times* editorialized that he sought a distinct identity, or character, for a building that was not a train station, library, or post office.[75] The *New York Times* further anticipated comparison with the Royal Albert Hall in London, noting that "it is novel and we must get used to it."[76] In the context of New York public buildings, Lowell's Roman references announced a change from the Georgian, Palladian, Second Empire, and Northern Renaissance styles used by previous generations to represent civic identity at the City Hall, Tweed Courthouse, Mullett Post Office, and Hall of Records, respectively. Lowell's design extended the municipal commitment to American Renaissance classicism evident in McKim, Mead & White's earlier Municipal Building, harmonizing stylistically with the Court of Honor model from Chicago.

As a horizontal block, however, Lowell's proposal more fully expressed classical civicism than did McKim, Mead & White's appropriation of a business-tower typology. In the early-twentieth-century American city, horizontality signified the collective identity of civic culture.[77] Buildings that were low and wide were wasteful from an economic perspective, and few businesses or property owners could build them. Only the state could afford to devote large urban areas to open space; to build low, horizontal buildings; and to control the large land holdings necessary for coordinated projects. Whereas McKim, Mead & White proposed a commercial image for government in their building, Lowell's form recalls City Beautiful critiques of individualism, offering a collective image of state control against the vertical disarray created by laissez-faire development on individual lots. As in Cleveland and San Francisco, the civic center initiated by Lowell and McAneny relied on the spatial extension of the agora or forum, rather than vertical dominance, to promote civic presence. Lowell disguised the height of his building, however, which required the equivalent of thirteen stories to fulfill its program on this small site. The central domed courtroom is not revealed on the façade, the horizontal orientation of which clearly differs from the loftiness of commercial skyscrapers.

Lowell's design refers to Roman antiquity in its form, style, structure, and site, all of which suggest comparison with Roman precedents. The circular form clearly recalls Roman amphitheaters, most notably the Colosseum in Rome, as noted at the time. The

design is not an archaeological reconstruction of a Roman building, however; like many American Renaissance designers, Lowell eclectically mixes classical elements both to recall antiquity and to present an original, American form. The four projecting Corinthian porticoes preserve the multidirectional orientation of the Roman building type, but Lowell's building appears primarily as an enclosed volume rather than as an open arcade. This deviation from the typical Roman form, and especially from the precedent of the Colosseum, suggests how Lowell incorporated a modern program into a classical building form. Like the Federal Hall Memorial discussed by Francis Morrone in Chapter 1 of this volume, the typical openness of the classical building is enclosed in New York to provide interior floor area for modern uses. Just as Town & Davis enclosed the side colonnades at the Federal Hall to accommodate offices and storerooms, so too does Lowell encircle his building with interior rooms rather than open porticoes. Lowell's 1913 proposal also deviated from the expected hierarchy of orders associated with the Roman Colosseum. By encircling the top of his building with a Doric colonnade above the Corinthian porches, Lowell subverted well-established design practice, eclectically mixing classical elements in a way that reflects the freedom of American Renaissance practice.

The project design and location went through many changes during the years after 1913, due to site conditions, budget constraints, changes of political administration, and the entry of the United States into World War I. Lowell retained many classical references throughout this process, especially the projecting Corinthian portico with its sculpted pediment and acroteria figures in the final, built courthouse at 60 Centre Street. The body of the hexagonal building preserves the balance between classical reference and interior program, tracing a surrounding colonnade with flat, Corinthian pilasters, which adorn walls that enclose interior courtrooms, office, and administrative spaces. The interior spaces further fulfill the classical image of the courthouse, especially the vaulted entry vestibule and the central rotunda (Figures 5.9–5.10). The New Deal mural cycles by Attilio Pusterla extend the synthesis of arts that inspired the American Renaissance, aggrandizing the practice of law within an atmosphere of classical legitimacy.

Examining the structure of the building erected at 60 Centre Street also yields interesting comparisons with classical precedents. The County Courthouse was built with a steel frame, as were the other American Renaissance monuments of New York, such as Pennsylvania Station, Grand Central Terminal, the New York Public Library, the United States Customs House, and the Municipal Building, as well as the other buildings in the civic center. Like these buildings, the exterior of 60 Centre Street is clad with carved stone to present the image of ancient masonry construction (Figure 5.11). Architects concerned with the rational logic of structure and materials famously criticized these buildings for their inconsistent handling of interior structure and exterior decoration.[78] Contemporaries like Louis Sullivan and Frank Lloyd Wright, as well as the next generation of Modernist architects, sought to integrate façades with underlying structures and to express building systems and material properties. The historicizing façades designed by Lowell and other American Renaissance architects in the face of rationalist criticism reveal how important it was for them to refer to a classical history for American civic and public buildings.[79] Today many accept historic reference as a function of architecture, in the general shift

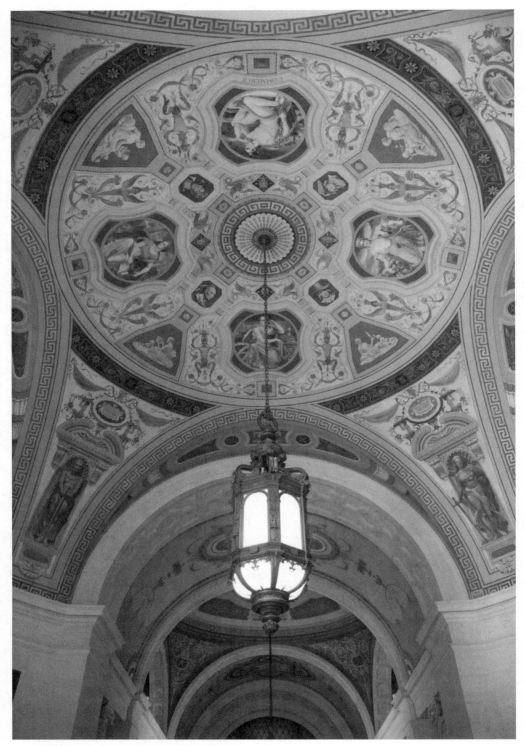

FIGURE 5.9. 60 Centre Street, vaulted vestibule.

Reproduced with the permission of The Historical Society of the New York Courts and its website: www
.nycourts.gov/history.

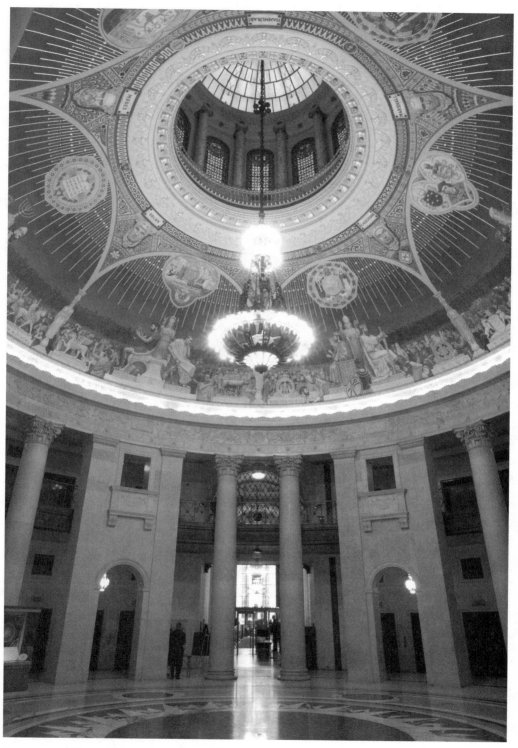

FIGURE 5.10. Centre Street, domed rotunda.

Reproduced with permission of The Historical Society of New York and its website: www.nycourts.gov/history.

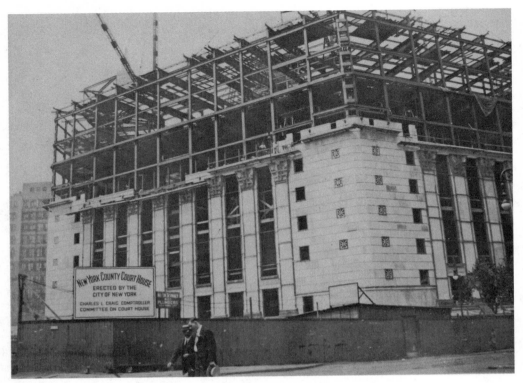

FIGURE 5.11. Construction view of New York County Courthouse, ca. 1926.
Irma and Paul Milstein Division of United States History, Local History and Genealogy, The New York Public Library.

toward postmodern tolerance for multiplicity and diversity,[80] and the Modernist, rationalist approach is understood to be only one of many ways to build and interpret architecture within contemporary culture.

Architectural inconsistencies between structure, materials, and façade also recall issues in classical architecture. Just as Lowell and other American Renaissance architects decorated one structural system (the steel frame) with others (arcuation and trabeation), so too did Romans appropriate Greek trabeation to decorate arcuation with symbols. Roman architecture is generally distinct from Greek building in its use of concrete, as well as the arch, vault, and dome, to enclose larger interior spaces than was possible with the classical Greek post-and-lintel system.[81] Roman buildings therefore relied on arched vaulting systems for structural support rather than on trabeated systems. Roman temples and public buildings tend to be decorated with Greek architectural elements, however, so the columns, architraves, entablatures, and cornices of buildings like the Roman Colosseum, the Pantheon, and myriad others can be seen as decorative rather than structural.[82] All these elements are attached to the building surface in ways that recall the American Renaissance cladding of steel-frame structures with historicizing stone.

Finally, the site of the New York Civic Center suggests comparison with the location of antique public spaces such as the Athenian Agora or the Roman Forum. The area selected in 1911 for the New York County Courthouse and the future civic center was the irregular intersection of Centre Street, Pearl Street, Worth Street, and Park Street, northeast of City Hall Park (see Figure 5.2). This had been the site of the Collect Pond up to the nineteenth century, which became the working-class and immigrant neighborhood known as Five Points after the city filled in the polluted pond by the early nineteenth century.[83] This low-lying, marshy area therefore occupied an interstitial zone between historic City Hall Park to the south, the commercial corridor of Broadway to the west, and the tenement district to the east. Unlike the centrally located fora typical of Roman colonial towns, the original Roman Forum also grew up in a low-lying, marginal, and marshy site between the Palatine and Capitoline Hills.[84] As successive generations expanded and improved the Forum around the site of the original Comitium, they imposed geometric order upon this irregular space, just as City Beautiful reformers sought to do at what became Foley Square in the 1920s.

Change and Growth of the Civic Center

Almost immediately after the announcement of Lowell's plan, the Court House Commission and the city began to consider changes to the building and the site. McAneny anticipated a shift in location to accommodate plans for a larger civic center, while judges and engineers considered changes to the building itself.[85] In 1914, the Courthouse Commission and the city agreed to design changes and to shift the site to the west (compare Figures 5.3 and 5.8).[86] The new site promised several advantages over the original location.[87] Building on existing blocks rather than over Centre Street limited disruption to traffic and subway lines, although the new design sacrificed the monumentality of the original conception. Foundations on the new site would be more stable, avoiding both the marshy soil of the former Collect Pond and the underground infrastructure of the subway loop. When work resumed on the project after the First World War in 1919, the effects of time and new political administrations again changed the plan. The fiscally conservative Tammany mayor John F. Hylan, elected in 1917, had abolished both the City Plan Commission of the Board of Equalization and the Courthouse Commission.[88] Acting with newly consolidated authority, Hylan demanded changes in the site and plan to reduce costs.[89] Although resisting renewed attempts to build on City Hall Park,[90] Hylan's Board of Equalization settled on a plan to build on a single city-owned block and to sell off much of the land that had been acquired for the original plan, spanning as it did several blocks.[91] Lowell's revised plan offered a hexagonal solution, preserving the classicism and horizontal unity of the original. The city did sell much of its newly acquired land, but most of the buyers were other government agencies, whose projects completed the civic center as McAneny intended, and it officially opened in 1934 with the completion of the Department of Health Building and the New York State Building.[92]

Conclusion

The New York projects studied here helped establish the civic center as an enduring element of urban planning.[93] But, like other civic centers initiated during these years, Foley Square fails to achieve the complete urban design of the Court of Honor or Roman Forum model. And it never fulfilled the Progressive-era and City Beautiful ambitions to define civic life around a robust public space.

Unlike the Athenian Agora or Roman Forum, American civic centers do not occupy the physical and social center of our cities. In New York, as elsewhere, this is largely because of the compromised location settled through the process of negotiation over site. A civic center around City Hall Park, adjacent to the commercial artery of Broadway, would be a visible and active part of the daily life of New Yorkers.[94] In its current location, however, the New York Civic Center remains marginal despite the political events that occur there from time to time. One goes to Foley Square only on official business, and so the civic center is not civic. It does not facilitate the rich public realm promised by City Beautiful rhetoric about citizenship and democracy.

The reasons for this failure have to do with spatial negotiation and functional segregation. The compromises over location in Cleveland, San Francisco, and New York pitted Progressive reformers, property owners, and fiscal pragmatists against one another. The siting of the civic center at Foley Square removed it from the commercial corridor on Broadway. This not only limited the visibility of government buildings in public life, but it also preserved the area around City Hall Park for commercial rather than civic development. The resulting landscape of shops and stores on Broadway promoted the centrality of business in the city rather than installing a civic hierarchy, just as it had done in Cleveland and San Francisco.

Further, the civic center as built lacks commercial activity, which also isolates the civic precinct. This is due to both the competition for commercial real estate that dictated the site and to the legacy of land-use zoning as it was defined in the 1916 New York zoning law. Unlike its classical precedents, the New York Civic Center is an exclusively governmental and administrative precinct. In planning terms, the civic center is a single-use district, and as such, it does not attract the diverse functions that animate public spaces by encouraging both planned and chance encounters. Such robust public life was the heart of ancient urbanism, at least in the idealized conception of City Beautiful reformers, but it does not coalesce in Foley Square or in other civic centers of the period.

It is therefore the planning of site and function, not the neoclassical architectural idiom, that limits the public life of the civic center. American Renaissance architecture characterizes many of New York's most well-known public places, from institutions like the Metropolitan Museum, the New York Public Library, and the Washington Memorial Arch, to commercial places like Grand Central Terminal, the former Siegel-Cooper Store on Ladies' Mile, the Lunt-Fontaine Theater, or the Ansonia apartments. These largely succeed in ennobling the public realm with what the MAS considered to be "beauty" and dignity," and they endure today to frame our public life in the twenty-first century.[95] The New York Civic Center failed to express civic life not because the classical symbols

were impotent but because it failed to replace the commercial character of the American city with a civic hierarchy.

NOTES

1. "New Court House Like the Coliseum," *New York Times*, April 14, 1913.

2. "State Departments Want Building Here," *New York Times*, December 30, 1912, 10; "A State Building Needed," *New York Times*, April 13, 1915, 10; "Court House Plans Save $14,000,000," *New York Times*, December 14, 1919.

3. Jon A. Peterson, *The Birth of City Planning in the United States, 1840–1917* (Baltimore, MD: Johns Hopkins University Press, 2003), 118–22, 40–41; William H. Wilson, *The City Beautiful Movement* (Baltimore, MD: Johns Hopkins University Press, 1989), 45–47; Joan E. Draper, "The San Francisco Civic Center: Architecture, Planning, and Politics," PhD diss., University of California, Berkeley, 1979, 6.

4. Wilson, *The City Beautiful Movement*, 53–74; Peterson, *The Birth of City Planning*, 61–73; Spiro Kostof and Greg Castillo, *A History of Architecture: Settings and Rituals* (New York: Oxford University Press, 1995), 670; Thomas S. Hines, *Burnham of Chicago, Architect and Planner* (New York: Oxford University Press, 1974), 119–24.

5. See Malamud's chapter in this volume.

6. Charles Zueblin, "The Civic Renascence: 'The White City' and After," *Chautauquan* 38 (1903): 373–84. See also Malamud's chapter in this volume.

7. Thomas Hines, *Burnham of Chicago*, 139–57; Peterson, *The Birth of City Planning*, 77–97.

8. Bates Lowry, *Building a National Image: Architectural Drawings for the American Democracy, 1789–1912* (Washington, DC: National Building Museum: New York, 1985), 74–88.

9. Brooklyn Museum, *The American Renaissance, 1876–1917* (Brooklyn: Brooklyn Museum, 1979), 12; Kostof and Castillo, *A History of Architecture*, 669–73; Leland Roth, *A Concise History of American Architecture* (Boulder, CO: Westview, 1979), 191–96.

10. Robert A. M. Stern, Gregory Gilmartin, and John Massengale, *New York 1900* (New York: Rizzoli, 1983), 22–23.

11. M. Christine Boyer, *Dreaming the Rational City: The Myth of American City Planning* (Cambridge, MA: MIT Press, 1983), 5, 55–56; Spiro Kostof, *The City Assembled: The Elements of Urban Form through History* (Boston: Little, Brown, 1992), 671–73; Brooklyn Museum, *The American Renaissance*, 15.

12. On Knox-Taylor, see Lowry, *Building a National Image*, 77–78; "Government Buildings to Be of Classic Design," *Ohio Architect and Builder* 3, no. 1 (1904); Antoinette Lee, *Architects to the Nation: The Rise and Decline of the Supervising Architect's Office* (New York: Oxford University Press, 2000), 189–236.

13. James Knox-Taylor, "Why Public Buildings Should Be Dignified," *Architect and Engineer of California and Pacific Coast States* 29, no. 2 (1912): 100. On the exclusive use of the classical idiom for public buildings during this period, see Lowry, *Building a National Image*, 78–80; "Government Buildings to Be of Classic Design."

14. Municipal Art Society of New York, "Bulletin 15, Report of the Committee on Civic Centers," (New York: The Society, 1904), 8.

15. M. Christine Boyer, *Manhattan Manners: Architecture and Style, 1850–1900* (New York: Rizzoli, 1985), 223; Lewis Mumford, *The Culture of Cities* (New York: Harcourt, Brace and Co., 1938), 82. On the City Beautiful, see also Simard's chapter in this volume.

16. On the Grand Manner, Baroque, or Monumental planning mode, see Spiro Kostof, *The City Shaped: Urban Patterns and Meanings through History* (Boston: Little, Brown, 1991), 209–78.

17. Henry James, *The American Scene* (London: Chapman and Hall, 1907), 100.

18. James, *American Scene*, 101.

19. James, *American Scene*, 110.

20. John Brisben Walker, "The City of the Future: A Prophecy," *The Cosmopolitan* 31 (1901): 474. *The Cosmopolitan* was at this time a literary magazine.

21. Walker, "The City of the Future: A Prophecy," 474.

22. Charles R. Lamb, "Civic Architecture from Its Constructive Side," *Municipal Affairs* 2 (1898): 48. Lamb and Walker's shared prejudice toward the medieval is worth noting here. The City Beautiful championed Classical, Renaissance, and Baroque forms and plans to express their collective ideal.

23. Paul Boyer, *Urban Masses and Moral Order in America, 1820–1920* (Cambridge, MA: Harvard University Press, 1978), 256, 64–65; Boyer, *Manhattan Manners*, 7; Boyer, *Dreaming the Rational City*, 56; Kostof and Castillo, *A History of Architecture*, 671–73; William H. Wilson, "J. Horace Mcfarland and the City Beautiful Movement," *Journal of Urban History* 7, no. 3 (1981): 316. For good discussions of the moral program of the City Beautiful, see William H. Wilson, "The Ideology, Aesthetics, and Politics of the City Beautiful Movement," in *The Rise of Modern Urban Planning, 1800–1914*, ed. Anthony Sutcliffe (London: Mansell, 1980); Brooklyn Museum, *The American Renaissance*, 28–30; Wilson, *The City Beautiful Movement*, 80–81.

24. David Moisseiff Scobey, "Empire City: Politics, Culture, and Urbanism in Gilded-Age New York," PhD diss., Yale University, 1989, 414–15, 37. See also Boyer, *Urban Masses and Moral Order in America*, 265.

25. Brooklyn Museum, *The American Renaissance*, 21.

26. Municipal Art Society of New York, *Yearbook* (New York: The Society, 1910), 10.

27. Scobey, "Empire City," 414–15, places this City Beautiful strategy within the context of the antebellum depression and militant strikes of the 1880s.

28. Gilbert D. Lamb, "The New Courthouse Site, Last Plea Is Made for the Chambers Street 'Civic Centre,'" *New York Tribune*, August 13, 1913, 6.

29. Galen Cranz, *The Politics of Park Design: A History of Urban Parks in America* (Cambridge, MA: MIT Press, 1982), 61–100; Peterson, *The Birth of City Planning*, 235–37.

30. Peterson, *The Birth of City Planning*, 157; Mel Scott, *American City Planning since 1890* (Berkeley: University of California Press, 1969), 40–43; David Bruce Brownlee, *Building the City Beautiful: The Benjamin Franklin Parkway and the Philadelphia Museum of Art* (Philadelphia: The Museum, 1989), 11.

31. Arnold W. Brunner, "The Civic Center," *National Municipal Review* (1923): 18.

32. Peterson, *The Birth of City Planning*, 157.

33. Thomas S. Hines, "The City Beautiful in American Urban Planning, 1890–1920," *Transactions*, no. 7 (1985): 31; Charles Mulford Robinson, *The Improvement of Towns and Cities* (New York: G. P. Putnam's Sons, 1901), 234.

34. Thomas Adams, *Outline of Town and City Planning, a Review of Past Efforts and Modern Aims* (New York: Russell Sage Foundation, 1935), 238–40; Draper, *The San Francisco Civic Center*, 354–98.

35. John DeWitt Warner, "Civic Centers," *Municipal Affairs* 6 (1902): 4.

36. Warner, "Civic Centers," 1–23. See also Milo Roy Maltbie, "The Grouping of Public Buildings," *Outlook* 78 (1904): 37–48. On Warner as a leader of the City Beautiful and the Municipal Art Society of New York, see Gregory F. Gilmartin, *Shaping the City: New York and the Municipal Art Society* (New York: Clarkson Potter, 1995), 37–38. On *Municipal Affairs* as a major reform journal, see Peterson, *The Birth of City Planning*, 376n15.

37. Warner, "Civic Centers," 4.

38. Warner, "Civic Centers," 7–8.

39. Peterson, *The Birth of City Planning*, 157. See also George Wagner, "Freedom and Glue: Architecture, Seriality, and Identity in the American City," *Harvard Architecture Review* 8 (1992): 78;

Michelle H. Bogart, *Public Sculpture and the Civic Ideal in New York City, 1890–1930* (Washington, DC: Smithsonian Institution Press, 1997), 264.

40. J. H. Wright, "Review of Naukratis, Part I," *American Journal of Archaeology and of the History of Fine Arts* 3, no. 1/2 (1887): 105. Petrie used the term "civil centre" rather than "civic centre" in referring to this sanctuary. See W. M. Flinders Petrie, *Naukratis: Part 1, 1884–85* (London: Trübner & Co., 1886). Warner's American publication changed the term to "civic center."

41. A. L. Frothingham Jr., "Archaeological News," *American Journal of Archaeology and of the History of the Fine Arts* 11, no. 3 (1896): 454, 55, 58. See also the report excavations at the "civic centre" of Praesos in eastern Crete by the British archaeologist R. C. Bosanquet, in J. L. Myres, "Crete: Prehistoric, Abstract of the Report of the Committee of the British Association on Explorations in Crete," *MAN: A Monthly Record of Anthropological Science* 1 (1901): 184.

42. Evans was referring to the place known today as Milatos. Arthur J. Evans, "Further Discoveries of Cretan and Aegean Script: With Libyan and Proto-Egyptian Comparisons," *Journal of Hellenic Studies* 17 (1897): 333; *The Palace of Minos: A Comparative Account of the Successive Stages of the Early Cretan Civilization as Illustrated by the Discoveries at Knossos*, 4 vols. (New York: Biblo and Tannen, 1921–35), 2.1:84, 229, 53.

43. See, for example, Kostof, *The City Shaped*, 60, 142.

44. Draper, *The San Francisco Civic Center*, 354–98.

45. Walter C. Leedy, "Cleveland's Struggle for Self-Identity: Aesthetics, Economics, and Politics," in *Modern Architecture in America: Visions and Revisions*, ed. Richard Guy Wilson and Sidney K. Robinson (Ames: Iowa State University Press, 1991); Holly Rarick Witchey, Andrew T. Chakalis, and Cleveland Museum of Art, *Progressive Vision: The Planning of Downtown Cleveland, 1903–1930* (Cleveland, OH: Cleveland Museum of Art, 1986); Daniel H. Burnham, John M. Carrére, and Arnold W. Brunner, *The Group Plan of the Public Buildings of the City of Cleveland. Report Made to the Honorable Tom L. Johnson, Mayor, and to the Honorable Board of Public Service by Daniel H. Burnham, John M. Carrére, Arnold W. Brunner, Board of Supervision*, 2nd ed. (Cleveland: The Britton Printing Co., 1907 [1903]).

46. Burnham, Carrére, and Brunner, *The Group Plan of the Public Buildings of the City of Cleveland*, n.p.

47. Leedy, "Cleveland's Struggle for Self-Identity," 104.

48. Charles E. Bolton, *A Few Civic Problems of Greater Cleveland* (Cleveland, 1897), 26–28; Leedy, "Cleveland's Struggle for Self-Identity," 79–80; Witchey, Chakalis, and Cleveland Museum of Art, *Progressive Vision*, 15.

49. Leedy, "Cleveland's Struggle for Self-Identity," 89–90.

50. Daniel Hudson Burnham and Edward H. Bennett, *Report on a Plan for San Francisco* (Berkeley, CA: Urban Books, 1905, 1971), 88.

51. B. J. S. Cahill, "The Bond Issue and the Burnham Plan—a Study in 'Panhandling,'" *Architect and Engineer of California and Pacific Coast States* 17, no. 2 (1909); Burnham and Bennett, *Report on a Plan for San Francisco*, 39–42, 88; Draper, *The San Francisco Civic Center*, 90–97; Mel Scott, *The San Francisco Bay Area: A Metropolis in Perspective* (Berkeley: University of California Press, 1959), 102–4, 21.

52. Scott, *The San Francisco Bay Area*, 121–22; Willis Polk, "Letter to Daniel Burnham, Apr 15, 1909, Enclosing Clipping from San Francisco Chronicle, Apr 15, 1909," Daniel H. Burnham Collection, Ryerson and Burnham Archives, Art Institute of Chicago, box 3, folder 58; Draper, *The San Francisco Civic Center*, 117, 43; Herbert Croly, "The Promised City of San Francisco," *Architectural Record* (1906): 81.

53. The École des Beaux-Arts–trained partners based their design on the horizontality of French Renaissance models, notably Ange-Jacques Gabriel's Place de la Concorde. See Draper, *The San Francisco Civic Center*, 208–14.

54. David C. Hammack, *Power and Society: Greater New York at the Turn of the Century* (New York: Russell Sage Foundation, 1982), 188, 95, 209, 15–18; Municipal Art Society of New York, "Bulletin 15, Report of the Committee on Civic Centers."

55. Stern, Gilmartin, and Massengale, *New York 1900*, 81.

56. Gilmartin, *Shaping the City*, 69.

57. Gilmartin, *Shaping the City*, 75–81.

58. Municipal Art Society of New York, *To the Honorable the Board of Estimate and Apportionment of the City of New York. Letter, Dated New York, April 27, 1903, Relative to the Proposed Changes in and About the City Hall* (New York: The Society, 1903).

59. "Memorial of the Society Relative to Proposed Changes in and About City Hall Square" (New York: The Society, 1902), 3–5; "Civic Centers," *New York Times*, March 16, 1905, 8. See also "Grouped Public Buildings," *New York Sun*, November 23, 1911.

60. By 1910, the American Institute of Architects, the Architectural League, the Bar Association, the City Club of New York, the Scenic and Historic Preservation Society, the Merchants Association, and the Realtor's Association had all endorsed the idea of restoring the park to its 1812 plan. *Memorial of the Municipal Art Society Relative to Proposed Changes in and About City Hall Square, New York City. Sept. 1, 1902* (New York: The Society, 1902); "City Park Defenders Talk to Kellogg," *New York Times*, April 6, 1910, 20; "Civic Bodies Try to Save City Hall Park," *New York Times*, May 6, 1911, 10–11; "Civic Centre Plan May Be Restricted," *New York Times*, May 6, 1912, 13; "City Hall Park's Defenders Aroused," *New York Times*, June 17, 1911, 3. The *New York Times* also editorialized in favor of restoring the park: "Preserve City Hall Park," *New York Times*, May 4, 1911, 10; "Save City Hall Park Now," *New York Times*, June 30, 1911, 8.

61. Gilmartin, *Shaping the City*, 20, 69, 75.

62. Gilmartin, *Shaping the City*, 69.

63. The post office remained in City Hall Park until 1935, however, by which time it was used exclusively as federal offices. During the intervening years, the city and officials in Washington often disagreed about how and where to move federal offices and the post office. In 1912 the federal government moved the main postal offices out of the city hall area, to the James A. Farley Post Office on Thirty-Fourth Street, an American Renaissance building designed in conjunction with McKim, Mead & White's Pennsylvania Station. "New Law Courts and the Redemption of a Park," *New York Times*, January 14, 1912, 14; "The Post Office Site," *New York Times*, May 4, 1912, 12.

64. "Civic Bodies Try to Save City Hall Park," *New York Times*, May 6, 1911, 10.

65. Kenneth Finegold, *Experts and Politicians: Reform Challenges to Machine Politics in New York, Cleveland, and Chicago* (Princeton, NJ: Princeton University Press, 1995), 51; "How the City Can Save Millions, Told by Mcaneny," *New York Times*, June 15, 1913, SM8; "Fusionists Grim over the Ticket," *New York Times*, August 2, 1913, 1; "Medal for Mcaneny," *New York Times*, May 28, 1913, 11; Randall Mason, *Once and Future New York: Historic Preservation and the Modern City* (Minneapolis: University of Minnesota Press, 2009), 63–120.

66. Gilmartin, *Shaping the City*, 181–202, 71; Kenneth T. Jackson, *The Encyclopedia of New York City*, 2nd ed. (New Haven, CT: Yale University Press, 2010), 703.

67. "The New Law Courts," *New York Times*, January 19, 1912, 10; "New Court House in Park of Its Own," *New York Times*, January 12, 1912, 22.

68. "The New Law Courts," 10.

69. "The Court House Site," *New York Times*, June 7, 1912, 12.

70. "Straighten Baxter Street," *New York Times*, January 26, 1912, 4. On the land-condemnation process, see "Building Boom Aimed at Civic Centre Plan," *New York Times*, February 17, 1912, 7, on the Compensation Committee; "Court House Site Costs $6,138,653," *New York Times*, May 10, 1913, 10, on the committee report; "To Take Court House Site," *New York Times*, July 18, 1913, 8, on the city's acquisition of title.

71. "The Court House Design," *New York Times*, April 14, 1913, 8; "New Court House Like the Coliseum," 2.

72. "The Court House Design," 8.

73. "The Court House Design," 8.

74. "New Court House Like the Coliseum," 8.

75. "The Court House Design."

76. "The Court House Design," 2.

77. William R. Taylor, *In Pursuit of Gotham: Culture and Commerce in New York* (New York: Oxford University Press, 1992), 51–53.

78. Wagner, "Freedom and Glue," 82, 85, 88, 90; Hines, "The City Beautiful in American Urban Planning," 30. Sullivan, quoted in Charles N. Glaab and A. Theodore Brown, *A History of Urban America*, 2nd ed. (New York: Macmillan, 1976), 240.

79. Elizabeth Macaulay-Lewis, "Triumphal Washington, New York City's First 'Roman Arch,'" in *War as Spectacle: Ancient and Modern Perspectives on the Display of Armed Conflict*, ed. Anastasia Bakogianni and Valerie M. Hope (London: Bloomsbury Academic, 2015), 209.

80. Robert Venturi, *Complexity and Contradiction in Architecture* (New York: Museum of Modern Art, 1977), 18–19, 44–52.

81. Pier Luigi Tucci, "The Materials and Techniques of Greek and Roman Architecture," in *The Oxford Handbook of Greek and Roman Art and Architecture*, ed. Clemente Marconi (New York: Oxford University Press, 2015), 242–65.

82. Tucci, "The Materials and Techniques of Greek and Roman Architecture."

83. Michele Herman, "Five Points," in *The Encyclopedia of New York City*, ed. Kenneth T. Jackson (New Haven, CT: Yale University Press, 2010), 456; Carol Groneman, "Collect," in *The Encyclopedia of New York City*, ed. Kenneth T. Jackson (New Haven, CT: Yale University Press, 2010), 277; Norval White and Elliot Willensky, *AIA Guide to New York City*, 4th ed. (New York: Three Rivers, 2000), 72.

84. David Watkin, *The Roman Forum* (Cambridge, MA: Harvard University Press, 2009), 16–18; Kostof, *The City Shaped*, 61.

85. "Court House Board Will See Justices," *New York Times*, June 25, 1913, 4; "The Court House Deadlock," *New York Times*, October 3, 1913, 10.

86. "Now Build the Court House," *New York Times*, March 29, 1914, C4.

87. "Test Borings Urged for Court House," *New York Times*, May 3, 1914, SM4.

88. Finegold, *Experts and Politicians*, 65; "Drop Court House Plan," *New York Times*, July 25, 1919, 11.

89. "Drop Court House Plan," 11.

90. "Court House Plans Save $14,000,000," S5.

91. "Court House Plans Save $14,000,000," S5.

92. Lewis Mumford, *Sidewalk Critic: Lewis Mumford's Writings on New York*, ed. Robert Wojtowicz (New York: Princeton Architectural Press, 1998), 120.

93. Adams, *Outline of Town and City Planning*, 238–40.

94. Lamb, "The New Courthouse Site, Last Plea Is Made for the Chambers Street 'Civic Centre.'"

95. On the Washington Memorial Arch, for example, see Macaulay-Lewis, "Triumphal Washington, New York City's First 'Roman Arch.'"

The Titans of Rockefeller Center: *Prometheus* and *Atlas*

Jared A. Simard

Rockefeller Center was constructed during the 1930s in the midst of the Great Depression. Its construction employed tens of thousands. Composed of sixteen individual buildings, the Center is a massive complex on twenty-one acres (Figure 6.1). Its organization emphasizes the central tower located at 30 Rockefeller Plaza. It also features a substantial art program that consists of large freestanding sculptures, architectural sculpture, and murals. The art program is organized around the theme of "New Frontiers and the March of Civilization." Most histories of Rockefeller Center, however, do not notice the many ways that the reception of the Greco-Roman past are manifest in its design and art. The orientation and placement of the buildings together with the art program call to mind the City Beautiful movement, which peaked in popularity during the first decade of the twentieth century.[1] The movement stressed the importance of comprehensive town plans that featured groupings of civic buildings usually erected in a neoclassical style. Beauty, symmetry, and vistas were all key design features of City Beautiful plans. Rockefeller Center is unique for translating the concepts of the City Beautiful movement to the skyscraper idiom. This is accomplished in particular through the use and placement of mythologically inspired art. The sculptures of Prometheus and Atlas are the most important artworks of Rockefeller Center, and their prominent locations are meant to call attention to the design of the entire complex. Their iconography and reception histories cast their respective myths in a new light, one that heightens the monumentalization of the space.

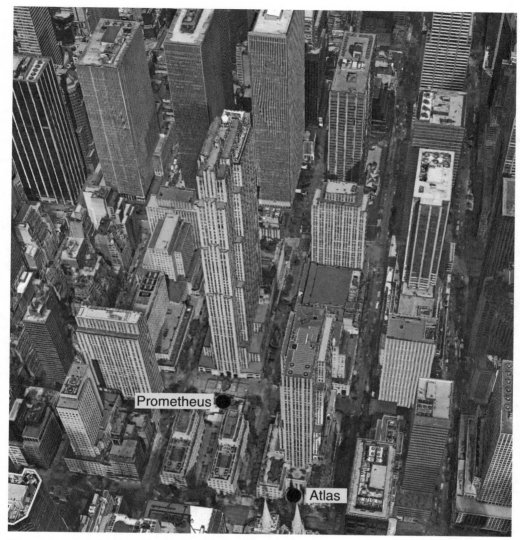

Figure 6.1. Aerial view of Rockefeller Center, 2017.
J. Simard after Google Earth.

Rockefeller Center: Facts and Origins

Rockefeller Center is named for the Rockefeller family and its most ambitiously philanthropic son, John D. Rockefeller Jr. (1874–1960), who leased the land from Columbia University in 1928 and was the main force behind the development of the sprawling complex in its first decade. Its eleven original structures established a dramatically large footprint in the center of Manhattan, encompassing some twelve acres from Forty-Eighth Street to Fifty-First Street, between Fifth Avenue and Sixth Avenue. The "city within a city,"[2] as the Center has often been called, featured space for offices, entertainment, retail, and restaurants in one integrated development.[3] In terms of style, the Center is often categorized

with Art Deco skyscrapers,[4] but it has many features more reminiscent of the New York style or International style that became popular after World War II.[5] Nonetheless, much of the exterior artwork exhibits the familiar marks of the Art Deco style, and Radio City Music Hall, the Center's iconic entertainment venue, remains one of the finest examples of Art Deco interior decoration in New York City.[6]

Rockefeller Center is unique thanks to the actual parcel of land on which it was built. Such a three-block area would be prohibitively expensive to acquire in today's real estate market.[7] The plot was particularly appealing to Rockefeller because he owned large sections of Fifty-Third and Fifty-Fourth Streets. Originally, Rockefeller worked with the Metropolitan Opera Company to develop the property for a new opera house.[8] After the opera company withdrew from the agreement, Rockefeller developed the property as a business venture.[9]

The City Beautiful Movement

The City Beautiful movement was an important factor in the development of Rockefeller Center. This movement had its origins in the nineteenth century as part of developments in urban planning that sought to transform American cities by emulating their European counterparts.[10] Village improvement efforts in the nineteenth century also contributed ideologically, with their emphasis on the beautification of streets, presentable shop fronts, promenades, and open grounds.[11] In the last decade of the nineteenth century, municipal art societies were founded to promote the building of public squares and the artistic adornment of cities, all of which, these societies argued, "paid" for themselves by attracting tourists.[12] Finally, the 1893 Columbian Exposition (also known as the Chicago World's Fair and the White City) influenced the City Beautiful movement with its emphasis on comprehensive city plans that added grandeur through neoclassical architecture and art.[13]

Ultimately, the City Beautiful movement promoted a new way of thinking about modern, industrializing cities. Neoclassical architecture was a favored choice among City Beautiful planners, many of whom had attended the École des Beaux-Arts in Paris.[14] The school emphasized design principles such as proportion, harmony, symmetry, and scale.[15] City Beautiful planners thought these elements contributed to the beauty of cities.[16] In their plans, architects grouped civic buildings together, thereby adding to their efficiency and utility.[17] Neoclassical architecture and art also connected the United States to the Old World's ancient heritage and many regal and imperial capitols in a way no other style could. It spoke to an urban elite that desired a connection to an imperial status.[18] Thus, John DeWitt Warner, writing in the March 1902 issue of *Municipal Affairs*, likened the civic centers of the City Beautiful movement to the Athenian Acropolis and the Roman Forum.[19] This is best epitomized by the Columbian Exposition's Court of Honor, which featured a rectangular space, uniform cornice line, neoclassical architecture, grand open spaces for pedestrians, and purposefully placed sculptures such as Daniel Chester French's partially gilded *Statue of the Republic* (see Figures 2.1, 5.4). Many of the elements of the Columbian Exposition and subsequent City Beautiful town plans were later echoed in the design of Rockefeller Center.

Rockefeller Center and the City Beautiful Movement

The original buildings of Rockefeller Center constitute a success of the City Beautiful movement. The Center was built under the direction of John D. Rockefeller Jr., manager John R. Todd, and a team of architects, among whom Raymond Hood was a leading force.[20] These individuals did not consciously apply the principles of the City Beautiful movement, as the movement had already faded in popularity and strength decades earlier. But the principles that the movement had argued for had found a home within the architectural profession. As Kurt Schlichting has argued, there is a forgotten legacy of the City Beautiful movement among private enterprise.[21] The "city within a city" was so named for good reason: It self-consciously understood its place in Midtown and in greater Manhattan. The City Beautiful movement concerned itself with large civic spaces open to the public. Though Rockefeller Center was a private business enterprise, it had a good deal of public space, and its planners had a keen awareness of how people would use that space.

Several principles of the City Beautiful movement appear in the design of Rockefeller Center. First and foremost, Rockefeller Center is comprehensive. The design of the buildings accounts for nearly every possible function of building and space. The placement, orientation, and heights of the buildings create a unified composition around the plaza and its keystone building, 30 Rockefeller Plaza. One of the ways this is achieved is through the grouping of four low-rise buildings along Fifth Avenue that feature identically shaped façades (Figure 6.2). Each of these façades is adorned with architectural sculpture on both the street level and on the spandrels, which are just a few stories high and still visible from the street. These uniform façades are reminiscent of the uniform cornice line that many groupings of City Beautiful civic buildings featured. The uniformity here directly links all four buildings architecturally, which is also fitting because collectively they are known as the International Buildings, the French, British, Italian, and International North Building. Form and function are thus intertwined. The art program also ties these buildings together. The entrance of each building is decorated with representations of the country associated with that building. Rockefeller was very committed to the idea of international peace, and these buildings were a testament to that belief.

Another example of City Beautiful principles in the design of Rockefeller Center is the Channel Gardens. The Channel, also known as the Promenade, is a walkway between the French and British International Buildings (Figure 6.3). The Channel is so named for the body of water separating France and Great Britain. The walkway slopes downward to the sunken plaza and thus gives the Center a centripetal force. Along the center of the walkway are a series of fountains, each decorated with tritons and nereids. Planted flowers and gardens also adorn the space. The beautification of this street-level walkway with fountains, artworks, and gardens is evocative of the City Beautiful movement.

As one walks down the promenade, one is drawn in toward the sunken plaza and the central tower, 30 Rockefeller Plaza, which creates an inspiring vista. The City Beautiful movement cultivated the idea that the comprehensive city plans, for which they advocated, were beautiful and pleasing to the city dweller in part because they created views of architecturally stunning buildings. By the 1930s, much of lower Manhattan, now known

FIGURE 6.2. View of Fifth Avenue, the four low-rise International Buildings, and *Atlas*.
J. Simard.

as the Financial District, was crowded with skyscrapers that created canyons of darkness.[22] The architects for Rockefeller Center created a "five-spot card" design on the three-block property, with the central block afforded the tallest, most architecturally ornate building and the central sunken plaza.[23] The remaining skyscrapers were either placed perpendicular to the central tower or at the corner of the block; in this way, the entire complex allows for ample natural light and air circulation (see Figure 6.1). Furthermore, by locating the tallest building in the center of the complex and the center of the middle block, and by bisecting that block at the end of Fifth Avenue with the Promenade in between the French and British buildings, a remarkable vista of the sunken plaza and skyscraper was created. This was something that had not been done before, especially with skyscrapers, and it represents one of the key ways the City Beautiful movement influenced the design of Rockefeller Center. The symmetry and axial design, along with the four low-rise buildings along Fifth Avenue, imposed an inspiring vista in the heart of the city.[24]

Rockefeller Center's Art Program

Perhaps the main influence the City Beautiful movement had on the design of Rockefeller Center was to allow for the space in which to create a fully integrated art program. If City Beautiful was partly inspired by the idea of rebuilding ancient fora, the use of mythologically inspired sculpture in the spaces of Rockefeller Center further deepens that connection. A focus on *Prometheus* and *Atlas* will illustrate this connection. The project's main proponent and financial backer, John D. Rockefeller Jr., was personally in control of the art program.[25] He initially backed the inclusion of art after

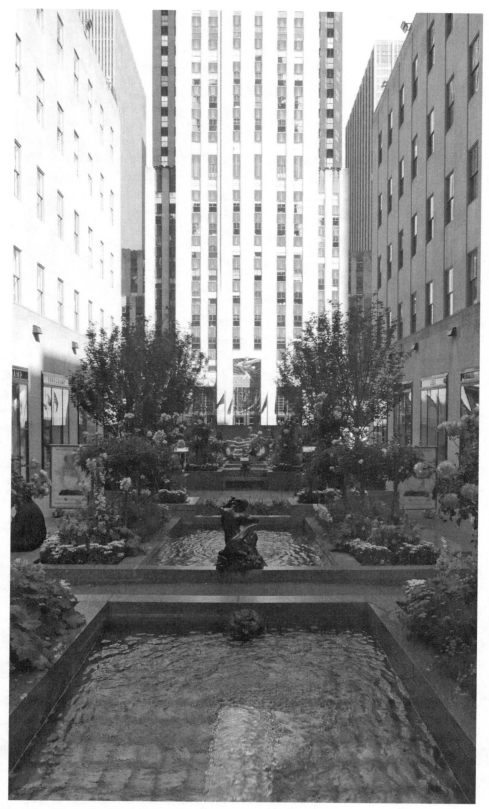

FIGURE 6.3. View of 30 Rockefeller Plaza from the Channel Gardens. *Prometheus* is visible in the distance. In the foreground are the tritons and nereids of the fountains.
J. Simard.

a public showcase of the design for the Center was met with negative feedback. He would end up spending over one million dollars, during the Great Depression, on art alone. He convened an art committee early on in the process, which was composed of prominent members of the art world. This committee was soon disbanded, however, and ultimately Rockefeller, the architects, and the artists worked closely together on the individual commissions. Rockefeller, it should be noted, received a classical education at a series of private schools in New York City, including the Browning School, where he studied Latin and Greek. He continued his classical studies at Brown University, where he enrolled in several art history courses that focused on ancient Greece and Rome and their influence on Western art.[26] This education is an important context for Rockefeller's own views on art and the depiction of classical gods in Rockefeller Center.

TRITONS AND NEREIDS

A mythological corridor was created along the axis of the Channel Gardens and the vista within the central block. The art program of this corridor begins with the mythological iconography of tritons and nereids that, blowing on their conches, announce the visitor's procession down toward the sunken plaza (see Figure 6.3). Collectively, these maritime criers, created by Rene Chambellan, are titled *Qualities That Spurred Mankind*, and the six individual fountainheads represent *Leadership, Will, Thought, Imagination, Energy,* and *Alertness*.[27] These qualities are emblematic of John D. Rockefeller Jr., who embarked on this daring business venture during the Great Depression in spite of great personal risk. He thereby felt himself to embody those very qualities.[28] These creatures introduce a classical iconography and mythic theme and, combined with the centripetal force of the promenade, usher the visitor toward the sunken plaza.

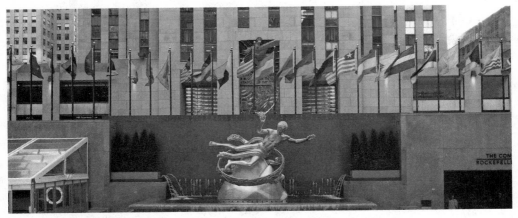

FIGURE 6.4. Paul Manship's *Prometheus* in the sunken plaza of Rockefeller Center.
J. Simard.

This mythological corridor culminates in Paul Manship's statue of *Prometheus* (Figure 6.4), which is located in the sunken plaza, directly below and in front of the main entrance to 30 Rockefeller Plaza. Manship's *Prometheus* was installed in January 1934 and fully exemplifies the art program's "New Frontiers" theme.[29] *Prometheus* stands out as a symbolic representative of Rockefeller Center's entire art program; on another level, it also represents John D. Rockefeller Jr. himself. A close analysis of the location, iconography, and reception histories of the Prometheus myth brings out the dual function of the statue.

Its location in the heart of Rockefeller Center sets it apart from all other artworks in the complex (see Figure 6.1). It is on view from all of the major towers that gird the sunken plaza. It is also visible from Fifth Avenue, functioning as a focal point at the base of 30 Rockefeller Plaza. Thus, just as the skyscraper draws one's view upward, *Prometheus* simultaneously draws the viewer's eye back to ground level. This visual effect is amplified by the downward sloping promenade and the two low-rise International Buildings on either side of it, which, although only a few stories high, nonetheless successfully block the viewer's peripheral vision and focus the eye on a distant point. *Prometheus* is also only one of a few freestanding public sculptures in an art program that encompasses over one hundred individual works. Because of its location and visual prominence, *Prometheus* conveys the larger themes of Rockefeller Center.

Prometheus is a sculptural fountain composed of a statue of Prometheus, the Titan god,[30] a mountain, a zodiac ring, water jets, and an inscription. Originally, the sculpture was not gilded but remained uncoated bronze. It was gilded in 1937 and has been regilded several times since.[31] The very existence of a figurative sculpture associated with a building (or complex of buildings) in the 1930s is counter to contemporary trends in architecture, especially skyscrapers. Thus, considering that the art theme was based around the future and in the popular Art Deco style, and considering that the buildings were designed in a Modern style, it is all the more interesting that for Rockefeller Center the most important location for artistic treatment received a figurative sculpture of a mythological deity.

The sculptural fountain has a few bold, iconographical attributes, and these are combined in such a way to communicate a complex thematic message. Prometheus descends from Olympus, depicted as the mountain in the background. As he descends, he passes through the zodiac ring.[32] The pool created at the base of the mountain thus represents the ocean encircling the earth. His gaze downward and his flowing drapery both emphasize his swift descent. He holds a flame in his right hand. An inscription appears in gilded letters on the marble wall behind the sculpture (see Figure 6.4), which reads: "Prometheus, teacher in every art, brought the fire that hath proved to mortals a means to mighty ends."[33] The inscription attributes the quotation to Aeschylus and paraphrases Prometheus's own words from *Prometheus Bound:* "I gave privileges to mortals: I hunted for, and stole, a source of fire . . . and it has shown itself to be mortals' great resource and their teacher of every skill."[34] In fact, all of the sculpture's attributes unmistakably reference one of the central myths about Prometheus: his theft of fire from Zeus for the benefit of humanity. Manship's

Prometheus uses the mythological character of the Titan to underscore the beneficent role that Rockefeller Center—and its central backer, John D. Rockefeller Jr.—had the potential to play in New York City. Indeed, the iconography of *Prometheus* casts the commercial and corporate functions of Rockefeller Center as aspirational.

Prometheus is a highly sophisticated and unique reception of the myth of Prometheus both in the context of the technological innovations of the 1920s and 1930s and in view of John D. Rockefeller Jr.'s commitment to such a massive building project during the Great Depression. A first impression may suggest that the sculpture's iconography is standard and generically representative of the myth, yet a closer examination reveals a more nuanced understanding of the figure of Prometheus and a syncretic rereading of the myth for this specific context. The myth is figuratively represented, and Prometheus is sculpted with proportions and a body that directly echoes classical style. The pose, however, is not classical. Prometheus descends from Olympus not on foot; he flies through the air. The pose highlights Prometheus's divine status. The zodiac ring also emphasizes the cosmic and divine origin of both Prometheus and fire. This horizontal pose is one of the original aspects of this composition. It is also a powerful rereading of the ancient sources for the myth.

The gilding of the statue and the entire sculpture is also striking. Gilding of bronzes is attested in antiquity.[35] The gilding here, however, seems to be more reflective of Art Deco tastes than of ancient practices.[36] Thus, the treatment of the sculpture contributes to the uniqueness of this figuration of Prometheus. The gilding also ensures that the sculpture stands out, especially when viewed from a distance either on ground level or from within the Center's buildings. While the spacing of the buildings ensures all tenants had ample light and sky views, when one looks down upon the sunken plaza, *Prometheus* glitters in the sunlight, catching the eye and holding the viewer's gaze, perhaps even long enough for the viewer to become pensive. Furthermore, the gilding and its prominent location recalls the placement of figurative sculpture in the plans of the City Beautiful movement, especially French's *Statue of the Republic* from the Court of Honor of the 1893 Columbian Exposition (see Figure 5.4).

The specific integration of Prometheus into a fountain is unique to Rockefeller Center. A survey of receptions of Prometheus in figurative sculpture from the late medieval period to the late twentieth century offers no prior instance of the Titan as the centerpiece for a fountain.[37] The space can easily call for a large fountain with figurative sculpture. As a public, outdoor gathering space for visitors and occupants alike, a fountain is perhaps expected. The choice of Prometheus, then, and not something more predictable like Poseidon, especially considering the tritons and nereids in the Channel Gardens, disrupts the viewer's expectations for the space. The Greco-Roman tradition is clearly referenced by the classical style and subject, but the incorporation of Prometheus into a fountain startles and excites the visitor to question the sculpture. Prometheus is clearly chosen for programmatic reasons and not as a result of slavishly following artistic tradition.

So much of the iconography surprises the viewer aware of the myth and its depiction in the arts. That iconography seems to derive from some of the main sources for the Prometheus myth in ancient literature. Each source laid the groundwork not only for the myth's reception but also for its depiction in the arts. One of the earliest sources is Hes-

iod's *Theogony* and *Works and Days*.[38] In the *Theogony*, Prometheus is man's benefactor, negotiating for humans to retain the better portions of animals sacrificed to the gods and later stealing fire for them. For these acts, Prometheus is punished and chained to a column (or rock or mountainside) but is eventually freed by Hercules.[39] There is no mention in the myth of why Prometheus helps mankind. In *Works and Days*, Pandora, the first woman, is added to the myth, as a clear punishment meted out to mankind for Prometheus's theft of fire, which he hid in a fennel stalk. Thus, Hesiod does attest that Prometheus steals fire to help mankind, but Prometheus is also portrayed as a trickster, deceiving Zeus at every possible turn.[40]

Another major treatment of the myth stems from *Prometheus Bound*, attributed to Aeschylus.[41] The playwright makes several changes to the myth, eliminating the account of the sacrifice and Pandora and instead focusing on Prometheus's punishment in the Caucasus Mountains. Significantly, in the play Prometheus speaks at length about the transformational gift of fire he gave to mankind.[42] Prometheus even asserts that *"all arts"* (πᾶσαι τέχναι, v. 506) stem from him. Thus, instead of bringing about a downfall for man, in *Prometheus Bound* Prometheus is responsible for all technological innovations that help create a functional and prosperous civilization. Furthermore, Prometheus emerges as a "philanthropist" or "lover of humanity" in the play attributed to Aeschylus.[43] It was his deep affection for humans that led him to put their well-being ahead of his own. The focus on Prometheus's suffering transforms him from a trickster to a rebel defiant of Zeus's tyranny. The punishment for this defiance results in the daily torture of an eagle eating out his liver, as foretold later in the play.[44]

Another important account of the Prometheus myth is found in Ovid's *Metamorphoses*.[45] In a mere eight lines (Book I, 80–88), Ovid attributes the creation of man to Prometheus, saying that man came from a mixing of clay and water.[46] This is one of the earliest accounts in extant sources that regards Prometheus as the creator of man. Ovid has made him into Prometheus *plasticator*.[47] All three accounts, Hesiod's trickster, the rebel from the *Prometheus Bound*, and Ovid's creator were influential in the reception history of the Prometheus myth both in literature and the arts.

In light of these reception histories, a close analysis of the iconography of *Prometheus* at Rockefeller Center reveals an identifiably innovative portrayal. Contrary to much of the artistic tradition, the fire is not in a fennel stalk, as in Hesiod, but instead Prometheus holds fire directly in his hand, which more clearly demonstrates his divine status. Furthermore, it shows that fire cannot be contained. It is a primal force that has the potential to spark great things once in humanity's possession. This message is reinforced by the quotation attributed to Aeschylus carved in gold letters into the wall directly behind the sculpture: "Prometheus, teacher in every art, brought the fire that hath proved to mortals a means to mighty ends."

The pose of the statue is also important to understanding its iconography. It highlights Prometheus's divine status as he descends from Olympus and flies through the zodiac ring. This is a dramatic departure from earlier depictions of Prometheus, which focused on his punishment or his relationship to Zeus. He is shown with fire, presumably after having stolen it from Zeus in Hesiod's account, but the depiction at Rockefeller Center has more

in common with the telling of the myth from the tragedy *Prometheus Bound*. Fire is the sculpture's most potent attribute, and Prometheus is triumphantly giving it to *humanity*. Thus, while the play's account does feature Prometheus going on at length about the contributions fire made to humanity, he was chained while giving that speech. Here, Prometheus's potential defiance of Zeus in *Prometheus Bound* is translated into a celebration of his gift of fire. The emphasis on the transformational moment of fire being given to humanity is further reinforced by the figures of *Man* and *Woman*, two additional sculptures originally located to the left and right of *Prometheus* (Figure 6.5) and now situated at the top of the staircase leading down to the sunken plaza. Man and woman are universal figures here, meant to represent the direct beneficiaries of Prometheus's gift. Thus, Manship's complete sculptural program recasts the initial negative role woman played in Hesiod's account, in the character of Pandora, and underscores how all of humanity directly benefits from Prometheus's affection.

As a whole, the statue of Prometheus, with its iconographical attributes and the focus on fire, the quotation attributed to Aeschylus, and the representation of universal man and woman, coalesce to create the syncretization of the ancient mythic sources and the subsequent artistic tradition. Prometheus is not a trickster here, nor is he rebelling against Zeus.

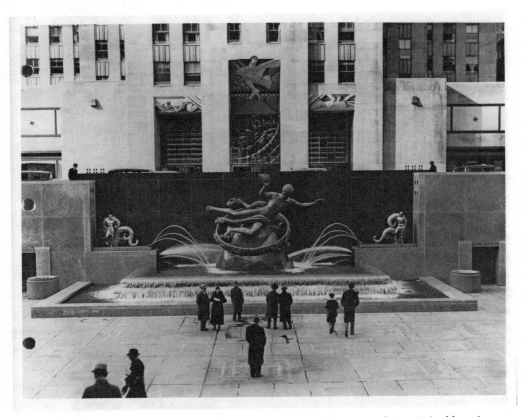

FIGURE 6.5. Paul Manship's *Prometheus*, along with *Man* and *Woman* in their original locations, 1934.
© 2016 Rockefeller Group Inc./Rockefeller Center Archives.

Whether he created humanity is not discernable from the sculpture, but it is clear that he is reveling in bringing fire to humanity: The smile on his face reveals that much. The quotation attributed to Aeschylus reinforces the notion that in the hands of humanity, fire is a "means to mighty ends." The choice of quotation, over others from the many mythological sources portraying Prometheus as a lover of humanity, shifts the focus away from Prometheus's intention and emphasizes the great things humans can bring about with fire.[48] Thus, in the context of Rockefeller Center, its location in the sunken plaza, and its role in the art program, Manship's *Prometheus* represents the spark of innovation that led to the technologies on display at Rockefeller Center, technologies that built the skyscrapers of the Center and the discoveries in light and sound, represented by the corporate tenants of 30 Rockefeller Plaza just behind *Prometheus*, RCA and NBC, leaders in the commercial expansion of radio and television. These technologies were rapidly changing the world. Prometheus here is a wise and benevolent teacher of these arts—creation, luminescence, and long-distance communication—to humanity. *Prometheus* monumentalizes and memorializes those gifts at Rockefeller Center and simultaneously glorifies the use of technology by the Center's corporate tenants. Against the backdrop of the Great Depression, *Prometheus* forcefully attests to the triumphant use of technology and the creativity of human labor.

ATLAS

Like *Prometheus*, *Atlas* is another large sculpture and mythological deity used to brand the space and thereby to become an emblem of it.[49] *Atlas* was the product of a collaboration between Lee Lawrie and Rene Chambellan (Figure 6.6), who both received several independent commissions for Rockefeller Center. The two were commissioned for *Atlas* in 1934, the same year *Prometheus* was dedicated.[50] This was probably not a coincidence, since both sculptures occupy important spaces in the design of Rockefeller Center. Furthermore, Atlas, as a fellow Titan and Prometheus's brother, connects the two pieces and deepens the role of mythologically inspired art in conveying the themes of the Center's entire artistic program. *Atlas* also extends the mythological corridor that bisects the central block in the complex, lining up with the promenade and the main tower, 30 Rockefeller Plaza. *Atlas*, located in the forecourt of the International Building on Fifth Avenue, mirrors the location of *Prometheus* in relation to 30 Rockefeller Plaza. The two sculptures are also connected by being positioned in front of large towers (see Figure 6.1). In the case of *Atlas*, the International Building is the second tallest building of the complex and also the second most ornate in terms of setbacks and architectural design. As the most prominent freestanding public sculptures of the entire art program, *Prometheus* and *Atlas* are important symbols for Rockefeller Center itself.

Atlas's location in the forecourt of the International Building is significant for other reasons. He anchors the four low-rise international buildings that line Fifth Avenue (see Figure 6.2). In this way, Atlas becomes a symbol for John D. Rockefeller's belief in "internationalism."[51] Rockefeller was very involved with the production of *Atlas*, visiting Lawrie's studio several times and making suggestions at every step of the process.[52] He was so pleased with Lawrie's maquette (rough molding) of the statue during one such visit that

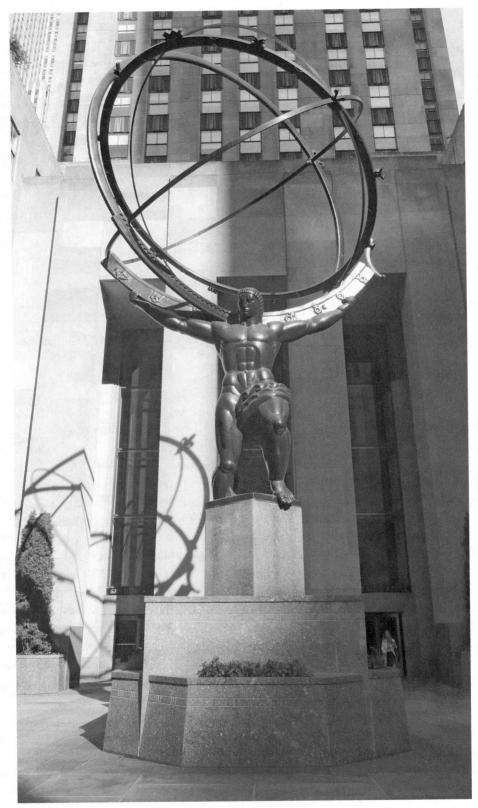

FIGURE 6.6. Lee Lawrie and Rene Chambellan's *Atlas* in the forecourt of the International Building at Rockefeller Center.

J. Simard.

he authorized the cast to be done in bronze, at significant additional expense, instead of aluminum.[53] That Rockefeller was a believer in internationalism and peace through mutual understanding is shown by many of his philanthropic causes, for example, the sixteen acres on Manhattan's east side he donated in 1946 for the construction of the United Nations headquarters or the restoration work on the Palace of Versailles, France, which he helped fund during the 1930s.[54] He was also involved in securing the various business syndicates that would be tenants in the five International Buildings along Fifth Avenue. Three of the four low-rise buildings received names based on the country of origin of their tenants: the French, British, and Italian Buildings. The fourth low-rise was called simply the International North Building. Along with the skyscraper International Building, these buildings along Fifth Avenue represented another aspect of the thematic art program. *Prometheus* was symbolic of innovation, *Atlas* of international relations. The latter could not be more fitting in light of European and world affairs during the 1930s. Atlas was known from mythology for holding up the sky on his shoulders, for supporting alone the celestial sphere, often depicted in art as a globe. Thus he was a perfect choice to represent internationalism and simultaneously provide a thematic connection to Prometheus in the sunken plaza.

Taking a closer look at the iconography of *Atlas* reveals its complex arrangement. The statue is not only a symbol with significance within the context of the art program of Rockefeller Center; it is also a sophisticated melding of ancient sources. Unlike Prometheus, who has been a nearly constant presence in the Western tradition, both in literature and the fine arts, Atlas is a relatively minor character from Greco-Roman mythology.[55] Yet he appears in *Prometheus Bound*, attributed to Aeschylus, which seems to have been the source of some inspiration for Manship's *Prometheus*. In the play, Prometheus grieves for the punishment of his brother, represented as holding the pillar of heaven and earth on his shoulder.[56] Atlas is often depicted this way in art, laboring under his heavy burden, knees bent, head lowered. The Farnese Atlas, for example, a second-century CE Roman copy of a Hellenistic original statue, demonstrates this clearly. Early on in ancient art and throughout the tradition, Atlas was a symbol for endurance and physical prowess.

At forty-five feet above street level, *Atlas* dominates Fifth Avenue and the pedestrians and office workers who pass by (see Figure 6.6). Lawrie and Chambellan's *Atlas*, erected in 1937, is very much in the Art Deco style. *Prometheus* retains a classical body, even if turned on its side. Although there is a shift in style from something echoing classical style in *Prometheus* to the contemporary Art Deco style of *Atlas*, which shows that the art program moved with the art trends of the time, nevertheless, the use of mythological subject matter remained a fixed character of the art program and its method of conveying complex symbolism. Among *Atlas*'s Art Deco features is his rounded, Art Deco musculature, which adds dramatically to the effect of the sculpture by allowing Atlas to appear in complete control of the sphere above him.

One of the most frequent iconographical attributes for Atlas in his depiction in art is the bent knee. At first glance it would appear that *Atlas* at Rockefeller Center also features this bent-knee motif, which is meant to symbolize that Atlas is struggling under the great weight of the world. However, a closer inspection of his stance, his facial expression, and upper back suggests a different interpretation. Low planting boxes have obscured the

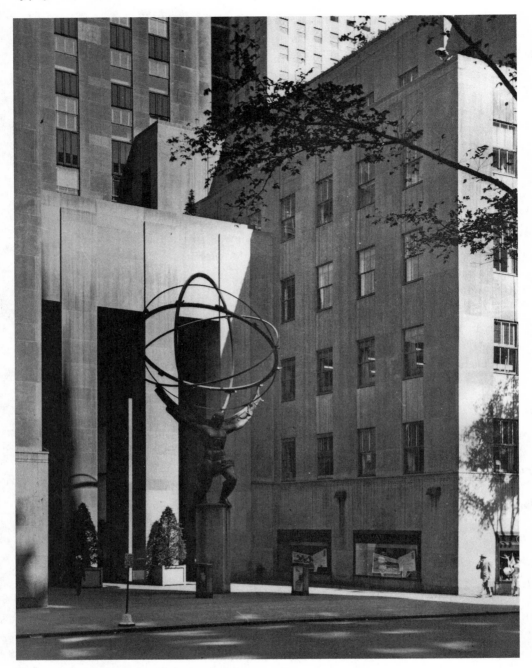

FIGURE 6.7. *Atlas* with the original pedestal, 1947.
© 2016 Rockefeller Group Inc./Rockefeller Center Archives.

original pedestal and created a tiered effect. The effect of the original pedestal may have been to suggest that Atlas was teetering on the edge, unable to control the great sphere on his back (Figure 6.7). Instead, Atlas's bent knee implies that he is stepping *up* onto his tiny platform, and his right leg then follows behind in that stepping motion. The slenderness

of the original pedestal gave the impression of height and would have added to the interpretation that Atlas is stepping up. Thus, although the weight of the world is literally on his shoulders, he is in complete control of the sphere. His facial expression is not one of stressed endurance but instead is relatively calm (Figure 6.8). His jaw seems slightly clenched; his chin and lower lip are drawn up as if he is contemplating something. His eyebrows are noticeably arched, and his forehead features stylized circular wrinkles. From the side profile, Atlas's head is slightly bent forward, but this does not appear to suggest a struggle. It is, rather, in line with his body's stepping-up motion. There is almost a complete absence of strain in this sculpture. This is a studied departure from previous depictions of Atlas, which tended to show him hunched over with a globe on his back and anguish on his face. The facial features of Lawrie and Chambellan's statue, combined with his robust musculature and his overall erect body posture, produce an Atlas capably discharging his task. The traditional depiction of Atlas as a symbol of endurance is here diminished. In fact, like Manship's *Prometheus*, the Rockefeller Center *Atlas* suggests a dramatic rereading of the source materials. He is a symbol of endurance, to be sure. But as might be expected for an art program tied to John D. Rockefeller Jr., he is also a figure of triumph: Atlas steps up in Rockefeller Center; he overcomes. As with *Prometheus*, the art program is suffused with uplifting symbolism.

Another interesting element of the Rockefeller Center *Atlas* is the sphere he bears on his shoulders. If Atlas is shown with the world on his back, often it is a closed sphere. In this case, Atlas holds up an armillary sphere. An armillary sphere is a model of objects in the sky depicted as spherical rings representing longitude, latitude, and ecliptic lines.[57] The zodiac is also represented on the most prominent ring. This further creates a

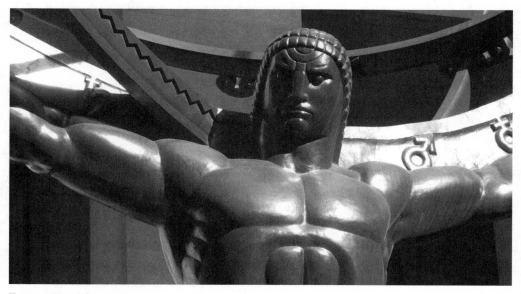

FIGURE 6.8. *Atlas.*
J. Simard.

cohesiveness with *Prometheus*, which also features a zodiac ring. The axis of the entire sphere points to the North Star.[58] Thus, Lawrie and Chambellan's *Atlas* departs from the traditional iconographical attribute, perhaps even the most recognizable one for Atlas, a globe. For Rockefeller Center, this is significant. An armillary sphere is most commonly associated with astronomical texts. This association goes back to the Renaissance and perhaps earlier. Atlas shown with an armillary sphere instead of a simple closed globe is attested in several mathematical and astronomical texts, such as *The Cosmographical Glass* by William Cunningham (1559). There, an engraving depicts Atlas holding an armillary sphere; a banner reads "*Caelifer Atlas*" (sky-bearing Atlas), an epithet from Virgil's *Aeneid* (Book 6.1.796). Verses located beneath him on the woodcut come from the first book of the *Aeneid*, in which Iopas, the Punic bard now at home in North Africa, sings of Atlas, who taught him the wanderings of the moon and the labors of the sun.[59] This telling of the Atlas myth, casting Atlas as a teacher of astronomy, is not found in the oldest canonical sources. Yet Diodorus Siculus, a Greek historian and near contemporary of Virgil from the first century BCE, rationalized the Atlas myth by noting that he lived in the west, learned astrology, and taught the doctrine of the spheres to Hercules.[60] As today, knowledge of the stars was associated in antiquity with navigation at sea, a key component of what Rockefeller Center's International Building was built to celebrate: international travel and communication. The armillary sphere in Lawrie and Chambellan's *Atlas* alludes to this aspect of the myth and adds another layer to the figure's symbolism: By virtue of holding up the world, Atlas is a ready-made icon for internationalism. In the 1930s, travel across the Atlantic was still mostly conducted by ship. In fact, many of the major ocean-liner touring companies had offices within the various International Buildings at Rockefeller Center. In addition, a sizable US post office and one of the largest official passport offices in New York City were located in the International Building. Thus, visitors and office tenants alike had all the resources they needed to arrange their plans for international business and travel. On the other hand, the armillary sphere is also representative of scientific learning and technological innovation. Atlas, like Prometheus, was a teacher and helper of humanity; knowledge of the stars has afforded humanity the ability to navigate the seas, which has connected nations across vast distances.

Conclusion

As a bringer of the knowledge of astronomy and navigation, Atlas directly mirrors Prometheus as a bringer of fire and inventiveness. Paul Manship's *Prometheus* metaphorically represented the technological innovations of Rockefeller Center's corporate tenants RCA and NBC, key components of the radio and television industries. Likewise, Lawrie and Chambellan's *Atlas* represented the internationalism associated with Rockefeller's own philanthropic efforts, realized in the International Buildings along Fifth Avenue. *Atlas* anchors this section of Rockefeller Center and functions in his iconographical symbolism in much the same way that *Prometheus* does for the sunken plaza, the central tower of 30 Rockefeller Plaza, and the complex as a whole.

The choice of Greco-Roman mythological figures for the two most important sculptures of the entire Center stems from a mixture of the personal preferences of Rockefeller, the artists, the architects, the management team, and the wider trends of the 1930s. Most of the interior murals of Rockefeller Center are devoid of mythologically inspired art. Such art was used more heavily on the exterior of the complex for the most publicly viewable and, thus, most symbolically potent artworks and spaces. Figurative art and mythologically inspired art had already fallen out of favor by the 1930s. Its continued use at Rockefeller Center represents an anomaly of sorts but is surely related to the symbolic potency of these figures and their widespread familiarity in public art.

Furthermore, the specific iconographical choices that appear in *Prometheus* and *Atlas* are themselves unique. The two Titans, despite being brothers, are not usually depicted together, either in literature or the fine arts. Indeed, individually, their depictions at Rockefeller Center present new interpretations of source material. Their locations in the most important spaces of Rockefeller Center cast them as symbols for the Center, its tenants, and Rockefeller the man. In addition, as triumphant benefactors to humanity, each Titan represents a powerful syncretization of various sources both literary and artistic. Their placement in equally important locations, the sunken plaza and the forecourt of the International Building, recalls the principles of the City Beautiful movement, which emphasized axial symmetry and the placement of artwork along those lines for strategic viewing impact. In the end, the statues of Prometheus and Atlas at Rockefeller Center offer compelling examples of the ways in which ancient mythological deities continue to be important vehicles for conveying to the public thematic cohesion and complex symbolism.

NOTES

1. See Ritter's chapter in this volume.

2. The phrase "city within a city" has an obscure origin. It is not possible to say definitively who coined it, but it was used before Rockefeller Center to refer to Grand Central Terminal. Its use in reference to Rockefeller Center probably originates with John R. Todd. In a June 17, 1930, article entitled "Rockefeller Plans Revealed for Radio City" in the *New York Herald Tribune*, Todd is quoted in the article calling the complex a city within a city.

3. Rockefeller Group Inc., *The Facts of Rockefeller Center* (New York: Rockefeller Group Inc., 1994), 2.

4. See, for example, Norbert Wolf, *Art Deco* (Munich: Prestel, 2013), 193. See also Donald Martin Reynolds, *The Architecture of New York City, Histories and Views of Important Structures, Sites, and Symbols* (New York: Macmillan, 1984), 256–57, where he discusses the style of Rockefeller Center without identifying it one way or the other.

5. Hanno-Walter Kruft, *A History of Architectural Theory from Vitruvius to the Present* (New York: Princeton Architectural Press, 1994), 430–31.

6. On the art of Radio City Music Hall, see Christine Roussel, *The Art of Rockefeller Center* (New York: Norton, 2006), 25–81.

7. Rockefeller paid a steep rent considering the historical context. For more information on the history of the plot of land, see David Loth, *The City within a City: The Romance of Rockefeller Center* (New York: William Morrow, 1966), 7–21.

8. Alan Balfour, *Rockefeller Center Architecture as Theatre* (New York: McGraw-Hill, Inc, 1978), 3–8, has the most concise retelling of the early history with the opera house.

9. Balfour, *Rockefeller Center*, 11.

10. For the most up-to-date information on the City Beautiful, see Jon A. Peterson, *The Birth of City Planning in the United States: 1840–1914* (Baltimore, MD: Johns Hopkins University Press, 2003). See also William Wilson, *The City Beautiful Movement* (Baltimore, MD: Johns Hopkins University Press, 1989).

11. Wilson, *The City Beautiful Movement*, 41.

12. Mel Scott, *American City Planning since 1890* (Berkeley: University of California Press, 1969), 44. See also Jon A. Peterson, "The City Beautiful Movement: Forgotten Origins and Lost Meanings," *Journal of Urban History* 2 (1976): 416. For a discussion of the Municipal Art Society's role in developing New York City, see Michele Bogart, *The Politics of Urban Beauty: New York and Its Art Commission* (Chicago: University of Chicago Press, 2006).

13. Wilson, *The City Beautiful Movement*, 57; Scott, *American City Planning*, 44.

14. Wilson, *The City Beautiful Movement*, 4. For an overview of the key Americans who studied at the École, see Jean Paul Carlhian and Margot M. Ellis, *Americans in Paris, Foundations of America's Architectural Gilded Age, Architecture Students at the École des Beaux-Arts, 1846–1946* (New York: Rizzoli, 2014). Several of the architects of Rockefeller Center also attended the school, including Raymond Hood, Harvey Corbett, and Wallace Harrison.

15. For more information on the curriculum of the École, see Arthur Drexler, ed., *The Architecture of École des Beaux-Arts* (New York: Museum of Modern Art, 1977).

16. Wilson, *The City Beautiful Movement*, 79.

17. For more on the City Beautiful movement and city planning in New York, see Ritter's chapter in this volume.

18. In particular, Americans looked to imperial Rome for art, architecture, and culture. For studies of the reception of Roman grandeur in America, see Stephen L. Dyson, "Rome in America," in *Images of Rome: Perceptions of Ancient Rome in Europe and the United States in the Modern Age*, ed. Richard Hingley, *Journal of Roman Archaeology* Monographs Supplement Series 44 (Portsmouth, RI, 2000), 57–69; and Margaret Malamud, *Ancient Rome in Modern America* (Malden, MA: Wiley-Blackwell, 2009), esp. chap. 6.

19. John DeWitt Warner, "Civic Centers," *Municipal Affairs* (1902): 4–9. For a discussion of Warner in the context of rhetoric surrounding the development of civic centers, see Wilson, *The City Beautiful Movement*, 88–92. See also Ritter's chapter in this volume.

20. The three architectural firms were Reinhard & Hofmeister, Corbett, Harrison & MacMurray, and Hood & Fouilhoux.

21. Kurt Schlichting, "Grand Central Terminal and the City Beautiful in New York," *Journal of Urban History* 22, no. 3 (March 1996): 332.

22. The 1916 zoning law sought to alleviate this feature of skyscrapers by means of a setback system. Nonetheless, those buildings built prior to 1916 in Lower Manhattan remained. On the 1916 zoning laws and their influence on Rockefeller Center, see Walter Karp, *The Center: A History and Guide to Rockefeller Center* (New York: American Heritage, 1982), 55–57.

23. Karp, *The Center*, 56.

24. No doubt an additional two low-rise buildings would have completed the symmetry on the block between Forty-Eighth and Forty-Ninth Streets, but there was a holdout who would not sell to Rockefeller at the time. For more information on the holdout, see Loth, *The City within a City*, 62–65; and Daniel Okrent, *Great Fortune: The Epic of Rockefeller Center* (New York: Viking, 2003), 95–98.

25. For an extended discussion of Rockefeller's involvement with the art program, see Jared A. Simard, "Classics and Rockefeller Center: John D. Rockefeller Jr. and the Use of Classicism in Public Space," PhD diss., The Graduate Center, City University of New York, 2016, 122–206.

26. For an in-depth discussion of Rockefeller's education, see Simard, "Classics and Rockefeller Center," 10–46.

27. Roussell, *The Art of Rockefeller Center*, 188–95.

28. In 1962, after Rockefeller's death, a commemorative plaque was dedicated to him in Rockefeller Center. Titled "I Believe," the plaque reprints Rockefeller's words given in a radio broadcast in 1941 on behalf of the USO and National War Fund. The speech is generally viewed as a concise statement of his philosophy of life. The speech, however, was given in an entirely different context and after the completion of the original structures of Rockefeller Center. Furthermore, because Rockefeller would never have agreed to its dedication—it went against his principles regarding public recognition—caution is needed when understanding its potential meaning in relation to its physical surroundings in Rockefeller Center.

29. Balfour, *Rockefeller Center*, 137–39.

30. The Titans were the first generation of gods in Greek mythology. Cronos was their leader, who with his wife Rhea produced the first generation of Olympians, including Poseidon, Hera, Hades, Hestia, Demeter, and Zeus.

31. Roussel, *The Art of Rockefeller Center*, 204–7. There seems to have been some debate about whether to gild it or not. The gilding, however, does make the piece fit with the gilding used on much of the architectural sculpture.

32. The zodiac ring is often used to symbolize that the gods live above the earth. It can also carry a connotation of astrology and learnedness.

33. Roussel, *The Art of Rockefeller Center*, 204, records that Manship proposed the quotation, and based on RCAC, Architects Meetings/Notes 1934, Minutes from Architects' Office, June 13, 1934, "Inscription Manship Fountain," we know that Rockefeller ultimately approved it.

34. Quoted from *Prometheus Bound*, 108–11, trans. Alan H. Sommerstein (Cambridge, MA: Harvard University Press, 2009), 457. Most scholars no longer attribute the play to Aeschylus, as Sommerstein notes: "A majority of scholars would regard it as being by a slightly later hand" (433n2).

35. On the topic of polychromy in sculpture, see Roberta Panzanelli, Eike D. Schmidt, and Kenneth Lapatin, eds., *The Color of Life: Polychromy in Sculpture from Antiquity to the Present* (Los Angeles: J. Paul Getty Museum and the Getty Research Institute, 2008); and Vinzenz Brinkmann and Raimund Wünsche, *Gods in Color: Painted Sculpture of Classical Antiquity* (Munich: Stiftung Archäologie Glyptothek, 2008), which have several essays on the topic. Specifically for gilded bronzes, see W. A. Oddy, Licia Borrelli Vlad, and N. D. Meeks, "The Gilding of Bronze Statues in the Greek and Roman World," in *The Horses of San Marco Venice*, trans. John Wilton-Ely and Valerie Wilton-Ely (Italy: Olivetti, 1979).

36. Throughout Art Deco style, there was a strong inclination toward the metallic. Chrome and nickel-plated metals were frequently used, as was polished bronze and gilded surfaces. For examples of this aesthetic, see Alfred W. Edward, *Art Deco Sculpture and Metalware* (Atglen: Schiffer, 1996); Ghislaine Wood, *Essential Art Deco* (Boston: Bulfinch, 2003); and Wolf, *Art Deco*.

37. For overviews of the histories and reception of the Prometheus myth, see Maria Moog-Grünewald, ed., *The Reception of Myth and Mythology*, Brill's New Pauly Supplements 4 (Leiden: New Pauly, 2010), 557–58, 561–63, 565–67; and Jane Davidson Reid, *The Oxford Guide to Classical Mythology in the Arts, 1300–1990s* (Oxford: Oxford University Press, 1993), 923–37.

38. Hesiod, *Theogony*, 521–616; and *Works and Days*, 42–105. Hesiod is generally dated to the last half of the eighth century and the first half of the seventh century BCE. For a discussion of these two passages, see Timothy Gantz, *Early Greek Myth: A Guide to Literary and Artistic Sources* (Baltimore, MD: Johns Hopkins University Press, 1993), 152–65.

39. Gantz, *Early Greek Myth*, 155, argues that lines 527–28, "freed Prometheus from anxiety," refer back to Hercules's slaying of the eagle and not that Hercules also unchained Prometheus. This is supported by line 616, where Hesiod says clearly that Prometheus is still chained.

40. For discussion of Prometheus as a trickster, see Cristiano Grottanelli, "Tricksters, Scape-Goats, Champions, Saviors," *History of Religions* 23 (1983): 135.

41. See Gantz, *Early Greek Myth*, 158–65. On the dubious Aeschylean authorship of the play, see note 33 and the helpful summary of the major arguments for and against in Hugh Lloyd-Jones, "Zeus, Prometheus, and Greek Ethics," *Harvard Studies in Classical Philology* 101 (2003): 53–55. Even though scholarly consensus is moving away from Aeschylean authorship, for the sake of this study, it is important to remember that in the 1930s and the time of Manship's sculpture, Aeschylus was accepted as the author of *Prometheus Bound*, and this may have influenced Rockefeller's willingness to approve the quotation.

42. For example, *PB* 109–11 and again at *PB* 436–71, 476–506.

43. For example, *PB* 119–23 express the concept that Prometheus's actions were motivated by a great φιλότητα, "love," for mortals.

44. *PB* 1021–25 (Loeb, Sommerstein trans., cited above n. 36): "Then, I tell you, the winged hound of Zeus, the bloodthirsty eagle, will greedily butcher your body into great ragged shreds, coming uninvited for a banquet that lasts all day, and will feast on your liver, which will turn black with gnawing."

45. The work was likely published in the first decade of the first century CE, most likely prior to his exile by Augustus in 8 CE.

46. Prometheus is referred to as *satus Iapeto*, or the son of Iapetus.

47. For a brief discussion of early accounts of Prometheus as creator or *plasticator*, see Caroline Corbeau-Parsons, *Prometheus in the Nineteenth Century from Myth to Symbol* (London: Legenda, Modern Humanities Research Association and Maney Publishing, 2013), 13.

48. The focus on fire as a spark for innovation simultaneously serves to distance any possible correlation between Prometheus as "philanthropist" and Rockefeller as philanthropist or, in the case of Rockefeller Center, businessman. One cannot but help to see Rockefeller reflected in *Prometheus*, but that connection is not as "lover of humanity."

49. David Lubin, "Aesthetic Space," in *Rethinking the American City: An International Dialogue*, ed. Miles Orvell and Klaus Benesch (Philadelphia: University of Pennsylvania Press, 2013), 103, discusses the notion of using art to brand public spaces and promote civic well-being.

50. Roussel, *The Art of Rockefeller Center*, 230.

51. Roussel, *The Art of Rockefeller Center*, 230.

52. RCAC, 1935 Meetings Architects/Engineers, Architects' Office Minutes, March 13, 1935, "Regarding Building 4ab6." RCAC, 1935 Meetings Architects/Engineers, Architects' Office Minutes, June 21, 1935, "Atlas."

53. Okrent, *Great Fortune*, 376.

54. For more information on Rockefeller's involvement with Versailles, see Pascale Richard, *Versailles, the American Story* (Paris, 1999), 124–27.

55. For example, in Moog-Grünewald, ed., *The Reception of Myth and Mythology*, there is no standalone article on Atlas; he only appears in the index in reference to entries such as "Gorgon," "Heracles," "Hermes," "Perseus," and "Zeus."

56. *Prometheus Bound*, 347–50 (trans. Sommerstein): "[Prometheus speaks]: Seeing how distressed I am by the fate of my brother Atlas, who stands in the lands of the west, supporting on his shoulders the pillars of heaven and earth, a grievous burden on his arms."

57. For a discussion of armillary spheres, see Adam Mosley, "The Armillary Sphere," Department of History and Philosophy of Science, Cambridge University (1999), http://www.hps.cam.ac.uk/starry/armillary.html.

58. Roussel, *The Art of Rockefeller Center*, 230.

59. Virgil, *Aeneid* 1.742–44: "*Hic canit errantem lunam solisque labore / . . . / Arcturum pluviasque Hyadas geminosque Triones.*"

60. Diod. Sic. *Bibliotheca Historica* 3.60, 4.27.

Rome Reborn: Old Pennsylvania Station and the Legacy of the Baths of Caracalla

Maryl B. Gensheimer

Introduction

By the last years of the nineteenth century, New York had assumed a leading role in the economic life of the United States and was arguably the leading commercial capital of the world. For all its economic successes, however, the city's development was frustrated by simple geography. Notwithstanding the nineteenth century's transportation revolution, from horse power to steam power to electric power, the ferries crisscrossing the Hudson and East Rivers were a constant reminder that Manhattan was an island accessible almost exclusively by boat. In fact, as late as 1900, the Brooklyn Bridge was the only span across either river.

For a city poised to take its place as a global commercial power, Manhattan's transit situation and relative isolation from the rest of the country became untenable. The two preeminent and rival train companies in the metropolitan region, the Pennsylvania Railroad Company and the New York Central, were competing for speed records at the turn of the century. In 1839, for instance, when the first long-distance run between Philadelphia and Jersey City was introduced, the trip took four-and-a-half hours. By 1902, the Pennsylvania Railroad had made the trip in seventy-nine minutes.[1] Yet even as travel times between New York, Philadelphia, Chicago, and elsewhere were shrinking exponentially, the Pennsylvania Railroad could not actually reach Manhattan. Since 1871, when the Pennsylvania had acquired the United Railroads of New Jersey, the line had terminated at Jersey City. Passengers needed to disembark from trains and transfer to

one of four ferry lines in order to cross the Hudson to docks in Lower Manhattan or Brooklyn.[2]

It was precisely that last mile across the Hudson—from the trains' terminus at Jersey City to the docks in Manhattan—that loomed large as an obstacle to development. The ferries shuttling passengers across the river could satisfy neither the appetite for speed nor the newfound efficiency that the railroad had pioneered elsewhere. Whereas the Pennsylvania Railroad transported travelers to Jersey City from virtually any major American city at average speeds of forty to eighty miles per hour, the last mile across the Hudson took twenty minutes in fair weather, an embarrassingly slow pace by comparison.[3]

New York City's explosive growth at the turn of the century exacerbated the need for some sort of solution to the ferries operated by the six different railroad companies serving the region. In 1896, ninety-four million New York–bound passengers disembarked from trains in Jersey City. Within ten years, 140 million passengers were arriving at the same destination and with the same end goal.[4] To accommodate the surge in passenger traffic, a growing fleet of railroad ferries jockeyed for space on a river already choked by heavy traffic from ocean-bound steamships and freighters.

In short, the Pennsylvania Railroad, the titan of American railroad transportation, needed to reach Manhattan by alternative, and more efficient, means. Ultimately, the solution adopted in order to do so was sweeping in scope.[5] The Pennsylvania Railroad constructed a new and grandiose station, the largest of its kind in the world at the time of its inauguration in 1910, as well as associated tunnels linking Pennsylvania Station with New Jersey and Long Island (Figure 7.1).

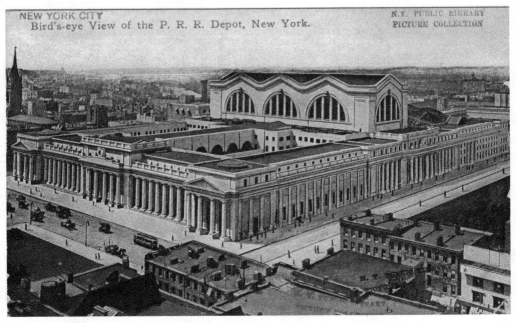

FIGURE 7.1. Pennsylvania Station, New York, inaugurated 1910. Aerial view.
Courtesy of the Picture Collection, The New York Public Library, Astor, Lenox and Tilden Foundations.

Pennsylvania Station and its tunnels depended on both bold leadership and technological advancement. The former was achieved with the election of Alexander Cassatt (1839–1906) as president of the Pennsylvania Railroad in June 1899. Cassatt was determined to connect his railroad with Manhattan and beyond, to New England lines, to form an uninterrupted transit line running the length of the East Coast and into the Midwest. Technological insights were inspired by Cassatt's attendance of the opening of the Gare d'Orsay in Paris in the summer of 1900, where he witnessed electrically powered trains entering the city through underground tunnels.[6] Cassatt quickly realized that electric power could also service the trains of the Pennsylvania Railroad. Over the next sixteen months, Cassatt and his assistant, Samuel Rea, planned for the Pennsylvania's entrance into Manhattan and embarked on a capital campaign of unprecedented scale to finance the initiative. The Pennsylvania Tunnel Extension and Terminal Project, as it was officially named, was launched in December 1901.[7]

At a meeting in his Philadelphia office on April 24, 1902, Cassatt commissioned Charles Follen McKim, a partner of the renowned architectural firm McKim, Mead & White, to design the new Pennsylvania Station.[8] Construction on the station began in 1903. After McKim withdrew from active practice in 1906 because of his failing health, responsibility for Pennsylvania Station passed to William Symmes Richardson, who had been made a partner at McKim, Mead & White in the same year. Richardson oversaw the final stages of construction and was responsible for late refinements to McKim's designs of the ornamental details. Sadly, by the time Pennsylvania Station officially opened on September 18, 1910, both Cassatt and McKim, the visionaries behind the project, had died.

In total, the Pennsylvania's tunnel extension and new station cost $113 million, "a greater expenditure than was ever before incurred by a private corporation for a single undertaking," the Pennsylvania Railroad proudly boasted.[9] Press reports equated the project with the Panama Canal for its vision, scale, and complexity.[10] Yet unlike the Panama Canal, which was funded and built by the US government, the extension into New York was a private venture of the Pennsylvania Railroad. The tunnels, tracks, and station were built without public funding.[11] Why, then, go to so much trouble and expense? In Rea's words, "New York City is at present isolated, and all of our plans for the tunnel extension of the New York Connecting Railroad are . . . because of the fact that New York is the commercial metropolis of the Country."[12]

The New York extension and Pennsylvania Station forever changed New York City. Pennsylvania Station alone occupied eight acres, bounded by Seventh and Eighth Avenues on the east and west and Thirty-Third and Thirty-First Streets on the north and south. Including the rail yard, which extended west to Tenth Avenue, the entire site encompassed some twenty-eight acres. In the course of construction, five hundred buildings that formerly stood on its site were razed, and more than fifteen hundred people relocated. Entire blocks of tenements, shops, factories, and eventually a Catholic church were leveled to accommodate the tunnels coming into the new station from under the Hudson.[13]

Although, again, entirely a private venture, Pennsylvania Station became enshrined as a public monument because of its fundamental role in the life of New York City in the early decades of the twentieth century. The Pennsylvania Railroad's steel track and

tunnel system reshaped the landscape of New Jersey and Manhattan, linking the city to the continent for the first time. Those steel tracks terminated below the glazed vaults of the concourse of Pennsylvania Station. Half a million people were accommodated within on a daily basis, yet the building was much more than a simple transportation hub. The station was designed to facilitate unimpeded movement within a framework of immovable walls. It was designed to dignify the transit system essential to modern American life. And it was designed to endure, like the monuments of ancient Rome that it emulated. In other words, the monumentality of the Pennsylvania Railroad's great station was a reflection of the power and ambition of the city and of the railroad that endowed it.

In all of these ways, Pennsylvania Station bears marked resemblances to its Roman architectural antecedents, most notably the Baths of Caracalla (inaugurated 216 CE). This chapter contrasts the recreated spaces of the Baths of Caracalla in Pennsylvania Station with their original design and investigates the underlying ambitions of various patrons, whether the emperor Caracalla or Alexander Cassatt. In so doing, it attests to the rich and varied afterlife of the Baths of Caracalla (and other imperial *thermae*) and reveals the ways in which Roman baths were fundamental to the reception of the classical past and the expression of modern life in twentieth-century New York.

Caracalla and His Eponymous Baths

In the few years of his reign, the young emperor Marcus Aurelius Severus Antoninus Pius Felix Augustus (r. February 211–April 217 CE), more popularly known as Caracalla, for the type of Celtic cloak he favored, commissioned a monumental new bath building in the city of Rome. Stretching over twenty-seven acres, the eponymous Baths of Caracalla were the largest of their kind at the time of their inauguration in 216 CE, and they marked the culmination of his family's dynastic building program in the southern part of the city. Caracalla's father, the emperor Septimius Severus (r. 193–211 CE), had previously monumentalized this zone through the endowment of, among other things, the Septizodium (a monumental fountain façade) and a smaller bathing complex.[14]

Today, despite losses and damage, the plan of the Baths of Caracalla and their exterior precinct is clear (Figure 7.2). The main bathing block, measuring 702 by 361 feet, stood on a nearly square terrace and was surrounded by the gardens, porticoes, and secondary rooms accessible from the garden precinct. The main block, as is characteristic of all of Rome's so-called imperial baths,[15] was rigidly symmetrical around the building's central axis, which was composed of the *natatio, frigidarium, tepidarium,* and *caldarium*.[16] To either side of the central axis, rooms were arranged around the *palaestrae,* or exercise courts, which—in combination with the *frigidarium*—constituted the transverse axis through the main bathing block.

In the context of Pennsylvania Station and as the model for McKim, Mead & White's waiting room therein, the triple-bayed, cross-vaulted *frigidarium* of the Baths of Caracalla warrants the most attention here (Figures 7.3–7.4). The *frigidarium* is the largest room within the main bathing block, measuring 183 by 79 feet. Today, the ceiling vaults have

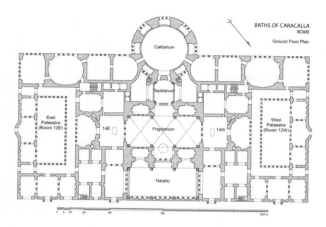

FIGURE 7.2. The Baths of Caracalla, Rome, inaugurated 216 CE. Plan of main bathing block.

J. Burden and J. Montgomery, *Building History Project*, after Janet DeLaine, *The Baths of Caracalla: A Study in the Design, Construction, and Economics of Large-Scale Building Projects in Imperial Rome* (Portsmouth, RI: Journal of Roman Archaeology, 1997), fig. 11.

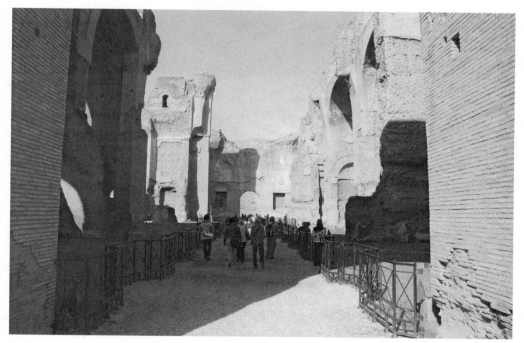

FIGURE 7.3. The Baths of Caracalla, Rome, inaugurated 216 CE. View of *frigidarium*.
M. Gensheimer.

collapsed, and the walls and floors have been denuded of their original decoration in stucco and inlaid stone. Some imagination is needed to envision this space as it would have appeared in antiquity.

In the years immediately after the baths' inauguration, though, the *frigidarium* must have created an awesome visual experience. Its coffered ceilings floated high overhead, 125 feet above the floor, suspended on an elaborate system of cross vaults supported by the massive columns that grew like tree trunks from the floor. Light filtered in through both the lunette clerestory windows below the vaults and the columnar screens dividing this

FIGURE 7.4. The Baths of Caracalla, Rome, inaugurated 216 CE. Reconstruction of *frigidarium*, from Guillaume-Abel Blouet, *Restauration des Thermes d'Antonin Caracalla à Rom* (Paris: Firmin Didot, 1828), pl. XV.

room from the adjacent *natatio* and *palaestrae*. Water splashed in freestanding fountain basins and in the bathing pools, and the space was made all the more dynamic through the display of statuary in recessed wall niches and on pedestals on the floor.

The overall impression of architectural splendor within the *frigidarium* depended, in large part, on the room's distinctive scale, exceptional materials, and costly decoration. The columns dispersed throughout the room, for instance, are indicative of this trifecta. The *frigidarium*'s main order was originally composed of eight monolithic, fifty-foot Compos-

ite columns of gray granite imported from Egypt.[17] Eight monolithic red porphyry columns belonging to a thirty-foot figured Composite order, also imported from Egypt, framed the entrances to the four individual cold pools.[18] The columnar screens dividing the *frigidarium* from Rooms 14E and 14W (antechambers leading toward the *palaestrae*; see Figure 7.2), meanwhile, are reconstructed as a monolithic Corinthian order with thirty-six-foot columns also of gray Egyptian granite, while the columnar screen of two columns between the *frigidarium* and the *natatio* was articulated with monolithic thirty-foot red porphyry columns.[19]

These types of decorative stone elements were a major expense within the context of Roman building projects.[20] In the case of the Baths of Caracalla, for instance, Janet DeLaine has demonstrated convincingly that, although the building was primarily constructed of brick and concrete, the cost of its decorative stone elements and their carving accounted for perhaps 15 percent of the total project cost and 80 percent of the cost of decoration.[21] As such a large part of the budget, one may assume that such materials were not used casually. Rather, this expensive stone decoration was a deliberate design element intended to convey the emperor's legitimacy and largesse to the diverse Roman audience that frequented the Baths of Caracalla. As noted above, the stones used in the columns of the *frigidarium* were imported from modern Egypt, while those used in the column bases, capitals, and entablature zone were imported from modern Turkey. Together, these brilliantly colored stones testified to the expansive empire under Caracalla's control. By stressing the emperor's unique command of material resources and remote geography, the *frigidarium*'s exotic materials underscored Caracalla's power and dominion over territories far beyond the city of Rome yet subject to the rule of Rome's emperor.[22]

Beyond its costly polychrome columns, marble- and stucco-covered walls, and inlaid stone floor, the *frigidarium* was further embellished with freestanding and architectural sculpture. To date, my research has documented at least seventy-five freestanding sculptures attributable to the Baths of Caracalla. Of these, the provenance of thirty-six statues is known. Eighteen of these works were found within the *frigidarium*. Space constraints prevent a thorough discussion of each of those sculptures here, but it should be stressed that within this group of eighteen sculptures, important thematic emphases can be discerned.[23] In particular, the two colossal statues of the Weary Hercules type[24] (Figure 7.5) found in the intercolumniations in the archway between the *frigidarium* and Room 14E[25] (see Figure 7.2) are important for their resonance with other decoration in the room. That is, the Weary Hercules statue type was repeated high above the floor as the primary face of one of the figured Composite capitals that crowned the eight porphyry monoliths of the cold pools (Figure 7.6).[26]

By the time of Caracalla's reign in the third century, the figure of the Roman emperor was often identified with that of Hercules,[27] given the propagandistic value of the latter having set a mythological precedent for a mortal man rewarded, ultimately, with deification. According to the Greek myth, Hercules was granted immortality following the successful completion of the last of his superhuman Labors, the retrieval of the Apples of the Hesperides.[28] In the Roman imperial period, Hercules and his deification became a proxy with which to understand an emperor's apotheosis after death. Just as Hercules became a

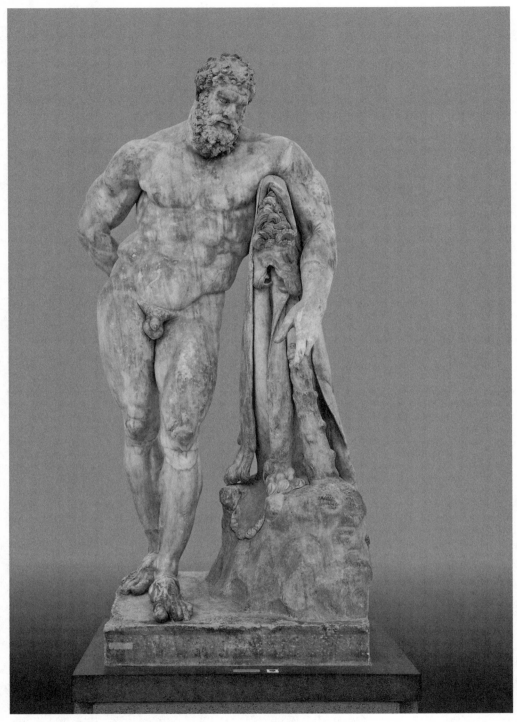

FIGURE 7.5. The Farnese Hercules, late second- to early third-century CE Roman replica, after a Greek original of c. 320 BCE by Lysippos. From the *frigidarium*, the Baths of Caracalla, Rome. © Art Resource, NY.

FIGURE 7.6. Figured capital with a Weary Hercules in relief. From the *frigidarium*, the Baths of Caracalla, Rome.

M. Gensheimer.

god for having fulfilled his Labors, so too the Roman emperor could be rewarded with divinity for having governed well and fairly.

In light of this tradition, the three examples of the Weary Hercules sculpture type found within the *frigidarium*—the two freestanding sculptures and the figured capital—are invaluable evidence with which to reconstruct further the distinctly imperial overtones of this room. Like the polychrome columns, these representations of Hercules, whether at floor level or high overhead, evoked the omnipresent, omnipotent, and beneficent patron of this space. To the viewer standing within or moving through the *frigidarium*, this visual repetition of Herculean imagery would have been a potent reminder of Caracalla and the imperial largesse that endowed the baths. Much like the bronze portrait of Alexander Cassatt that once stood in a niche above the entrance stairway to the waiting room of Pennsylvania Station,[29] these images of Hercules reminded those visiting the bath of the figure responsible for monumentalizing a routine aspect of Roman daily life (public bathing) and on whose authority such routines depended.

Whether in its sheer size, the expense of its building materials, or its elaborate decoration, the *frigidarium* of the Baths of Caracalla was a superlative space unlike many others in the city of Rome at the time of the baths' inauguration in 216 CE. Together, all three of these criteria (scale, materials, and decoration) operated in concert as part of a visual strategy intended both to honor the imperial patron and also to celebrate an urbane style of living. In a certain sense, therefore, both the patron and the lifestyle his patronage supported became inseparably intertwined within this grand architectural frame.

To turn to Alexander Cassatt and his new station, it is perhaps unsurprising that the president of the Pennsylvania Railroad and his architect, Charles McKim, looked to the *frigidarium* of the Baths of Caracalla as a prototype for Pennsylvania Station. There too, the scale, materials, and decoration deployed within the soaring spaces of the station would declare the power of the railroad and its centrality to modern American life in the early years of the twentieth century.

Alexander Cassatt, Charles McKim, and Pennsylvania Station

Much like the *frigidarium* of the Baths of Caracalla, the main waiting room of Pennsylvania Station was an architectural tour de force that lauded its patron's public vision while accommodating the individual's private experience. In doing so, it juxtaposed superhuman scale while facilitating human routine and celebrated tradition while introducing new solutions (themselves dependent on new construction techniques) for urban living (Figure 7.7).

Like the *frigidarium*, the waiting room was the main room around which the other rooms of the station were grouped. And like the *frigidarium*, the waiting room was vast: The promotional literature boasted that it was "the largest structure of its kind in the world."[30] Measuring 300 feet long by 110 feet wide, the waiting room extended for two city blocks, from Thirty-First to Thirty-Third Street. At the north and south ends of the room, colonnades of six thirty-one-foot Ionic columns flanked the entrances. Dispersed

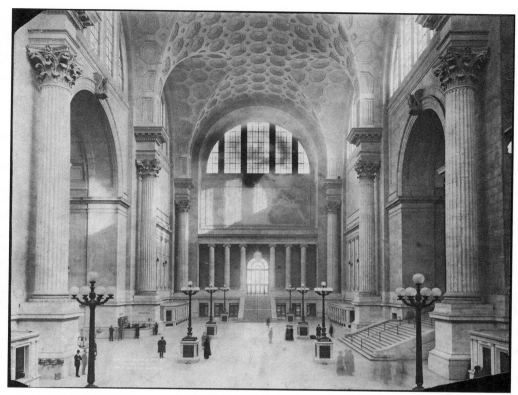

FIGURE 7.7. The waiting room of Pennsylvania Station.
© Art Resource, NY.

around the sides of the room, eight Corinthian columns measuring sixty feet high and seven feet in diameter framed the Ionic pilasters lining the lower zone of the walls. The Corinthian columns also carried the eye upward, in a breathtaking sweep that encompassed first Jules Guerin's painted topographical maps of the Pennsylvania Railroad system in the zone above the Ionic pilasters; then the eight lunette clerestory windows, each seventy-two feet in diameter; and finally the coffered, cross-vaulted ceiling 150 feet above floor level, each of its coffers ten feet in diameter. Large marble pedestals with wrought-iron candelabra were grouped in double rows along the floor, providing artificial light when that from the clerestory windows would not suffice. Only the ticket and telegraph offices against the walls were built on a human scale. Yet together, these disparate elements of the waiting room coalesced into a unified whole that evoked the monuments of the past while conjuring the promise of the present.

There are obvious—and important—similarities between the waiting room of Pennsylvania Station and the *frigidarium* of the Baths of Caracalla (see Figures 7.4, 7.7). At the most basic level, both in plan and elevation, the scale and design of the waiting room reflected its triple-bayed, cross-vaulted, lunette-lit Roman antecedent. From the exterior, precisely those eight lunette windows were the most prominent feature of Pennsylvania Station (as seen in Figure 7.1). Similarly, the classical orders deployed throughout the room—the Ionic and Corinthian columns as well as the Ionic pilasters—evoked ancient

Roman architecture in unmistakable ways. To some viewers and critics, the contrast between the overtly ancient architecture of the waiting room and its antithesis, the modern canopy of glass and steel in the concourse, must have been startling. To McKim, the Roman references in the waiting room were an essential part of his design for Pennsylvania Station. These, above all, were seen as fitting markers of monumentality in this new gateway to New York.

McKim had visited the Baths of Caracalla in June 1901 with friends and colleagues, including Daniel Burnham (the architect of Union Station, Washington, DC), Charles Moore (the urban planner best known for his role in Washington, DC's McMillan Commission), and Frederick Law Olmstead Jr. (the landscape architect behind much of New York City's urban and green space). Moore would eventually write a biography of McKim (1929), where he makes clear that McKim responded to the scale of the baths, even in their imperfectly preserved state, and that he went so far as to hire "willing but astonished workmen to pose among the ruins to give scale and movement" as McKim made sketches.[31] By 1901, the columns and vaults of the *frigidarium* had long since fallen down; therefore McKim would have seen only the standing walls during his visit. His interpretation of this space, therefore, was likely informed as much by famous nineteenth-century reconstructions, such as those undertaken by members of the École des Beaux-Arts, Paris, where McKim had been trained (see Figure 7.4),[32] as by his own spatial experiments on that day in June.

Several years after his Rome trip, the Baths of Caracalla inspired McKim's design of Pennsylvania Station. The Baths' *natatio*, for instance, served as the model for the station's concourse, and the transition between the *natatio* and *frigidarium* motivated the junction between Pennsylvania Station's concourse and general waiting room.[33] In the specific context of the waiting room, both its spatial layout and selected forms of its design—the columnar screens at the short ends of the room; the freestanding, colossal columns along its long walls; the lunette clerestory windows; and the cross vaults—clearly borrowed from the Baths of Caracalla.

The debt to Beaux-Arts reconstructions is obvious in the ways in which McKim evoked deliberately the scale of the *frigidarium* and its salient details (see Figures 7.4, 7.7) even while freely designing the waiting room's requisite décor, such as the ticket booths. No less important, however, is the legacy of McKim's spatial experiments within the Baths. The "astonished workmen" posing among the ruins clearly inflected McKim's understanding of human movement within a vast interior space. An estimated six to eight thousand bathers used the Baths of Caracalla on a daily basis.[34] The Baths' ability to accommodate large crowds and to move people effectively throughout the complex is one of the many ingenious aspects of their design and one that McKim seems to have absorbed in his visit. Overall, therefore, the Baths of Caracalla provided McKim with not just a model for architectural glamour and glory but also with a template for efficient crowd circulation.[35]

Both the extant state of the Baths of Caracalla and the influential French reconstructions of them in print at the time offered much in the way of a thought experiment for McKim. Interestingly, it seems that the fateful June 1901 visit to Rome exerted an incontrovertible influence on other members of the group as well. Daniel Burnham's design of

Union Station, Washington, DC (1903–1908), for instance, is equally indebted to ancient bath complexes (particularly those built by Diocletian and Constantine), as was the design of many train stations in both America and England in this period.[36]

To critics and the public alike, Union Station's design and plan, vast scale, and abundant use of white marble in its decoration evoked comparisons—albeit more favorable to Union Station than its antecedents—to ancient Rome. As one commentator noted, "At her greatest, Imperial Rome had no such hall as this [waiting room]."[37] Union Station was understood as a gateway to the United States capital and was praised as "the first of a series of great buildings which is to make Washington a White City that will indeed be the wonder of the world."[38] Not surprisingly, one finds echoes in the hyperbole surrounding Pennsylvania Station.[39]

Why should this have been the case? What, precisely, made ancient baths of such interest to modern architects and made the new train stations based on them such powerful— even "wondrous"—visual experiences for contemporary viewers? The Baths of Caracalla were so important to McKim and his design for Pennsylvania Station because the two spaces served parallel social functions. As McKim, Mead & White explained in publicity materials, "For inspiration, the great buildings of ancient Rome were studied, and in particular such buildings as the baths of Caracalla, of Titus, and of Diocletian, and the Basilica of Constantine, which are the greatest examples in architectural history of large, roofed-in areas adapted to assemblages of people."[40] The Baths of Caracalla are among the best preserved of these "great buildings"; presumably, both their archaeological remains and the Beaux-Arts reconstructions of them allowed McKim to develop a design for Pennsylvania Station with an aesthetic that wed the traditions of classicism with the realities of contemporary life. Indeed, McKim seems to have envisioned his general waiting room as the modern equivalent of the *frigidarium* of the Baths of Caracalla, as an enormous interior space where the largest number of people in the city were likely to congregate. The railroad lines, after all, made Pennsylvania Station a bustling urban center able to accommodate some half a million passengers each day.

McKim aimed to make Pennsylvania Station's main waiting room a place of gathering, of coming and going between journeys, as well as a monumental gateway to the metropolis. It was thus designed as a soaring space of expensive stone and giant vaults, its superhuman scale meant to impress upon the viewer both the significance of the railroad and of the city it served. In short, the architecture of the waiting room asserted the power of the Pennsylvania Railroad in much the same way that the *frigidarium* did Caracalla himself.

McKim's debt to the Baths of Caracalla is obvious in the scale and forms described above—the enormous columns and columnar screens, the lunette windows, the coffered vaults, and so on. It is equally apparent in the materials used in the waiting room (and throughout the station, for that matter). In this sense, much like the *frigidarium* of the Baths of Caracalla, the waiting room of Pennsylvania Station was also strategically decorated. But whereas the Baths of Caracalla were decorated with any number of freestanding statues,[41] sculpture was deployed on a more limited basis at Pennsylvania Station and was generally found on the exterior rather than in the interior. Both the Seventh and Eighth Avenue façades, for instance, were composed of an imposing granite colonnade of thirty-five-foot-tall,

unfluted Doric columns (see Figure 7.1). Above, the entablature and pediments (three spaced evenly along the length of each façade) were similarly unadorned. The eagles and personifications of Day and Night flanking the clocks in the central pediments were the only figural elements that relieved the powerful impression of monumental scale and the unmitigated sense of mass. The four main entrances on the cross axes of Pennsylvania Station were distinguished by personifications of *Day* and *Night* carved by A. A. Weinman. *Day* held a garland of sunflowers and looked out toward the approaching traveler; *Night* wore a cloak draped over her head and looked down to suggest the onset of darkness. As the focal point of the exterior façades of McKim's monumental gateway to New York, these personifications were evocative symbols of "the city that never sleeps."

Overall, Pennsylvania Station was comparatively more austere than its ancient predecessor. This is all the more clear when one compares nineteenth-century reconstructions of the *frigidarium*'s interior, like the one by Blouet (Figure 7.4), which implies a highly detailed surface of color, texture, and ornament, with the almost monochromatic and matte decoration of Pennsylvania Station's waiting room (Figure 7.7). With the exception of the portrait statue of Alexander Cassatt, McKim's design for the waiting room eschewed the figural tradition of, say, representations of Hercules as surrogates for Caracalla. Instead, it employed primarily aniconic elements, that is, the materials themselves. Just as the *frigidarium* of the Baths of Caracalla was embellished with polychrome marbles and granites imported from across the breadth of the Roman Empire, the waiting room of the Pennsylvania Station was decorated with travertine, the archetypal ancient Roman stone.[42]

Some critics have erroneously written that the waiting room was constructed entirely of travertine.[43] In fact, the waiting room was fashioned with a thin travertine veneer over a steel and concrete frame. This important point is most obvious in a series of photographs taken by Louis Dreyer, a commercial photographer hired by McKim, Mead & White in 1908 to document Pennsylvania Station as it was being built. Dreyer's photographs clearly reveal Pennsylvania Station's steel skeleton and curtain-wall construction. In the concourse, for instance, 650 concrete-covered steel piers, spaced around the train tracks, supported the superstructure. Above these footings rose the complex steel vaults, which took engineers two years to design. Granite was cut in panels and then attached to the steel frame as a veneer.[44] Similarly, in the waiting room, the eight giant Corinthian columns were hollow. Thin veneers of fluted travertine were wrapped around and pinned to an interior steel support. High overhead, scaffolds served as both the workroom in which the plaster coffers were cast and also as the platforms from which they were attached to the steel trusses of the vaults (Figure 7.8).[45]

The waiting room presented the viewer with a material illusion—and allusion to ancient Rome—that was ingeniously wrought. The plaster of the ceiling coffers, for instance, was dyed slightly so that its color would match the travertine veneer of the walls. And, in fact, much of what appeared to be travertine was not actually travertine. Even while promotional literature proudly advertised the fact that Pennsylvania Station was the first building in America to use travertine from the same quarries used in Roman antiquity, that travertine was used quite sparingly for pilaster bases and low-lying trim—in other words, those areas of the waiting room at, or just above, eye level with travelers. McKim, Mead &

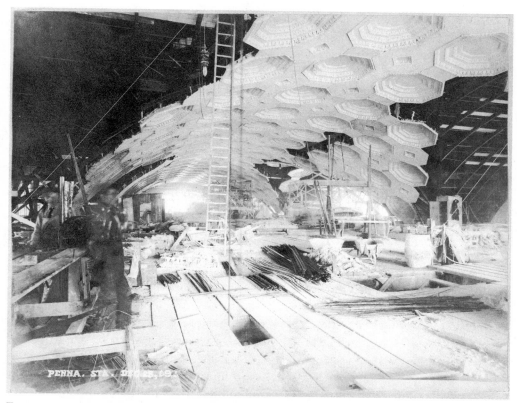

FIGURE 7.8. The waiting room of Pennsylvania Station under construction. Photograph by Louis Dreyer.
Courtesy of Avery Architectural & Fine Arts Library, Columbia University.

White created a formula for synthetic stone that was mixed by the workers on site for the upper zones of the walls. This faux travertine was obviously less expensive and easier to supply than its real cousin while looking enough like the real thing to fool the eye of the unwitting viewer.[46]

This faux travertine betrays an important point underlying the rationale for, and design of, Pennsylvania Station and its waiting room. Clearly McKim had absorbed the lessons of the Baths of Caracalla and been impressed by both the *frigidarium*'s real forms and implied splendor, collapsed vaults notwithstanding. Indeed, like the ancient architects of Roman baths, who covered the brick and concrete cores of those buildings with expensive, imported stones, McKim hid the steel skeleton of Pennsylvania Station behind a veneer of granite and travertine.

Within the *frigidarium*, the so-called imperial marbles and granites used throughout the room signified the emperor Caracalla's omnipotence and global reach, while the Herculean imagery underscored the beneficent patronage that endowed not just the baths themselves but the style of living they enabled. In lieu of Egyptian granite or porphyry, McKim turned to travertine (or, in places, the illusion of travertine) to signal a similar message. In Pennsylvania Station's waiting room, the strategic use of travertine—that most

quintessential of Roman stones—likewise heralded the Pennsylvania Railroad's reach. As a visual reinforcement to the aniconic stone elements deployed on the lower zones of the walls, Jules Guerin's topographical maps just above, in the middle zone of the walls below the clerestory windows, eloquently illustrated and emphasized the widespread geography united by the Pennsylvania Railroad and brought together, at their tracks' terminus, at Pennsylvania Station (see Figure 7.7).

Conclusion

This chapter has aimed to understand the connotative potential of the Baths of Caracalla and to highlight the ways in which the scale, materials, and decoration of their largest room, the *frigidarium*, stressed the accomplishments and ambition of the baths' eponymous imperial patron. In so doing, the *frigidarium* served as an invaluable archetype after which the main waiting room of Pennsylvania Station could be modeled. There too, the architecture and its decoration signaled the achievements of the Pennsylvania Railroad nearly two millennia later.

Within the waiting room, the viewer was presented with a grandiose space unlike any other in the city, one in which he or she witnessed the power of the railroad. A traveler in Pennsylvania Station's waiting room, seeing Alexander Cassatt's portrait statue or Jules Guerin's topographical maps of the Pennsylvania lines, would be reminded that the Pennsylvania Railroad had forged tunnels of steel under canyons of water, linking city and continent for the first time.

In the end, Cassatt and McKim's vision created a monument not just to the railroad but also to New York City. Pennsylvania Station, although in reality a private building, lived in the public mind and in daily routines as a civic space. Small wonder, then, that throughout its construction and lifetime of use Pennsylvania Station captured the imagination. Almost as soon as the clearing of the site had begun, spectators came to Seventh Avenue and Thirty-Second Street to watch the new station emerge from the dust and debris of the buildings that had once stood there. As construction neared completion, anticipation swept New York.

September 8, 1910, marked the official opening of the new Pennsylvania Station, although the only trains operating that day were commuter ones for the Long Island Railroad. Two months later, on November 27, full service began for long-distance passengers. On that momentous Sunday, more than two thousand people waited to come inside when the doors of the new station opened. In all, more than one hundred thousand curious spectators and twenty-five thousand westbound passengers mobbed Pennsylvania Station on its first day (Figure 7.9).[47] Visitors and passengers alike were not disappointed. "The station," the *New York Times* reported, "is the largest and handsomest in the world. Any idea of it formed from description and pictures falls short of the impression it makes upon the eye."

In retrospect, it is difficult to fathom the ambition and scale of the planning that led to the successful completion of Pennsylvania Station and its associated tunnels. It is also incredible to reconcile this new station, and all that it stood for at the time of its inaugura-

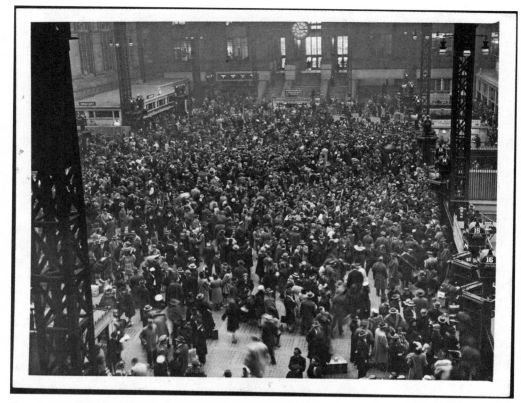

FIGURE 7.9. Crowds at Pennsylvania Station, New York, on opening day, November 27, 1910. © Art Resource, NY.

tion in 1910, with the fact that within decades, modern American life had been so completely transformed that Pennsylvania Station could change from being an indispensible part of daily life to an anachronism of previous eras, much like the Roman baths after which the station was modeled. Planes and cars displaced the train, and Pennsylvania Station met an inglorious end, its glorious architecture demolished in 1963 to make way for the new Madison Square Garden.

NOTES

1. Carl Condit, *The Port of New York*, vol. 1: *A History of the Rail and Terminal System from the Beginnings to Pennsylvania Station* (Chicago: University of Chicago Press, 1980), 162.

2. Brian J. Cudahy, *Over and Back: The History of Ferryboats in New York Harbor* (New York: Fordham University Press, 1990).

3. Condit, *Port of New York*, 1:162.

4. The Pennsylvania Railroad Company, *The New York Improvement Project and Tunnel Extension of the Pennsylvania Railroad* (Philadelphia: Pennsylvania Railroad Company, 1910), 6.

5. In 1892, the Pennsylvania Railroad's options were assessed in a special report prepared by Samuel Rea, then special assistant to the president of the railroad and later its ninth president (1913–25). Rea outlined five potential solutions—whether by bridge or tunnel, whether with long-distance or rapid-transit trains, and so on—by which the Pennsylvania Railroad might reach

Manhattan. Ultimately, none of these five preliminary options corresponded exactly with the final, executed plan. On Rea's 1892 report, see the summaries in H. W. Schotter, *The Growth and Development of the Pennsylvania Railroad Company: A Review of the Charter and Annual Reports of the Pennsylvania Railroad Company 1846 to 1926, Inclusive* (Philadelphia: Allen, Lane & Scott, 1927), 271–74; Condit, *Port of New York*, 1:264–65; Hilary Ballon, *New York's Pennsylvania Stations* (New York: Norton, 2002), 21–23.

6. On the importance of European models for the design of Pennsylvania Station, see Janet DeLaine, "The *Romanitas* of the Railway Station," in *The Uses and Abuses of Antiquity*, ed. Michael Biddiss and Maria Wyke (New York: Peter Lang, 1999), 152–55; Jill Jonnes, *Conquering Gotham: A Gilded Age Epic: The Construction of Penn Station and Its Tunnels* (New York: Viking, 2007), 55–62.

7. For a precise description of the route, construction methods, and costs of the Pennsylvania Tunnel Extension and Terminal Project, one of the largest and most expensive civil-engineering projects to that date in the United States, see Coverdale & Colpitts Consulting Engineers, *The Pennsylvania Railroad Company: Corporate, Financial, and Construction History of the Lines Owned, Operated and Controlled to December 31, 1945*, vol. 1: *Leased Lines East of Pittsburgh* (New York: Coverdale & Colpitts Consulting Engineers, 1946), 3–43. For a summary of the project, see Ballon, *New York's Pennsylvania Stations*, 24–25.

8. The appointment letter that Cassatt sent McKim later that day is today preserved as Letter from Alexander Cassatt to Charles McKim, April 24, 1902, New-York Historical Society, McKim, Mead & White Corr., Pennsylvania Station, File 3.

9. In 1902, when the extension was launched, the gross revenues of the Pennsylvania Railroad were slightly under $113 million, with both passenger and freight traffic increasing every year. The company could afford the building program. Condit, *Port of New York*, 1:268. The exact cost as of December 31, 1910, was reported as $112,965,415 in the Pennsylvania Railroad's annual report. *The New York Improvement and Tunnel Extension of the Pennsylvania Railroad*, 4; Schotter, *Growth and Development of the PRR*, 318.

10. On October 29, 1905, for instance, the *New York Herald* reported: "The appearance of the busiest sections of the Panama Canal is reproduced in realistic fashion within a block of Broadway. The immense tract bounded by Seventh and Ninth Avenues and Thirty-First and Thirty-Third Streets today is a very anthill of activity. As quickly as the buildings disappeared from this once closely populated district an immense amount of excavating machinery was installed. Railroad tracks were laid in every direction and the ground soon lost all semblance of its former civilization. To-day the resemblance to the canal zone is complete."

11. New York City did close Thirty-Second Street between Seventh and Tenth Avenues and transferred ownership of that street to the Pennsylvania Railroad for a relatively low price; this was the only form of municipal subsidy the project or railroad received. See Ballon, *New York's Pennsylvania Stations*, 25.

12. Letter from Samuel Rea to Ivy Lee, January 11, 1907, Hagley Museum and Library, Acc. 1810, box 149, folder 22. See also Ballon, *New York's Pennsylvania Stations*, 33n22.

13. The scale of the tunnels' construction is hard to imagine. By August 1907, five million bricks and six thousand truckloads of timber, iron fixtures, and stone had been hauled to the building site. By May 7, 1908, when the final heading of the second Hudson River tube, the last of all the headings and tunnels the Pennsylvania Railroad had driven, was blown away in a final blast of dynamite, thirteen miles of tunnels had been dug and three million cubic yards of rock and earth scooped out by the "sandhogs" excavating the tunnel systems. See Lorraine B. Diehl, *The Late, Great Pennsylvania Station* (New York: American Heritage, 1985), 75, 77, 96.

14. On the Baths of Caracalla, see Janet DeLaine, *The Baths of Caracalla: A Study in the Design, Construction, and Economics of Large-Scale Building Projects in Imperial Rome* (Portsmouth, RI: Journal of Roman Archaeology, 1997); Maryl B. Gensheimer, *Decoration and Display in Rome's Imperial Thermae: Messages of Power and Their Popular Reception at the Baths of Caracalla* (Oxford:

Oxford University Press, forthcoming). On the Septizodium and other Severan buildings in this area of the city, see Susann S. Lusnia, *Creating Severan Rome: The Architecture and Self-Image of L. Septimius Severus, AD 193–211* (Brussels: Collection Latomus, 2014).

15. The imperial baths' standard plan is defined as having cross-axial symmetry; centralized main rooms with a projecting *caldarium*; internal *palaestrae*; a large *natatio*; and a formal, exterior precinct with secondary spaces for cultural activities unrelated to bathing. Daniel Krencker, *Die Trierer Kaiserthermen* (Augsburg: B. Filser, 1929), 263–82; Fikret Yegül, *Baths and Bathing in Classical Antiquity* (Cambridge, MA: MIT Press, 1992), 128–33.

16. These are, in order, the open-air swimming pool, the room with cold bathing pools, the room with tepid bathing pools, and the room with warm bathing pools.

17. Neither DeLaine's nor Jenewein's discussion of these architectural elements definitively identify the stone used in their construction as either Aswan or Mons Claudianus granite. In the absence of isotopic analysis, I refer to this stone only as "Egyptian" granite. See DeLaine, *Baths of Caracalla*, 262; Gunhild Jenewein, *Die Architetkturdekoration der Caracallathermen*, vol. 1: *Textband* (Vienna: Verlage der Österreichische Akademie der Wissenshaften, 2008), 123–36.

18. The *frigidarium* accommodated four large basins of cold water. The two northern pools were directly linked to the *natatio*, feeding into the latter via a waterfall. See Marina Pirano-monte, "Thermae Antoninianae," in *Lexicon Topographicum Urbis Romae*, vol. 5: *T–Z, Addenda et corrigenda*, ed. Eva Margareta Steinby (Rome: Edizioni Quasar, 1996), 46.

19. DeLaine, *Baths of Caracalla*, 262–63; Jenewein, *Architekturdekoration der Caracallathermen*, 123–36. For a synthesis, see Gensheimer, *Decoration and Display*.

20. Building projects that made extensive use of stone are among the most expensive of those recorded in the epigraphic record. See Ben Russell, *The Economics of the Roman Stone Trade* (Oxford: Oxford University Press, 2014), 27n111–14.

21. DeLaine, *Baths of Caracalla*, 218–19.

22. For a more extensive discussion, see Gensheimer, *Decoration and Display*.

23. For a fuller treatment of both these statues and the figural decoration of the *frigidarium* and the Baths of Caracalla more generally, see Gensheimer, *Decoration and Display*.

24. This statue type shows Hercules exhausted after the successful completion of his final Labor. He leans on his club for support while holding the Apples of the Hesperides behind his back, in his right hand. See Olga Palagia, "Heracles," in *Lexicon iconographicum mythologiae classicae*, vol. 4: *Eros–Herakles* (Zurich: Artemis Verlag, 1988), 728–838.

25. Antonio da Sangallo notes their findspot on a sketch (Uffizi 1206) that records the ongoing Farnese family excavations of 1545–46. This is reproduced in Paolo Moreno, "Il Farnese ritrovato ed altri tipi di Eracle in riposo," *Mélanges de l'École française de Rome* 94 (1982): 391, fig. 5; Miranda Marvin, "Freestanding Sculptures from the Baths of Caracalla," *American Journal of Archaeology* 87 (1983): 356, fig. 4; Leonardo Lombardi, Angelo Corazza, and Filippo Coarelli, *Le Terme di Caracalla* (Rome: Fratelli Palombi, 1995), 197, fig. 123.

26. Eugen von Mercklin, *Antike Figuralkapitelle* (Berlin: de Gruyter, 1962), 158–60, no. 385a–d, figs. 751–58; DeLaine, *Baths of Caracalla*, 71, fig. 43; Jenewein, *Architekturdekoration der Caracallathermen*, 44–52.

27. See, for instance, Palagia, "Heracles," 796, nos. 550, 695, 696. A particularly well-preserved example is the so-called Conservatori Commodus portrait of that emperor, which depicts Commodus in the guise of Hercules, wearing the Nemean lion skin and holding his club in one hand, the Apples of the Hesperides in the other. On this portrait, see Robert Hannah, "The Emperor's Stars: The Conservatori Portrait of Commodus," *American Journal of Archaeology* 90 (1986): 337–42.

28. Ovid, *Metamorphoses*, trans. F. Miller, rev. G. P. Goold (Cambridge, MA: Harvard University Press, 1984), 9.249–272.

29. Patricia T. Davis, *End of the Line: Alexander J. Cassatt and the Pennsylvania Railroad* (New York: Neale Watson Academic Publications, 1978), 4. Sadly, when Pennsylvania Station was

demolished in 1963, Cassatt's portrait statue, along with thousands of tons of rubble, was dumped unceremoniously in New Jersey's Meadowlands.

30. It was so large, in fact, that in 1929, when the Pennsylvania Railroad partnered with the Santa Fe Railroad and Transcontinental Air Transport, Inc., to inaugurate a rail-air service between New York City and Los Angeles, a Ford Trimotor plane could be comfortably installed in the waiting room to promote the new route. See Diehl, *Late, Great Pennsylvania Station*, 124, 128. "The Pennsylvania Station in New York City, at Seventh Avenue and Thirty-Second Street, now completed, covers more territory than any other building ever constructed at one time in the history of the world. The Vatican, the Tuileries, the St. Petersburg Winter Palace, are larger buildings, but they have occupied centuries in their construction. The Pennsylvania Station is unique, covering as it does eight acres of ground, with exterior walls extending approximately one-half of a mile, all told, and having been erected in less than six years' time. This Station is not only the largest structure of its kind in the world, but it epitomizes and embodies the highest development in the art of transportation." The Pennsylvania Railroad Company, *The New York Improvement Project*, 3.

31. Charles Moore, *The Life and Times of Charles Follen McKim* (New York: Houghton Mifflin, 1929), 275. See also Ballon, *New York's Pennsylvania Stations*, 65n59.

32. Mosette Broderick, *Triumvirate: McKim, Mead & White: Art, Architecture, Scandal, and Class in America's Gilded Age* (New York: Knopf, 2010), 13–22. Given McKim's training, it seems likely that he would have been familiar with the reconstruction by Guillaume-Abel Blouet, the École's Prix de Rome winner in 1821, published in Blouet's *Restaurations des thermes d'Atonin Caracalla* (Paris: Firmin Didot, 1828), pl. 15.

33. DeLaine, "The *Romanitas* of the Railway Station," 153.

34. Lombardi, Corazza, and Coarelli, *Le Terme di Caracalla*, 58.

35. It is interesting to know that whereas McKim's design for a modern train station derived from his understanding of an ancient bath complex, his partners did not likewise share that aesthetic. When the New York Central held a design competition for its new station early in 1903, Stanford White chaired the McKim, Mead & White entry. White's design for the Grand Central Terminal envisioned a sixty-story skyscraper straddling Forty-Second Street, with vehicular traffic passing through arcades on the street level. Although the design was declined, after White's death, his office tweaked White's scheme for Grand Central. William Kendall's modified version was submitted for the Manhattan Municipal Building, which was built between 1907 and 1914 and still stands. Broderick, *Triumvirate*, 461–64.

36. DeLaine, "The *Romanitas* of the Railway Station."

37. L. Mechlin, "New Public Buildings at Washington, II. The Union Station," *Architectural Record* 24 (1908): 192. Quoted in DeLaine, "The *Romanitas* of the Railway Station," 153n36.

38. T. Starrett, "The Washington Terminal," *Architectural Record* 18 (1905): 437. Quoted in DeLaine, "The *Romanitas* of the Railway Station," 153n34.

39. See the "Notes and Comments" section of *Architectural Record* 27 (June 1910): 519–20. "Probably no larger nor costlier building than the station has been under construction concur-rently with it. . . . The area of the station is enormous. . . . The area is thus not far from 300,000 square feet, half as much again as that of St. Peter's, nearly three times that of Milan. Doubtless we are dealing with a 'big thing.'" See also note 30.

40. Columbia University, Avery Architectural and Fine Arts Library, Dept. of Drawings and Archives, McKim, Mead & White Collection, Operations Records Notebook, 2. See also Ballon, *New York's Pennsylvania Stations*, 66n62; Broderick, *Triumvirate*, 463–64.

41. Gensheimer, *Decoration and Display*.

42. Pliny, *Natural History*, trans. D. E. Eichholz (Cambridge, MA: Harvard University Press, 1962), 36.5, recounts Cicero's facetious reply to the people of Chios, who showed him their multicolored marble walls: "I should be more amazed if you had made them of stone from Tibur

[travertine]." See Russell, *Economics of the Roman Stone Trade*, 14, for the symbolism attached by the Romans to local travertine versus imported marbles.

43. Diehl, *Late, Great Pennsylvania Station*, 109, for instance, writes that the room was "built almost entirely of travertine."

44. Note that while the interior of Pennsylvania Station made use of stone veneers, the exterior façade and its Doric colonnades were built with solid stone. A total of 550,000 cubic feet of pink granite, transported in 1,140 freight cars from the quarry at Milford, Massachusetts, went into the exterior construction. See Davis, *End of the Line*, 174.

45. Ballon, *New York's Pennsylvania Stations*, 43–52; Broderick, *Triumvirate*, 464.

46. Columbia University, Avery Architectural and Fine Arts Library, Dept. of Drawings and Archives, McKim, Mead & White Collection, Operations Records Notebook, 2. See also Ballon, *New York's Pennsylvania Stations*, 52n48.

47. Jonnes, *Conquering Gotham*, 292, quotes the figures given in the *New York World* on Pennsylvania Station's opening day.

The Roman Bath in New York: Public Bathing, the Pursuit of Pleasure, and Monumental Delight

Allyson McDavid

Introduction

During the Progressive Era (ca. 1890–1920), American cities aspiring to urban sophistication admired and often appropriated the architectural grandeur of Roman baths, and New York was no exception. In ancient Rome, the massive structures that housed the *thermae* (hot springs or baths) reflected the importance of public bathing throughout the empire. At the same time, they met several other municipal aims: They integrated impressive design and complex engineering, won praise for their founding emperors and aristocratic sponsors, and gained cultural preeminence for the cities in which they were built.[1] In addition, they celebrated the empire's prosperity and were accessible to even the poorest plebeians. Indeed, baths proved indispensable to urban monumentalization—in particular during the high imperial period (ca. 100–300 CE)—for three key reasons: They provided an incomparable service to public health, furnished a social destination, and demonstrated highly sophisticated architectural feats. Being able to imitate at least some features of the Roman bathing model was desirable for many American cities at the turn of the nineteenth and twentieth centuries, but the process of assimilation was often slow and evolutionary.

As the epitome of Roman thermal architecture, the Baths of Caracalla (217 CE) and of Diocletian (306 CE) were sources of particular inspiration for New York City (Figure 8.1). Beyond the provision of bathing facilities, they included amenities for exercise, leisure, dining, and study that offered the inhabitants of high imperial Rome an unparalleled phenomenological experience. Given their architectural and experiential legacy, these baths appealed

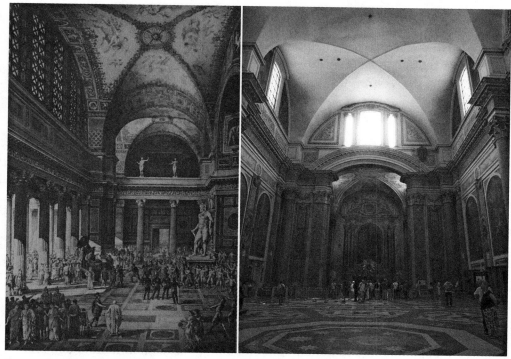

FIGURE 8.1. *Frigidarium* of the Roman Baths of Diocletian, 306 CE.
(*left*) Artist's rendition. The Wriston Art Center Galleries, Lawrence University. (*right*) Restoration as the Church of Santa Maria degli Angeli. A. McDavid.

to New York City in its pursuit of metropolitan status, but the burgeoning city's adoption of the classical ideal was neither instantaneous nor fully replicated. It instead took considerable time and significant adaptation of the Roman model to approximate that definitive synthesis of functional, civic, and aesthetic goals.

While studies in the reception of imperial baths in New York City have largely centered on the aesthetic formalism of such buildings as Old Pennsylvania Station (1910) and the New York Public Library (1911), these outstanding civic monuments may be considered the mature phase of a longer trajectory in the city's cultural evolution and in its attitude toward ancient bath complexes. For Romans, the baths' impressive structure was but one aspect of an institution devoted to hygienic practice, communal experience, and technical ingenuity. By comparison in New York, civic duty, social inclusion, and providing basic infrastructure were issues fraught with debate and compromise. This chapter investigates how contemporary social and economic policy influenced the adoption of ancient bathing culture in New York City at a time of intense urban development, between the mid–nineteenth and early twentieth centuries. It presents a survey of architecture that variously informed public bathing, gave residents a sense of community, and symbolized the city's cultural aspirations. I focus in particular on the benefits to hygiene, the importance of recreation and the prospect of pleasure, and monumentality as a principle of design. New York City seems to have prioritized singular Roman ideals to develop bathing

facilities for an impoverished public, social clubs, and transportation and cultural infrastructure. Although these buildings reflect Roman thermal ancestry, their diverse interpretation reveals that the cohesive enterprise of imperial *thermae*—at once offering public bathing, the pursuit of pleasure, and monumental delight—had fragmented into discrete imperatives for the progressive city.

A Philanthropic and Municipal Necessity

Public bathing in New York was cautiously implemented in the nineteenth century. Though the first philanthropic baths were founded in 1852, the institution only became a municipal priority in the late 1800s; still, the city was at the forefront of what was to become a nationwide trend. Gotham's need of public baths reflected concern about the rapid urban growth, increasing population density, and burgeoning class disparities of the Industrial Revolution.[2] Taking cues on slum improvement from older, European urban centers, public baths addressed social ills and planning challenges in their provision to the predominantly poor: They would stem the spread of disease through tenement neighborhoods, promote good health, and reduce the visible (and olfactory) scourge of immigrant populations thought to be reluctant to wash. The apparent predilection of these new residents to endure personal uncleanliness was considered a sign of their otherness, even though by the end of the nineteenth century, some 97 percent of tenement residents had neither private washrooms nor access to public ones.[3] Even after passage of the Tenement House Act of 1867, landlords remained exempt through the early twentieth century from retrofitting existing buildings to include private washing facilities, which left only one in seventy-nine apartments with access to a specific bathing room. The 1901 Tenement House Commission codes also persisted in omitting bathtubs as a requirement so as not to unduly burden property owners.[4]

A dearth of bathing facilities for the working-class populace and the widespread uncleanliness that resulted were emblematic of material poverty, but being physically unclean also implied spiritual destitution and an unwillingness to assimilate into American society.[5] Public bathing's début in New York optimistically sought to bring about physical, moral, patriotic, and economic rectitude. For Lower Manhattan during the Progressive Era, the need for this amenity as a municipal (and Christian) engine of social control to "serve the public good" was voiced by a coalition of reformists and associations with patrician agendas running the gamut of social, political, and religious policy.[6] These groups, including the Temperance Society, the Young Men's Christian Association, the Society of St. Tammany, the Committee of Seventy, and the Association for Improving the Condition of the Poor (AICP, founded in 1843, later becoming the American Association for Promoting Hygiene and Public Baths in 1912), were composed primarily of upper-middle-class citizens. Their aim was not only to see to the physical well-being of the poor but also to inculcate self-respect and abolish the violence, vice, and crime that incubated in the slums. The public bath became a means to reform in late-nineteenth-century New York, as one of society's educational and disciplinary tools.[7]

With the successful completion of the Croton Aqueduct in 1842 and a comprehensive sewer system in the 1850s, crucial infrastructure was finally in place for citywide hygienic improvement. Still, municipal sponsorship of public bathing facilities only began in earnest fifty years later, due either to skepticism about their civic benefit or to an inability or reluctance to underwrite them. Instead, New York's private, reformist groups took on the philanthropic responsibility and looked to England and France for architectural solutions to the problem of making the city's burgeoning population clean. With neoclassical templates from the British architects Allsop and Cross readily available in print, these ambitious complexes promised amelioration for the disadvantaged in New York.[8] By 1852, the AICP built, with private funds including the support of one of its moneyed founders, Robert B. Minturn, the city's first public bath on 141–43 Mott Street. The People's Washing and Bathing Establishment opened to acclaim, with plunge pools and ambulatory leisure spaces that drew design inspiration from British models, built for distinct social classes and additionally separated by gender.[9] The civic experiment was a success, serving over ninety thousand bathers per year, which encouraged the AICP to lobby municipal government to provide additional baths for the poor as a right rather than as an unjustifiably expensive luxury. Less than a decade after their inauguration, however, the Mott Street baths closed in 1861, on account of low attendance stemming from Civil War economic austerity; they were summarily demolished. The institution of public bathing required sustained government backing to thrive, but almost forty years elapsed before the city intervened in 1901.

Thanks in part to the groundbreaking study of germ theory in the preventable spread of disease in London during the 1880s, systemic hygienic measures were implemented in New York City, particularly in the overcrowded tenements south of Fourteenth Street.[10] Public baths had proven an effective deterrent to the spread of disease in urban nineteenth-century Europe, where officials embraced the model endorsed by the ancient Greek physician Galen (129–ca. 200 CE), a physician of highest regard in the Roman Empire. His opinion on the medical benefits of bathing echoed those held by earlier Hippocratic masters, but Galen's advice centered on active ritual, not just ablutions per se. His holistic regimen recommended using pools of varied temperature, including hot (*caldaria*), warm (*tepidaria*), cold (*frigidaria*), or open-air pools (*natationes*); the efficacy of moving through these spaces to aid circulation; and a reliance on exercise in *gymnasia* within the complex prior to washing.[11]

Despite the longstanding tradition of European bathing establishments, their adoption was a risky proposal for New York, given that its poor would be situated in uncomfortably close proximity to the wealthy, regardless of formal division by social class. By comparison, the recent invention of the *Volksbad* ("people's bath") shower in 1883, designed by the German physician Oscar Lassar for the sole use of the lower classes, became a preferred option, given its ease of construction, efficiency, and low maintenance costs. Its introduction in lieu of communal pools matched the American embrace of innovation, efficiency, and economy during the Industrial Age.[12] But the decision between Roman-style communal baths and a solitary, prescriptive experience had not yet been made in New York; the city oscillated between modified versions of each, with each counting powerful political allies.

In 1890, Richard Morris Hunt and Cornelius Vanderbilt II solicited the expertise of the American architect and École des Beaux-Arts graduate John Galen Howard, who proposed a monumental public-bathing project. While simultaneously poised to redesign University of California–Berkeley campus into a neoclassical "City of Learning," he envisioned for New York an expansive Roman, freestanding architectural complex akin to the Baths of Caracalla, which would include communal pools, steam rooms, lounges, and an elegant domed gymnasium (Figure 8.2).

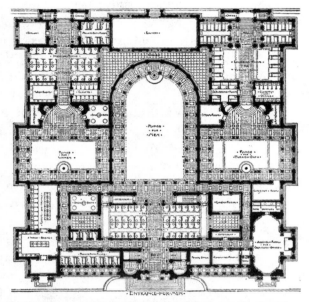

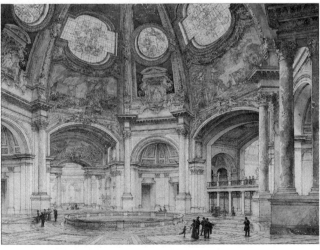

FIGURE 8.2. Plan and Central Hall of John Galen Howard's winning municipal bath proposal for New York, 1890. Never built.

(*top*) *Cosmopolitan*, August 9, 1890, 416. (*bottom*) University of Californa–Berkeley, Environmental Design Archives. Howard (John G.) Collection.

This bath, to be underwritten by private philanthropy,

> would be an American imitation of the noblest work of a Roman emperor—a truly imperial gift not out of keeping with the highest ambitions for the welfare of one's fellow citizens . . . to at once beautify the city, to render a forever-to-be-appreciated favor to the public and bestow an immense benefit upon the very poor. . . . Should a building be erected with one tenth of the adornments found in the old Roman baths, which contained the most beautiful statuary, mosaics and sculptures, it would be impossible for anyone to assume for a moment that an unworthy gift was being thrust upon one taking a bath at the price of seven cents.[13]

The bath was never built. Instead, advocates of military efficiency and new hydrotherapeutic methods envisioned baths for the poor as primarily remedial, not as a luxurious enterprise. Championed by Simon Baruch, a German-born physician and staunch proponent of the *Volksbad* model who had the ear of AICP reformists (whose first baths on Mott Street had failed in 1861), these new philanthropic baths would adopt showers because they seemed successfully to eliminate "the danger of contagion."[14] Individual shower stalls obviated the need for pools or communal tubs, whose use was considered both poor hygienic practice and a waste of resources. New York City's public baths followed this new model, which prioritized economy, eliminated aspects of leisure and community activity that were part of the Roman ideal, and transformed baths into instruments solely of reform. The first bath to be commissioned using this strategy, the People's Bath at 9 Centre Market Place in Little Italy, was inaugurated in 1901.[15] Not only a vehicle for cleanliness, baths were to instill proper etiquette, deter radical politics, and, at least on a superficial level, promote tolerance among the classes.[16]

By this point, only two philanthropic baths had been built, the first already defunct. Municipal leaders were in despair, as a Mayor's Committee report from 1897 reveals: "What a melancholy contrast to such enlightened public zeal (as Rome showed by its numerous public baths) in behalf of the health of its people does New York City present?"[17] The authors of this report clearly understood that Roman baths could be both physical and cultural models for the city; they railed against the inert political will that prevented the all-inclusive Roman archetype from being built. It was only at the turn of the twentieth century that government took the lead in underwriting public baths, with consultation from influential members of the charitable reformist groups. The first of these municipal baths was the 326 Rivington Street Baths, established in 1901 (Figure 8.3).

Initially to be built on Tompkins Square Park, at double the size of the People's Bath and boasting a freestanding, neoclassical exterior envelope in the spirit of European bathhouses, it was intended to reflect the social and architectural monumentality sought by the city—but only superficially, as it was to be fitted with shower stalls instead of pools.[18] Protests, however, by area residents over its seemingly outsized scale compared to that of the existing neighborhood forced the baths to instead be built on two contiguous lots of Rivington Street. The grand exterior that had been envisioned was reduced to a fifty-foot decorated façade wedged into the city grid. The extraordinary success of this design, which combined efficacy with the restorative facilities of brief and upright showers, ensured a

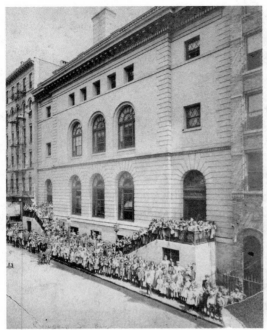

FIGURE 8.3. 326 Rivington Street Baths.
(*left*) Courtesy of the Museum of the City of New York. (*right*) Courtesy of the Library of Congress.

high turnover of clientele; its ease of maintenance led to the almost wholesale adoption of the form throughout the city. Its modularity, ideal for insertion into the twenty-five-foot-wide grid lots of Manhattan, became a template that enabled rapid construction of new facilities and the renovation of existing buildings to accommodate this sought-after utility. Between 1901 and 1914, some seventeen public baths were constructed in Manhattan, following a template developed by the American architects York & Sawyer for single and double lots.[19] On the political front, the needs of the voting public affected what was built and what was not: Location, scale, funding, and legacy were all factors in the resulting accessible bath infrastructure of the city. The New York–style shower bath became the de facto template for municipal baths across the country, favoring efficiency over the provision of leisure or the integration of the social classes.

The success of the Rivington Street model forever precluded the need for a sprawling footprint. Bathhouses were instead designed to fit narrow Manhattan lots by eliminating lounge and rest spaces and replacing communal pools with showers. Public bathing became a mundane duty, with the added indignity of rushed, unceremonious egress through the rear of the building. The People's Baths and subsequent establishments eschewed the vaulted, decorative, light-filled interiors that were hallmarks of imperial *thermae*, opting instead for flat, unarticulated surfaces finished with cement, tile, and enamel—industrial materials easy to maintain. The exterior frontage became the sole opportunity for decoration. Early execution was varied and reflected ongoing debate over the responsibility of philanthropic and municipal baths to the public. For philanthropic baths backed by private

reformist groups, decoration was seen as an economically wasteful architectural pretense that did not serve the poor for whom the baths were built; these sponsors also believed that the lower classes did not appreciate beauty. The resulting exteriors expressed restraint, ostensibly so as not to intimidate the bather but effectively to devote construction funds entirely to function. Municipal advocates, on the other hand, observed the civic potential of architecture to convey the dignity of the institution (at least on the outside), and imitated classical Roman architecture for this purpose.[20] Arnold W. Brunner, an architect of municipal baths, wrote in 1904:

> All the buildings erected by the city should have a distinguishing character; and there is not a gain, but a distinct loss, in allowing the use of unrelated styles or no styles, in schools, fire, police and hospital buildings; that it would be much better to hold the designing within certain lines for these buildings, and that uniform architecture be maintained for each function which shall make it recognizable at first glance.[21]

Though the buildings were primarily built of brick, neoclassical flourishes in limestone were applied to their façades, expressed in impressive tripartite arches, monumental columns or pilasters, grand entry platforms, and large windows. Reflecting Victorian sensibilities, gendered entrances were placed on opposite ends of the exterior, which led to separate waiting and shower rooms. The white limestone masonry affixed to these frontages appropriately suggested a cleanliness that would encourage use of the bathing facility. Cartouches typically depicting nautical themes bracketed the upper façade, and a classical entablature contained a frieze identifying the baths, all capped with an additional flourish of a neoclassical balustrade. The 347 West Forty-First Street Baths (1904), the city's second municipal sponsorship, was the first of the standardized plans bearing the neoclassical façade for which the New York baths became known and that were subsequently adopted nationally.[22]

Bathing for Recreation

While Roman baths were well known for keeping citizens clean and healthy, it was the pursuit of pleasure that made them premier social destinations and incubators of an extraordinary sensual experience.[23] But New York's early, piecemeal adoption of Roman bathing culture—first and foremost as a means to promote personal hygiene—reveals an uncoupling of the relationship between thermal architecture and its sensual potential. Progressive Era values conceptualized public bathing through the puritan lens of societal reform and acculturation; there was also Victorian discomfort with any sensory engagement that potentially could encourage vice. Municipal and philanthropic baths established by the turn of the twentieth century were therefore eviscerated versions of the Roman model, physically diminished by the high cost of real estate and an abiding focus on efficiency and resource conservation at the expense of pleasure. This was standard practice in the years following the Depression of 1893: Bath construction advocated clinical virtues of industry, technology, and scientific discovery and disdained the component of leisure.[24]

But even the poor cringed at the establishment of New York's public baths as purely remedial missions, being granted brief, twenty-minute showers after waiting for hours in utilitarian, gender-segregated halls, monitored by security guards and attendants who ejected them from the premises immediately afterward. While the lowest classes did use these baths, they complied reluctantly and seasonally, largely abandoning the effort to become clean, virtuous, and more American during the winter months. When they did avail themselves of this charity, breaches of etiquette were frequent, though these often were harmless attempts to wring some semblance of pleasure from the experience.[25] The holistic notion of Roman bath culture that simultaneously addressed functional, aesthetic, and civic aspirations was not yet achieved by New York, which instead institutionalized a practice with limited opportunity for relaxation and enjoyment.[26]

The poor largely rejected this experiment in efficiency and germ abatement for freestanding, floating pools that were first docked along the East and Hudson Rivers in 1870, which grew to fifteen by 1890.[27] Their immense popularity was impossible to ignore and was closely linked to the decline in attendance at the public baths, which lacked recreational pools, as was duly noted in this 1907 assessment:

> A *natatorium* can have, of course, only partial value as a cleansing place; but as an instrument for teaching the habit of bathing in cool weather, the natatorium could be far more useful than any other feature that might be introduced into a public bath. They would accelerate . . . the acquisition, especially in the formative period of life among the young, of the habit of bathing.[28]

Public bathing would become a social and economic failure if it continued as a solely hygienic mission.

Seizing the opportunity to combine function and recreation, the new West Sixtieth Street Baths (1906, Werner & Windolph) (Figure 8.4) incorporated a basement-level swimming pool within its four-level plan, whose large skylights illuminated the underground facility. A similar pool had been successfully installed in the private New York Athletic Club on Fifty-Ninth Street at Central Park South two decades earlier, in 1886.[29] By 1908, the ideological shift to view bathing as both hygienic *and* recreational was cemented in municipal consciousness with the construction of the Public Baths at Asser Levy Place and East Twenty-Third Street (1908, Aiken and Brunner), on a generous plot of land donated by the Department of Parks and Recreation (Figure 8.5).

Having been awarded adequate space and finances, a Beaux-Arts-style, single-story, expansive bath complex long desired by the city was built, surviving pressure from the AICP that changed the initial design from two large pools to a single pool and the newly pervasive, gender-segregated shower stalls.[30] Still in use today as a public recreation center and gymnasium, its monumental red-brick envelope is dressed with white limestone features that imitate the marble once imported from prized quarries to decorate imperial baths. The building's tripartite façade is divided by eight freestanding monolithic columns that support a stone entablature inscribed with a dedication by the City of New York, in much the same way as imperial monuments were once designated. The large, arched windows framing the gendered entryways recall the thermal fenestration of

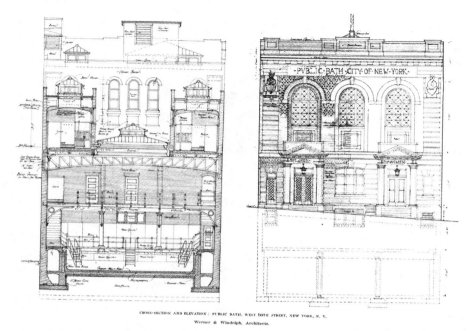

CROSS-SECTION AND ELEVATION : PUBLIC BATH, WEST 60TH STREET, NEW YORK, N. Y.
Werner & Windolph, Architects.

FIGURE 8.4. West Sixtieth Street Baths, Werner and Windolph, 1906.
The American Architect and Building News.

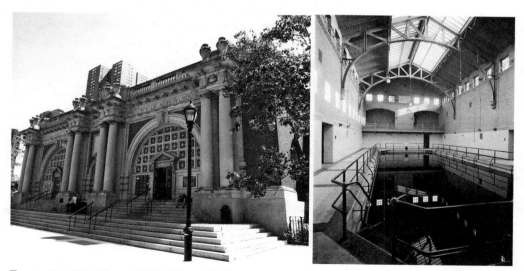

FIGURE 8.5. East Twenty-Third Street Public Baths, later renamed Asser Levy Baths. Aiken and Brunner, 1906.

(*left*) A. McDavid. (*right*) Courtesy of the Museum of the City of New York.

barrel-vaulted Roman baths, all supported on a raised platform that distinguished highly visible imperial buildings. The Asser Levy Baths' bathing and leisure activities drew up to 18,000 visitors a day, compared to the paltry three thousand who attended the earliest People's Baths for showers alone.

Despite this successful provision of indoor and outdoor pools, the AICP clung for some time to the suspicion that these facilities harbored disease. It was generally agreed, however, that building gymnasia for competitive sport could provide additional health benefits, as had been standard ancient practice and as was part of the unrealized proposal by John Galen Howard back in 1890. Between 1908 and 1915, the city eventually commissioned four new bathing facilities with gymnasia, but stubbornly without pools. These baths were failures, as were the early municipal shower baths, and the AICP could no longer deny the commercial value of pools to the institution. Cognizant of the rising popularity of swimming and water exercises, the AICP began to advocate for pools in future establishments and even supported incorporating them into preexisting bathhouses through extensive retrofit campaigns. Certainly, additional revenue and communal enjoyment would be welcome consequences of this reversal. By 1909, following the recommendation of the Citizens' Recreation Committee, funding was made available to include swimming pools in later municipal baths.[31] The AICP, however, remained wary of contagion. Faced with the inevitability of pools in public bathhouses, the group used them to test water-filtration technology that put New York's baths at the forefront of hygienic innovation.[32] Competitive play was introduced into the city's public baths as a civilizing technique governed by strict rules and etiquette; unstructured and youthful play solely for pleasure was neither accommodated nor tolerated.[33] In the retrofitted older bathhouses rebranded as recreation centers, communal use likely would have also eased divisions between the poor and upper classes, as in Roman baths, where all were equal and the poor could perhaps bathe in the vicinity of an emperor.[34] But while having imitated private institutions like the New York Athletic Club, public baths still did not attract the wealthiest citizens of New York, despite the potential for a variety of entertainments. The city's economic and demographic disparity between the richest and the poorest endured, since the rich preferred to swim at exclusive, members-only clubs. Furthermore, private family baths had become the norm in wealthy and middle-class homes by 1910, rendering public bathing facilities for this group unnecessary; the poor, however, had few options apart from the local bathhouse and outdoor floating pools. The Roman poor, on the other hand, had what was seen as a right to access even the most luxurious bathing facilities, whether free or for a nominal fee, during which time the message to enjoy the pleasure of bathing was the same for rich and poor.[35]

Bathing for Pleasure

While municipal and philanthropic baths at the beginning of the twentieth century struggled to reconcile the value of recreation and relaxation with the hygienic needs of the poor, they were additionally tasked to inculcate civic virtue. Indeed, as public bathing in

New York was being developed to cleanse both physically and spiritually, fear among the patrician class persisted that these venues had the potential to foster sexual activity. In a city still largely under Protestant leadership wary of sex and pleasure, illicit behavior was discouraged by eliminating the experience of luxury, strict control of nudity, and by reducing the opportunity for group interaction. But for immigrant communities in New York, group bathing was deeply ingrained in their cultural psyche; the venues they frequented in their homelands had afforded them cleanliness, relaxation, and joy, and in choosing not to dictate social mores, those baths had allowed all visitors to make themselves comfortable. In their adopted city, émigrés had largely settled in Lower Manhattan; between 1852 and 1906, the clientele of the Rivington Street baths was largely of Hungarian and Russian Jewish heritage.[36] Even though immigrants made use of the convenience of municipal baths within their tenement districts, these baths did not provide the welcome and sense of community that those in their home countries provided. As a result, privately owned ethnic baths sprang up in Lower Manhattan. Built on existing lots with unassuming exteriors that did not overtly advertize their mission, their interiors instead drew upon predominantly eastern Roman bath architecture, providing amenities that facilitated communal association and relaxation.[37] These were well attended, drawing at first émigrés who shared common bathing traditions and who preferred attending them to the clinical, impersonal municipal and philanthropic foundations. But by the early 1900s, these "exotic" baths drew even the wealthy and well traveled to experience a transportive environment that blurred class divisions. They grew rapidly in popularity, and in them a crucial element of the egalitarian social intercourse claimed by Roman baths in antiquity was reclaimed in New York.[38]

The architecture of these ethnic baths is diverse. No new foundations were laid for them; all were converted from existing residential and commercial building stock. Jewish and Turkish baths in New York continued their longstanding Roman tradition of providing communal immersion pools of varied temperature akin to the ancient *caldaria, tepidaria,* and *frigidaria*. There were additional entertainments including dining and massage, the experience of which encouraged visitors to remain long after their ablutions. The earliest of these communal baths included the Russian Vapor Marble Baths (1871), the Imperial Russian Baths (prior to 1873), and Angell's Turkish Baths on Twenty-Fifth Street (1872) (Appendix and Figure 8.6). The Russian & Turkish Baths in the East Village (1892) and the St. Mark's Turkish Baths (1906), which had been converted from the former home of the author James Fenimore Cooper (d. 1836), also centered their activity around large interior pools within contemporary, Federal-style (Victorian) tenement façades that gave little indication of their social and commercial function.

One of the most successful of these enterprises was the Fleischman Baths on Forty-Second Street and Sixth Avenue, which occupied the three uppermost stories of the Bryant Park Building in 1908 (Figure 8.7). Advertised as "the most palatial and perfect exposition of the Fine Art of Bathing," it was fully equipped with massage, hairdressing and health amenities and a penthouse solarium. Primarily Eastern European male immigrants were employed by the baths to perform massage, an essential aspect of the ancient bathing ritual. Its prized amenity, the Diocletian Club, was intended to invoke that emperor's namesake

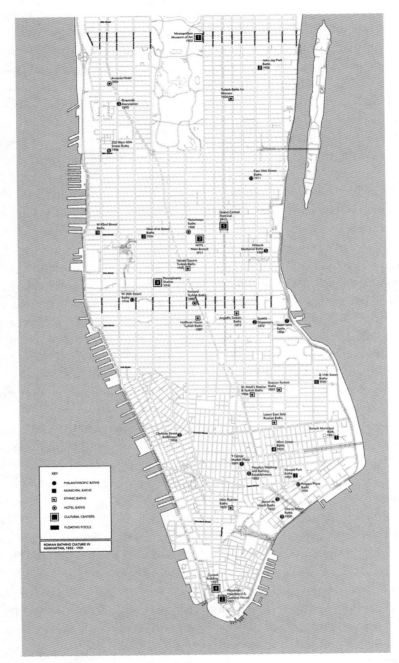

FIGURE 8.6. Map of bathing culture in Manhattan.
A. McDavid.

baths in Rome.[39] Advertising of the time appealed to the upper classes, who would have known of the Roman ruin, by illustrating its new interiors as a replica of imperial-period *thermae*. A vaulted marble-clad interior replete with arched piers, elegant stone colonnettes, large thermal windows, statuary, and foliage surrounded delighted bathers.

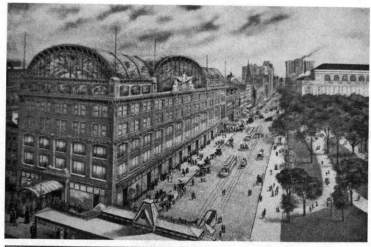

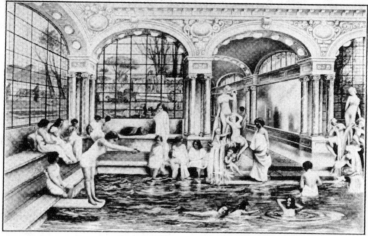

FIGURE 8.7. Advertisement for Fleischman Baths, Bryant Park Building, Forty-Second Street and Sixth Avenue, 1910.
The Theatre Magazine Advertiser, 1910.

Another architecturally distinctive example, introduced to the public with the newspaper headline "Rome's Baths Eclipsed," was the Everard Turkish, Roman, and Electric Baths established by the beer magnate James Everard (1888). The nineteenth-century building was described as the "classiest . . . and best known of the baths" and had been converted from the former Disciples of Christ and later Free Will Baptist churches. At its inauguration, the baths retained the playful grandeur of the former churches' eclectic Victorian façade, which was magnified by a false entablature extending five meters above the actual roofline.[40] Only a neon sign indicated to passersby what was to be experienced inside (Figure 8.8).

Reports described the interior as richly painted with large, bright, luxuriously furnished, Moorish-influenced rooms. Stairs with silver railings led to one hundred sleeping apartments on the baths' four floors, generously lit by four hundred electric fixtures; an artesian

FIGURE 8.8. Everard Baths, 1888.
(*left*) Original Victorian exterior, New-York Historical Society. (*right*) Classical renovation of 1921 destroyed by fire in 1977, Bettmann Archive.

well fed marble pools for cold, warm, or hot baths that were variously identified as Turkish, Russian, and medicinal. Grand arched spaces framed Roman- and Arabian-themed rooms, invoking the arcaded promenade of ancient *thermae*. In the leisure rooms for reading and sitting, rich furnishings invited patrons to stay long after bathing. The resounding success of this establishment enabled a modernization campaign in 1921, at which time the Victorian façade was recast as an elegantly restrained, neoclassical stone exterior containing a monumental arched doorway. A classical pediment replaced the original parapet; at its center a large oculus reflected a detail of neoclassical civic architecture, itself drawn from the Roman Pantheon, affirming by association the social importance of these baths.[41] This renovation signaled a perceptible shift toward a burgeoning architectural taste for the neoclassical, which was being adopted by the city's newer monuments. It cost Everard $150,000 to build, and he was praised for his civic-minded spirit, wisdom, and enterprise in developing this property for the enjoyment of people wealthy enough to enjoy the experience.

Though established for the general health and well-being of men and women, this sensorial and captivating "Oriental" bathhouse became an exclusively male enclave soon after its opening. By 1919, the Everard was known as a homoerotic rendezvous, by which time this genre of pleasure baths had acquired a reputation for facilitating sexual activity. It became a frequent target of the New York Society for the Suppression of Vice.[42] Despite this, it and similar bathhouses survived into the late 1970s, but all were finally shuttered after 1985 when the New York City Health Department ordered the closure of the city's gay bathhouses after fear of the spread of AIDS made them targets of vandalism, arson, and moral condemnation.[43] Some, like the infamous Club Baths at 24 First Avenue (1971),

which had been converted from the earlier, turn-of-the-century Lower East Side Russian baths, substantially altered their purview to become more socially acceptable entertainment venues. They eliminated bathing and overnight rooms, while retaining their pools and decorative interiors for ostensibly theatrical (and clothed) purposes. The Club Baths summarily became Cave Canem (Beware of dog) in 1986, a Roman dining club that capitalized on the baths' atmospheric vaulted ceilings, which allowed occasional paddling in the now decorative pool and provided a lush environment of foliage, birds, and statuary for entertaining guests. In 1980, a mosaic panel of a dog was installed along the entry floor, a replica of one in the first-century CE House of the Tragic Poet in Pompeii. Was it inspired by the account of a similar decoration in the Latin picaresque and often homoerotic novel, Petronius's *Satyricon* (29), mentioned when Encolpius and his companions visit the private baths of Trimalchio?[44] It exists to the present day.

In the 1800s, apartment hotels revolutionized living for the wealthier strata of society in an increasingly dense New York. Along with the provision of both private and communal spaces such as dining rooms, lounges, and kitchens, some were outfitted with communal indoor pools and massage facilities, similar to Roman baths but on a reduced scale. There one could socialize with other hotel residents or with the public who paid to gain access for the day, as at the United States Hotel near Wall Street (1828), the Turkish Bath Hotel on West Twenty-Sixth Street (1874), and the Ansonia Hotel on the Upper West Side (1904).[45] The Ansonia, financed by the copper heir William Earl Dodge Stokes and designed by a graduate of the French École des Beaux-Arts, the architect Paul Emile M. DuBoy, represented the largest and most ornate apartment complex in New York at the time. The seventeen-story, steel-framed structure was clad in carved, fireproof masonry and embellished with the ornamental style of the Parisian Second Empire; in the interior, a grand central stairwell rose toward a domed skylight reminiscent of the Heliocaminus Baths at Hadrian's Villa in Tivoli. An exuberant fountain with live seals greeted entrants in the lobby; heated baths with a palm court and two additional swimming pools in the excavated floors below Broadway's street level were also part of the highly visible, opulent amenities available to both residents and visitors.

In 1968, the Ansonia's pool complex was leased to commercial interests and became known as the Continental Baths (Figure 8.9). Using its original architecture as a backdrop for the enjoyment of music, theater, and opera, with additional entertainments that recalled the sensual brilliance of imperial Roman baths, it became a popular gay venue whose infamy continued a decade later as Plato's Retreat (1977–80), a heterosexual and bisexual swingers' club. New York's enthusiastic appreciation of this hedonistic retreat was likely thanks to the skillful combination of the amenities of the bathing ritual with interiors designed to compel the senses. Repeated raids by the Department of Health and Human Services, however, forced its closure in 1985, in compliance with the antidiscrimination law that considered both gay and straight bathhouses to be health risks.[46] It was no longer possible to keep Plato's Retreat open, signaling the end of public baths as swingers' clubs in New York City. This fate was known in the ancient world too; indeed, baths were seen in the later Roman period as symbols of moral decay and contributing factors in the empire's downfall.[47] Archaeological evidence for prostitution at Roman baths exists; they

Figure 8.9. The Ansonia Hotel.
(*left*) Building exterior. The New York Public Library Digital Collections. (*right*) RCA Red Seal record label, *Eleanor Steber Live at the Continental Baths*, 1974. Courtesy of A. McDavid.

were sumptuously tactile environments that fed sexual appetites, creating venues where promiscuity was hard to avoid.[48] The bacchic festivities that took place at hotels like the Ansonia and its Continental Baths fueled popular and persistent opinion of bathing culture as an incubator of the carnal—that the architecture and interiors of excess dedicated to bathing, per the Roman model, created an environment prone to immorality.

Monumental Triumph

As New York City approached public bathing in piecemeal fashion, with the construction of municipal and philanthropic facilities for the poor as well as communal, ethnic spas through small-scale, private enterprise, the evolving city had begun to recognize the potential for monumental architecture to express civic stature. This aesthetic was captured in the Beaux-Arts neoclassicism of Chicago's "White City" at the World's Columbian Exposition in 1893, which befit the exceptionalism to which urban centers aspired at the beginning of the twentieth century.[49] New York City took note, having lost its bid for the fair despite the patronage of Cornelius Vanderbilt II, William Waldorf Astor, and J. P. Morgan. Chicago's success motivated these benefactors to commission neoclassically trained architects to design a cohesive, monumental civic aesthetic for New York. During the City Beautiful movement of the early 1900s, these buildings materially and visually transformed the urban landscape. While their architects certainly focused on building monumental structures, the movement also envisioned architectural beauty as a means to encourage moral and civic virtue.

For New York, imperial baths fulfilled all of these aims—beauty, monumentality, and cultural prestige—but it was perhaps the integration of these features with unparalleled technical ingenuity that made them ideal for the city's large and growing population. Still staggering to comprehend in the present day, the Baths of Caracalla could host 1,600 bathers at a time (six thousand to eight thousand per day) within its footprint of over 202,000 square meters; the Baths of Diocletian could hold twice that capacity.[50] These ancient complexes, often described as "cities within a city," were engineering and distribution marvels that efficiently controlled circulation, provided impressive clear-span superstructures for mass congregation, generous ambulatories that could easily process large numbers of people, and elaborate service infrastructure below ground level. Virtually unmatched as iconic of civic identity, ancient baths became an influential template upon which Beaux-Arts architects relied to give visitors an extraordinary sense of place and fellowship. Now, however, the memorable experience was orchestrated entirely without the bathing function. While New York's municipal government was reluctant to fully adopt neoclassical baths because of social, political, and economic constraints, the city's private and philanthropic cultural institutions embraced imperial thermal architecture as their public aesthetic. This is clear in the design of the Metropolitan Museum of Art (1902), the Alexander Hamilton US Custom House (1907), Pennsylvania Station (1910),[51] the New York Public Library (1911), Grand Central Terminal (1913), and the Cunard Building (1921), which are among the largest and most complex examples of urban construction in any American city during the early twentieth century.

The Metropolitan Museum of Art (est. 1870), having been granted land along the eastern edge of Central Park by the city in 1871, moved uptown to its current location at the center of the park's Fifth Avenue exposure. Given Calvert Vaux's principal role in the design of the park and his interests in integrating select buildings into its landscape, he was commissioned to design a High Victorian Gothic museum that was almost instantaneously decried as a "mausoleum" and a "mistake" by the time of its construction.[52] To reconcile its unfashionable design with the nascent, classicizing aesthetic of the City Beautiful movement, the museum quickly retained the Metropolitan trustee Richard Morris Hunt—the first American to attend the École des Beaux-Arts—to design Fifth Avenue's Great Hall frontage, by which the institution, to date, is most closely identified. Completed in 1902, the Great Hall successfully hid the Victorian behemoth from the avenue. Evocative of imperial *thermae* upon approach, its limestone façade and raised platform build anticipation through to the vaulted interior and grand stairway, culminating in impressive spaces filled with statuary that mirrored the *frigidarium* of the Baths of Caracalla (Figure 8.10).

Sixteenth-century excavations of these baths provided a glimpse of the exuberant statuary typically on display in Roman *thermae*. Famous ancient works included the Farnese Bull, the Farnese Hercules, and the Latin Hercules.[53] The monumental architecture of imperial baths expressively framed these works of art for visitors' viewing pleasure, rendering the structural shell of ancient baths ideal for the mission of a modern museum. The privately owned Metropolitan Museum of Art, in building an architectural masterpiece through philanthropic means, provided a lasting cultural institution for public enjoyment.

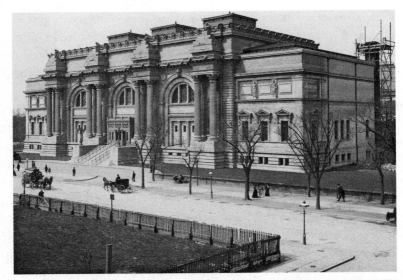

FIGURE 8.10. Metropolitan Museum of Art, 1907. Fifth Avenue façade and Statuary Hall.
Courtesy of the Library of Congress.

The organizational rationale of Roman *thermae* also offered a perfect solution to both the storage of and access to books in the Main Branch of the New York Public Library (1911) (Figure 8.11). Charged by the city benefactor Samuel J. Tilden, who bequeathed $2.4 million to the existing Astor and Lenox Foundations in 1895, and executors of the Carnegie Trust ($5.2 million), the library's board of trustees sponsored a competition for the Fifth Avenue building and additionally recruited Beaux-Arts-trained architects to maintain neoclassical uniformity across the city's eighty-seven branch libraries.[54] Carrère and Hastings claimed the winning entry over a field of eighty-eight that included McKim,

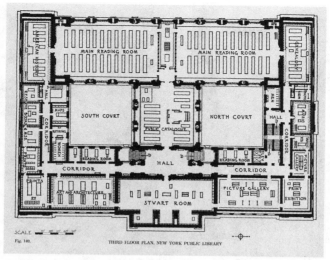

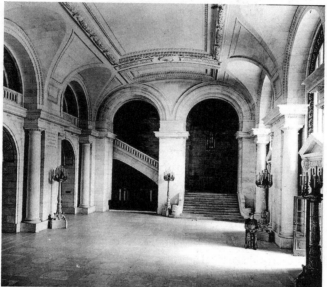

FIGURE 8.11. New York Public Library, Main Branch, East Forty-Second Street and Fifth Ave., 1911. Plan and first floor lobby.
Courtesy of the Library of Congress.

Mead & White and Warren & Wetmore. The victorious team described its vision for the library in 1897:

> In design, the endeavor has been to make the building very monumental in character, with classical proportions, and very big and impressive in scale. . . . The style of the architecture is Renaissance; it is based upon classical principles, but modern in feeling, and it has been the purpose of the architects to express the spirit of our times . . . without endeavoring to invent a new style.[55]

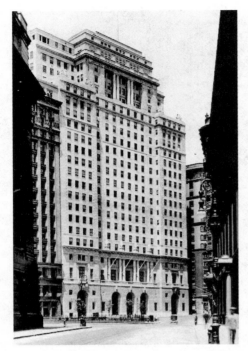 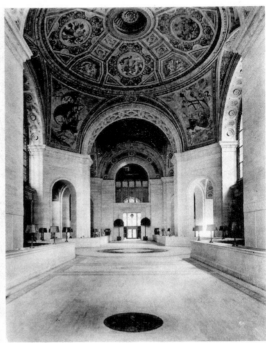

Figure 8.12. Cunard Building, 1921. Exterior and great ticketing hall.
Courtesy of the Library of Congress.

The architects' Renaissance inspiration undoubtedly found its origin in the imperial thermal template. While the monumental aesthetic of important urban buildings of the early twentieth century were conveyed using broadly classical principles of construction, order, and decoration, the influence of the imperial thermal brand gained particular traction for functions other than bathing. Carrère and Hastings continued this trend by reinterpreting the Roman bath model for the NYPL's Main Building. Its design and construction methods derived from classical antiquity: Meter-thick blocks of Indiana marble were transported long distances to clad the library's brick and steel core, monolithic Ionic columns almost fifteen meters in height adorned the tripartite arched entry off Fifth Avenue, and an elegant configuration of space—a master class in facilities management exemplified by imperial Roman baths—created the largest public library of its time. Here, as at the Metropolitan Museum and in Roman *thermae*, grand entrances primed the visitor for climactic experiences farther on—from engaging works of art at the top of its broad staircase to the promise of enlightenment in the third-floor Rose Main Reading Room.

The Great Ticketing Hall of the Cunard Building (1921, Benjamin Wistar Morris, Carrère & Hastings) was a virtuoso execution of Beaux-Arts interior design (Figure 8.12). Morris closely studied the architecture of imperial *thermae* during his matriculation at the École; in his subsequent apprenticeship at the firm of Carrère & Hastings, he was responsible for the winning design of the New York Public Library Main Building. The Cunard

Building, the headquarters of the British Cunard Line, which had a near monopoly on maritime tourism, is located at 25 Broadway, near the southern tip of Manhattan, in what had then been the commercial heart of the city. The building was intended as a monument to luxurious transatlantic travel. But not only did the well heeled flock to this ticket office to book passage on ocean liners; large numbers of European immigrants were also transported in the ships' steerage to New York. Although the latter likely never saw the interior of the Cunard Building after settling in the city, wealthy travelers were treated to a sumptuous welcome in the Great Ticketing Hall, whose imperial architecture alluded to the majesty of the ancient ruins they were likely to visit. The Great Hall's interior, taking its inspiration from the *frigidarium* of the Baths of Diocletian, was entered directly from a triple-arched neoclassical exterior facing Broadway and through bronze doors modeled on ancient fenestrated thermal windows. The five-domed vestibule clad in glass mosaic is a comparatively restrained introduction to the cavernous, vaulted hall behind. Its central space—octagonal, domed, axially aligned with the vestibule—soars over eighteen meters and is framed by two groin-vaulted rooms that extend into semidomed niches. Engaged Ionic columns and massive piers, from which enormous squinches spring to meet the hall's crowning dome, also seem to be made entirely of stone, but their lavish interior finishes of marble and travertine hide the steel skeleton that facilitated its rapid, one-year construction.[56] The hall's decorative program includes a wealth of sculpted stone reliefs, molded stucco, and painted surfaces; its coffered semidomes, arches, and painted ceilings were decorated with rosettes and arabesques in the *fresco a secco* technique that imitated the highly decorated plaster interiors of imperial baths. Sculptors, painters, and metal craftsmen employed to complete this luxurious interior illuminated a quotation in Latin from Cicero's *Letters to Atticus* (10.8.4) that commended the power gained through control of the seas: "EXISTIMAT ENIM QVI MARE TENEAT EVM NECESSE RERVM POTIRI" (For he [Pompey] supposes that the one who holds the sea must possess the world).[57] In the creation of this interior space and others that celebrate the civic virtues of beauty (in art), education (books), and access (mass transportation), architects looked to the Roman imperial past to design centers of assembly. While these examples were not in the service of bathing, their disciplined adherence to the function, organization, and aesthetic of historic *thermae* gave to modern private commissions a monumentality that certified New York as a metropolis.

Conclusion

In the decades between the 1880s and 1920s, New York exploited Roman imperial bathing culture to build a civil society in the throes of rapid population expansion and urban growth. The city's early attempt to provide free or subsidized washing facilities to the poor marked the beginning of an evolutionary period that prioritized hygiene, public sanitation, and mechanized efficiency over enjoyment in developing a strong, healthy populace. But not all the factors invested in the beloved, ancient bathing culture—the functional, the

phenomenological, and the monumental aesthetic—were adopted in the philanthropic and municipal baths of New York. Most notably, Roman amenities such as communal pools, grand entry halls and staircases, ambulatory and gathering spaces, and rooms for grooming and leisure were excluded. New technologies such as cold-water shower stalls, unidirectional egress that ran counter to the complexity of circulation in ancient *thermae*, and the typically unpleasant brevity of the bathing process limited the success of what had been achieved in Rome centuries before. The expense of urban real estate and the architectural limitations of the grid plan constrained the generous footprint and impressive vaulting of Roman baths. The façadism practiced by attaching a neoclassical frontage to a utilitarian interior appears to be the only architectural nod to its ancient precursor. New York's spatial omissions, substitutions, and economies had palpable repercussions on the city's public bathing culture.

While municipal and philanthropic foundations at the end of the nineteenth century made clear the distinction between facilitating cleanliness and providing recreation for the bathing poor—by eliminating the opportunity for relaxation—markedly different ethnic bathing venues grew in popularity for providing this seemingly intangible amenity in their welcoming, communal interiors. But these locations also underwent a process of evolution, one perhaps similar to the evolution of the baths in Rome. At first architecturally indiscriminate on the exterior, they focused on interiors that approximated the Roman provision of heated pools, lounge and recreational spaces, and other sensorial entertainments. Many of these ethnic and hotel baths employed classical bathing practices not only to facilitate physical cleanliness but additionally to offer corporeal and spiritual rejuvenation. Their corollary sexual permissiveness was in contrast to the etiquette of philanthropic and municipal baths; looser controls on behavior framed the perception of these bathhouses as places of iniquity that eventually led to their closure. Few survived to continue their legitimate pursuit of communal bathing and relaxation. Despite this, their longevity and notoriety earned a place of distinction in modern urban life for this genre of bathhouse, as their cleansing and social aspects hewed most closely to the Roman ideal.

One of the most significant aspects of Roman bathing culture—the sensory experience—was facilitated by its architecture. Imperial baths, a powerful demonstration of architecture's ability to captivate and engage the senses, were reinterpreted during the City Beautiful movement of the early 1900s, expanding architectural discourse beyond aesthetic formalism to issues of urban development and civic responsibility. The complex language of thermal civic architecture was to be expressed in modern, transformative contexts. The form and the spatial experience of the Roman bath both influenced and were altered by New York society, whose needs were at once practical and aspirational. In its mature iteration, the ancient model successfully communicated the vision of New York City as a cultural destination with monuments to art, transportation, commerce, and education, though none for bathing. Few other classical institutions combined municipal responsibility with architectural brilliance as profoundly as did the Roman bath. In its adoption, adaptation, and transformation in New York City during the Progressive Era, we find a compelling trajectory of social and political innovation.

Appendix

This appendix lists Manhattan bath architecture erected between 1852 and 1925. It is divided into three categories:

(1) Philanthropic and municipal baths;
(2) Ethnic and hotel communal baths;
(3) Civic institutions using the imperial Roman bath template.

Architects and dates of foundation are omitted when not known.

(R) indicates rain baths (= showers);
(G) indicates gymnasium;
(S) indicates a public bath founded with a swimming pool;
(S)* indicates the later addition of swimming pool.

1. BATHS BEFORE 1890

The People's Washing and Bathing Establishment 141–43 Mott Street 1852

2. PHILANTHROPIC AND MUNICIPAL BATHS

Philanthropic Baths

The People's Baths	9 Centre Market Place	J. C. Cady & Co., 1891 **(R)**
Demilt Dispensary Baths	East 23rd St. and 2nd Ave.	W. P. Gerhard, Brunner & Tryon, 1892 **(R)**
Baron de Hirsch Baths	Henry and Market Sts.	Brunner & Tryon, 1892 **(R)**
Riverside Association	259 West 69th St.	1895 **(R)**
Milbank Memorial Bath	325–27 East 38th St.	1904 **(R)**
232 West 60th St. Bath		Werner & Windolph, 1906 **(R)(S)**—*extant*
23rd St. and Ave. A		A. W. Brunner and W. M. Aiken, 1908 **(R)(S)**—*extant*
Clarkson Street Bathhouse	83 Carmine St.	Renwick, Aspinwall, & Tucker, 1908 **(R)(G)**
100 Cherry at Oliver Sts.		1909 **(R)**
5 Rutgers Place		Horgan & Slattery, 1909 **(R)(G)(S)***
342 East 54th St.		Werner & Windolph, 1911 **(R)(G)(S)***—*extant*
407 West 28th St.		William Emerson, 1914 **(R)(S)**

Municipal Baths

Baruch Municipal Bath	326 Rivington St.	Cady, Berg & See, 1901 **(R)(S)***
327 West 41st St.		York & Sawyer, 1904 **(R)**
133 Allen St.		York & Sawyer, 1905 **(R)**—*extant*
243 East 109th St.		York & Sawyer, 1905 **(R)**
538 East 11th St.		A. W. Brunner, 1905 **(R)**
John Jay Park Baths	523 East 76th St.	Stoughton & Stoughton, 1906 **(R)**
Asser Levy Public Baths	East 23rd St. Bathhouse	Brunner & Aiken, 1904–6 **(R)(G)(S)**—*extant*

Seward Park Baths
Thomas Jefferson Park Baths
42nd St. and 11th Ave.
138th St. and 5th Ave.

3. ETHNIC AND HOTEL BATHS

Turkish

Angell's Turkish Baths	61 Lexington Ave., 25th St.	1872
Hoffman House Turkish Baths	7 West 24th St.	1887
Everard Turkish Baths	28–30 West 28th St.	1888
Turkish Baths for Women	1904 East 70th St. at Lexington Ave.	1904
Herald Square Turkish Baths	Herald Square	1905
Fleischman Baths	42nd St. & 6th Ave.	1908
10-cent Turkish Bath	Bowery District	1910
Mt. Morris Turkish Baths		

Russian

Russian Vapor Marble Baths		1871
Imperial Russian Bath		<1873
Wall Street Bath and Day Spa	88 Fulton St.	
New Russian Baths	18 Lafayette Place	1850s
Lower East Side Russian Baths (later Club Baths)	24 First Ave.	

Hybrid

Old Baths	Laight St.	
The Windsor Baths		
Russian and Turkish Marble Baths	25 E. 4th St. at Broadway	1854?
Russian-Turkish Baths Health Club	268 East 10th St., near 1st Ave.	1892
Greenwich Baths	337 Hudson St.	
St. Mark's Russian & Turkish Baths	6 St. Mark's Place	1906

Medicinal

Whitlaw's Patent Medicated Vapor Baths	280 Broadway	
Vergnes' ElectroChemical Baths	4–6 East 11th St.	

Hotel

Turkish Bath Hotel	41 West 26th St.	1874
Ansonia Hotel Turkish Baths	Broadway bet. 73rd & 74th Sts.	1904
The Apthorp	Broadway bet. 78th & 79th Sts.	1908

4. NONBATHING INSTITUTIONS

Metropolitan Museum of Art frontage	1000 5th Ave.	Richard M. Hunt, 1902
Alexander Hamilton US Custom House	1 Bowling Green	Cass Gilbert, 1907
New York Public Library	5th Ave. at 42nd St.	Carrère & Hastings, 1911
Pennsylvania Station Main Waiting Room	7th & 8th Ave., 31st & 33rd Sts.	McKim, Mead & White, 1910
Grand Central Terminal Main Concourse	89 E 42nd St.	Warren & Wetmore, Reed & Stem, 1913
Cunard Building interior	25 Broadway	B. W. Morris, Carrère & Hastings, 1921

NOTES

1. Janet DeLaine, *The Baths of Caracalla: A Study in the Design, Construction, and Economics of Large-Scale Building in Imperial Rome Projects, Journal of Roman Archaeology* Supplement 25 (Portsmouth, RI: Journal of Roman Archaeology, 1997); Fikret Yegül, *Baths and Bathing in Classical Antiquity* (Cambridge, MA: MIT Press, 1992).

2. David Glassberg, "The Design of Reform: The Public Bath Movement in America," *American Studies* 20, no. 2 (1979): 5–21; "Tammany Hall versus Reformers: The Public Baths of New York City," in Marilyn T. Williams, *Washing "the Great Unwashed": Public Baths in Urban America, 1840–1920* (Columbus: Ohio State University Press, 1991), 41–67.

3. Jacob Riis, *The Battle with the Slum* (New York: Macmillan, 1902); Mayor's Committee of New York City, *Report on Public Baths and Public Comfort Stations* (New York, 1897), 16.

4. Gerard T. Koeppel, *Water for Gotham: A History* (Princeton, NJ: Princeton University Press, 2000); *Advance Sheets of Part of the Report of the Tenement House Commission* (New York, 1901), 7–9, 62.

5. "Americanization by Bath," *Literary Digest* 47 (August 23, 1913): 280.

6. Paul Boyer, *Urban Masses and Moral Order in America, 1820–1920* (Cambridge, MA: Harvard University Press, 1978); Marvin E. Gettleman, "Philanthropy as Social Control in Late-Nineteenth-Century America," *Societas* 5 (Winter 1975): 49–59.

7. George Frank Lydston, *The Diseases of Society (the Vice and Crime Problem)* (Philadelphia: J. P. Lippincott, 1906), 569.

8. Pier-Head Baths: Edward H. Gibson III, "Baths and Washhouses in the English Public Health Agitation, 1839–48," *Journal of the History of Medicine and Allied Sciences* 9 (October 1954): 391–406. Pattern books: Robert Owen Allsop, *Public Baths and Wash-Houses* (London: E. & F. N. Spon, 1894); Alfred W. S. Cross, *Public Baths and Wash-Houses* (London: B. T. Batsford, 1906).

9. People's Washing and Bathing Association, *First Annual Report of the People's Washing and Bathing Association* (New York: Harrison, 1853), 6–7.

10. Alan M. Kraut, *Silent Travelers: Germs, Genes, and the "Immigrant Menace"* (New York: Basic Books, 1994); Metropolitan Board of Health, *Fourth Annual Report of the Metropolitan Board of Health of the State of New York* (New York: D. Appleton, 1870), 112.

11. Galen, 11, 10: C. G. Kühn, ed., *Opera Omnia* (Leipzig: Knobloch, 1821–33, repr., Hildesheim: Georg Olms, 1965) X, 708, 723. On gymnasia and pools: S. Mattern, *Galen and the Rhetoric of Healing* (Baltimore, MD: Johns Hopkins University Press, 2008), 51.

12. "Public Baths and Civic Improvement in Nineteenth-Century German Cities," *Journal of Urban History* 14 (May 1988): 372–93; William Paul Gerhard, "The Modern Rain Bath," *American Architect and Building News* 43 (February 10, 1894): 67–69.

13. John Brisben Walker, "Public Baths for the Poor," *The Cosmopolitan* 9 (August 1890): 418–21.

14. Simon Baruch, "A Plea for Public Baths, Together with an Inexpensive Method for Their Hygienic Utilization," *Dietetic Gazette* 7 (May 1891): 94–95, 397.

15. *The People's Baths, 9 Centre Market Place: A Study on Public Baths* (New York, 1896), 2.

16. "Public Baths," *Sun*, March 31, 1891; "Americanization by Bath," *Literary Digest* 47 (August 23, 1913): 280.

17. Mayor's Committee, *Report on Public Baths*, 27.

18. Mayor's Committee, *Report on Public Baths*, 166–68.

19. Andrea Renner, "A Nation That Bathes Together: New York City's Progressive Era Public Baths," *Journal of the Society of Architectural Historians* 67, no. 4 (December 2008): 512–16.

20. Baruch, "A Plea for Public Baths," 95; Bertha H. Smith, "The Public Bath," *Outlook* 79 (March 4, 1905): 571. Cf. Mayor's Committee, *Report on Public Baths*, 166–68.

21. "The City Beautiful," *New York Tribune*, February 13, 1904, 4.

22. Williams, *Washing*, 32–33.

23. Thus, this excerpt from a late-antique (sixth century?) anonymous epigram from the *Latin Anthology* 108.5–8: "He who aims to take this enjoyment with a double benefit, and who knows how to enjoy life as it passes by, let him bathe here. Here, refreshing his body and relaxing his mind, he will soothe his eyes with the pictures and his limbs with the waters" (trans. Kay) (*Gaudia qui gemino gestit decerpere fructu | et vita novit praetereunte frui, | hic lavet; hic corpus reparans mentemque relaxans, | lumina picturis, membra fo<ve>bit aquis*). The Latin text is from D. R. Shackleton-Bailey's 1982 Teubner edition (= Riese 119 [Teubner 1894–1906²]). On the authorship and date of this epigram, cf. N. M. Kay, *Epigrams from the* Anthologia Latina: *Text, Translation, and Commentary* (London: Duckworth, 2006), 1–13, esp. 173–76 on these particular lines about the baths and the "double benefit" they provide to mind and body: the paintings delight the mind; the bath waters refresh the body.

24. Melvin G. Holli, "Urban Reform in the Progressive Era," in *The Progressive Era*, ed. Lewis L. Gould (New York: Syracuse University Press, 1974), 133–52.

25. Frank E. Wing, "The Popularization of a Public Bath-House," *Charities* 14 (April 29, 1905): 694–96.

26. Jacqueline S. Wilkie, "Submerged Sensuality: Technology and Perceptions of Bathing," *Journal of Social History* 19 (1986): 654–55.

27. Citizens' Recreation Committee, "Opportunities for Recreation: Afforded by the Municipality of the City of New York and Maintained by Appropriation of Public Funds" (New York: Citizens' Recreation Committee, 1909), 7.

28. Robert E. Todd, "The Municipal Baths of Manhattan," *Charities* 19 (October 19, 1907): 901.

29. "Baths of the New York Athletic Club," *American Plumbing Practice* (New York, 1896): 193–94; "Branch Public Bath, West Sixtieth Street, New York, N.Y.," *American Architect and Building News* 90, no. 1600 (August 25, 1906): 71–72.

30. Correspondence from AICP (Association for Improving the Condition of the Poor) to architects Arnold W. Brunner and William Martin Aiken in 1905; box 37, folder 218, Community Service Society Archives, Columbia University, New York.

31. Citizens' Recreation Committee, "Opportunities for Recreation: Afforded by the Municipality of the City of New York and Maintained by Appropriation of Public Funds" (New York: Citizens' Recreation Committee, 1909).

32. Wallace A. Manheimer, "Comparison of Methods for Disinfecting Swimming Pools," *Journal of Infectious Diseases* 20 (1917): 1–9.

33. Naomi Adiv, "Paidia Meets Ludus: New York City Municipal Pools and the Infrastructure of Play," *Journal of Social Science History* 39, no. 3 (September 2015): 431–52.

34. *Hadrian* 17.5–7, in *Scriptores Historiae Augustae*, trans. David Magie (Cambridge, MA: Harvard University,1921), 52; Garret Fagan, *Bathing in Public in the Roman World* (Ann Arbor: University of Michigan Press, 1999), 190–92.

35. K. Dunbabin, "Pleasures and Dangers of the Baths," *Papers of the British School at Rome* 57 (1989): 6–46.

36. *Municipal Journal* 38 (Municipal Journal and Engineer, Inc., 1915): 689.

37. Jones, Newman, & Ewbank, *The Illuminated Pictorial Directory of New York* (New York, 1848); *The Oldest Established Russian Vapor (Marble) Baths* (New York: Jones, Newman, & Ewbank, 1871).

38. "Russian and Turkish Baths, New York City," in *Descant* 141 (January 2008): 89.

39. "Fleischman Baths Open for Public," *New York Times*, February 7, 1908, 4. See Malamud's chapter in this volume.

40. "Rome's Baths Eclipsed; The Palatial Establishment Which James Everard Has Completed," *Daily Graphic*, May 5, 1888, 507; David W. Dunlap, *From Abyssinian to Zion: A Guide to Manhattan's Houses of Worship* (New York: Columbia University, 2012), 56.

41. Richard F. Shepard, "Broadway That Once Was," *New York Times*, February 4, 1977.

42. John Potvin, "Vapour and Steam: The Victorian Turkish Bath, Homosocial Health, and Male Bodies on Display," *Journal of Design History* 18, no. 4 (2005): 319–33.

43. Jane Gross, "Bathhouses Reflect AIDS Concerns," *New York Times*, October 14, 1985.

44. Petronius, *The Satyricon*, trans. Michael Heseltine (Cambridge, MA: Harvard University Press, 1913), 29: "I was gazing at all this, when I nearly fell backwards and broke my leg. For on the left hand as you went in, not far from the porter's office, a great dog on a chain was painted on the wall, and over him was written in large letters 'BEWARE OF THE DOG.' My friends laughed at me, but I plucked up courage and went on to examine the whole wall" (*Ceterum ego dum omnia stupeo, paene resupinatus cruramea fregi. Ad sinistram enim intrantibus non longe ab ostiarii cella canis ingens, catena vinctus, in pariete erat pictus superque quadrata littera scriptum "Cave canem." Et collegae quidem mei riserunt, ego autem collecto spiritu non destiti totum parietem persequi*).

45. George Chauncey, "Privacy Could Only Be Had in Public" and "The Social World of the Baths," in *Gay New York: Gender, Urban Culture, and the Making of the Gay Male World, 1890–1940* (New York: Basic Books, 1995), 181–89, 207–25.

46. S. Golubski and B. Kappstatter, "Swinging Doors Shut: City Probe KO's Plato's," *New York Daily News*, January 1, 1986.

47. J. P. Toner, *Leisure and Ancient Rome* (Cambridge: Polity, 1996), 53–64.

48. R. Bar-Nathan and G. Mazor, "City Center (South) and Tel Iztabba Area. Excavations of the Antiquities Authority Expedition, the Bet She'an Excavation Project (1989–1991)," *Excavations and Surveys in Israel* 11 (1993): 43–44; L. E. Stager, "Eroticism and Infanticide at Ashkelon," *Biblical Archaeology Review* 17, no. 4 (July–August 1991): 34–53.

49. Benjamin Truman, *History of the World's Fair: Being a Complete and Authentic Description of the Columbian Exposition from Its Inception* (Philadelphia: J. W. Keller & Co., 1893).

50. Olympiodorus of Thebes' *History*, fragment 43, in John F. Matthews, "Olympiodorus of Thebes and the History of the West (AD 407–425)," *Journal of Roman Studies* 60 (1970): 80. There has been much debate since of the baths' actual capacity, as the poet may have cited inflated numbers for dramatic effect.

51. See Gensheimer's chapter in this volume.

52. Michael Gross, *Rogues' Gallery, The Secret History of the Moguls and the Money That Made the Metropolitan Museum* (New York: Broadway Books, 2009), 75.

53. Miranda Marvin, "Freestanding Sculptures from the Baths of Caracalla," *American Journal of Archaeology* 87, no. 3 (July 1983): 347–84. For the Farnese Hercules, also called the Weary Hercules, see figure 7.5 in Gensheimer's chapter in this volume.

54. Abigail A. Van Slyck, *Free to All: Carnegie Libraries & American Culture, 1890–1920* (Chicago: University of Chicago Press, 1995), 113–14.

55. "Public Library Plans," *New-York Tribune*, December 5, 1897, 13.

56. David M. Breiner, "The Cunard Building," in *Landmarks Preservation Commission Report* (New York, September 19, 1995), 1–26.

57. Cic. *Att.* 10.8.4. For more on the use of classical quotation in New York's Latin inscriptions, see McGowan's chapter in this volume.

"In Ancient and Permanent Language": Artful Dialogue in the Latin Inscriptions of New York City

Matthew M. McGowan

> The language of the country of which a learned man was a native, is not the language fit for his epitaph, which should be in ancient and permanent language . . . everything intended to be universal and permanent should be [in Latin].
>
> —SAMUEL JOHNSON, *from Boswell's Life of Johnson (1791)*

Introduction

Doctor Johnson is said to have offered the response used as this chapter's epigraph in defense of composing an epitaph in Latin (and not in English) to honor the Irish poet and polymath Oliver Goldsmith. In discussing Johnson's defense, his biographer James Boswell adds, "For my own part I think it would be best to have Epitaphs written both in a learned language, and in the language of the country; so that that they might have the advantage of being more universally understood, and at the same time be secured of classical stability."[1] The ever-accommodating Boswell wants to have it both ways—more comprehensible *and* universal, English *and* Latin—but for Johnson there is no accommodation: Latin lays special claim to the universal, and its power lies in permanence. Today, the very idea of a "learned language" that might bestow "classical stability" seems outdated and perhaps hard to fathom beyond select religious circles. Yet well into the twentieth century, the Latin language was used to project permanence on both religious and secular buildings and monuments in New York City. This chapter analyzes that projection and attempts to address the dynamic tension between universality and comprehensibility on view in New York's Latin inscriptions from the late eighteenth to the middle of the twentieth century.

This tension is visible, for example, on one of Central Park's most beloved benches, the white granite *exedra* near the park's eastside entrance at Seventy-Second Street (Figure 9.1).[2] There we read "ALTERI VIVAS OPORTET SI VIS TIBI VIVERE" (You must live for

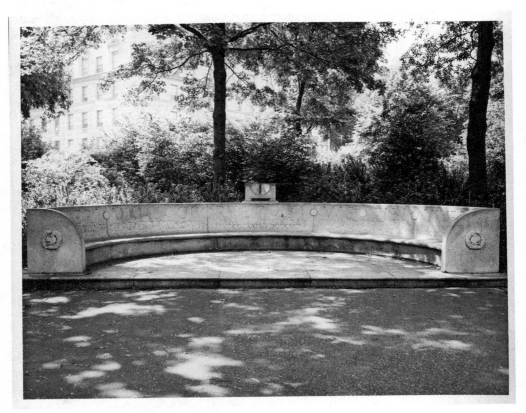

FIGURE 9.1. The Waldo Hutchins Memorial Bench in Central Park, designed by Eric Gugler (1932). Latin quotation by Seneca: "ALTERI VIVAS OPORTET SI VIS TIBI VIVERE" (You must live for another if you wish to live for yourself [*Moral Epistles* 48.2]).
Collection of the Public Design Commission of the City of New York.

another if you wish to live for yourself), a quotation from the *Moral Epistles* (48.2) of the Roman philosopher Seneca (4 BCE–65 CE). The bench is dedicated as a memorial to Waldo Hutchins (1822–89), a member of the first Central Park Commission (1857–70) and among the more important figures in the park's early history. In the late 1920s, Hutchins's eldest son, Augustus (b. 1856), engaged the emerging sculptor and architect Eric Gugler (1889–1974) to design a monument in his father's memory. After some negotiation with the Park Commission, the bench was finally installed in its current location in 1932.[3] The site may have been subject to negotiation, but there appears to have been no doubt that the Hutchins memorial bench would be inscribed in Latin.

In fact, the Public Design Commission Archives contains a pencil sketch of the proposed monument with the inscription "IPSA QVIDEM VIRTVS" (Virtue itself) and the note: "The paths and surroundings, of course, would be changed depending on the site. The inscriptions, too, would be determined upon in consultation with the Art Commission."[4] The inscription in question stems from the opening verse, "ipsa quidem Virtus pretium sibi" (Virtue is its own reward), of a late-antique poem of the poet Claudian (370–404 CE).[5] We cannot know for sure whether Claudian's verse was Augustus Hutchins's first choice

for his father's memorial, but its emphasis on personal virtue looks inward at individual behavior. By contrast, the Senecan quotation that makes it onto the bench—YOU MUST LIVE FOR ANOTHER IF YOU WISH TO LIVE FOR YOURSELF—turns outward toward the public with a more inclusive Stoic maxim on civic engagement. At this distance, it is hard to say how accurately a memorial inscription captures an individual's habits and values, but the elder Hutchins's stints in the New York State Assembly (1852) and US Congress (1878–85)—to say nothing of his work for Central Park—suggest a genuine dedication to public service, and one would not be surprised to learn that the Art Commission chose Seneca over Claudian.

On site, there is no translation or indication that the words are Seneca's. Myriad parkgoers continue to wonder, as they have since the *exedra* was erected, at the meaning of the stately letters, perhaps assured by the form that it is indeed Latin they are looking at. The sentiment, however fitting for a public servant of Hutchins's stature, does not have the "advantage of being more universally understood," as Boswell may have wished. On the bench's center-back panel, moreover, behind the compact sundial designed by Albert Stewart (1900–1965) with a central bronze statue accredited to Paul Manship (1885–1965), can be found another untranslated Latin inscription: "NE DIRVATVR FVGÂ TEMPORVM" (Let it not be destroyed by the flight of time) (Figure 9.2). The understood subject of this sentence is *memoria*, the memory of Waldo Hutchins, as in a poem from a well-known collection of Greek, Latin, and English verse that appeared in the United

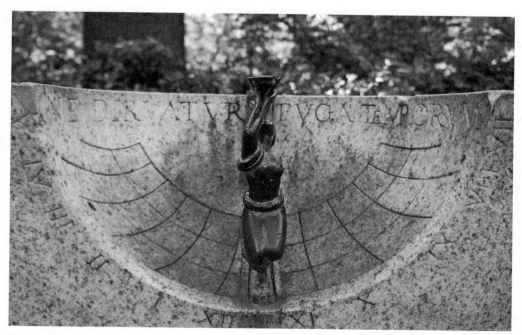

FIGURE 9.2. From the central back panel of the Waldo Hutchins memorial bench, a sundial designed by Albert Stewart with a central bronze statue accredited to Paul Manship, has the inscription "NE DIRVATVR FVGÂ TEMPORVM" (Let it not be destroyed by the flight of time). B. Schewel.

States in 1914, by Henry Montagu Butler, master of Trinity College, Cambridge (1886–1918), and before that, headmaster of the Harrow School (1860–85).[6] In that collection Butler includes a commemorative epitaph he had composed for Harrow's chapel in honor of a deceased colleague, William Oxenham: "NE MEMORIA/TAM CARI CAPITIS/FUGA TEMPORUM DIRUATUR/TESTETUR TURRIS/HUIC AEDI IMPOSITA/QUAM GRATUS SUIS VIXERIT/QUAM FLEBILIS OBIERIT" (**Lest the memory** of so dear a man **be erased by the flight of time,** the tower placed on top of this building bears witness to how beloved he was to his own while alive and how lamented in death). The sentiment in both cases is that human memory, if well cultivated, can challenge the passage of time and lay claim to something immortal, or, in the words of Samuel Johnson, what is "universal and permanent." Clearly, Johnson's understanding of the power of Latin to bestow permanence on its subject matter is still operating in Hutchins's memorial bench and, as we shall see, on several similar structures in New York well into the middle of the twentieth century.

In what follows, I offer a survey of select Latin inscriptions on public memorials, funerary monuments, and a distinguished academic institution in Manhattan during our period. I have opted for breadth over depth, perhaps not unaware that the other papers in this volume tend to concentrate more narrowly in space or span of time. Chronology and geography have been my primary guides, but I have tried to keep in mind that there is always a gap between the projection of attitudes and values in writing on stone and lives lived in flesh and blood.[7] The reception of Latin as a classical language—or as a Christian, medieval, Renaissance, and late-modern language, for that matter—is a complex process that plays out in peculiar ways over centuries; our task as scholars is to analyze its appropriation and reproduction in context.[8] The question of context is paramount when considering New York's Latin inscriptions, and each structure is analyzed here in the light of its cultural and historical setting. At the same time, the language itself also helps shape context and, by virtue of its own rich and diverse history, alters the dynamic of how an individual building or monument relates to classical and later classicizing cultures: Does an inscription signal continuation, transformation, or rupture? These seemingly contradictory considerations need to be kept in the interpretive mix at the same time. Yet, on some level, all the patrons, politicians, and artists behind the inscriptions we treat are using the Latin language to engage in dialogue with the past, the *artful dialogue* of my subtitle. The cadence of that conversation is sometimes rich and attuned to an ethos of civic responsibility, academic integrity, or religious piety; sometimes it is tenuous and peters out in inconclusiveness. At all times, the mere presence of Latin on a building or monument initiates a "shuttling back and forth" between past and present.[9] If in that process Johnson's notion of an "ancient and permanent language" begins to waver, that may be because of the limited use of Latin on buildings and monuments today: Latin, it seems, has lost its purchase on permanence in New York. Yet any inscription—especially a Latin one that channels classical antiquity or the Christian tradition—initiates a dialogue between reader and object that deepens the understanding of that object in relation to its current surroundings and original construction.

Memorials and Funerary Monuments

Among the most original constructions in the United States—in fact, the country's very first publicly commissioned memorial—is the Montgomery Monument at Saint Paul's Chapel in Lower Manhattan (Figure 9.3).[10] It honors Richard Montgomery (1738–75), the Irish-born British officer, then major general in the Continental Army, who died at the Battle of Quebec (December 31, 1775). Montgomery was swiftly declared an American hero, and the Continental Congress commissioned a memorial in his honor within a month of his death, that is, on January 25, 1776. It was originally meant for Philadelphia's Independence Hall, and only through the vicissitudes of war and politics did it wind up in 1787 at St. Paul's. There it was installed the following year (probably by Pierre L'Enfant, the designer of Washington, DC)[11] at the base of the Palladian window of the chapel's east façade. Benjamin Franklin had seen to the making of the monument in Paris in 1777 at the beginning of his tenure as ambassador to France. He commissioned the royal sculptor, Jean-Jacques Caffieri, who included an English inscription recounting Montgomery's heroism on a rectangular marble block at the monument's base.[12] Caffieri also signed his name in Latin: "INVENIT ET SCULPSIT. PARISIIS JJ CAFFIERI SCULPTOR REGIUS ANNO DOMINI MDCCLXXVII" (J. J. Caffieri, sculptor to the king, designed and sculpted this in Paris in 1777). Signatures in Latin are standard[13] and perhaps unworthy of mention. Surely noteworthy, however, is the Latin inscription on the club of Hercules: "LIBERTAS RESTITUTA" (Liberty restored) (Figure 9.4).

The abstract Latin noun *Libertas* (freedom) achieved deified status in Republican Rome: She had her own temple and statues, and her image often appeared on coins. The word was invoked along with her likeness by Brutus and Cassius to justify the death of Julius Caesar, whom they likened to a repressive tyrant poised to snatch liberty from the free Roman people.[14] The phrase *libertas restituta* became a popular slogan during the interregnum that followed the downfall of the emperor Nero in 68 CE.[15] It is used by Caffieri, no doubt on Franklin's instruction, to symbolize the colonies' declaration of freedom from English hegemony, represented in the broken yoke smashed by Hercules's club. The club symbolizes the aid of France[16] and is flanked on one side by the *pileus*, the cap of liberty worn by manumitted slaves at Rome and generally emblematic of freedom from bondage. On the other side of the club are fronds of a palm tree, which here portend a victory that was hardly inevitable in 1777. The explicit use of Roman images for a memorial instead of, say, Christian symbolism is in keeping with the ideals of the Enlightenment and of the deist Founding Fathers, and the monument produces a hybrid Franco-American aesthetic.[17] At the same time, it establishes a precedent for memorials in New York, where a Latin inscription helps invoke Roman (republican) iconography richly symbolic of the liberation from tyranny. The Latin here does not suggest permanence so much as antiquity, the other half of Johnson's "ancient and permanent language." In short, it contributes to a familiar dialogue with the classical past, where freedom is known to be better than bondage and worthy not merely of struggle but even of death.

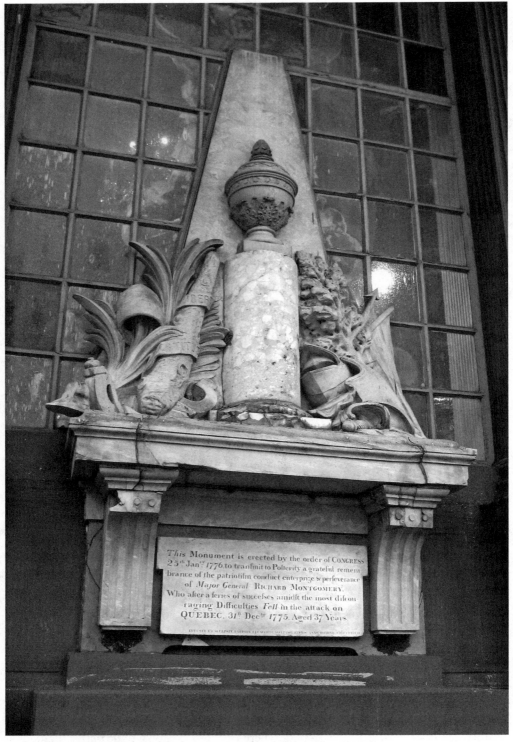

FIGURE 9.3. Montgomery Monument by J. J. Caffieri, Paris, 1777, resting on a podium in front of Palladian window of St. Paul's Chapel.

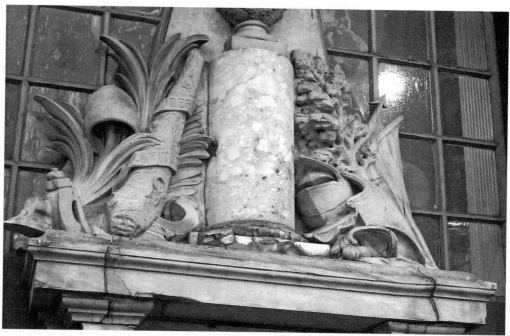

FIGURE 9.4. Montgomery Monument, detail of inscription "LIBERTAS RESTITUTA," with *pileus* or "cap of freedom," Hercules's club, urn on pilaster, palm (left) and cypress branches (right).

W. Gobetz (CC BY-NC-ND 2.0).

The cemetery at St. Paul's holds at least two other related monuments, those of Thomas Addis Emmet Esq. (1764–1827) and Dr. William James MacNeven (1763–1841). Like Montgomery, Emmet and MacNeven were born in Ireland, and their funerary monuments are fittingly adorned with inscriptions in three languages: English, Irish-Gaelic, and Latin. The massive obelisk, nearly thirty-five feet tall, erected in 1833 in honor of Emmet on the cemetery's south side, is one of the more majestic funerary monuments in New York City.[18] The letters of the Latin inscription have been eroded and are no longer legible to the naked eye. Yet, as the transcription attests, the Latin is of especially fine quality:

<div align="center">

M. S.

THOMÆ ADDIS EMMET.

Qui

Ingenio illustri, studiis altioribus,

Moribus integris,

Dignum

Se præstabat laudibus illis,

Illa reverentia, illo

Amore

Quæ semper eum viventem

Prosequebantur ;

Et subita illo erepto morte,

</div>

Universæ in luctum civitatis,
Se effuderunt,
Quum raro extiterit vir
Naturæve dotibus, doctrinæve subsidiis
Omnibus illo instructior ;
Tum eloquentia, altâ illâ et verâ
Qualem olim mirabantur Roma
Athenæque,
Præcipue alios anteibat :
Gravis, varius, vehemens, fervidus,
Omnes animi motus sic regere norît,
Uti eos qui audirent, quo vellet
Et invitos impelleret.
Hiberniâ natus,
Dilectam sibi patriam diu subjectam
Alieno, servis tantum ferendo, jugo,
Ad libertatem, ad sua jura vocare
Magno est ausus animo ;
At præclara et consilia et vota
Fefellere fata.
Tum infelicis littora Iernæ
Reliquit,
Spe, non animo, dejectus
Nobilis exsul ;
Et hæc Americana libens Respublica
Illum excepit, civemque, sibi
Gratulans adscivit ;
Dein hæc civitas illi domus,
Hæc patria fuit,
Hæc gloriam illi auxit, hæc
Spiritus ultimos
Recepit.

Mærentium civium voluntas
Hoc exegit monumentum.

(TO THE SACRED MEMORY OF THOMAS ADDIS EMMET, who by his distin-
guished talents, his devotion to higher learning, and the integrity of his character showed
himself worthy of those praises, that reverence, and love which always attended him
during his life and which, when he was snatched away by a sudden death, were poured out
to express the grief of the entire community, since rarely has a man appeared who was
better equipped than he with the gifts of nature and every complement of learning. He
excelled others, in particular, in that true and lofty eloquence which long ago was
admired by Rome and Athens. Earnest, versatile, vigorous, and passionate, he knew how
to control men's every emotion so that he could compel his hearers even against their will
in whatever direction he wished. Born in Ireland, he dared with great courage to summon
to freedom and self-rule that land, so beloved by him, yet for so long subject to a foreign

yoke which only slaves ought to bear; but fate disappointed his noble plans and wishes. Then, a noble exile, downcast in hope, but not in heart, he quit the shores of luckless Erin. And this American republic gladly received him and was proud to make him her citizen. From then on, this community was his home and homeland, increased his glory and received his last breath. The good will of his fellow-citizens in mourning has erected this monument.)[19]

The text is said to have been composed by William Alexander Duer, a New York State Supreme Court judge (1822–29) and president of Columbia College (1829–42). Duer knew Emmet from court and had compared him as orator to his countryman and contemporary Edmund Burke (1729–97).[20] The vigorous Latin here is fitting for the eventful life of Emmet, the older brother of Robert Emmet, who was executed for leading the Irish Rebellion of 1803. Thomas had himself been a leading member of the Society of United Irishmen, for which he was arrested and imprisoned from 1798 to 1802. He was then exiled to Europe and sailed in 1804 to New York, where he made a career as a lawyer and, for a short time, New York State attorney general (1812–13).

Duer's praise of Emmet hits several classical notes, which are used to construct a kind of "call to classical culture." Its close, for example, "hoc exigit monumentum" (has erected this monument), quotes the opening of one of Horace's most famous *Odes*, 3.30.1: "exegi monumentum aere perennius" (I have built a monument more lasting than bronze). The opening tricolon describing Emmet's talent, skill, and character, "ingenio illustri, studiis altioribus, moribus integris" (his distinguished talents, his devotion to higher learning, and the integrity of his character), has the balance of a Ciceronian turn of phrase, but its roots and actual diction are to be found in Tacitus's *Histories* 5.3: "ingenium inlustre altioribus studiis iuvenis admodum dedit" ([Helvidius Priscus] dedicated his distinguished talents to higher learning as a youth). Duer's emphasis on Emmet's eloquence leads naturally to the explicit mention of Greece and Rome: "eloquentiam . . . qualem olim mirabantur Roma Athenaeque" (the kind of eloquence that long ago was admired by Rome and Athens). The Latin here is elegant and erudite and projects an ethos of culture—even beyond Caroline Winterer's sense of the term[21]—where classical learning is not merely a value but an expectation. It may have been a challenge for even an educated passerby, who in any case would have had difficulty seeing it high up on the obelisk. What appears to be more important than comprehensibility or, for that matter, permanence is the projection of erudition and culture in the commemoration of a powerful man who used his own erudition to influence others.

William James MacNeven was also erudite and influential enough to receive a funerary monument in close proximity to Emmet's on the north side of St. Paul's. MacNeven was a founding member of the College of Physicians and Surgeons in New York (1807), where he served over twenty years as a professor of midwifery, chemistry, and *materia medica* before teaching briefly at Rutgers Medical College (then also in New York). He is linked to Thomas Emmet not merely by the place of their memorials but as another political exile from Ireland. While in jail at Fort George, Scotland, MacNeven is said to have compiled for Emmet's children a "grammar," no doubt of Irish and of Latin.[22] One of those children, Thomas Addis Jr., eventually married MacNeven's stepdaughter Anna, in whose house the

doctor died in 1841. MacNeven was buried on the Riker Farm in the Astoria section of Queens, but a granite column with a simple Corinthian capital was set up in his honor in St. Paul's cemetery. A commemorative column of this kind is common for the period,[23] although at over twenty feet MacNeven's is noteworthy for its size. On the south side of the column's square granite base, we find standard Latin for a commemorative inscription:

IN. MEMORIAM.
GUILIELMI. JACOBI. MACNEVEN. M.D.
QUI. HIBERNIA. NATUS
DIE. MENSIS. MARTII. XXI. A.D. MDCCLXIII.
E. VITA. IN. HAC. URBE. DECESSIT.
DIE MENSIS JULII. XII.
ANNO. SALUTIS.
MDCCCXLI.

(In memory of William James MacNeven MD, who was born in Ireland on March 21, 1763, and departed from life in this city on the 12th day of July, in the year of salvation 1841.)

The Latin is begrudging on MacNeven's accomplishments and has none of the markers of classical erudition that characterize the inscription on Emmet's obelisk. Of course, the English inscription on the monument offers a fuller account of MacNeven's life and deeds: "WHO IN THE CAUSE OF HIS NATIVE LAND/SACRIFICED THE BRIGHT PROSPECTS OF HIS YOUTH/AND PASSED YEARS IN POVERTY AND EXILE/TILL IN AMERICA HE FOUND A COUNTRY/WHICH HE LOVED AS TRULY AS HE DID/THE LAND OF HIS BIRTH./TO THE SERVICE OF THIS COUNTRY WHICH/HAD RECEIVED HIM AS A SON/HE DEVOTED HIGH SCIENTIFIC ACQUIREMENTS/WITH EMINENT ABILITY."[24]

As on the Emmet monument, the inscriptions in three languages speak to the different roles MacNeven played in life: a patriot (Irish), a learned physician (Latin), and an influential presence in American professional and political life (English). The English text quoted here is appropriate for the professional accomplishments of MacNeven, who was considered in his own lifetime to be the father of American chemistry and who exercised influence on a range of social and political issues beyond science and medicine. One of his biographers, John W. Francis, writes, "no medical man of the faculty among whom he resided surpassed him in philological pursuits, and in the acquisition of languages. He was a classical scholar, and ready with citations from the most approved English writers."[25] The Latin on his inscription may be unforthcoming about his exploits as a political activist, exile, medical doctor, and scholar. Yet it adds, together with the English and Irish inscriptions and the somber Corinthian column on whose base they all stand, more texture to the monument and to the fullness of MacNeven's very full life. Latin was part of his routine in class, at the lab, and in his study. It was, in short, part of the cultivated, civically inclined man's daily life, and as such it is duly represented on his memorial.

MacNeven's memorial was erected between the important bans on burials in Manhattan south of Canal Street in 1823 and on interments in vaults in 1851.[26] In response

to these bans, the Episcopal parish of Trinity Church on Broadway at Wall Street, to which St. Paul's Chapel belongs, established a cemetery in 1842 on twenty-four acres between 153rd and 155th Streets in Upper Manhattan. On several monuments are various Latin phrases from family mottos—for example, "NEC TEMERE NEC TIMIDE" (Neither rashly nor meekly) on the Simmons family monument (1884)—to the familiar Christian epitaph "JESU MISERERE" (Have mercy, Jesus). The most surprising Latin inscription is found on the gravestone of George Folliott Harison (1776–1846) in the southeastern corner of the cemetery (Figure 9.5). It comes from the first *Satire* of the Roman poet Persius (34–62 CE): "Nec te quaesiveris extra" (And do not look beyond yourself). For a Roman Stoic like Persius, this probably meant, "seek not the approval of others since a truly wise man ought to be guided by his own reason." The verse had already been interpreted as proverbial by Erasmus in the *Adagia* (1508), his massive collection of ancient proverbs, and other Latin phrase collectors surely followed suit.[27] An adapted, untranslated version of the phrase served as the first of three epigraphs to the first edition of Ralph Waldo Emerson's 1841 essay on "Self-Reliance": "Ne te quaesiveris extra."

Whether George Folliott Harison was reading Emerson late in life I cannot say, but "Self-Reliance" is not likely to have been the source for the Persius quotation on his funerary monument. Harison belonged to one of New York's most illustrious families, as his tombstone is at pains to point out: "a gentleman and head of that branch of the family . . . that came to this (then) Province in Dec. A.D. 1708." His father was a well-known federalist politician and the first US attorney for the District of New York, Richard Harison (1747–1829), law partner of Alexander Hamilton, at whose funeral he was a pallbearer. From his father, George Folliott Harison inherited the land between Eighth and Ninth Avenues and Thirtieth and Thirty-Second Streets, just south of the James A. Farley (General) Post Office Building today. On that land, he is said to have cultivated for the first time one of America's most beloved flowers: *Rosa* "Harison's Yellow," aka *R. x Harisonii* or "The Yellow Rose of Texas," which was recently replanted around his grave.[28] Harison inherited not only his land but also his family motto, "Nec te quaesiveris extra," as we learn from his father's Chippendale Armorial bookplate, engraved by Peter R. Maverick (1755–1811).[29] Such bookplates bespeak a world where learning—or the trappings of learning—is a commodity and where knowledge of the classical past is of cultural and commercial value.

Latin fits naturally into this world and thus readily adorns the funerary monuments of our silver-tongued lawyer, philological doctor, and amateur botanist. In each case, there is another language (or two) on the monument, and on Harison's gravestone, the main inscription is in English, with only a four-word quotation in Latin. This is not to say we have arrived at Boswell's ideal of "being more universally understood." On the contrary, limiting understanding to the educated few may have been an ancillary goal of the Latin inscriptions from around New York in our period. At the very least, to include an original (and erudite) composition in Latin or even to quote ancient authors on a funerary monument is a demonstration of learning, a public performance of sorts that is renewed and reengaged every time the inscription is encountered and (re)read.

Not far from the site of Harison's grave, still on the grounds of Trinity Cemetery, is the Episcopal Church of the Intercession—originally the Chapel of the Intercession and

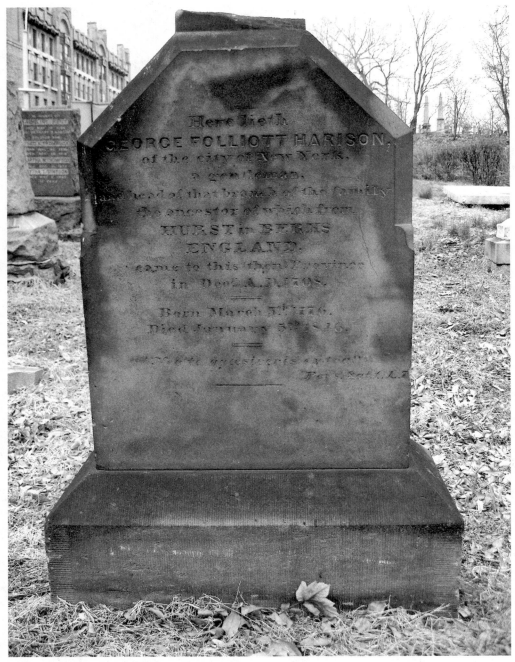

FIGURE 9.5. Gravestone of George Folliott Harison (1776–1846), with the quotation from Persius's *Satires* 1.7: "Nec te quaesiveris extra" (And do not seek outside of yourself).

G. Guderian.

Vicarage (1912–15)—designed in the Gothic Revival style by Bertram Grosvenor Goodhue (1869–1924). Goodhue considered it his masterpiece and chose it for his resting place.[30] His tomb is also recognized as a masterpiece and was designed by his longtime collaborator Lee Lawrie (1877–1963), the foremost architectural sculptor of his era (Figure 9.6).

The *AIA Guide to New York City* notes that Lawrie's design "gives a Protestant interpretation to the royal tombs of St. Denis [Paris]."[31] This may capture the monument's grandeur, but it seems to miss its very personal character for Lawrie, who notes of Goodhue, "my first milestone was reached when I answered the 'Boy Wanted' ad of Richard Henry Park in 1891. The second was the day I met Bertram Grosvenor Goodhue."[32] Lawrie's great admiration for Goodhue and his work helps, in my view, to explain the choice of the monument's Latin inscription: "NIHIL TETIGET QUOD NON ORNAVIT" (He touched nothing he did not make beautiful) (Figure 9.7).

Although the Latin has a mistake—*tetiget* should be *tetigit*—the sentiment aptly expresses for Lawrie and, no doubt, for many of his colleagues the extraordinary architectural achievements of Goodhue. The source is Samuel Johnson's epitaph for Oliver Goldsmith (1776), the discussion of which began this chapter. Johnson's Latin tribute is still visible in the Poets' Corner at Westminster Abbey:

> Olivarii Goldsmith
> Poetae, Physici, Historici,
> Qui Nullum fere scribendi genus
> Non tetigit,
> Nullum quod tetigit non ornavit:
> Sive risus essent movendi,
> Sive lachrymæ,
> Affectum potens, at lenis dominator:
> Ingenio sublimis, vividus, versatilis.
> Oratione grandis, nitidus, venustus:
> Hoc monumento memoriam coluit,
> Sodalium amor,
> Amicorum fides,
> Lectorum veneratio.[33]

(To Oliver Goldsmith, poet, scientist, historian, who left nearly no kind of writing untouched, and what he touched he made beautiful, whether moving his readers to smiles or to tears, he was a forceful, but lenient master of emotions; in mind he was lofty, clear, versatile; in speech grand, brilliant, pleasing. With this memorial his memory is honored by the love of his colleagues, the loyalty of his friends, and the respect of his readers.)

Lawrie set out to honor Goodhue's memory and had added to his tomb a nearly proverbial Latin phrase in a form slightly altered[34] from perhaps the most famous memorial to artists in the world: Poets' Corner. By quoting Johnson, Lawrie brings the *veneratio* shown to artists in Westminster Abbey to bear on the memorialization of Goodhue. Whether wittingly or not, Lawrie also suggests that Johnson's understanding of the power of Latin to make its subject universal and permanent still applies here.

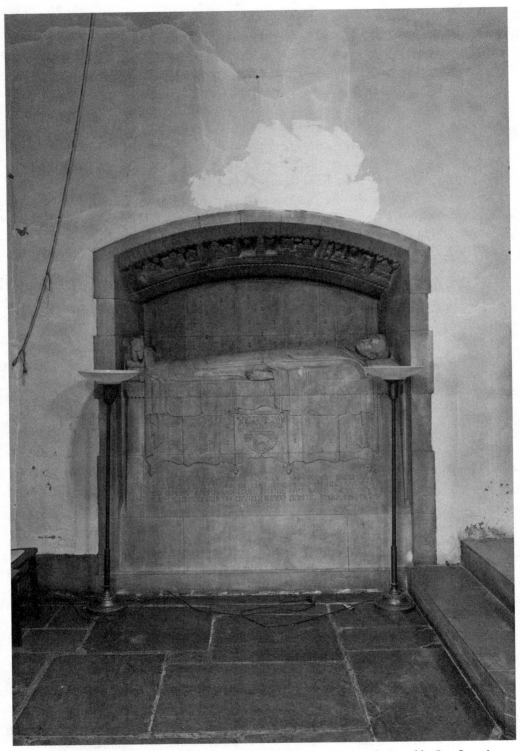

FIGURE 9.6. Goodhue's Tomb, 1924, The Church of the Intercession, designed by Lee Lawrie, according to the *AIA Guide to NYC*, as "a Protestant interpretation to the royal tombs of St. Denis [Paris]."

J. J. P. Haskins.

FIGURE 9.7. Although the Latin inscription on Goodhue's tomb, "NIHIL TETIGET QUOD NON ORNAVIT" (He touched nothing he did not make beautiful), has a mistake—*tetiget* should be *tetigit*—it alludes to Samuel Johnson's epitaph for Oliver Goldsmith (1776) in Poets' Corner in Westminster Abbey, London.
J. J. P. Haskins.

Both Lawrie and Goodhue were self-taught and had not the formal education of, say, a Thomas Addis Emmet or George Folliott Harison. Yet they reached the pinnacle of their professions, where Latin was a regular part of their world, the vibrant world of early-twentieth-century American ecclesiastical and civic design. Their relationship had been built over decades on mutual respect and a shared sense of taste,[35] and the tomb seems to give physical shape to Lawrie's grief. The high quality of the artistry can be seen in the handsomely carved Goodhue family crest and its Latin motto: "NEC INVIDEO NEC DESPICIO" (I neither envy nor despise) (Figure 9.8).

I cannot say how this phrase came to be associated with Goodhue's family—what looks ancient can also be a recent invention—but the lesson of tolerance and good will suits the world of artists, where envy and scorn can play such a powerful and corrosive role. Even if the inscription is meant to suggest a certain emotional detachment or self-sufficiency, as, for example, what we saw in the Persius line "nec te quaesiveris extra" (and look not beyond yourself) from Harison's tomb, the escutcheon itself, which Lawrie renders in subtle lines, seems to lend an air of antiquity and permanence. The Latin here, whatever its precise meaning, simply fits: It bestows further dignity on the already dignified aura that characterizes the tomb.

The New York Academy of Medicine

The New York Academy of Medicine is located on Fifth Avenue at 103rd Street on Manhattan's Upper East Side. Built in 1926 by the architectural firm York and Sawyer in a mixed Romanesque and Byzantine revival style, the Academy seems, Janus-like, to look forward and backward at the same time. On the one hand, it houses a vibrant scientific academy, an important voice for public health in New York City and the world. On the other hand, it is home to a world-class library in the history of medicine and offers some fifteen Latin inscriptions on its façade. Most of these are drawn from classical antiquity

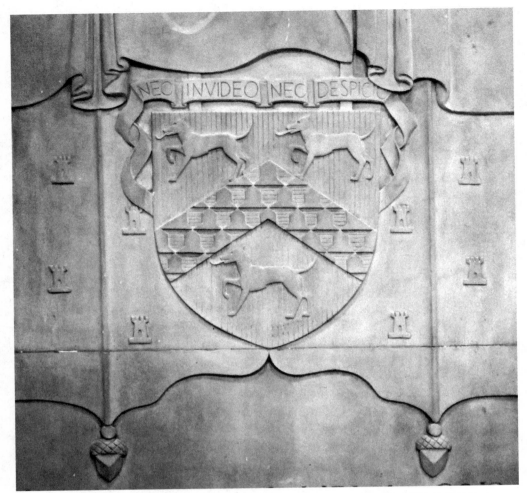

FIGURE 9.8. Goodhue's tomb with family crest and Latin motto: "NEC INVIDEO NEC DESPICIO" (I neither envy nor despise).

J. J. P. Haskins.

and include, among others, citations from Cicero, Seneca, Virgil, Hippocrates (in translation from the Greek), and Juvenal the satirist. The story of the Academy's Latin inscriptions deserves an essay of its own, not least because of the excellent archival records regarding how they were chosen. Most of these come in the form of assiduous notes made by the medical doctor, scholar, and one-time Academy president Dr. Charles Loomis Dana (1852–1935).[36] Here, I shall limit myself to two inscriptions, which also happen to be found on the original Academy seal.

Founded in 1847, the Academy had a seal engraved with the head of Hippocrates, the Greek founder of the art of medicine, in its innermost circle, together with his name in Greek. On the outer rim can be read in Latin a version of a quotation from Cicero about the nearly "divine" art of giving health to men: "HOMINES DEOS ACCEDUNT

HOMINIBUS DANDO SALUTEM N.E.A.M." The last four letters here—
N.E.A.M.—stand for the Academy's Latin title: Neo-Eboracensis Academia Medicinae
(New York Academy of Medicine). The translation of the rest is: "Men approach the gods
by giving health to other men." In fact, the text of Cicero's speech *Pro Ligario* 12 (45 BCE)
reads: "Homines ad deos nulla re propius accedunt quam salutem hominibus dando" (In
nothing do men more nearly approach the gods than in giving health to men). This full
version also appears on the frieze below the five large arched windows of the Academy's
north façade.[37] Its relevance for a medical academy is beyond question, and there is no
doubt that it is one of the earlier quotations settled on by Dr. Dana in his lengthy reflec-
tions on the subject.[38]

Unfortunately, Dana and the rest of the Academy members—including then director
Dr. Linsly Williams and librarian Dr. Archibald Malloch—were misled into thinking that
a more correct rendering of the Academy's Latin title than what was on the original seal
was necessary for their grand, new building. The error created from this folly, "Academia
Medicinae Nova Eboracensis"—which means "The New Academy of Medicine at York"—
is still on view on the Academy façade today. It was the brainchild of Dr. Andrew West,
inaugural Giger professor of Latin and later dean of the Graduate School at Princeton
University, president of the American Philological Association, and founder of the
American Classical League.[39] Dana, Williams, and Malloch were no doubt impressed
by the reputation of the classics professor from Princeton and readily yielded to his
expertise.

But not all were convinced or remained silent. In a letter to Malloch from May 2, 1933,
in response to a related matter involving the Academy's Latin title for the printing of a
book, Dr. William Francis, a librarian at the Osler Library of McGill University, brings
up the Latin of Professor West: "To me, your professor's ACADEMIA MEDICINAE
NOVA EBORACENSIS can ONLY mean 'The new academy of medicine at York' or, on
his own theory, 'the new academy of York medicine.'" Francis goes on to add: "With all
due tact and respect, drop the Princeton professor and consult the Latin secretary of the
Cardinal Archbishop of New York. There must be an official modern Roman adjective for
your town." Malloch did not go to the archbishop but to Fordham University, where two
(unnamed) Latin professors suggested "Academia Medica Neo-Eboracensis."[40] A remedy,
perhaps, but the Academy was in no position to alter or redo the inscription, and the
matter appears to have faded from administrative concerns. That is, until 1938, toward the
end of the tenure of the Academy's president Dr. James Miller, who appears to have been
reminded of the mistake by the Columbia classics professor Frank Gardner Moore. Moore
calls the title proposed by West and, in fact, carved into the Academy façade "an error,
which in such stately lettering is literally monumental!"[41] He writes two spirited letters on
the subject to Miller, the last of which, on February 1, 1939, closes thus:

> May I add the opinion of Professor Edward Capps of Princeton, general editor of the
> Loeb Classical Library: "I hope you will be able to persuade the retiring president to urge
> that the inscription be done over, and done before foreigners arrive for the Fair, no matter
> what the expense; for it is most discreditable as it stands."

It is strange to think of a Princeton professor concerned about the opinion of "foreigners" in New York for the 1939 New York World's Fair, let alone to be engaged in the fixing of a "discreditable" error in a Latin inscription on a Manhattan building. The world was evidently smaller then, and such things occupied the minds of scholars, even the editor of the Loeb Classical Library.

The matter, however, was settled as it always is: by money. The next Academy president, Malcolm Goodridge, presents the following case for doing nothing:

> With the finances of the Academy of Medicine what they are, I guess we'll leave the inscription as is, inasmuch as the estimated cost of the change would be $653. It is in my opinion unimportant whether the Neo-Caesariensis or the Nova-Caesariensis is correct on my Princeton diploma. After all, my diploma represents very largely a receipt for four years' tuition. I used to think that Andy West's Latin was good enough for me, and so did he. I have an idea we were both right.[42]

It may be remarkable that an early-twentieth-century Princeton professor of classics and dean of the Graduate School did not know how to say "New York Academy of Medicine" in Latin, but the fiscal calculations of a President Goodridge, however lamentable, are never avoidable. Of course, Professor Moore was disconsolate—what about the foreigners coming for the fair!—and sent a letter on May 19, 1939, expressing his disappointment to the Academy trustee Dr. Lewis Frissell, who wrote back to him the next day: "[the mistake] was noted years ago, but we trusted that the inexpertness of the average New Yorker in Latin might cover up the deplorable ignorance of the inscription. How to remedy it architecturally has been the crux of the matter, let alone the expense." Of course, Dr. Frissell and the Academy trustees blithely miscalculated. Average New Yorkers continue to notice the inscription's ignorance, but we are not surprised, and we certainly no longer deplore.

In an article about Latin as an "ancient and permanent language," a mistake of this kind, still visible after nearly a century, resonates in a slightly different way from how Dr. Johnson meant "permanent." Latin is hard, and the epigraphical idiom that has been used to adorn buildings and monuments from ancient Rome to modern New York has always been a challenge to master. This was surely the case for Dr. West, the Princeton professor and, as he readily admits, for Samuel Johnson, too.[43] Getting it right today has become even more difficult since the practice has virtually disappeared, and comparatively few schools continue to teach classical languages. Quite distant in time seems the world in which Latin belonged to the learned idiom of those putting up buildings and monuments in New York City. Into the mid–twentieth century, at least some New Yorkers were motivated to incorporate into their building projects not only classical forms—the mute columns, capitals, and pediments that we find in the rest of this volume—but words with identifiable sources and ideas. The New York Academy of Medicine is perhaps the prime example of this, and an essay on the other dozen or so inscriptions such as "medicas adhibere manus" (lay on healing hands), from Virgil's *Georgics* (3.455), and "nulla umquam de morte hominis cunctatio longa est" (there is no room for delay when human life is at stake), from Juvenal's *Satires* (6.221), would make a welcome addition to the study of the reception of classical antiquity in New York.

Conclusion

The practice of putting Latin on buildings and monuments has not entirely disappeared. It is just exceedingly rare, and civic art like *Under Bryant Park* by the mosaicist Samm Kunce is an exception. In 2002, Kunce had her dazzling mosaic of glazed tile, colored glass, and etched granite installed in the passageway between the IND and IRT subway lines at Forty-Second Street. The mosaic features subterranean forms like soil, roots, and water framing a series of quotations on the interplay of nature and art, including one in Latin with an English translation from Ovid's *Letters from the Black Sea* 4.10.5: "Gutta cavat lapidem" (Dripping water hollows out the stone).

More recently, New York's most important commemorative building project of the last two decades, the National September 11 Memorial & Museum (opened 2011–14), includes a verse from Virgil's *Aeneid*. The quotation is notably in English, "NO DAY SHALL ERASE YOU FROM THE MEMORY OF TIME,"[44] and not in Latin (Figure 9.9).

Of course, the subject matter here is permanence, and the English translation of Virgil poses a challenge, as if one were needed, to Samuel Johnson's idea that "everything intended to be universal and permanent should be [in Latin]." At the same time, the very presence of Virgil seems to support Boswell's notion of "classical stability," by which he meant "a sense of continuity and permanence" conveyed in language clearly linked to the classical past and its tradition.

On one level, there appears to be no place for Latin on a contemporary public monument of such gravity, whose surface meaning has to be understood, even if its deeper con-

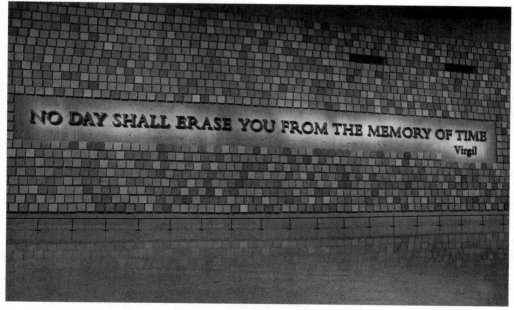

FIGURE 9.9. Virgil quotation from the *Aeneid* with Spencer Finch installation. The National September 11 Memorial & Museum.

J. Lee.

text is not. (A word on the context: In this scene from which the verse is drawn, Virgil addresses a pair of male lovers after a nighttime excursion in which they butcher their slumbering enemies before being killed themselves. The poet commemorates their deeds and willingness to sacrifice their lives for each other and their cause.)[45] On another level, Johnson's idea of "ancient and permanent" may be applied not to the Latin language itself but to Virgil's *Aeneid* as a repository of Western culture. When the City of New York—a microcosm of the world—needed the words to begin to capture the grief, anger, and sense of loss created by that day, it turned to Virgil, the ultimate classic, as the paradigmatic representative of an entire cultural epoch: classical antiquity. That epoch, it seems, lies beyond the claim of an individual people or contemporary religion. The classics are not Christian, Muslim, Jewish, Hindu, or Buddhist, and although undeniably "Western" in origin and character, they are open to all people, regardless of creed or background. Encountering the classics in translation can still be a powerful experience, as at the National September 11 Memorial & Museum. Sometimes, however, there is no translation, as on the Hutchins memorial bench or George Folliott Harison's gravestone, and if the reader has no Latin, there can be no conversation. Clearly, the richness of classical—and Christian, medieval, Renaissance, late-modern, and, in some places, contemporary—Latin literature provides an argument for learning the language well. At the same time, untranslated Latin continues to occupy the space we move through every day, and knowing how to read it enriches our experience of the world we live in. It is this sense, perhaps, in which Johnson's idea of the "permanent" is most relevant: Latin need not only be about the past; it helps us understand the present and—*dis volentibus*—the future.

NOTES

1. *Boswell's Life of Johnson*, ed. G. Birkbeck Hill (Oxford: Oxford University Press, 1887), 3:84n2.

2. Melody Barnett Deusner, "The Impossible *Exedra*: Engineering Contemplation and Conviviality in Turn-of-the-Century America," in *Housing the New Romans: Architectural Reception and the Classical Style in the Modern World*, ed. Katharine von Stackelberg and Elizabeth Macaulay-Lewis (New York: Oxford University Press, 2017), 153–89. This chapter carefully charts the rise in public and private *exedrae* during our period. She writes, "Whether erected on the street, in the parlor, in the garden, or in the cemetery, American *exedrae* typically memorialized individual accomplishment while at the same time inviting groups of people to sit face to face, thereby forcing continual renegotiations of the relationships between self, community, nation, and history" (160). Often, however, "these broader cultural expectations collided with patterns of actual use" (171).

3. According to the New York City Public Design Commission Archives (Series 1626, Exhibit A), Augustus S. Hutchins Esq. submitted the proposal for the bench on or around June 6, 1929, at the estimated cost of $12–15,000. See Exhibit B on the negotiation regarding location.

4. New York City Public Design Commission Archives, Series 1626, Exhibit C.

5. Claud. *De consulatu Fl. Manlii Theodori Panegyricus* (399 CE); cf. Ovid *Tristia* 5.14.31: *pretium virtus sibi ipsa* (Virtue is its own reward).

6. Henry Montagu Butler, *Some Leisure Hours of a Long Life: Translations into Greek, Latin and English Verse from 1850–1914* (Cambridge: Bowes & Bowes, 1914), 276. Both the sundial's inscription and Butler's commemorative piece in honor of Oxenham draw on Horace's *Odes* 3.30.1–5:

Exegi monumentum aere perennius, / regalique situ pyramidum altius, / quod non imber edax, non Aquilo impotens / possit diruere aut innumerabilis / annorum series et fuga temporum (I have erected a monument more lasting than bronze and more lofty than the height of royal pyramids, which no biting rain, no powerful north wind or countless years and the flight of will have the power to destroy.)

7. After all, "Nero spoke the same language as Seneca," as Greg Guderian, founder of the New Jersey Latin Inscriptions Project, has reminded me in his trenchant comments on an earlier draft of this essay.

8. Cf. Lorna Hardwick, *Reception Studies: Greece & Rome*, New Surveys in the Classics 33 (Oxford: Oxford University Press, 2003), 2–4, on the difference between the *classical tradition*, where "influence" and "legacy" are the operative interpretive terms, and the process of *classical reception*, with its emphasis on reappropriation and reworking, "where the focus is on the two-way relationship between the source text or culture and the new work and receiving culture. Analysis of the principles and assumptions underlying selectivity and contextual comparisons between source and receiving conditions are vital tools."

9. Tim Whitmarsh, "True Histories: Lucian, Bakhtin, and the Pragmatics of Reception," in *Classics and the Uses of Reception*, ed. Charles Martindale and Richard Thomas (Oxford: Blackwell, 2006), 115. He advocates for the term "recipience (an ongoing process)" over against "reception, indeed . . . an unfortunate word for this process: it implies too simplistic a model of departure and arrival. What is needed is a richer sense of the constant shuttling back and forth between text, interpreter and intermediaries." Simon Goldhill, "Touch of Sappho," in *Classics and the Uses of Reception*, ed. Charles Martindale and Richard Thomas (Oxford: Blackwell, 2006), 250, has similar advice, "putting the viewer [of an object that engages with the classical past] in *Rezeptionsgeschichte* reminds us that reception is best seen as a continuing, dynamic process, where our object of study is not the picture as a static and stable receptacle of meaning, but rather the viewer's engagement with the picture as a cultural event."

10. Sally Webster, *The Nation's First Monument and the Origins of the American Memorial Tradition: Liberty Enshrined* (Burlington, VT: Ashgate, 2015), offers a compelling reading of the Montgomery Monument for the tradition of American (heroic) memorial art.

11. Webster, *Nation's First Monument*, 170–72.

12. The inscription reads: "*This* Monument is erected by the order of Congress / 25th Jan.ry 1776. to transmit to Poſterity a grateful remem- / brance of the patriotism conduct enterprize & perseverance / of *Major General* Richard Montgomery / who after a ſeries of succeſses amidst discou- / raging difficulties *Fell* in the attack on / Quebec. 31st Decbr 1775. Aged 37 Years."

13. Even today the abbreviation *sc.* (= *sculpsit*, "he sculpted") on sculptures before the artist's name refers to the Renaissance practice of signing work.

14. Valentina Arena, *Libertas and the Practice of Politics in the Late Roman Republic* (Cambridge: Cambridge University Press, 2012), 42–43.

15. See C. H. Wirszubski, *Libertas as a Political Idea at Rome during the Late Republic and Early Principate* (Cambridge: Cambridge University Press, 1950), 124. For coins, see M. H. Crawford, *Roman Republican Coinage* (Cambridge: Cambridge University Press, 1974), 508/3, among the most famous coins from antiquity, the original *EID MAR* with *pileus* flanked by daggers on the *denarius* of Brutus, the assassin of Julius Caesar. There are numerous examples of the derivative *denarii* struck by Galba and Vitellius in 69 BCE, the year of the four emperors, which frequently represent LIBERTAS, even with the phrase "P.R. RESTITVTA" (Freedom of the Roman People Restored), e.g., C. H. V. Sutherland and R. A. G. Carson, eds., *Roman Imperial Coinage*, 2nd ed., vol. 1, Galba 39, 69 CE, silver denarius. Images available at OCRE (*Online Coins from the Roman Empire*), http://numismatics.org/ocre/results?q=libertas.

16. See the 1778 engraving of Antoine Borel, "L'Amérique Independante Dédiee au Congres des États unis de l'Amerique," record no. 31165, John Carter Brown Library of Brown University, Archive of Early American Images. Borel originally dedicated the engraving to Benjamin

Franklin, who appears in the image as a sage of the wood, gently guiding America crowned with the bird feathers of a Native American headdress. The figure of Hercules bears on his helmet a rooster [=Latin *gallus*, homonym of *Gallus*, "French"], which identifies him as a stand-in for France. Here he is striking down the female representative of England and breaking her chains of enslavement together with Neptune, representative of England's sea power. Mercury and Ceres look on from the left; behind the image of *Libertas* with her familiar staff and cap is Minerva flying in arms with a spear to the aid of America. In the background stands a palm tree, again a symbol of (future) victory.

17. Cf. Joy Giguere, *Characteristically American: Memorial Architecture, National Identity, and the Egyptian Revival* (Knoxville: University of Tennessee Press, 2014), 98, on the early appearance of the obelisk in American funerary monuments. Giguere may go too far in her assessment of Egyptanizing, but her larger point is that we are often dealing in these monuments with an amalgam of images drawn from different traditions. That is certainly the case here with our classical symbols of the *pileus* and Hercules's club inscribed in Latin with a contemporary urn and what appear to be late-medieval-style arms. *Cf.* Webster, *Nation's First Monument*, 154 with n59.

18. Charles Wingate, *St. Paul's Chapel: The Oldest Public Building and the Only Colonial Church Edifice in New York City* (New York: Albert B. King & Co., 1905), 19, who adds "his body lies in St. Mark's Church (in-the-Bowery)."

19. I owe a special thanks to the Trinity Church archivist Anne Petrimoulx, who furnished the transcription and translation, which I've adapted. Ms. Petrimoulx also included the English and Irish inscriptions, which I reproduce here: "IN MEMORY OF THOMAS ADDIS EMMET/who/exemplified in his conduct/and adorned by his integrity/the Policy and Principles/of the United Irishmen/ "To forward a Brotherhood/Of affection/A Community of Rights/An identity of interest, /And a Union of Power/among Irishmen/of every religious persuasion, /As the only means of Irish Parliament." /For this/ (Mysterious Fate of Virtue) /exiled from his native land/In America, the Land of Freedom, /He found a second country, /which paid his love/By reverencing his genius, /Learned in our laws, /and in the laws of Europe, /in the literature of our times, and in that of antiquity/all knowledge/seemed subject to his use. /An orator of the first order, /clear, copious, fervid, /alike powerful/To kindle the imagination, /touch the affections, /and sway the reason and the will. /Simple in his tastes, /unassuming in his manners, /frank, generous, kind-hearted, /and honorable, /his private life was beautiful/as his public course was/brilliant. /Anxious to perpetuate/the name and example of such a man, /alike illustrious by his/genius, his virtues and his fate; /consecrated to their affections/by his perils, his sacrifices, /and the deeper calamities/Of his kindred/In a just and holy Cause, /his sympa-thizing countrymen/erected this monument and/cenotaph. /Born at Cork 24th April 1764, He died in the City, /14th November 1827. /40°, 42',40", N/74°,03',21"5.W.L.G." The numbers at the end appear to mark the latitude and longitude of the monument's site. The Irish inscription reads: "Do mhiannaich sé árdmath/Cum tír a bhreith/Do thug sé clú a's fuair sé moladh/An deig a bhais." Michael J. O'Brien, *In Old New York: The Irish Dead in the Trinity and St. Paul's Churchyards* (1928; repr., Baltimore, MD: Clearfield, 1997), 103, translates: "He contemplated invaluable benefits for the land of his birth, he gave *éclat* to the land of his death; and received in return her love and admiration."

20. Wingate, *St. Paul's Chapel*, 18–19.

21. Caroline Winterer, *The Culture of Classicism: Ancient Greece and Rome in American Intellectual Life, 1780–1910* (Baltimore, MD: Johns Hopkins University Press, 2002), 110.

22. Alfred Webb, *A Compendium of Irish Biography: Comprising Sketches of Distinguished Irishmen* (Dublin: Gill & Son, 1878), 321.

23. For example, the Civil War Soldiers' Monument (1869) in Brooklyn's Green-Wood Cemetery.

24. The Irish-Gaelic inscription reads, "Do thogbhadh an liag-so/Le saothar/A chomh-dhúthchasach agas a g-clann/Ag síor-chuimhniughadh/Ar/Uilliams-Sheamas MacNeimhinn, /Do rugadh in Éirinn/Ar an dara lá deag d'an Mharta/ 1763; D'eag insan g-cathair-so/Ar an d-treas lá ar fichead d'an Mchitheamh/ 1841" (This stone was laid with effort by his country-men and family, in everlasting memory of WILLIAM JAMES MACNEVEN, born in Ireland on March 12, 1763, and died in this city on June 23, 1841). Notably, the Irish-language inscription changes the month of his death from July to June.

25. John W. Francis, "William James MacNeven," in *Lives of Eminent American Physicians and Surgeons of the Nineteenth Century*, ed. Samuel D. Gross (Philadelphia: Lindsay & Blakiston, 1861), 487.

26. Edwin G. Burrows and Mike Wallace, *Gotham: A History of New York City to 1898* (Oxford: Oxford University Press, 1999), 582–83.

27. Desiderius Erasmus *Adagia* 1437: *Extra quaerere sese*. In M. Szymanski, ed., *Adagiorum Chilias Secunda* (Leiden: Brill, 2005), 429–30, https://jvpoll.home.xs4all.nl/back/Web/erasmusa15.htm.

28. Anne Raver, "New York's Roses, Home to Root," *New York Times*, April 29, 2009. *Rosa* "Harison's Yellow" is probably a hybrid of Austrian briar, *R. foetida*, and the Burnet or Scotch rose, *R. spinosissima*, or perhaps *R. pimpinellifolia*. According to most accounts, the Harison rose first bloomed in the early 1830s, when it was cut and marketed by the Long Island nurseryman William Prince, who introduced it to the American public in time for it to join the great migration west, even as far as the Oregon Trail, whence it takes its still other name as the "Oregon Trail Rose."

29. C. D. Allen, *American Book-Plates: A Guide to their Study with Examples* (New York: Macmillan & Co., 1894), 215, #348.

30. Richard Oliver, *Bertram Grosvenor Goodhue* (Cambridge, MA: Architectural History Foundation, 1983), 87–93.

31. Norval White and Elliot Willensky with Fran Leadon, *AIA Guide to New York City*, 5th ed. (New York: Oxford University Press, 2010), 558.

32. Cf. Lee Lawrie, *Boy Wanted: Incidents in the life of Lee Lawrie, Sculptor, as Related to His Wife* (unpublished autobiography), 48, available on request from the Department of Drawings & Archives, Avery Architectural & Fine Arts Library, Columbia University in the City of New York.

33. The text is reproduced and discussed in *Boswell's Life of Johnson*, 3:80–85.

34. Cf. C. W. E. Miller, "Brief Mention," *American Journal of Philology* 38 (1917): 460–62.

35. In his letters, Goodhue always has a favorable word for Lawrie; e.g., Bertram Grosvenor Goodhue Architectural Drawings and Papers, 1882–1980, box 1, folder 22 (1911), Department of Drawings and Archives, Avery Architectural & Fine Arts Library, Columbia University. For his part, Lawrie could not have been more grateful to his mentor and friend; e.g., *Boy Wanted*, 70–78, which offers a loose account of their working relationship, which ends with Lawrie's reflection on an overly expensive decorative element for the Chapel at West Point, the costs for which had long outstripped the price of production: "This mantel, I realize, was probably wanted more by Goodhue and me than by anyone else—I always felt a good deal of satisfaction that it was built" (78).

36. See, e.g., Bernard Sachs, "Charles Loomis Dana: An Appreciation," *Journal of Nervous and Mental Disease* 83 (1936): 249–51.

37. The dative *hominibus* is abbreviated as *hom.*

38. The NYAM archives are full of Dr. Dana's notes on the subject as well as his and other Academy members' correspondence with friends in New York and New Jersey and various universities in and around New York, such as Columbia, Princeton, and Fordham.

39. A letter of Director Williams to Dr. Dana, September 7, 1927: "The translation of The New York Academy of Medicine was referred to Dean Andrew West of Princeton. The 'Nova Eboracensis' is his translation." Indeed, in his letter from October 14, 1925, West makes the suggestion, which he later stands by in his handwritten letter from April 13, 1933.

40. Communicated in a letter of November 2, 1932, by Fordham College Dean, Rev. Charles J. Deane, SJ.

41. Letter of January 18, 1939, classics professor Frank Gardner Moore of Columbia to James Alexander Miller, outgoing president of NYAM, to be succeeded by Goodridge.

42. Letter dated March 8, 1939, to Dr. Samuel Lambert of the NYAM's Library Committee.

43. *Boswell's Life*, 3:82–83.

44. *Aeneid* 9.447: *nulla dies umquam memori vos eximet aevo.*

45. Cf. Caroline Alexander, "Out of Context," *New York Times*, op-ed, April 6, 2011: "The disastrous 9/11 memorial quotation was, evidently, never intended to be more than a high-sounding, stand-alone phrase, never intended to lead visitors to any more profound thoughts or emotions. Finding words that do justice to a momentous event is always difficult—especially so, perhaps, in the age of Internet trawling, when a wary eye needs to be kept for the bothersome baggage that may be attached to the perfect-sounding expression. There is an easy mechanism, also time-hallowed, for winnowing out what may be right from what is clearly wrong: it's called reading." And see the follow-up by David W. Dunlap, "A Memorial Inscription's Grim Origins," *New York Times*, April 2, 2014.

Reflections

Elizabeth Macaulay-Lewis and Matthew M. McGowan

At the outset of this work, we acknowledged that our survey was selective and that we had only begun to scratch the proverbial surface of classical New York. Beneath that surface lies, no doubt, a vast expanse of undiscovered traces of ancient Greece and Rome. It would be worthwhile, we think, to continue to scratch, even to dig, and to see whether we can further enrich our understanding of the world we move through every day. Or, if not on a daily basis, then at least on weekend trips to museums, college campuses, well-manicured cemeteries, and far-flung subway stations (Nereid Avenue, anyone?). For whatever we have done here—however incomplete and generally insufficient—it is hoped that we have gained some insight on where to go next. At the very least, we have learned that the sheer variety of structures and material objects treated in this volume speaks to the great diversity inherent in the reception of classical antiquity in New York City. There is no fixed or prefabricated antiquity that artists and architects in New York have ever been able to draw upon; there is no single meaning to the word "classical" in this book's title, since classicizing structures and objects—and the very presence of the Latin language for that matter—can convey different things at different times. As Brooke Holmes has noted, the "tenacious hold of classical antiquity" depends not on any "timeless value" but on "the minds and imaginations of so many people," real people engaging with the classical past, caring for it, recreating it, and ultimately reimagining it in some significant way.[1]

In the same place, Holmes notes that *rejection* is also significant to the story of the reception of classical antiquity.[2] Indeed, early in the course of the twentieth century, a need began to arise for artists and architects in the United States to break free from the past

and to leave classical forms largely behind in order to forge new and distinctly American kinds of art and architecture. Not surprisingly, New York City played an integral role in this process as the quintessentially modern metropolis, often defined by the skyscrapers that came to dominate its skyline. As Jared Simard's chapter demonstrates, the ready separation between Greco-Roman (mythic) content and classical (sculptural) form at Rockefeller Center signals the decline of the appropriation and redeployment of classical elements on New York's public monuments and private buildings. After 1940, there is an evident lack of visibly classical elements in art and architecture in New York City. Even before this, Art Deco and Modernism had begun to take hold and to keep the attention of artists and architects at home. While Americans continued to turn to Europe for inspiration in art and architecture, they now looked to the works of Le Corbusier and the Bauhaus movement—not to the neoclassical forms of the eighteenth and nineteenth centuries. The 1939 World's Fair, held in New York City, was futuristic in scope: The design of its built environment was now meant to look forward and focus on the future. Lewis Mumford, the *New Yorker*'s architecture critic, embraced these trends and ridiculed projects that took the form of a triumphal Roman arch, such as the New York State Memorial to Theodore Roosevelt, which serves as the main entrance to the American Museum of Natural History.[3] Classical art and architecture were now out of date and, apparently, out of fashion, a fact that seemed to contravene contemporary trends in American literature, theater, and film, which continued to embrace classical antiquity as a source of material and inspiration.[4]

Even though ancient Greece and Rome never regained their hold on the architects and artists of New York City, the aesthetic was revisited in later important architectural works, such as Philipp Johnson's ATT building at 550 Madison Avenue. Atop this important skyscraper sits a broken pediment similar to those that appear in countless buildings in the eastern Roman Empire. Thus, forms of classical art and architecture like the pediment, while no longer *practical* and rarely repurposed for entire buildings, were still *useable*. Even detached from their original meaning, they remind us that the classical past continues to lurk in New York City, where we least expect it. Perhaps here, among the forgotten fragments of an unobserved or misunderstood classical quotation, lies the path to "deep" classical New York, to borrow a phrase again from Shane Butler.[5] A follow-up volume to this one could easily stretch the chronological span of the present book, and it might also recast the focus from art and architecture to intellectual history, education, and literature. It might even venture off the island of Manhattan to the wonderfully classicizing structures and spaces of the outer boroughs. There are myriad possibilities: so many buildings, works of art, and inscriptions to discover and interpret in light of the lengthy reception of classical antiquity in New York and beyond. Whatever the emphasis, whatever the scope, and, in a sense, whatever the angle, the more assiduously we attempt to understand the place of ancient Greece and Rome in our experience of the world we inhabit, the richer our experience of that world will be. This book has attempted to contribute to the conversation on the classical and classicizing art and architecture of New York City from the late eighteenth to the mid–twentieth century. It is for others to decide whether that has been successful; our work is not yet done.

NOTES

1. Brooke Holmes, "Cosmopoiesis in the Field of 'the Classical,'" in *Deep Classics: Rethinking Classical Reception*, ed. Shane Butler (London: Bloomsbury Academic, 2016), 279.

2. Holmes, "Cosmopoiesis," 279.

3. Lewis Mumford, *Sidewalk Critic: Lewis Mumford's Writings on New York*, ed. Robert Wojtowicz (New York: Princeton Architectural Press, 1998), 69–70.

4. The scholarship on these subjects is vast and lies outside the scope of this study. Still, an argument can be made that the "golden age" of reproducing classical antiquity on film—i.e., Greek myth and Roman history—which perhaps begins with Cecil B. DeMille's *Cleopatra* (1934), is as yet ongoing. At least that appears to be a reasonable conclusion from the scholarship published on the subject in the last two decades, e.g., Maria Wyke, *Projecting the Past: Ancient Rome, Cinema, and History* (London: Routledge 1997); Jon Solomon, *The Ancient World in Cinema*, rev. ed. (New Haven, CT: Yale University Press, 2001); Monica Silveira Cyrino, *Big Screen Rome* (Malden, MA: Blackwell, 2005); Martin M. Winkler, ed., *Cinema and Classical Texts: Apollo's New Light* (Cambridge: Cambridge University Press, 2009); Elena Theodorakopoulos, *Ancient Rome and the Cinema: Story and Spectacle in Hollywood and Rome* (Exeter: Bristol Phoenix, 2010); Alastair J. L. Blanshard and Kim Shahabudin, eds., *Classics on Screen: Ancient Greece and Rome on Film* (London: Bristol Classical, 2011); and more recently, Thomas E. Jenkins, *Antiquity Now: The Classical World in the Contemporary American Imagination* (Cambridge: Cambridge University Press, 2015).

5. Shane Butler, ed., *Deep Classics: Rethinking Classical Reception* (London: Bloomsbury, 2016), "Introduction: On Origins of 'Deep Classics.'"

Note: These architectural and artistic terms are defined with respect to their use in classical architecture and in the architecture of New York City.

acanthus: a type of herbaceous plant often used in classical decoration and in Corinthian and Composite capitals.

acroterion (pl. acroteria): an ornament or figure located at the apex or lower angles of a pediment, typically supported on a plinth.

agora (pl. agorai): a public space in ancient Greek cities used for public assemblies and as a marketplace.

arabesques: a decorative pattern of stylized foliage, characterized by numerous intertwining stems.

arcade: a row of arches supporting a wall; also often a covered passageway. Sometimes called a loggia.

arch: a curved structure over an opening that supports a wall, roof, bridge, or another opening above it.

architrave: the main beam, or the lowest part of an entablature, which rests on top of columns.

arcuation: the use of arches in a building.

atrium: the main hall in a Roman house that was partially open to the sky.

balustrade: a railing supported by balusters (small pillars or columns), often part of an ornamental parapet (the protective wall of a roof or balcony).

caldarium: room with a hot plunge pool in a Roman bath.

capital: the head of a column, pillar, or pilaster. The classical orders each have distinctive capitals.

circus: a Roman arena with curved ends, used for chariot races. In the Greek-speaking world, known as a hippodrome.

classical orders: in classical architecture, a vertical assembly of a column, a capital, sometimes a base, and an entablature.

clerestory: a window, or series of windows, located in the upper part of building.

coffering: a series of recessed panels, typically in the shape of a square, rectangle, or octagon, in a ceiling, soffit, or vault.

colonnade: a row of columns supporting a wall, also often a covered passageway. Sometimes called a loggia.

column: an upright pillar, generally cylindrical, made of stone or concrete that supports an arch, entablature, or another structure. Also erected as a standalone monument.

Composite order: one of the classical orders with a base, column, and capital, which combines volutes of the Ionic order with the acanthus of the Corinthian order.

Corinthian order: one of the classical orders with a base, column, and capital, of which acanthus leaves are the primary decorative element.

cornice: the topmost element of the entablature, often decorative, in the classical orders; also a horizontal decorative molding that tops a building.

decastyle: a building with ten columns at one or both ends.

dentils: rows of small, tooth-like blocks, usually located on the underside of a cornice.

distyle: a building with two columns at one or both ends.

dormer: a window that projects vertically from a sloping roof, with its own roof and sides.

Doric order: one of the classical orders, with columns that normally lack bases and have a simple capital and a frieze that alternates between triglyphs and metopes.

egg-and-dart: a decorative device where an egg-shaped motif alternates with a dart-shaped motif.

engaged columns: columns that are partially built into wall and are not freestanding.

entablature: a horizontal, continuous lintel that is supported by columns; it is composed of an architrave, frieze, and cornice.

exedra **(pl.** *exedrae***):** an outdoor rounded bench.

frieze: the part of an entablature between the architrave and the cornice.

fresco a secco: a wall painting technique where pigments are mixed with an organic binding medium and then are applied onto a dry plaster surface.

frigidarium: room with a cold plunge pool in Roman *thermae.*

forum (pl. fora): a public space in ancient Roman city used for public assemblies and as a marketplace.

garland: a decorative cord of leaves, fruits, or flowers.

Greek-cross plan: a plan with a square central mass and four arms of equal length.

groin vault: compound vaults where barrel vaults intersect to form ridges called groins.

gymnasium: a space for physical exercise in ancient Greece, often associated with philosophical schools in Athens; later associated with Roman baths.

hexastyle: a building with six columns at one or both ends.

Hippodrome: a Greek arena with curved ends, used for chariot races; the Roman equivalent is a circus.

Ionic order: one of the classical orders, composed of a base, a column, a capital with volutes and carved moldings, and a continuous frieze.

lintel: a horizontal structural beam or member that spans an opening (i.e., a door or window) and carries the weight of the wall above it.

lunette window: a semicircular arched opening or window in a wall or vaulted ceiling.

metope: a square space that alternates with a triglyph in a Doric frieze.

natatio: a swimming pool in Roman bath.

natatorium: a post-classical term for a cold plunge pool in a Roman bath.

octastyle: a building with eight columns at one or both ends.

oculus: a high circular, often round window in a façade or dome that provides extra light.

opus sectile: a floor or wall decoration technique that used large, cut pieces of colored stone (typically marble) to make geometric or decorative patterns.

palaestra: a Greek or Roman building or court used for athletic training. During the late Republic and Roman Empire, *palaestrae* were incorporated into the imperial *thermae*.

palmette: a stylized plant motif, in which the leaves are fanned out and appear like the leaves of a palm; used as ornamental decoration.

pediment: the triangular upper part of a classical building, located above its cornice; sometimes a triangular element (also broken or curved) that tops a portico or opening.

peripteral: a building with a continuous row of columns around it.

pilaster: a shallow pier or column that only slightly projects from a wall, often similar to a column in one of the classical orders in its inclusion of an entablature and sometimes a capital.

pillar: a tall vertical structure of stone, wood, metal, or some other material, used as a support for some type of substructure (a building, monument, or ornament).

portico: a structure with a roof supported by columns, which often serves as a porch for a building and is often associated with a building entrance.

raking cornice: the cornice that follows the slope of a pediment or gable.

rosettes: a decorative motif in the form of stylized rose, often with petals opening outward from the center.

rotunda: a large round room, often with a dome.

squinch: an arched structure that spans the interior angle of a square tower (i.e., corner), to support a circular or polygonal superstructure such as a dome.

temenos: the inaugurated, bounded sacred space of a classical temple.

tepidarium: the warm room in Roman *thermae*. Often with underfloor heating.

tessera: small block of glass, stone, tile, pottery, or other material used in the construction of a mosaic.

tetrastyle: a building with four columns at one or both ends.

thermae: the large bath complexes erected in the Roman Empire.

tondo (pl. tondi): decorative roundel, which contains a painting or sculpture.

trabeation: construction using horizontal beams rather than arches or vaults.

travertine: a type of white or light-colored limestone, used extensively in ancient Roman architecture.

triglyph: part of a Doric frieze with three vertical grooves; alternates with a metope.

vault: an arched form that serves as a roof for an interior surface.

vestibule: an entrance hall.

ACKNOWLEDGMENTS

The editors would like to thank the New York Classical Club for its organization and support of the March 2015 conference "Classical New York: Greece and Rome in NYC's Art, Architecture, and History," where several of the chapters that appear here were first presented as papers. The club generously offered a subvention to speed along the publication of this volume, for which it deserves hearty thanks and eternal glory.

Many colleagues assisted with and contributed images for this project. Jeffery Burden and Jason Montgomery of the Building History Project, the Macaulay Honors College, the City University of New York, created several of the plans that appear within. Thank you to Gregory Guderian, Jason John Paul Haskins, Dragana Mladenović, and Bertram Schewel for the use of their photographs. George Lewis and Jennifer Udell kindly edited some of the photographs.

Elizabeth Macaulay-Lewis would like to thank the archivists and librarians of the Bobst Library at New York University for their assistance with the papers on the Gould Memorial Library and Hall of Fame. Thanks are also due to the staff at the Gould Memorial Library, specifically Remo Cosentino and Wendell Joyner, who kindly allowed me to visit the library multiple times, and to Cynthia Tobar, the archivist at the Bronx Community College library. Thanks are also due to students in the MA program in Liberal Studies at the Graduate Center, the City University of New York, upon whom many of the ideas in the volume were first tried out. Ellie, Arthur, and George were wonderful supporters through the writing and editing of this book. They had a very good sense of humor about being dragged across so many boroughs to look at monuments, memorials, buildings, and, of course, cemeteries. Karen Grenke and David Vining of the Onteora Library supplied much needed caffeine and WiFi, which helped speed the completion of the volume. She would also like to thank Matt McGowan, who has been a wonderful, thoughtful coeditor.

Matthew McGowan would like to thank all those who offered support and feedback along the way, in particular Patrick Burns, Harry Evans, Greg Guderian, John Kuhner, Gerald McGowan, Erin McKenna-Hanses, Lee Pearcy, and Frank Sypher. He is especially grateful to Bertram Schewel for the photographs, to Christopher Burns for help with the index, and to Jennifer Udell for help with Photoshop and just about everything else from Nereid to Utica. Anne Petrimoulx, archivist at the Trinity Wall Street Archives, furnished helpful transcriptions and translations as well as a crucial bibliography on the

Emmet and MacNeven monuments. Julianna Monjeau, archivist and records manager at the Public Design Commission of the City of New York, tracked down the proper records for Central Park and provided fine images of the Waldo Hutchins Memorial. Arlene Shaner, librarian of historical collections at the New York Academy of Medicine, opened up the academy's archives and was extraordinarily generous with her time and erudition. Jane Parks, curator of drawings and archives at the Avery Architectural and Fine Arts Library at Columbia University, and her assistant, Nichole Richard, were unfailingly accommodating with the Bertram Grosvenor Goodhue Architectural Drawings and Papers, 1882–1980. His family consistently showed Penelopean patience in the face of yet another serendipitously discovered inscription: Thank you all, Katie, Lucy, and Nell! He would like to thank most of all his tireless coeditor, Lizzie Macaulay-Lewis, whose energy, intelligence, and uncommonly fine common sense made it all possible.

Both editors would like to thank the anonymous readers, whose trenchant criticism greatly improved this volume. The support of a superb directorial and editorial team at Fordham University Press—Fredric Nachbaur, Will Cerbone, Eric Newman, and Rob Fellman—has been crucial to seeing this work through to publication. Without their initial enthusiasm for the project and gentle encouragement along the way, this book would never have seen the light of day. Of course, the mistakes that remain are ours alone.

EML: Dedicated to William and Linda Macaulay, two true New Yorkers, and the best of parents.

MM: Dedicated to the New York Classical Club:
laus illi debetur et a me gratia maior

BIBLIOGRAPHY

Adams, Bluford. *E Pluribus Barnum: The Great Showman and the Making of United States Popular Culture*. Minneapolis: University of Minnesota Press, 1997.

Adams, Thomas. *Outline of Town and City Planning: A Review of Past Efforts and Modern Aims*. New York: Russell Sage Foundation, 1935.

Adiv, Naomi. "Paidia Meets Ludus: New York City Municipal Pools and the Infrastructure of Play." *Journal Social Science History* 39, no. 3 (September 2015): 431–52.

Aeschylus. *Prometheus Bound*. Translated by Alan H. Sommerstein. Cambridge, MA: Harvard University Press, 2009.

Alder, Fred T., and Harry C. Green. *Official Programme and Souvenir Reception of Admiral Dewey by the City of New York to Admiral Dewey, September 29th and 30th, 1899*. New York: F. T. Alder and G. C. Green, 1899.

Alexander, Caroline. "Out of Context." *New York Times*. Op-Ed. April 6, 2011.

Allen, C. D. *American Book-Plates: A Guide to Their Study with Examples*. New York: Macmillan & Co., 1894.

Allsop, Robert Owen. *Public Baths and Wash Houses*. London: E. & F. N. Spon, 1894.

"American Director for Art Museum," *New York Times*, November 1, 1910.

American Society of Civil Engineers. "The New York Tunnel Extension of the Pennsylvania Railroad." *Transactions of the American Society of Civil Engineers* 68 (January 1910): Paper 1150.

———. "The New York Tunnel Extension of the Pennsylvania Railroad." *Transactions of the American Society of Civil Engineers* 69 (October 1910): Paper 1165.

"Americanization by Bath." *Literary Digest* 47, no 23 (August 1913): 280–81.

Anderson, Karen W. "Regilding a Bronx Landmark; Getty Gives Community College a $228,000 Architectural Grant." *New York Times*, July 30, 2004.

Andrews, Wayne. *Architecture, Ambition, and Americans*. New York: Harper & Row, 1955.

Architect of the Capitol, "Thomas Jefferson Library." http://www.aoc.gov/capitol-buildings/thomas-jefferson-building.

Arena, Valentina. *Libertas and the Practice of Politics in the Late Roman Republic*. Cambridge: Cambridge University Press, 2012.

Ashmole, Bernard. Review of *Greek and Roman Sculpture in American Collections* by George Chase. *Journal of Hellenic Studies* 45 (1925): 139.

Bacon, Francis. *The Advancement of Learning*. Edited by Henry Morley. London: Cassell and Company, Limited, 1893.

Balfour, Alan. *Rockefeller Center Architecture as Theatre*. New York: McGraw-Hill, 1978.

Ballon, Hilary. *New York's Pennsylvania Stations*. New York: Norton, 2002.

Bancroft, Hubert, H. *The Book of the Fair; An Historical and Descriptive Presentation of the World's Science, Art, and Industry, as Viewed through the Columbian Exposition at Chicago in 1893, Designed to Set Forth the Display Made by the Congress of Nations, of Human Achievement in Material Form,*

So as the More Effectually to Illustrate the Progress of Mankind in All the Departments of Civilized Life. Chicago: The Bancroft Company, 1893.

Barker, Barbara M. "Imre Kiralfy's Patriotic Spectacles: Columbus, and the *Discovery of America* (1892–1892) and *America* (1893)." *Dance Chronicle* 17, no. 2 (1994): 149–78.

Bar-Nathan, R., and G. Mazor. "City Center (South) and Tel Iztabba Area. Excavations of the Antiquities Authority Expedition, the Bet She'an Excavation Project (1989–1991)." *Excavations and Surveys in Israel* 11 (1993): 43–44.

Barnum, Phineas Taylor. *Nero, or The Destruction of Rome Souvenir Program.* Circus File, City Museum of New York, 1890.

Barry, Gerald J. *The Sailors' Snug Harbor: A History, 1801–2001.* New York: Fordham University Press, 2000.

Baruch, Simon. "A Plea for Public Baths, Together with an Inexpensive Method for Their Hygienic Utilization." *Dietetic Gazette* 7 (May 1891): 94.

"Baths of the New York Athletic Club." *American Plumbing Practice* (1896): 193–94.

Beard, Mary. "Cast: Between Art and Science." In *Les moulages de sculptures antiques et l'histoire de l'archéologie. Actes du colloque international, Paris, 24 Octobre 1997,* edited by Henri Lavagne and François Queyrel, 157–66. Geneva: Droz, 2000.

Beiswanger, William L. "Monticello." Grove Art Online, Oxford Art Online. http://www.oxfordartonline.com/subscriber/article/grove/art/T059356.

Benson, Frank Sherman. "The Ward Collection of Ancient Greek Coins." *Bulletin of the Metropolitan Museum of Art* 1, no. 3 (February 1906): 42–43.

Bertuca, David J., Donald Hartman, and Susan Neumeister, comps. *The World's Columbian Exposition: A Centennial Bibliographic Guide.* Westport, CT: Greenwood, 1996.

Beveridge, Albert J. "Policy regarding the Philippines." *Congressional Record,* 56th Congress, 1st session, January 9, 1900: 704–12. http://social.chass.ncsu.edu/slatta/hi216/documents/imperialism.htm.

Bevington, Charles R. *New York Plaisance—An Illustrated Series of New York Places of Amusement.* Vol. 1. New York: New York Plaisance, 1908.

Beyer, Andreas. "Palladio, Andrea." Grove Art Online, Oxford Art Online. http://www.oxfordartonline.com/subscriber/article/grove/art/T064879.

Bezilla, Michael. *Electric Traction on the Pennsylvania Railroad: 1895–1968.* University Park: Pennsylvania State University Press, 1980.

Blanshard, Alastair J. L., and Kim Shahabudin, eds. *Classics on Screen: Ancient Greece and Rome on Film.* London: Bristol Classical, 2011.

Blouet, Guillaume-Abel. *Restauration des Thermes d'Antonin Caracalla à Rom.* Paris: Firmin Didot, 1828.

Bogart, Michele H. *The Politics of Urban Beauty: New York and Its Art Commission.* Chicago: University of Chicago Press, 2006.

———. *Public Sculpture and the Civic Ideal in New York City, 1890–1930.* Chicago: University of Chicago Press, 1989.

Bolgar, R. R. *The Classical Heritage and Its Beneficiaries.* Cambridge: Cambridge University Press, 1954.

Bolton, Charles E. *A Few Civic Problems of Greater Cleveland.* Cleveland: s.n., 1897.

Boswell, James. *Boswell's Life of Johnson.* Edited by G. Birkbeck Hill. Oxford: Oxford University Press, 1887.

Boyer, M. Christine. *Dreaming the Rational City: The Myth of American City Planning.* Cambridge, MA: MIT Press, 1983.

———. *Manhattan Manners: Architecture and Style, 1850–1900.* New York: Rizzoli, 1985.

Boyer, Paul. *Urban Masses and Moral Order in America, 1820–1920.* Cambridge, MA: Harvard University Press, 1978.

Bradley, Mark, ed. *Classics and Imperialism in the British Empire*. Oxford: Oxford University Press, 2010.

"Branch Public Bath, West Sixtieth Street, New York, N. Y." *American Architect and Building News* 90, no. 1600 (August 25, 1906): 71–72.

Breiner, David M. "The Cunard Building." Landmarks Preservation Commission Report. New York: September 19, 1995.

Bresc-Bautier, Geneviève, and Henri Bresc. *Une maison des mots: inventaires de maisons, de boutiques, d'ateliers et de châteaux de siècle XIIIe–XVe siècles*. Vol. 6. Palermo: Associazione Mediterranea, 2014.

Brier, Bob. *Egyptomania*. Brookville, NY: Hillwood Art Museum, 1992.

Brinkmann, Vinzenz, and Raimund Wünsche. *Gods in Color: Painted Sculpture of Classical Antiquity*. Exhibition at the Arthur M. Sackler Museum, Harvard University Art Museums, September 22, 2007–January 20, 2008. Munich: Stiftung Archäologie Glyptothek, 2008.

Broderick, Mosette Glaser. *Triumvirate: McKim, Mead, and White: Art, Architecture, Scandal, and Class in America's Gilded Age*. New York: Knopf, 2011.

Brody, David. *Visualizing American Empire: Orientalism and Imperialism in the Philippines*. Chicago: University of Chicago Press, 2010.

Brooklyn Museum. *The American Renaissance, 1876–1917*. New York: Pantheon, 1979.

Brooks, H. Allen. "The House of Ithiel Town: Its Date of Construction and Original Appearance." *Journal of the Society of Architectural Historians* 12, no. 1 (Winter 1980): 27–28.

Brown, Frank. "Gisela Marie Augusta Richter." *Studi Etruschi* 41 (1973): 597–600.

Brownlee, David B. *Building the City Beautiful: The Benjamin Franklin Parkway and the Philadelphia Museum of Art*. Philadelphia: The Museum, 1989.

Brunner, Arnold. "The Civic Center." *National Municipal Review* (January 1923): 14–19.

"Building Boom Aimed at Civic Centre Plan." *New York Times*, February 17, 1912, 7.

Bulwer-Lytton, Edward. *The Last Days of Pompeii*. 1834. Garden City, NY: Doubleday, 1946.

Burg, David F. *Chicago's White City of 1893*. Lexington: University of Kentucky Press, 1976.

Burnham, Daniel H., John M. Carrére, and Arnold W. Brunner. *The Group Plan of the Public Buildings of the City of Cleveland. Report Made to the Honorable Tom L. Johnson, Mayor, and to the Honorable Board of Public Service by Daniel H. Burnham, John M. Carrére, Arnold W. Brunner, Board of Supervision*. 2nd ed. Cleveland: The Britton Printing Co., 1907 [first ed. 1903].

Burnham, Daniel H., and Edward H. Bennett. *Report on a Plan for San Francisco*. 1905. Berkeley, CA: Urban Books, 1971.

Burrows, Edwin G., and Mike Wallace. *Gotham: A History of New York City to 1898*. New York: Oxford University Press, 1999.

Butler, Henry Montagu. *Some Leisure Hours of a Long Life: Translations into Greek, Latin and English Verse from 1850–1914*. Cambridge: Bowes & Bowes, 1914.

Butler, Shane, ed. *Deep Classics: Rethinking Classical Reception*. London: Bloomsbury Academic, 2016.

Cahill, B. J. S. "The Bond Issue and the Burnham Plan—A Study in 'Panhandling.'" *Architect and Engineer of California and Pacific Coast States* 17, no. 2 (June 1909): 65–72.

Catalogue of the Collection of Casts. 2nd ed. with supplement. New York: Metropolitan Museum of Art, 1910.

Carlhian, Jean Paul, and Margot M. Ellis. *Americans in Paris: Foundations of America's Architectural Gilded Age: Architecture Students at the École Des Beaux-Arts, 1846–1946*. New York: Rizzoli, 2014.

Carrott, Richard G. *The Egyptian Revival: Its Sources, Monuments, and Meaning, 1808–1858*. Berkeley: University of California Press, 1978.

The Center of the First City of the World: Concerning the New Grand Central Station, Forty-Second Street, New York. New York: Rare Books Division of the Avery Architecture Library, Columbia University, 1904.

Chase, George H. *Greek and Roman Sculpture in American Collections.* Cambridge, MA: Harvard University Press, 1924.

Chauncey, George. *Gay New York: Gender, Urban Culture, and the Making of the Gay Male World, 1890–1940.* New York: Basic Books, 1995.

"Civic Bodies Try to Save City Hall Park." *New York Times,* May 6, 1911, 10–11.

"Civic Centers." *New York Times,* March 16, 1905, 8.

Citizens' Recreation Committee. "Opportunities for Recreation: Afforded by the Municipality of the City of New York and Maintained by Appropriation of Public Funds." New York: Citizens' Recreation Committee, 1909.

"The City Beautiful." *New-York Tribune,* February 13, 1904, 4.

Claridge, Amanda. *Rome: An Oxford Archaeological Guide.* Rev. ed. Oxford: Oxford University Press, 2010.

Colvin, H. M. "Architecture." In *The History of the University of Oxford.* Vol. 6: *The Eighteenth Century,* edited by L. S. Sutherland and L. G. Mitchell, 846. Oxford: Oxford University Press, 1986.

Condit, Carl. *The Port of New York.* Vol. 1: *A History of the Rail and Terminal System from the Beginnings to Pennsylvania Station.* Chicago: University of Chicago Press, 1980.

———. *The Port of New York.* Vol. 2: *A History of the Rail and Terminal System from the Grand Central Electrification to the Present.* Chicago: University of Chicago Press, 1981.

Corbeau-Parsons, Caroline. *Prometheus in the Nineteenth Century from Myth to Symbol.* London: Legenda, Modern Humanities Research Association, and Maney, 2013.

"Court House Board Will See Justices." *New York Times,* June 25, 1913, 4.

"The Court House Deadlock." *New York Times,* October 3, 1913, 10.

"The Court House Design." *New York Times,* April 14, 1913, 8.

"Court House Plans Save $14,000,000." *New York Times,* December 14, 1919, S5.

"The Court House Site." *New York Times,* June 7 1912, 12.

"Court House Site Costs $6,138,653." *New York Times,* May 10, 1913, 10.

Coverdale & Colpitts Consulting Engineers. *The Pennsylvania Railroad Company: Corporate, Financial and Construction History of Lines Owned, Operated and Controlled to December 31, 1945.* Vol. 1: *Leased Lines East of Pittsburgh.* New York: Coverdale & Colpitts Consulting Engineers, 1946.

Cram, Ralph. "The Place of the Fine Arts in Higher Education." *Bulletin of the College Art Association of America* 4 (1918): 129–35.

Cranz, Galen. *The Politics of Park Design: A History of Urban Parks in America.* Cambridge, MA: MIT Press, 1982.

Crawford, Michael H. *Roman Republican Coinage.* Cambridge: Cambridge University Press, 1974.

Croly, Herbert. "The Promised City of San Francisco." *Architectural Record* (June 1906): 425–36.

Crosby, N. B. "The Brookline Public Baths." *Current Literature* 26, no. 3 (1899): 255.

Cross, Alfred W. S. *Public Baths and Wash Houses.* London: B. T. Batsford, 1906.

Cudahy, Brian. *Over and Back: The History of Ferryboats in New York Harbor.* New York: Fordham University Press, 1990.

———. *Rails under the Mighty Hudson.* Brattleboro, VT: Stephen Green, 1975.

———. *Under the Sidewalks of New York: The Story of the Greatest Subway System in the World.* 2nd ed. New York: Fordham University Press, 1995.

Culhane, John. *The American Circus: An Illustrated History.* New York: Holt, 1990.

Curran, Kathleen. *The Invention of the American Art Museum: From Craft to Kulturgeschichte, 1870–1930.* Los Angeles, Getty Research Institute, 2016.

Cyrino, Monica Silveira. *Big Screen Rome.* Malden, MA: Blackwell, 2005.

Dain, Phyllis. *The New York Public Library: A History of Its Founding and Early Years.* New York: New York Public Library, 1972.

Daughen, Joseph, and Peter Binzen. *The Wreck of the Penn Central*. Boston: Little, Brown, 1971.

Davies, Jane B., "Alexander Jackson Davis." *American National Biography Online*. http://www.anb .org/articles/17/17-00208.html.

Davies, Paul, David Hemsoll, and Mark Wilson Jones. "The Pantheon: Triumph of Rome or Triumph of Compromise?" *Art History* 10 (1987): 133–53.

Davis, Patricia. *End of the Line: Alexander J. Cassatt and the Pennsylvania Railroad*. New York: Neale Watson Academic Publications, 1978.

De Giorgi, Andrea U. Review of *Antioch on the Orontes: Early Explorations in the City of Mosaics*, edited by Scott Redford. *Journal of Roman Archaeology* 28 (2015): 873–76.

DeLaine, Janet. *The Baths of Caracalla: A Study in the Design, Construction, and Economics of Large-Scale Building Projects in Imperial Rome. Journal of Roman Archaeology* Supplement 25. Portsmouth, RI: Journal of Roman Archaeology, 1997.

———. "The *Romanitas* of the Railway Station." In *The Uses and Abuses of Antiquity*, edited by Maria Wyke and Michael Biddiss, 145–66. Bern: Peter Lang, 1999.

Daly, Nicholas. "The Volcanic Disaster Narrative: From Pleasure Garden to Canvas, Page, and Stage," *Victorian Studies* 53, no. 2 (Winter 2011).

"Department of Classical Art." *Bulletin of the Metropolitan Museum of Art* 5, no. 3 (March 1910): 56–57.

De Puma, Richard. *Etruscan Art in the Metropolitan Museum of Art*. New York: Metropolitan Museum of Art, 2013.

Derks, Scott. *The Value of a Dollar: Price and Incomes in the United States, 1860–2004*. 3rd ed. Millerton, NY: Grey House, 2004.

Derrick, Peter. *Tunneling to the Future: The Story of the Great Subway Expansion That Saved New York*. New York: New York University Press, 2001.

Deusner, Melody Barnett. "The Impossible *Exedra*: Engineering Contemplation and Conviviality in Turn-of-the-Century America." In *Housing the New Romans: Architectural Reception and the Classical Style in the Modern World*, edited by Katharine T. von Stackelberg and Elizabeth Macaulay-Lewis, 153–89. New York: Oxford University Press, 2017.

Diehl, Lorraine. *The Late, Great Pennsylvania Station*. 2nd ed. New York: American Heritage, 1985.

Dim, Joan Marans, and Nancy Murphy Cricco. *The Miracle on Washington Square: New York University*. Lanham, MD: Lexington, 2001.

Dolink, Sam. "A Hall of Fame, Forgotten and Forlorn." *New York Times*, December 4, 2009.

Dolkart, Andrew S. "Gould Memorial Library, Ground Floor Interior—Landmarks Preservation Commission, August 11, 1981, Designation List 146, LP-1087." http://www .neighborhoodpreservationcenter.org/db/bb_files/81-GOULD-LIB-INT.pdf.

Draper, Joan E. "The San Francisco Civic Center: Architecture, Planning, and Politics." PhD diss., University of California, Berkeley, 1979.

Drexler, Arthur, ed. *The Architecture of École des Beaux-Arts*. New York: Museum of Modern Art, 1977.

"Drop Court House Plan." *New York Times*, July 25, 1919, 11.

Dunbabin, Katherine. "Pleasures and Dangers of the Baths." *Papers of the British School at Rome* 57 (1989): 6–46.

Dunlap, David W. *From Abyssinian to Zion: A Guide to Manhattan's Houses of Worship*. New York: Columbia University Press, 2004.

———. "A Memorial Inscription's Grim Origins," *New York Times*, April 2, 2014.

Dunn, Samuel. "The Problem of the Modern Terminal." *Scribner's Magazine* 52, no. 4 (October 1912): 416–42.

Dyson, Stephen. *Ancient Marbles to American Shores: Classical Archaeology in the United States*. Philadelphia: University of Pennsylvania Press, 1998.

———. "Cast Collecting in the United States." In *Plaster Casts: Making, Collecting, and Displaying from Classical Antiquity to the Present*, edited by Rune Frederiksen and Eckart Marchand, 556–75. Transformationen der Antike 18. Berlin: Walter de Gruyter, 2010.

———. *In Pursuit of Ancient Pasts: A History of Classical Archaeology in the Nineteenth and Twentieth Centuries*. New Haven, CT: Yale University Press, 2006.

———. "Rome in America." In *Images of Rome: Perceptions of Ancient Rome in Europe and the United States in the Modern Age*, edited by Richard Hingley, 57–69. *Journal of Roman Archaeology* Monographs Supplement Series 44. Portsmouth, RI, 2000.

———. "Temple of Beauty & Learning. The New Greek and Roman Galleries at the Metropolitan Museum of Art." *Apollo* 165 (May 2007): 40.

Easton Architects. *Conservation Master Plan for the Stanford White Complex Located on the Campus of Bronx Community College of the City University of New York*. 3 vols. 2005. http://www.campusheritage.org/page/bronx-community-college.html.

Edlund, Ingrid, Anna Margarite McCann, and Claire Richter Sherman. "Gisela Marie Augusta Richter (1882–1972): Scholar of Classical Art and Museum Archaeologist." In *Women as Interpreters of the Visual Arts, 1820–1879*, edited by Claire Richter Sherman with Adele Holcomb, 275–300. Westport, CT: Greenwood, 1981.

Edward, Alfred W. *Art Deco Sculpture and Metalware*. Atglen: Schiffer, 1996.

Edwards, Catharine. *Writing Rome: Textual Approaches to the City*. Cambridge: Cambridge University Press, 1996.

Eldem, Edhem. *Mendel-Sebah. Müzei Hümauyan'u Belgelemek. Documenting the Imperial Museum*. Istanbul: Hamidiye Mahallesi, 2014.

Erasmus, Desiderius. "*Extra quaerere sese*." In *Adagiorum Chilias Secunda* (Adagium 1437, 429–430), edited by M. Szymanski. Leiden: Brill, 2005. https://jvpoll.home.xs4all.nl/back/Web/erasmusa15.htm

Erkins, Henry. "Murray's Roman Gardens." *Architects' and Builders' Magazine* 8 (1907): 574–79.

Evans, Arthur J. "Further Discoveries of Cretan and Aegean Script: With Libyan and Proto-Egyptian Comparisons." *Journal of Hellenic Studies* 17 (1897): 327–95.

———. *The Palace of Minos: A Comparative Account of the Successive Stages of the Early Cretan Civilization as Illustrated by the Discoveries at Knossos*. 4 vols. Vol. 2, part 1, New York: Biblo and Tannen, 1921–35.

Fagan, Garrett. *Bathing in Public in the Roman World*. Ann Arbor: University of Michigan Press, 1999.

Fagan, Louis. *The Life of Sir Anthony Panizzi: K. C. B., Late Principal Librarian of the British Museum, Senator of Italy, &c., &c.* 2 vols. London: Remington & Company, 1880.

Fenske, Gail. "City Beautiful Movement." Grove Art Online, Oxford Art Online. http://www.oxfordartonline.com /subscriber/article/grove/art/T017886.

Finegold, Kenneth. *Experts and Politicians: Reform Challenges to Machine Politics in New York, Cleveland, and Chicago*. Princeton Studies in American Politics. Princeton, NJ: Princeton University Press, 1995.

"Fire Damages NYU's Gould Library" *New York Times*, April 18, 1969.

The Fleischman Baths: Bryant Park Building, Forty-Second St. & Sixth Ave., New York City. New York: Gudé-Bayer Co., 1908.

"Fleischman Baths Open for Public." *New York Times*, February 7, 1908, 4.

Flowers, Benjamin. *Skyscraper: The Politics and Power of Building New York City in the Twentieth Century*. Philadelphia: University of Pennsylvania Press, 2009.

Forbes, Edward. "The Art Museum and the Teaching of the Fine Arts." *Bulletin of the College Art Association of America* 4 (1918): 120–29.

Forepaugh-Sells Company. *Official Route Book of the Circuses*. Circus File, Billy Rose Theatre Collection, New York Public Library, 1898.

Foutou, Yasso, and Ann Brown. "Harriet Boyd Hawes, 1871–1945." In *Breaking Ground: Pioneering Women Archaeologists*, edited by Getzel M. Cohen and Martha Sharp Joukowsky, 198–203. Ann Arbor: University of Michigan Press, 2004.

Fox, Charles P., and Francis B. Kelley. *The Great Circus Street Parade in Pictures*. New York: Dover, 1978.

Fox, Charles P., and Tom Parkinson. *Billers, Banners, and Bombast: The Story of Circus Advertising*. Boulder: University of Colorado Press, 1985.

Fox, Richard W., and T. J. Jackson Lears, eds. *The Culture of Consumption: Critical Essays in American History, 1880–1980*. New York: Pantheon, 1983.

Francis, John W. "William James MacNeven." In *Lives of Eminent American Physicians and Surgeons of the Nineteenth Century*, edited by Samuel D. Gross, 479–87. Philadelphia: Lindsay & Blakiston, 1861.

Frothingham, A. L., Jr. "Archaeological News." *American Journal of Archaeology and of the History of the Fine Arts* 11, no. 3 (July–September 1896): 373–523.

Frusciano, Thomas J., and Marilyn H. Pettit. *New York University and the City: An Illustrated History*. New Brunswick, NJ: Rutgers University Press, 1997.

"Fusionists Grim over the Ticket." *New York Times*, August 2, 1913, 1.

Gaber, Pamela. Review of *The Cesnola Collection of Cypriot Art: Stone Sculpture* by Antoine Hermary and Joan Mertens. *Bryn Mawr Classical Review*, February 15, 2016.

Gantz, Timothy. *Early Greek Myth: A Guide to Literary and Artistic Sources*. Baltimore, MD: Johns Hopkins University Press, 1993.

Geffcken, Katherine. "The History of the Collection." In *The Collection of Antiquities in the American Academy in Rome*, edited by Larissa Bonfante and Helen Nagy with the collaboration of Jacquelyn Collins-Clinton, 21–78. *Memoirs of the American Academy in Rome* Supplement 11. Ann Arbor: University of Michigan Press, 2015.

Gell, William. *Pompeiana: The Topography, Edifices, and Ornaments of Pompeii*. London: Rodwell and Martin, 1817–19.

———. *Pompeiana: The Topography, Edifices, and Ornaments of Pompeii, the Result of Excavations since 1819*. London: Jennings and Chaplin, 1832.

Gensheimer, Maryl B. *Decoration and Display in Rome's Imperial Thermae: Messages of Power and Their Popular Reception at the Baths of Caracalla*. Oxford: Oxford University Press, 2018.

Gerhard, William Paul. "The Modern Rain Bath." *American Architect and Building News* 43 (February 10, 1894): 67–69.

Gettleman, Marvin E. "Philanthropy as Social Control in Late-Nineteenth-Century America." *Societas* 5 (Winter 1975): 49–59.

Gibson, Edward H, III. "Baths and Washhouses in the English Public Health Agitation, 1839–48." *Journal of the History of Medicine and Allied Sciences* 9 (October 1954): 391–406.

Giguere, Joy. *Characteristically American: Memorial Architecture, National Identity, and the Egyptian Revival*. Knoxville: University of Tennessee Press, 2014.

Gilchrist, Agnes, *William Strickland, Architect and Engineer, 1788–1854*. New York: Da Capo, 1969.

Gilmartin, Gregory F. *Shaping the City: New York and the Municipal Art Society*. New York: Clarkson Potter, 1995.

Glaab, Charles N., and A. Theodore Brown. *A History of Urban America*. 2nd ed. New York: Macmillan, 1976.

Glassberg, David. "The Design of Reform: The Public Bath Movement in America." *American Studies* 20, no. 2 (1979): 5–21.

Gleason, Hima Mallampati. "Collecting in Early America." In *The Oxford Handbook of Roman Sculpture*, edited by Elise Friedland and Melanie Grunow Sobocinski, with the assistance of Elaine Gazda, 44–58. Oxford: Oxford University Press, 2015.

Goldhill, Simon. "The Touch of Sappho." In *Classics and the Uses of Reception*, edited by Charles Martindale and Richard Thomas, 250–73. Malden, MA: Blackwell, 2006.

Golubski, S., and B. Kappstatter. "Swinging Doors Shut: City Probe KO's Plato's." *New York Daily News*, January 1, 1986.

Gordon, John Steele, *An Empire of Wealth: The Epic History of American Economic Power*. New York: HarperCollins, 2004.

Gould, Lewis L., ed. *The Progressive Era*. New York: Syracuse University Press, 1974.

"Government Buildings to Be of Classic Design." *Ohio Architect and Builder* 3, no. 1 (January 1904): 20–21.

Granger, Alfred. *Charles Follen McKim: A Study of His Life and Work*. Boston: Houghton Mifflin Co., Inc., 1913.

Gray, Christopher. "The Library's Extremely Useful Predecessor—Streetscapes." *New York Times*, January 20, 2011.

Greiff, Constance. *Lost America*: Princeton, NJ: Pyne, 1971.

Groneman, Carol. "Collect." In *The Encyclopedia of New York City*, edited by Kenneth T. Jackson, 250. New Haven, CT: Yale University Press, 2010.

Gross, Jane. "Bathhouses Reflect AIDS Concerns." *New York Times*, October 14, 1985.

Gross, Michael. *Rogues' Gallery: The Secret History of the Moguls and the Money That Made the Metropolitan Museum*. New York: Broadway, 2009.

Grottanelli, Cirstiano. "Tricksters, Scape-Goats, Champions, Saviors." *History of Religions* 23, no. 2 (November 1983): 117–39.

"Grouped Public Buildings." *New York Sun*, November 23, 1911.

Grow, Lawrence. *Waiting for the 5:05*. New York: Universe, 1977.

Grundfest, Jerry. *Great Americans: A Guide to the Hall of Fame for Great Americans*. New York: New York University, 1977.

Gummere, Richard. *The American Colonial Mind and the Classical Tradition*. Cambridge, MA: Harvard University Press, 1963.

Hamlin, Talbot, *Greek Revival Architecture in America: Being an Account of Important Trends in American Architecture and American Life Prior to the War between the States*. New York: Oxford University Press, 1944.

Hammack, David C. *Power and Society: Greater New York at the Turn of the Century*. New York: Russell Sage Foundation, 1982.

Hannah, Robert. "The Emperor's Stars: The Conservatori Portrait of Commodus." *American Journal of Archaeology* 90 (1986): 337–42.

Hardwick, Lorna, *Reception Studies: Greece & Rome*. New Surveys in the Classics 33. Oxford: Oxford University Press, 2003.

Hardwick, Lorna, and Carol Gillespie, eds. *Classics in Post-Colonial Worlds*. Oxford: Oxford University Press, 2007.

Harris, Neil. "Expository Expositions: Preparing for Theme Parks." In *Designing Disney's Theme Parks: The Architecture of Reassurance*, edited by Karla A. Marling, 19–27. New York: Flammarion, 1997.

Harris, Neil, Wim de Wit, and James Gilbert, eds. *Grand Illusions: Chicago's World's Fair of 1893*. Chicago: University of Chicago Press, 1993.

Hawes, Harriet B. et al., eds. *Gournia, Vasiliki, and Other Prehistoric Sites in the Isthmus of Hierapetra, Crete: Excavation of the Wells-Houston-Cramp Expeditions, 1901, 1903, 1904*. Reprint. Philadelphia: INSTAP, 2014.

Heckscher, Morrison H. "The Metropolitan Museum of Art: An Architectural History." *Bulletin of the Metropolitan Museum of Art* 53, no. 1 (Summer 1995).

Herman, Michele. "Five Points." In *The Encyclopedia of New York City*, edited by Kenneth T. Jackson, 414–15. New Haven, CT: Yale University Press, 2010.

Hetland, Lise M. "Dating the Pantheon." *Journal of Roman Archaeology* 20 (2007): 95–112.

Highet, Gilbert. *The Classical Tradition: Greek and Roman Influences on Western Literature.* New York: Oxford University Press, 1949.

Hill, G. Birkbeck, ed. *Boswell's Life of Johnson.* 4 Vols. Oxford: Oxford University Press, 1887.

Hines, Thomas S. *Burnham of Chicago, Architect and Planner.* New York: Oxford University Press, 1974.

———. "The City Beautiful in American Urban Planning, 1890–1920." *Transactions* 7 (1985): 28–44.

Hitchcock, Henry-Russell. *Architecture: Nineteenth and Twentieth Centuries.* New York: Viking Penguin, 1987.

Homberger, Eric. *New York: A Cultural and Literary Companion.* Oxford: Signal, 2002.

"How the City Can Save Millions, Told by Mcaneny." *New York Times,* June 15, 1913, SM8.

Howe, Winifred. *A History of the Metropolitan Museum of Art.* 2 vols. New York: Metropolitan Museum of Art, 1913.

Humbert, Jean-Marcel, Michael Pantazzi, and Christiane Ziegler, eds. *Imhotep Today: Egyptianizing Architecture.* London: University College London Press, Institute of Archaeology, 2003.

Hungerford, Edward. *Men and Iron: A History of the New York Central.* New York: Thomas Y. Crowell Company, 1938.

Huxtable, Ada Louise. *Classic New York: From Georgian Gentility to Greek Elegance.* New York: Anchor, 1964.

Ivins, William M., Jr. *Art and Geometry: A Study in Space Intuitions.* Cambridge, MA: Harvard University Press, 1946; facsimile ed., New York: Dover, 1964.

———. *Prints and Visual Communication.* 1953. Cambridge, MA: MIT Press, 1969.

Jackson, Kenneth T. *The Encyclopedia of New York City.* 2nd ed. New Haven, CT: Yale University Press, 2010.

Jashemski, Wilhelmina. *Gardens of Pompeii, Herculaneum, and the Villas Destroyed by Vesuvius.* New Rochelle, NY: Caratzas Brothers, 1993.

Jenewein, Gunhild. *Die Architektkurdekoration der Caracallathermen.* Vol. 1: *Textband.* Vienna: Verlage der Österreichische Akademie der Wissenshaften, 2008.

Jenkins, Ian. *Archaeologists and Aesthetes in the Sculpture Galleries of the British Museum 1800–1939.* London: British Museum, 1992.

Jenkins, Thomas E. *Antiquity Now: The Classical World in the Contemporary American Imagination.* Cambridge: Cambridge University Press, 2015.

Jensen, Oliver. *The American Heritage History of Railroads in America.* New York: American Heritage, 1975.

Jervis, John B. *Description of the Croton Aqueduct.* New York: Slamm & Guion, 1842.

Jones, Frances. "Antioch Mosaics in Princeton." *Record of the Art Museum, Princeton University* 40, no. 2 (1981): 2–26.

Jones, Newman, & Ewbank, pubs. *The Illuminated Pictorial Directory of New York.* New York: Jones, Newman, & Ewbank, 1848.

Jonnes, Jill. *Conquering Gotham: A Gilded Age Epic: The Construction of Penn Station and Its Tunnels.* New York: Viking, 2007.

Josephson, Matthew. *The Robber Baron: The Great American Capitalists, 1861–1901.* 1934. New York: Harcourt, Brace, 1962.

Kallendorf, Craig, ed. *A Companion to the Classical Tradition.* Malden, MA: Blackwell, 2007.

Kantor-Kazovsky, Lola. "Pierre Jean Mariette and Piranesi: The Controversy Reconsidered." *Memoirs of the American Academy in Rome. Supplementary Volumes* 4 (2006): 149–68.

Karageorghis, Vassos, with Joan Mertens and Marice Rose. *Ancient Art from Cyprus: The Cesnola Collection in the Metropolitan Museum of Art.* New York: Metropolitan Museum of Art, 2000.

Karp, Walter. *The Center: A History and Guide to Rockefeller Center.* New York: American Heritage, 1982.

Kasson, John. F. *Amusing the Million: Coney Island at the Turn of the Century.* New York: Hill and Wang, 1978.

Kasson, Joy S. "Narratives of the Female Body: *The Greek Slave.*" In *Reading American Art,* edited by Marianne Doezema and Elizabeth Milroy, 163–89. New Haven, CT: Yale University Press, 1998.

Kay, Nigel M. *Epigrams from the* Anthologia Latina*: Text, Translation and Commentary.* London: Duckworth, 2006.

King, Moses. *The Dewey Reception in New York City.* Prints and Photographs Division, New-York Historical Society, 1899.

———. *New York: The American Cosmopolis, the Foremost City of the World.* Boston: M. King, 1894.

Kiralfy, Bolossy. *Bolossy Kiralfy, Creator of Great Musical Spectacles: An Autobiography,* edited by Barbara M. Barker. Ann Arbor: University of Michigan Press, 1988.

Kiralfy, Imre. *Nero, or The Destruction of Rome.* Copyrighted manuscript located in the Library of Congress, 1888.

———. *Nero, or The Destruction of Rome.* Souvenir Program for Staten Island performance. Circus File, Billy Rose Theatre Collection, New York Public Library, 1888.

Knox-Taylor, James. "Why Public Buildings Should Be Dignified." *Architect and Engineer of California and Pacific Coast States* 29, no. 2 (June 1912): 100.

Koeppel, Gerard T. *Water for Gotham: A History.* Princeton, NJ: Princeton University, 2000.

Kondoleon, Christine. *Antioch: The Lost Ancient City.* Princeton, NJ: Princeton University Press, 2001.

Koolhaas, Rem. *Delirious New York: A Retroactive Manifesto for Manhattan.* New York: Monicelli, 1994.

Kostof, Spiro. *The City Assembled: The Elements of Urban Form through History.* Boston: Little, Brown, 1992.

———. *The City Shaped: Urban Patterns and Meanings through History.* Boston: Little, Brown, 1991.

———. *A History of Architecture: Settings and Rituals.* 2nd ed. Oxford: Oxford University Press, 1995.

Kraut, Alan M. *Silent Travelers: Germs, Genes, and the "Immigrant Menace."* New York: Basic Books, 1994.

Krencker, Daniel. *Die Trierer Kaiserthermen.* Augsburg: B. Filser, 1929.

Kruft, Hanno-Walter. *A History of Architectural Theory from Vitruvius to the Present.* New York: Princeton Architectural Press, 1994.

Kühn, C. G., ed. *Opera Omnia.* 1821–33. Hildesheim: Georg Olms, 1965.

Kurtz, Donna, ed. *Bernard Ashmole, 1894–1988: An Autobiography.* Malibu, CA: J. Paul Getty Museum, 1994.

Lamb, Charles R. "Civic Architecture from Its Constructive Side." *Municipal Affairs* 2 (1898): 46–72.

Lamb, Gilbert D. "The New Courthouse Site, Last Plea Is Made for the Chambers Street 'Civic Centre.'" *New-York Tribune,* August 13, 1913, 1.

Landmarks Preservation Commission. "Gould Memorial Library—Landmarks Preservation Commission, February 15, 1966, Number 3, LP-0112," http://www .neighborhoodpreservationcenter.org/db/bb_files/66-GOULD-LIBARY.pdf.

Landy, Jacob. "Stuart and Revett: Pioneer Archaeologists." *Archaeology* 9, no. 4 (December 1956): 252–59.

Lapatin, Kenneth. *Luxus: The Sumptuous Arts of Greece and Rome.* Los Angeles: J. Paul Getty Museum, 2015.

Lasch, Christopher. "The Family as a Haven in a Heartless World." *Salmagundi* 35 (Fall 1976): 42–55.

Latrobe, Benjamin Henry. *The Journal of Latrobe*. New York: D. Appleton, 1905.

Laugier, Marc-Antoine. *An Essay on Architecture*. Translated by Wolfgang Herrmann and Anni Herrmann. Los Angeles: Hennessy & Ingalls, 1977.

Lawrence, Lesley. "Stuart and Revett: Their Literary and Architectural Careers." *Journal of the Warburg Institute* 2, no. 2 (October 1938): 128–46.

Lawrie, Lee. *Boy Wanted: Incidents in the Life of Lee Lawrie, Sculptor, as Related to His Wife*. Unpublished autobiography, held in the Department of Drawings & Archives, Avery Library, Columbia University.

Lears, T. J. Jackson. *Fables of Abundance: A Cultural History of Advertising in America*. New York: Basic Books, 1994.

Lee, Antoinette. *Architects to the Nation: The Rise and Decline of the Supervising Architect's Office*. New York: Oxford University Press, 2000.

Leedy, Walter C. "Cleveland's Struggle for Self-Identity: Aesthetics, Economics, and Politics." In *Modern Architecture in America: Visions and Revisions*, edited by Richard Guy Wilson and Sidney K. Robinson, 74–105. Ames: Iowa State University Press, 1991.

Leith, Sam. Review of *Luxus: The Sumptuous Arts of Greece and Rome* by Kenneth Lapatin. *Times Literary Supplement* 5896 (April 1, 2016): 5.

Lessard, Suzannah. *Architect of Desire: Beauty and Danger in the Stanford White Family*. New York: Dial, 1996.

Levine, Lawrence W. *Highbrow/Lowbrow: The Emergence of Cultural Hierarchy in America*. Cambridge, MA: Harvard University Press, 1988.

———. *The Opening of the American Mind: Canons, Culture, and History*. Boston: Beacon, 1996.

Lloyd-Jones, Hugh. "Zeus, Prometheus, and Greek Ethics." *Harvard Studies in Classical Philology* 101 (2003): 49–72.

Lombardi, Leonardo, Angelo Corazza, and Filippo Coarelli. *Le Terme di Caracalla*. Rome: Fratelli Palombi, 1995.

Loth, David. *The City within a City: The Romance of Rockefeller Center*. New York: William Morrow, 1966.

Lowe, David. *Stanford White's New York*. New York: Doubleday, 1992.

Lowry, Bates. *Building a National Image: Architectural Drawings for the American Democracy, 1789–1912*. Washington, DC: National Building Museum, 1985.

Lubin, David M. "Aesthetic Space." In *Rethinking the American City: An International Dialogue*, edited by Miles Orvell and Klaus Benesch, 93–118. Philadelphia: University of Pennsylvania Press, 2013.

Lusnia, Susann S. *Creating Severan Rome: The Architecture and Self-Image of L. Septimius Severus, AD 193–211*. Brussels: Collection Latomus, 2014.

Lydston, George Frank. *The Diseases of Society (the Vice and Crime Problem)*. Philadelphia: J. P. Lippincott, 1906.

Macaulay-Lewis, Elizabeth. "The Architecture of Memory and Commemoration: The Soldiers' and Sailors' Memorial Arch, Brooklyn, New York and the Reception of Classical Architecture in New York City." *Classical Receptions Journal* 8, no. 4 (2016): 447–78.

———. "Entombing Antiquity: A New Consideration of Classical and Egyptian Appropriation in the Funerary Architecture of Woodlawn Cemetery, New York City." In *Housing the New Romans: Architectural Reception and the Classical Style in the Modern World*, edited by Katharine T. von Stackelberg and Elizabeth Macaulay-Lewis, 190–231. New York: Oxford University Press, 2017.

———. "Triumphal Washington: New York City's First 'Roman' Arch." In *War as Spectacle: Ancient and Modern Perspectives on the Display of Armed Conflict*, edited by Anastasia Bakogianni and Valerie M. Hope, 209–38. London: Bloomsbury Academic, 2015.

MacCracken, Henry Mitchell. "The Hall of Fame." *American Monthly Review of Reviews* 22 (1900): 563–70.

———. *The Hall of Fame: Official Book*. New York: G. P. Putnam/Knickerbocker Press, 1901.

MacDonald, Sally, and Michael Rice, eds. *Consuming Ancient Egypt*. Abingdon: Routledge, 2016.

Malamud, Margaret. *Ancient Rome and Modern America*. Oxford: Wiley-Blackwell, 2009.

———. "On the Edge of the Volcano: *The Last Days of Pompeii* in the Early American Republic." In *Pompeii in the Public Imagination from Its Rediscovery to Today*, edited by Shelly Hale and Joanna Paul, 199–214. Oxford: Oxford University Press, 2011.

———. "*Translatio Imperii*: America as the New Rome c. 1900." In *Classics and Imperialism in the British Empire*, edited by Mark Bradley, 249–83. Oxford: Oxford University Press, 2010.

Manheimer, Wallace A. "Comparison of Methods for Disinfecting Swimming Pools." *Journal of Infectious Diseases* 20 (1917): 1–9.

Marlowe, Elizabeth. "Said to Be or Not Said to Be: The Findspot of the So-Called Trebonianus Gallus Statue at the Metropolitan Museum in New York." *Journal of the History of Collections* 27 (2014): 147–57.

Martindale, Charles, and Richard Thomas, eds. *Classics and the Uses of Reception*. Malden, MA: Blackwell, 2006.

Marvin, Miranda. "Freestanding Sculptures from the Baths of Caracalla." *American Journal of Archaeology* 87 (1983): 347–84.

Maltbie, Milo Roy. "The Grouping of Public Buildings." *Outlook* 78 (September 3, 1904): 37–48.

Mason, Randall. *Once and Future New York: Historic Preservation and the Modern City* Minneapolis: University of Minnesota Press, 2009.

Mattern, S. *Galen and the Rhetoric of Healing*. Baltimore, MD: Johns Hopkins University, 2008.

Matthews, John F. "Olympiodorus of Thebes and the History of the West (AD 407–425)." *Journal of Roman Studies* 60 (1970): 79–97.

Mayer, David. "Romans in Britain, 1886–1910: Pain's 'The Last Days of Pompeii.'" *Theatrephile* 2, no. 5 (1984–85): 41–50.

Mayer, Grace M. *Once upon a City: New York from 1890 to 1910 as Photographed by Byron and Described by Grace M. Mayer*. New York: Macmillan, 1958.

Mayor's Committee of New York City. *Report on Public Baths and Public Comfort Stations*. New York, 1897.

McClees, Helen. *The Daily Life of the Greeks and Romans as Illustrated in the Collections*. New York: Metropolitan Museum of Art, 1941.

McFadden, Elizabeth. *The Glitter and the Gold: A Spirited Account of the Metropolitan Museum of Art's First Director, the Audacious and High-Handed Luigi Palma de Cesnola*. New York: Dial, 1971.

Medina, Louisa H. *The Last Days of Pompeii: A Dramatic Spectacle*. 1835. New York: S. French, 1856.

"Medal for Mcaneny." *New York Times*, May 28, 1913, 11.

Meeks, Carroll. *The Railroad Station: An Architectural History*. 2nd ed. Mineola, NY: Dover, 1995.

Mertens, Joan R. *The Metropolitan Museum of Art: Greece and Rome*. New York: Metropolitan Museum of Art, 1987.

———. "The Publications of Gisela M. A. Richter: A Bibliography." *Metropolitan Museum Journal* 17 (1984): 119–32.

Metropolitan Board of Health. *Fourth Annual Report of the Metropolitan Board of Health of the State of New York*. New York: D. Appleton, 1870.

The Metropolitan Museum of Art: A Review of Fifty Years' Development Printed on the Occasion of the Fiftieth Anniversary of the Founding of the Museum. New York: The Metropolitan Museum of Art, 1920.

Michelakis, Pantelis, and Maria Wyke. *The Ancient World in Silent Cinema*. Cambridge: Cambridge University Press, 2013.

Middleton, William. *Manhattan Gateway: New York's Pennsylvania Station.* Waukesha, WI: Kalmbach, 1996.

Miller, C. W. E. "Brief Mention." *American Journal of Philology* 38 (1917): 460–62.

Moog-Grünewald, Maria, ed. *Brill's The Reception of Myth and Mythology.* Leiden: New Pauly, 2010.

Moltesen, Mette. *Perfect Partners: The Collaboration between Carl Jacobsen and His Agent in Rome Wolfgang Helbig in the Formation of the Ny Carlsberg Glyptotek, 1887–1914.* Copenhagen: Ny Carlsberg Glyptotek, 2012.

Moody, John. *The Railroad Builders.* New Haven, CT: Yale University Press, 1919.

Moore, Barbara. *The Destruction of Penn Station.* New York: DAP, 2000.

Moore, Charles. *The Life and Times of Charles Follen McKim.* New York: Houghton Mifflin, 1929.

Moreno, Paolo. "Il Farnese ritrovato ed altri tipi di Eracle in riposo." *Mélanges de l'École française de Rome* 94 (1982): 379–526.

Moser, Stephanie. "Reconstructing Ancient Worlds: Reception Studies, Archaeological Representation, and the Interpretation of Ancient Egypt." *Journal of Archaeological Method and Theory* 22, no. 4 (2015): 1263–1308.

Mosley, Adam. "The Armillary Sphere in Poetry, Literature, and Art." Department of the History and Philosophy of Science, University of Cambridge, 1999. http://www.hps.cam.ac.uk/starry/armillpoems.html.

Mostra Augustea della Romanità. Catalogo. 4th ed. Rome: Casa Editrice C. Colombo, 1938.

Mumford, Lewis. *The Culture of Cities.* New York: Harcourt, Brace, 1938.

———. "The Pennsylvania Station Nightmare." In *The Highway and the City.* New York: Harcourt, Brace & World, 1963.

———. *Roots of Contemporary American Architecture.* New York: Reinhold, 1952.

———. *Sidewalk Critic: Lewis Mumford's Writings on New York.* Edited by Robert Wojtowicz. New York: Princeton Architectural Press, 1998.

———. *Sticks and Stones: A Study of American Architecture and Civilization.* 2nd rev. ed. New York: Dover, 1955.

Municipal Art Society of New York. "Bulletin 15, Report of the Committee on Civic Centers." New York: Municipal Art Society, 1904.

———. "Memorial of the Society Relative to Proposed Changes in and About City Hall Square." New York: The Society, 1902.

———. *To the Honorable the Board of Estimate and Apportionment of the City of New York. Letter, Dated New York, April 27, 1903, Relative to the Proposed Changes in and about the City Hall.* New York: Municipal Art Society, 1903.

———. *Yearbook.* New York: Municipal Art Society, 1910.

Murley, James. "The Impact of Edward Perry Warren on the Study and Collections of Greek and Roman Antiquities in American Academia." PhD diss., University of Louisville, 2012.

Myres, John L. "The Cesnola Collection: Preliminary Note." *Bulletin of the Metropolitan Museum of Art* 4, no. 6 (June 1909): 95–96.

———. "Crete: Prehistoric, Abstract of the Report of the Committee of the British Association on Explorations in Crete." *MAN: A Monthly Record of Anthropological Science* 1 (1901): 183–84.

"New Court House in Park of Its Own." *New York Times,* January 12, 1912, 22.

"New Court House Like the Coliseum." *New York Times,* April 14, 1913, 2.

"The New Law Courts." *New York Times,* January 19, 1912, 10.

"New Law Courts and the Redemption of a Park." *New York Times,* January 14, 1912, 14.

New York Association for Improving the Condition of the Poor. *The People's Baths, 9 Centre Market Place: A Study on Public Baths.* New York, 1896.

"New York City's Public Baths: Location, Class of Patrons and Number of Appliances." *Municipal Journal & Public Works* 38. New York: Municipal Journal and Engineer, Inc., 1915.

Newton, Roger Hale. *Town and Davis, Architects, Pioneers in American Revivalist Architecture, 1812–1870*. New York: Columbia University Press, 1942.

Nichols, Frederick D. "Jefferson, Thomas." Grove Art Online, Oxford Art Online. http://www.oxfordartonline.com/subscriber/article/grove/art/T044540.

Nichols, Marden. "Domestic Interiors, National Concerns: The Pompeian Style in the United States." In *Housing the New Romans: Architectural Reception and Classical Style in the Modern World*, ed. Katharine T. von Stackelberg and Elizabeth Macaulay-Lewis. New York: Oxford University Press, 2017.

Noble, Birseye Glover, and Charles F. Stirling. *Nichols' Illustrated New York: A Series of Views of the Empire City and Its Environs*. New York: C. B. & F. B. Nichols, 1847.

"Notes." *Bulletin of the Metropolitan Museum of Art* 1, no. 3 (February 1906): 47.

"Now Build the Court House." *New York Times*, March 29, 1914, C4.

Nucci, Roberta. "Alle origini della tutela/The origins of conservation." In *Rovine e rinascite dell'arte in Italia/Ruins and the rebirth of art in Italy*, edited by Elena Cagiano de Azevedo and Roberta Nucci, 22–24. Milan: Electa, 2008.

O'Brien, Michael J. *In Old New York: The Irish Dead in the Trinity and St. Paul's Churchyards*. 1928. Baltimore, MD: Clearfield, 1997.

Oddy, W. A., Licia Borrelli Vlad, and N. D. Meeks. "The Gilding of Bronze Statues in the Greek and Roman World." Translated by John and Valerie Wilton-Ely. In *The Horses of San Marco Venice*, 182–87. Italy: Olivetti, 1979.

Official Route Book of the Circuses. Billy Rose Theater Collection, Circus File, New York Public Library, 1898.

Ogburn, Charlton. *Railroads: The Great American Adventure*. Washington, DC: National Geographic Society, 1977.

Okrent, Daniel. *Great Fortune: The Epic of Rockefeller Center*. New York: Viking, 2003.

Oliver, Richard. *Bertram Grosvenor Goodhue*. Cambridge, MA: Architectural History Foundation, 1983.

Ormond, Richard, and Elaine Kilmurray. *John Singer Sargent—The Later Portraits: Complete Paintings*. 3 vols. New Haven, CT: Yale University Press, 2003.

Orvell, Miles, and Klaus Benesch, eds. *Rethinking the American City: An International Dialogue*. Philadelphia: University of Pennsylvania Press, 2014.

Ostrow, Steven. Review of *Life and Work of Francis Willey Kelsey: Archaeology, Antiquity, and the Arts*, by John Pedley. *Journal of Roman Archaeology* 25 (2012): 1001.

Palagia, Olga. "Heracles." In *Lexicon iconographicum mythologiae classicae*, vol. 4: *Eros-Herakles*, 728–838. Zurich: Artemis Verlag, 1988.

Pallottino, Massimo. "La Mostra della Rivoluzione Fascista a Valle Giulia." *Capitolium* 12 (1937): 513–28.

Panzanelli, Roberta, Eike D. Schmidt, and Kenneth Lapatin, eds. *The Color of Life: Polychromy in Sculpture from Antiquity to the Present*. Los Angeles: J. Paul Getty Museum, 2008.

Parissien, Steven. *Pennsylvania Station: McKim, Mead and White*. London: Phaidon, 1996.

Parry, Ellwood C., III. "Thomas Cole's Imagination at Work in the Architect's Dream." *American Art Journal* 12, no. 1 (Winter 1980): 41–59.

Parshall, Peter. "The Education of a Curator: William Mills Ivins Jr." In *The Power of Prints: The Legacy of William M. Ivins and A. Hyatt Mayor*, edited by Freyda Spira and Peter Parshall, 13–25. New York: Metropolitan Museum of Art, 2016.

Paul, Joanna. *Film and the Classical Epic Tradition*. Oxford: Oxford University Press, 2013.

Pedley, John G. *Life and Work of Francis Willey Kelsey: Archaeology, Antiquity, and the Arts*. Ann Arbor: University of Michigan, 2012.

People's Washing and Bathing Association. *First Annual Report of the People's Washing and Bathing Association*. New York: Harrison, 1853.

Peterson, Jon A. *The Birth of City Planning in the United States: 1840–1914.* Baltimore, MD: Johns Hopkins University Press, 2003.

———. "The City Beautiful Movement: Forgotten Origins and Lost Meanings." *Journal of Urban History* 2, no. 4 (August 1976): 415–34.

Petrie, W. M. Flinders. *Naukratis.* Part 1: *1884–85.* London: Trübner & Co., 1886.

Petronius. *The Satyricon.* Translated by Michael Heseltine. Cambridge, MA: Harvard University Press, 1913.

The Pennsylvania Railroad Company. *Centennial History of the Pennsylvania Railroad Company: 1846–1946.* Philadelphia: Pennsylvania Railroad Company, 1949.

———. *The History of the Engineering Construction and Equipment of the Pennsylvania Railroad Company's New York Terminal and Approaches.* New York: Isaac H. Blanchard Co., 1912.

———. *The New York Improvement and Tunnel Extension of the Pennsylvania Railroad.* Philadelphia: Pennsylvania Railroad Company, 1910.

Picón, Carlos. "A History of the Department of Greek and Roman Art." In *Art of the Classical World in the Metropolitan Museum of Art: Greece, Cyprus, Etruria, Rome,* edited by Carlos Picón et al., 3–23. New York: Metropolitan Museum of Art, 2007.

Piranomonte, Marina. "Thermae Antoninianae." In *Lexicon Topographicum Urbis Romae,* vol. 5: *T–Z, Addenda et corrigenda,* edited by Eva Margareta Steinby, 46–48. Rome: Edizioni Quasar, 1996.

Pierson, William H., Jr. *American Buildings and Their Architects.* Vol. 1: *The Colonial and Neoclassical Styles.* New York: Oxford University Press, 1970.

"The Post Office Site." *New York Times,* May 4, 1912, 12.

Potvin, John. "Vapour and Steam: The Victorian Turkish Bath, Homosocial Health, and Male Bodies on Display." *Journal of Design History* 18, no. 4 (2005): 319–33.

Powell, Kenneth. *Grand Central Terminal: Warren and Wetmore.* London: Phaidon, 1996.

"Preserve City Hall Park." *New York Times,* May 4, 1911, 10.

"Public Baths." *The Sun,* March, 31 1891.

"Public Baths and Civic Improvement in Nineteenth-Century German Cities." *Journal of Urban History* 14 (May 1988): 372–93.

"Public Library Plans." *New-York Tribune,* December 5, 1897.

Quinn, Josephine Crawley. Review of *Ancient Worlds: An Epic History of East and West* by Michael Scott. *Times Literary Supplement* (January 6, 2017): 27.

Raver, Anne. "New York's Roses, Home to Root." *New York Times,* April 29, 2009.

Redford, Scott, ed. *Antioch on the Orontes: Early Explorations in the City of Mosaics.* Istanbul: Koç Üniversitesi Yayinlari, 2014.

Reed, Henry Hope. *The New York Public Library: Its Architecture and Decoration.* New York: Norton, 1986.

Reid, Jane Davidson. *The Oxford Guide to Classical Mythology in the Arts, 1300–1990s.* 2 Vols. Oxford: Oxford University Press, 1993.

Reinhold, Meyer. *Classica Americana: The Greek and Roman Heritage in the United States.* Detroit, MI: Wayne State University Press, 1984.

Reiss, Marcia. *Lost New York.* New York: Pavilion, 2011.

Renner, Andrea. "A Nation That Bathes Together: New York City's Progressive Era Public Baths." *Journal of the Society of Architectural Historians* 67, no. 4 (December 2008): 512–16.

Reps, John W. *Monumental Washington: The Planning and Development of the Capital Center.* Princeton, NJ: Princeton University Press, 1967.

Reynolds, Donald Martin. *The Architecture of New York City, Histories and Views of Important Structures, Sites, and Symbols.* New York: Macmillan, 1984.

Richard, Carl J. *The Founders and the Classics: Greece, Rome, and the American Enlightenment.* Cambridge, MA: Harvard University Press, 1994.

———. *The Golden Age of the Classics in America: Greece, Rome, and the Antebellum United States.* Cambridge, MA: Harvard University Press, 2009.

Richard, Pascale. *Versailles: The American Story.* Translated by Barbara Mellor. Paris: Alain de Gourcuff Editeur, 1999.

Richards, Jeffrey. *Hollywood's Ancient Worlds.* London: Continuum, 2008.

Richardson, William Symmes. "The Architectural Motif of the Pennsylvania Station." In *The History of the Engineering Construction and Equipment of the Pennsylvania Railroad Company's New York Terminal and Approaches,* edited by William M. Couper, 77–78. New York: Isaac H. Blanchard Co., 1912.

———. "The Terminal—The Gate of the City." *Scribner's Magazine* 52, no. 4 (October 1912): 401–16.

Richter, Gisela. "The Department of Greek and Roman Art: Triumphs and Tribulations." *Metropolitan Museum Journal* 3 (1970): 73–95.

———. *Handbook of the Classical Collection.* 5th ed. New York: Metropolitan Museum of Art, 1927.

———. *The Metropolitan Museum of Art Handbook of the Classical Collection.* New [6th] ed. New York: Metropolitan Museum of Art, 1930.

———. *My Memoirs: Recollections of an Archaeologist's Life.* Rome: privately published, 1970.

Richter, Gisela, with Christine Alexander. *Augustan Art: An Exhibition Commemorating the Bimillennium of the Birth of Augustus.* New York: Metropolitan Museum of Art, 1939.

Riencourt, Amaury de. *The Coming Caesars.* New York: Coward-McCann, 1957.

Riis, Jacob. *The Battle with the Slum.* New York: Macmillan, 1902.

Robinson, Charles Mulford. *The Improvement of Towns and Cities.* New York: G. P. Putnam's Sons, 1901.

Robinson, Edward. "New Greek and Roman Acquisitions." *Bulletin of the Metropolitan Museum of Art* 2, no.1 (January 1907): 5–9.

Rockefeller Group, Inc. *The Facts of Rockefeller Center.* New York: Rockefeller Group, Inc., 1994.

Rodgers, David. "London, British Museum." In *The Oxford Companion to Western Art.* http://www .oxfordartonline.com/subscriber/article/opr/t118/e1500.

"Rome's Baths Eclipsed; The Palatial Establishment Which James Everard Has Completed." *Daily Graphic,* May 5, 1888.

Ross, William. "Plan, Elevation, Section, &c., with a Descriptive Account of the Improvements Lately Made at the Custom House, New York." *Architectural Magazine* 2 (December 1835): 525–33.

———. "Street Houses of the City of New York." *Architectural Magazine* 2 (November 1835): 490–93.

Rostovtzeff, Michael, et al. *The Excavations at Dura-Europos, Preliminary and Final Reports.* New Haven, CT; Los Angeles; Ann Arbor: Yale University Press; University of California Press; University of Michigan Press, 1929–2001.

Roth, Leland. *A Concise History of American Architecture.* Boulder, CO: Westview, 1979.

———. *McKim, Mead & White, Architects.* New York: Harper & Row, 1983.

Roussel, Christine. *The Art of Rockefeller Center.* New York: Norton, 2006.

Russell, Ben. *The Economics of the Roman Stone Trade.* Oxford Studies on the Roman Economy. Oxford: Oxford University Press, 2014.

"Russian and Turkish Baths, New York City." *Journal Descant* 141 (January 2008): 89.

Rydell, Richard W. *All the World's a Fair: Visions of Empire at American International Expositions, 1876–1916.* Chicago: University of Chicago, 1984.

Sachs, Bernard, "Charles Loomis Dana: An Appreciation." *Journal of Nervous and Mental Disease* 83 (1936): 249–51.

Salsbury, Stephen. *No Way to Run a Railroad: The Untold Story of the Penn Central Crisis.* New York: McGraw-Hill, 1982.

Santora, Marc. "After a Big Gift, a New Name for the Library," *New York Times*, April 23, 2008.

"Save City Hall Park Now." *New York Times*, June 30, 1911, 8.

Schlichting, Kurt. "Grand Central Terminal and the City Beautiful in New York." *Journal of Urban History* 22, no. 3 (March 1996): 332–49.

———. *Grand Central Terminal: Railroads, Engineering, and Architecture in New York*. Baltimore, MD: Johns Hopkins University Press, 2001.

Schotter, H. W. *The Growth and Development of the Pennsylvania Railroad Company: A Review of the Charter and Annual Reports of the Pennsylvania Railroad Company 1846 to 1926, Inclusive*. Philadelphia: Allen, Lane & Scott, 1927.

Schuman, Henry, "The American Physician as Poet." *Bulletin of the Medical Library Association* 32, no. 1 (1944): 73–84.

Scobey, David Moisseiff. "Empire City: Politics, Culture, and Urbanism in Gilded Age New York." PhD diss., Yale University, 1989.

Scott, Geoffrey, *The Architecture of Humanism: A Study in the History of Taste*. New York: Norton, 1974.

Scott, Mel. *American City Planning since 1890*. Berkeley: University of California Press, 1969.

———. *The San Francisco Bay Area: A Metropolis in Perspective*. Berkeley: University of California Press, 1959.

Scriptores Historiae Augustae. Translated by David Magie. Cambridge, MA: Harvard University, 1921.

Seneca the Younger. *Moral Essays*. Vol. 2: *De Consolatione ad Marciam, De Vita Beata, De Otio, De Tranquillitate Animi, De Brevitate Vitae, De Consolatione ad Polybium, De Consolatione ad Helviam*, trans. John W. Basore. Cambridge, MA: Harvard University Press, 1932.

Shepard, Richard F. "Broadway That Once Was." *New York Times*, February 4, 1977.

Shepherd, Barnett. "Sailors' Snug Harbor Reattributed to Minard Lafever." *Journal of the Society of Architectural Historians* 35, no. 2 (May 1976): 108–23.

Silk, Michael, Ingo Gildenhard, and Rosemary Barrow, eds. *The Classical Tradition: Art, Literature, Thought*. Oxford: Wiley-Blackwell, 2014.

Silver, Nathan. *Lost New York*. Boston: Houghton Mifflin, 1967.

Simard, Jared. "Classics and Rockefeller Center: John D. Rockefeller Jr. and the Use of Classicism in Public Space." PhD diss., The Graduate Center, The City University of New York, 2016.

Smith, Bertha H. "The Public Bath." *Outlook* 79, no. 4 (March 1905): 571.

Sobel, Robert. *The Fallen Colossus*. New York: Weybright and Talley, 1977.

Solomon, Jon. *The Ancient World in Cinema*. Rev. ed. New Haven, CT: Yale University Press, 2001.

Sox, David. *Bachelors of Art: Edward Perry Warren and the Lewes House Brotherhood*. London: Fourth Estate, 1991.

Stager, L. E. "Eroticism and Infanticide at Ashkelon." *Biblical Archaeology Review* 17, No. 4. (July–August 1991): 34–35.

"A State Building Needed." *New York Times*, April 13, 1915, 10.

"State Departments Want Building Here." *New York Times*, December 30, 1912, 10.

Stern, Robert A. M., Gregory Gilmartin, and John M. Massengale, eds. *New York 1900: Metropolitan Architecture and Urbanism, 1890–1915*. New York: Rizzoli, 1983.

Stiles, Henry R. *A History of the City of Brooklyn*. Brooklyn: published by subscription, 1869.

Stilgoe, John. *Metropolitan Corridor: Railroads and the American Scene*. New Haven, CT: Yale University Press, 1983.

Strouse, Jean. "J. Pierpont Morgan: Financier and Collector." *Bulletin of the Metropolitan Museum of Art* 57, no. 3 (Winter 2000): 3–64.

———. *Morgan, American Financier*. New York: Random House, 1999.

"Straighten Baxter Street." *New York Times*, January 26, 1912, 4.

Stuart, James, and Nicholas Revett. *The Antiquities of Athens.* 4 Vols. London: printed by John Haberkorn, 1762–1816.

———. *The Antiquities of Athens.* Edited by Frank Salmon. New York: Princeton Architectural Press, 2008.

Sutcliffe, Anthony. *Metropolis 1890–1940.* Chicago: University of Chicago Press, 1984.

Sweet, Rebecca. "William Gell and *Pompeiana* (1817–19 and 1832)." *Papers of the British School at Rome* 83 (2015): 245–81.

Sutherland, C. H. V., and R. A. G. Carson, eds. *Roman Imperial Coinage.* Vol. 1: *From 31 BC to AD 69.* 2nd ed. London: Spink, 1984.

Tassel, Janet. "Antioch Revealed." *Harvard Magazine,* November 1, 2000.

Taylor, William R. *In Pursuit of Gotham: Culture and Commerce in New York.* New York: Oxford University Press, 1992.

"Test Borings Urged for Court House." *New York Times,* May 3, 1914, S4.

Theodorakopoulos, Elena. *Ancient Rome and the Cinema: Story and Spectacle in Hollywood and Rome.* Exeter: Bristol Phoenix, 2010.

Thomas, Edmund. "The Architectural History of the Pantheon from Agrippa to Septimius Severus via Hadrian." *Hephaistos* 15 (1997): 163–86.

Thompson, Homer. "Gisela M. A. Richter (1882–1972)." *American Philosophical Society Yearbook* (1973): 144–50.

"To Take Court House Site." *New York Times,* July 18, 1913, 8.

Tolles, Thayer. "Modeling a Reputation: The American Sculptor and New York City." In *Art and the Empire City: New York, 1825–1861,* edited by Catherine Hoover Voorsanger and John K. Howat, 135–68. New Haven, CT: Yale University Press, 2000.

Todd, Robert E. "The Municipal Baths of Manhattan." *Charities* 19 (October 19, 1907): 897–99.

Toner, J. P. *Leisure and Ancient Rome.* Cambridge: Polity, 1996.

Torres, Louis. "Federal Hall Revisited." *Journal of the Society of Architectural Historians* 29, no. 4 (December 1970): 327–38.

———. "John Frazee and the New York Custom House." *Journal of the Society of Architectural Historians* 23, no. 3 (October 1964): 143–50.

———. "Samuel Thomson and the Old Custom House." *Journal of the Society of Architectural Historians* 20, no. 4 (December 1961): 185–90.

Tompkins, Calvin. *Merchants and Masterpieces: The Story of the Metropolitan Museum of Art.* Rev. ed. New York: Dutton, 1989.

Trachtenberg, Alan. *The Incorporation of America: Culture and Society in the Gilded Age.* New York: Hill and Wang, 1982.

Truman, Benjamin. *History of the World's Fair: Being a Complete and Authentic Description of the Columbian Exposition from Its Inception.* Philadelphia: J. W. Keller & Co., 1893.

Tucci, Pier Luigi. "The Materials and Techniques of Greek and Roman Architecture." In *The Oxford Handbook of Greek and Roman Art and Architecture,* edited by Clemente Marconi, 242–65. New York: Oxford University Press, 2015.

Tunnard, Christopher, and Henry Hope Reed, *American Skyline: The Growth and Form of Our Cities and Towns.* New York: New American Library, 1956.

Turner, Frederick J. *The Significance of the Frontier in American History.* 1893. Ann Arbor: University of Michigan, 1966.

Turner, Jane. *Encyclopedia of American Art before 1914.* Oxford: Oxford University Press, 2002.

"U.S. Custom House, 28 Wall Street, New York, New York County, NY." Historic American Buildings Survey, National Park Service, US Department of the Interior. Prints and Photographs Division, Library of Congress. http://www.loc.gov/pictures/item/ny0363.

Van Slyck, Abigail A. *Free to All: Carnegie Libraries and American Culture, 1890–1920.* Chicago: University of Chicago, 1995.

Venturi, Robert. *Complexity and Contradiction in Architecture.* New York: Museum of Modern Art, 1977.

Vermeule, Cornelius. "Gisela M. A. Richter." *Burlington Magazine* 115 (1973): 329.

———. *Greek and Roman Sculpture in America: Masterpieces in Public Collections in the United States and Canada.* Malibu, CA: J. Paul Getty Museum, 1981.

———. "Roman Sarcophagi in America: A Short Inventory." In *Festschrift für Friedrich Matz,* edited by Nikolaus Himmelmann and Hagen Biesantz, 98–109. Mainz: Philip von Zabern, 1962.

Verplanck, Gulian C. *An Address Delivered at the Opening of the Tenth Exhibition of the American Academy of the Fine Arts.* New York: Charles Wiley, 1824.

von Bothmer, Dietrich, and Joseph Noble. "An Inquiry into the Forgery of the Etruscan Terracotta Warriors in the Metropolitan Museum of Art." *Metropolitan Museum of Art Papers* 11 (1961).

von Mercklin, Eugen. *Antike Figuralkapitelle.* Berlin: De Gruyter, 1962.

von Stackelberg, Katharine T., and Elizabeth Macaulay-Lewis. "Introduction: Architectural Reception and the Neo-Antique." In *Housing The New Romans: Architectural Reception and the Classical Style in the Modern World,* edited by Katharine T. von Stackelberg and Elizabeth Macaulay-Lewis, 1–23. New York: Oxford University Press, 2017.

Voorsanger, Catherine Hoover, and John K. Howat, eds. *Art and the Empire City: New York, 1825–1861.* New Haven, CT: Yale University Press, 2000.

Voss, Frederick S. "John Frazee." *American National Biography Online.* http://www.anb.org/articles/17/17-00297.html.

Wagner, George. "Freedom and Glue: Architecture, Seriality, and Identity in the American City." *Harvard Architecture Review* 8 (1992): 66–91.

Walker, John Brisben. "The City of the Future: A Prophecy." *The Cosmopolitan* 31 (May– October 1901): 473–75.

———. "Public Baths for the Poor." *The Cosmopolitan* 9 (August 1890): 420–21.

Warner, John DeWitt. "Civic Centers." *Municipal Affairs* 6, no. 1 (March 1902): 1–23.

Watkin, David. *The Roman Forum.* Cambridge, MA: Harvard University Press, 2009.

Webb, Alfred. *A Compendium of Irish Biography: Comprising Sketches of Distinguished Irishmen.* Dublin: Gill & Son, 1878.

Webster, Sally. *The Nation's First Monument and the Origins of the American Memorial Tradition: Liberty Enshrined.* Burlington, VT: Ashgate, 2015.

Weisman, Winston. "Who Designed Rockefeller Center?" *Journal of the Society of Architectural Historians* 10, no. 1 (March 1951): 11–17.

Westinghouse Church Kerr & Company Engineers. *The New York Passenger Terminal and Improvement of the Pennsylvania and Long Island Railroads Relating to Work Performed by Westinghouse Church Kerr & Co. Engineers.* New York: 1910.

Wharton, Edith. *The Age of Innocence.* New York: Collier, 1987.

Wheeler, Candace. "The Dream City." *Harper's Monthly* 86 (1893): 830–46.

Whitaker, Charles H., ed. *Bertram Grosvenor Goodhue, Architect and Master of Many Arts.* New York: American Institute of Architects Press, 1925.

White, Norval, and Elliot Willensky, with Fran Leadon. *AIA Guide to New York City.* 5th ed. New York: Oxford University Press, 2010.

White, Richard. "Frederick Jackson Turner and Buffalo Bill." In *The Frontier in American Culture: An Exhibition at the Newberry Library, August 26, 1994–January 7, 1995,* edited by Richard White, Patricia N. Limerick, and James R. Grossman, 7–66. Berkeley: University of California Press, 1994.

White, Roger. "Gibbs, James." Grove Art Online, Oxford Art Online. http://www.oxfordartonline.com/subscriber/article/grove/art/T032107.

White, Samuel, and Elizabeth White. *McKim, Mead & White: The Masterworks.* New York: Rizzoli, 2003.

Whitmarsh, Tim. "True Histories: Lucian, Bakhtin, and the Pragmatics of Reception." In *Classics and the Uses of Reception,* edited by Charles Martindale and Richard Thomas, 104–15. Malden, MA: Blackwell, 2006.

Wilkie, Jacqueline S. "Submerged Sensuality: Technology and Perceptions of Bathing." *Journal of Social History* 19 (1986): 649–64.

Williams, Marilyn T. *Washing "the Great Unwashed": Public Baths in Urban America, 1840–1920.* Columbus: Ohio State University, 1991.

Wilson, Richard. G. "The Great Civilization." In *The American Renaissance, 1876–1917,* 9–72. New York: Pantheon, 1979.

———. "The Ideology, Aesthetics, and Politics of the City Beautiful Movement." In *The Rise of Modern Urban Planning, 1800–1914,* edited by Anthony Sutcliffe, 165–97. London: Mansell, 1980.

———. "J. Horace Mcfarland and the City Beautiful Movement." *Journal of Urban History* 7, no. 3 (May 1981): 315–35.

———. *McKim, Mead and White Architects.* New York: Harper and Row, 1983.

Wilson, William H. *The City Beautiful Movement.* Baltimore, MD: Johns Hopkins University Press, 1989.

Wilson Jones, Mark. *Principles of Roman Architecture.* New Haven, CT: Yale University Press, 2000.

Wing, Frank E. "The Popularization of a Public Bath-House." *Charities* 14 (April 29, 1905: 694–96.

Wingate, Charles F. *St. Paul's Chapel: The Oldest Public Building and the Only Colonial Church Edifice in New York City.* New York: Albert B. King & Co., 1905.

Winkler, Martin M., ed. *Cinema and Classical Texts: Apollo's New Light.* Cambridge: Cambridge University Press, 2009.

———. *Classics and Cinema.* Lewisburg, PA: Bucknell University Press, 1991.

Winterer, Caroline. *The Culture of Classicism: Ancient Greece and Rome in American Intellectual Life, 1780–1910.* Baltimore, MD: Johns Hopkins University Press, 2002.

———. *The Mirror of Antiquity: American Women and the Classical Tradition, 1750–1900.* Ithaca, NY: Cornell University Press, 2007.

Wirszubski, C. H. *Libertas as a Political Idea at Rome During the Late Republic and Early Principate.* Cambridge: Cambridge University Press, 1950.

Witchey, Holly Rarick, Andrew T. Chakalis, and Cleveland Museum of Art. *Progressive Vision: The Planning of Downtown Cleveland, 1903–1930.* Cleveland, OH: Cleveland Museum of Art, 1986.

Wolf, Norbert. *Art Deco.* Munich: Prestel, 2013.

Wood, Ghislaine. *Essential Art Deco.* Boston: Bulfinch, 2003.

Woodbridge, Sally B. *John Galen Howard and the University of California: The Design of a Great Public University Campus.* Berkeley: University of California, 2002.

Wright, J. H. "Review of Naukratis, Part I." *American Journal of Archaeology and of the History of Fine Arts* 3, no. 1/2 (June 1887): 102–10.

Wyke, Maria. *Projecting the Past: Ancient Rome, Cinema, and History.* London: Routledge, 1997.

Yablon, Nick. "'A Picture Painted in Fire': Pain's Reenactments of *The Last Days of Pompeii,* 1879–1914." In *Antiquity Recovered: The Legacy of Pompeii and Herculaneum,* edited by Victoria Gardner Coates and Jon L. Seydl, 189–206. Los Angeles: J. Paul Getty Museum, 2007.

Yaggy, Levi, and Thomas Haines. *Museum of Antiquity—A Description of Ancient Life: The Employments, Amusements, Customs and Habits, The Cities, Palaces, Monuments and Tombs, The Literature and Fine Arts of 3,000 Years Ago.* Chicago: Western Publishing House, 1882.

Yegül, Fikret. *Baths and Bathing in Classical Antiquity.* Cambridge, MA: MIT Press, 1992.

Yetter, George Humphrey. "Stanford White at the University of Virginia: Some New Light on an Old Question." *Journal of the Society of Architectural Historians* 40, no. 4 (December 1981): 320–25.

Zanker, Paul. "Greek Art in Rome: A New Center in the First Century BC." In *Pergamon and the Hellenistic Kingdoms of the Ancient World,* edited by Carlos Picón and Seán Hemingway, 92–99. New York: Metropolitan Museum of Art, 2016.

Zueblin, Charles. "The Civic Renascence: 'The White City' and After." *Chautauquan* 38 (December 1903): 373–84.

Elizabeth Bartman is an independent scholar and past president of the Archaeological Institute of America. Her work focuses on Roman sculpture and its afterlife, and her books include *Ancient Sculptural Copies in Miniature* (Brill, 1992), *Portraits of Livia: Imaging the Imperial Woman in Augustan Rome* (Cambridge, 1999), and *The Ince Blundell Collection of Classical Sculpture*, vol. 3: *The Ideal Sculpture* (Liverpool, 2017). She is currently working on a study of the modern restoration of ancient marbles.

Maryl B. Gensheimer is a historian of Roman art and archaeology. Her research focuses on the art and architecture of the city of Rome, on the Bay of Naples, and in Asia Minor. She is particularly interested in ancient cities and urban life and on the social structures and interdependent systems of urban design and urban infrastructure that affected the ancient experience of monuments and spaces. Her work has been recognized by the Archaeological Institute of America, Lemmermann Foundation, Mellon Foundation, Society of Architectural Historians, and US-Italy Fulbright Commission. Her first book, *Decoration and Display in Rome's Imperial Thermae: Messages of Power and Their Popular Reception at the Baths of Caracalla*, is forthcoming from Oxford University Press.

Elizabeth Macaulay-Lewis is assistant professor and the acting executive officer of the MA program in Liberal Studies at the Graduate Center, the City University of New York. She is interested in the gardens and architecture of the Middle East and North Africa in the classical and Islamic periods and in their reception. She has published on a wide range of topics, from the topography of Roman Damascus to the reception of classical and Egyptian architecture in New York City. Her books include *Housing the New Romans: Architectural Reception and Classical Style in the Modern World* (Oxford 2017) and *Bayt Farhi and the Sephardic Palaces of Ottoman Damascus in the Late Eighteenth and Nineteenth Centuries* (Manar al-Athar / ASOR, 2018). She is deputy director of the open-access photo archive Manar al-Athar (www.manar-al-athar.ox.ac.uk) and co-director of the Upper Egypt Mosque Project.

Margaret Malamud is professor of ancient history and Islamic history at New Mexico State University. She is coeditor of and contributor to *Imperial Projections: Ancient Rome in Modern Popular Culture* (John Hopkins, 2001) and author of *Ancient Rome and Modern*

America (Wiley-Blackwell, 2009) and *African Americans and the Classics: Antiquity, Abolition, and Activism* (I. B. Tauris, 2016).

Allyson McDavid is assistant professor of material and visual culture of the ancient world at Parsons School of Design, in New York City. She teaches art and architectural design history, theory, and practice. She received her PhD in 2015 in architectural history and archaeology from the Institute of Fine Arts at New York University. She has an MA in the architectural history of Anatolian civilizations and cultural heritage management from Koç University in Istanbul, Turkey, and an MArch from the University of California–Berkeley. Her work focuses on the renovation, conservation, and sustainability of the built environment and the applications of history and theory to contemporary design, and she has published on the Hadrianic Baths of Aphrodisias in late antiquity.

Matthew M. McGowan is associate professor and chair of classics at Fordham University. His research focuses mainly on Roman poetry, ancient scholarship, and classical reception, in particular Neo-Latin. He has published broadly on a variety of Greek and Latin topics and is the author of *Ovid in Exile: Power and Poetic Redress in the* Tristia *and* Epistulae ex Ponto (Brill, 2009). He was president of the New York Classical Club (2009–15) and is now vice president for communications and outreach for the Society for Classical Studies.

Francis Morrone is an architectural historian and writer. He is the author of eleven books, including *Guide to New York City Urban Landscapes* (Norton, 2013) and, with Henry Hope Reed, *The New York Public Library: The Architecture and Decoration of the Stephen A. Schwarzman Building* (Norton, 2011), as well as architectural guidebooks to New York City, Philadelphia, and Brooklyn. He was for six years an art and architecture critic for the *New York Sun*. He teaches architectural and urban history at New York University's School of Professional Studies, where he was a recipient of the university's Excellence in Teaching Award. He was named by *Travel + Leisure* as one of the thirteen best tour guides in the world.

Jon Ritter is clinical associate professor in New York University's Department of Art History, where he is assistant director for both the Urban Design and Architecture Studies Program and the London-based MA in Historical and Sustainable Architecture. He earned his BA in history from Yale College in 1988 and his PhD in art history from from the Institute of Fine Arts at New York University in 2007. He currently serves as president of the New York Metropolitan chapter of the Society of Architectural Historians.

Jared A. Simard is a postdoctoral faculty fellow at New York University. His research and publications focus on mythology and its reception in the public artworks of ur-

ban spaces. He has recently published articles on mythologically inspired material culture in New York City. He is currently working on his first book, on the classical influences on John D. Rockefeller Jr., Rockefeller Center, and its art program. He is also the founder and director of Mapping Mythology (mappingmythology.com), a digital collection of classical mythology in postantique art.

INDEX OF GREEK, LATIN, AND BIBLICAL SOURCES

Select titles from Empire State Editions

Patrick Bunyan, *All Around the Town: Amazing Manhattan Facts and Curiosities, Second Edition*

Salvatore Basile, *Fifth Avenue Famous: The Extraordinary Story of Music at St. Patrick's Cathedral*. Foreword by Most Reverend Timothy M. Dolan, Archbishop of New York

William Seraile, *Angels of Mercy: White Women and the History of New York's Colored Orphan Asylum*

Andrew J. Sparberg, *From a Nickel to a Token: The Journey from Board of Transportation to MTA*

New York's Golden Age of Bridges. Paintings by Antonio Masi, Essays by Joan Marans Dim, Foreword by Harold Holzer

Anthony D. Andreassi, C.O., *Teach Me to Be Generous: The First Century of Regis High School in New York City*. Foreword by Timothy Michael Cardinal Dolan, Archbishop of New York

Daniel Campo, *The Accidental Playground: Brooklyn Waterfront Narratives of the Undesigned and Unplanned*

Gerard R. Wolfe, *The Synagogues of New York's Lower East Side: A Retrospective and Contemporary View, Second Edition*. Photographs by Jo Renée Fine and Norman Borden, Foreword by Joseph Berger

Joseph B. Raskin, *The Routes Not Taken: A Trip Through New York City's Unbuilt Subway System*

Phillip Deery, *Red Apple: Communism and McCarthyism in Cold War New York*

North Brother Island: The Last Unknown Place in New York City. Photographs by Christopher Payne, A History by Randall Mason, Essay by Robert Sullivan

Richard Kostelanetz, *Artists' SoHo: 49 Episodes of Intimate History*

Stephen Miller, *Walking New York: Reflections of American Writers from Walt Whitman to Teju Cole*

Tom Glynn, *Reading Publics: New York City's Public Libraries, 1754–1911*

R. Scott Hanson, *City of Gods: Religious Freedom, Immigration, and Pluralism in Flushing, Queens*. Foreword by Martin E. Marty

Dorothy Day and the Catholic Worker: The Miracle of Our Continuance. Edited, with an Introduction and Additional Text by Kate Hennessy, Photographs by Vivian Cherry, Text by Dorothy Day

Pamela Lewis, *Teaching While Black: A New Voice on Race and Education in New York City*

Mark Naison and Bob Gumbs, *Before the Fires: An Oral History of African American Life in the Bronx from the 1930s to the 1960s*

Robert Weldon Whalen, *Murder, Inc., and the Moral Life: Gangsters and Gangbusters in La Guardia's New York*

Joanne Witty and Henrik Krogius, *Brooklyn Bridge Park: A Dying Waterfront Transformed*

Sharon Egretta Sutton, *When Ivory Towers Were Black: A Story about Race in America's Cities and Universities*

Pamela Hanlon, *A Wordly Affair: New York, the United Nations, and the Story Behind Their Unlikely Bond*

Britt Haas, *Fighting Authoritarianism: American Youth Activism in the 1930s*

David J. Goodwin, *Left Bank of the Hudson: Jersey City and the Artists of 111 1st Street*. Foreword by DW Gibson

Nandini Bagchee, *Counter Institution: Activist Estates of the Lower East Side*

Carol Lamberg, *Neighborhood Success Stories: Creating and Sustaining Affordable Housing in New York*

Susan Celia Greenfield (ed.), *Sacred Shelter: Journeys of Homelessness and Healing*

Susan Opotow and Zachary Baron Shemtob (eds.), *New York after 9/11*

Andrew Feffer, *Bad Faith: Teachers, Liberalism, and the Origins of McCarthyism*

For a complete list, visit www.empirestateeditions.com.